VICTORIAN ILLUSTRATION

FOR CORINNA

VICTORIAN ILLUSTRATION

The Pre-Raphaelites, the Idyllic School and the High Victorians

PAUL GOLDMAN

Lund Humphries

First published in Great Britain in 1996 by Scolar Press

This paperback edition first published in Great Britain in 2004 by

Lund Humphries Suite 420
Gower House 101 Cherry Street
Croft Road Burlington
Aldershot VT 05401–4405
Hants GU11 3HR USA

British Library Cataloguing in Publication Data
A catalogue record from this book is available from the British Library

ISBN 0 85331 904 9

Library of Congress Control Number: 2004101601

Typeset in Bembo by Bournemouth Colour Press
Cover design by Chrissie Charlton & Co
Printed in China by Compass Press Ltd

Front cover: *Legend of the Portent*, Frederick Sandys (see pl.2.16, p.74)
Back cover: *Count Burkhardt*, James McNeil Whistler (see pl.5.22, p.257)

Contents

v

Plates

The illustrations in this book average 160 X 125mm

PLATES

Preface

This book aims to provide the reader with a reasoned and a comprehensive corpus of a substantial proportion of the wood-engraved book and magazine illustrations of the period generally referred to as 'The Sixties'. The two pioneering accounts by Gleeson White (1897) and Forrest Reid (1928) (see Select bibliography) remain unsurpassed, and my intention here has been to produce a work which it is hoped will complement them. While both my predecessors dealt with a larger number of artists, I have restricted myself to 31 whom I consider to be of interest and importance judged chiefly from an art-historical point of view. Unlike White or Reid, however, I have given more purely bibliographical information where it proved available, and I have also identified the engravers of most of the illustrations when it has been possible to ascertain them. Such an approach, which excludes certain undeniably major artists, inevitably lays the author open to criticism, but I have my reasons. For example, I felt it would have been superfluous to repeat here the detailed and exhaustive work done by Jan Reynolds on Birket Foster or Rodney Engen on Tenniel.[1] Similarly I decided against dealing with Walter Crane who, although an artist who sometimes worked in black and white, was nevertheless, primarily an outstanding illustrator in colour and hence lies beyond the field of this study. Other artists such as the prolific John Gilbert have also been omitted, largely for reasons of space.

The period covered is roughly 1855–80 although for the sake of completeness I have included one or two works which overlap at either end. It would have been over-rigid to have excluded Millais's very first illustration – the frontispiece to *Mr Wray's Cash-Box* because it appeared in 1852, or *Dalziel's Bible Gallery* simply on account of it not having reached publication until 1881. Both works belong in spirit and in style to the Sixties and in the case of the latter, nearly all the designs were prepared and engraved during the central years. It should also be stressed that the era is a crowded one, with so many books and magazines being published that I can offer no guarantee of completeness in the indices, in which I attempt to identify all the illustrations produced by the artists dealt with in the chapters. Unless stated to the contrary, I have examined every item discussed and thus aim, if nothing else, to provide some sort of 'bibliocritical' description of all that I have been able to study. I have also restricted myself entirely to published illustrations and do not list any projects which did not reach publication. I also include only designs which were made as original illustrations and, with the occasional exception, ignore reproductions of paintings or drawings or contributions made by some of these artists to comic magazines, notably *Punch*.

Since imaginative illustration to literature is at the core of this work, books dealing with topography, technical matters and reportage are largely outside its scope, as are similarly comic picture-books or toy books. However, even here there are exceptions to be found, especially among the oeuvres of Charles Keene, George du Maurier and Arthur Boyd Houghton. The treatment of the artists is essentially critical rather than biographical – readers searching for biographical detail should consult the invaluable *Dictionary of Victorian Wood Engravers* (Cambridge, 1985) by Rodney Engen. This book does not attempt to provide a detailed examination of the work of the engravers, crucially important though they are. Another entire book would be needed for a fair treatment of their contribution to the period.

The five chapters contain chronological discussion of each artist, with the magazine illustrations (where relevant) being dealt with before the book illustrations. After the comment on each practitioner there is a checklist of the books illustrated or contributed to. Further and more detailed bibliographical information on every volume included here, will be found in the Index of illustrated books which is arranged by author. All books referred to in the text were published in London unless otherwise noted. The exact date and position of any magazine design is provided in the Index of magazine illustrations which is arranged chronologically within each periodical. The artists themselves are listed here in alphabetical order.

Note

1 Jan Reynolds, *Birket Foster*, 1984; Rodney Engen, *Sir John Tenniel: Alice's White Knight*, Aldershot, 1991.

Acknowledgements

Many people have helped me in numerous ways and I wish to record here the names of those who have so patiently and sometimes so frequently answered enquiries in person, by letter or by telephone. Others have permitted me access to collections both public and private and several have been responsible for photography or have helped me over technical matters. I have pored over innumerable dealers' catalogues and have frequently been led to obscure publications I might never have discovered in so doing. I am deeply grateful to all who have assisted me: Clifford Ackley, Sarah Lou Ashby, Christopher Bacon, John Barr, Stephen Coppel, Morna Daniels, Robin de Beaumont, Anne de Lara, Jude de Lima, Christine Dixon, Amanda-Jane Doran, Paul Dove, Inge Dupont, Rodney Engen, George Fletcher, the late William E. Fredeman, Colin Harrison, Kate Hebditch, the late Ian Hodgkins, Simon Houfe, the late Gordon Huelin, Fiona James, Edmund King, Lionel Lambourne, Shelley Langdale, Brian Last, Kevin Lovelock, Heulwen Matthews, Claire Messenger, Frankie Morris, Sue Reed, Leonard Roberts, Angela Roche, Barbara Schapiro, Pamela White Trimpe and John Williams.

I also acknowledge the help given by the staffs of the following institutions: The British Museum, Department of Prints and Drawings; The Victoria and Albert Museum, Department of Paintings, Drawings and Photographs and the National Art Library; The British Library, Department of Printed Books, Department of Manuscripts and Newspaper Library, Colindale; The University of London Library (Senate House) and University College, London Library; The London Library; The *Punch* Archive, London; The Society for Promoting Christian Knowledge Archive, London; The National Library of Wales, Aberystwyth; The Hunterian Art Gallery, Glasgow; The Ashmolean Museum, Oxford (Forrest Reid Collection); The Pierpont Morgan Library, New York; The Museum of Fine Arts, Boston; The National Gallery of Australia, Canberra.

Additional thanks are due to Robin de Beaumont and Rodney Engen who read portions of the text in manuscript and made helpful comments and criticisms. Finally I must thank Nigel Farrow, the Chairman of Ashgate Publishing, for enabling and encouraging me to bring the book to fruition, Ellen Keeling who was responsible for the production and my editor, Rachel Lynch. My greatest debt of gratitude is to my wife, Corinna, who has not only inputted one of the longest files but has endured living with the Sixties over several years with constant interest, good humour, and unfailing support. For the new edition, I wish to thank also Beryl Gray, Gregory Jones and Maroussia Oakley who have so generously given me the benefits of their discoveries.

PAUL GOLDMAN

Introduction

The 1860s saw one of the most remarkable, crowded and complex periods in English publishing and illustration. In contrast to the 1820s and 1830s, wood-engraving now became the dominant medium for the reproduction of the designs, and developments in printing technology meant that more publications than ever before contained illustrations. Changes in education and a growth in literacy enlarged the readership, and economic developments ensured that publishers could afford to produce material on a scale unheard of in previous years. There was also money available to pay artists, engravers, designers and editors to keep the industry moving. Distribution of printed material was improved and simplified by the virtual completion of the rail network in the 1850s. In addition, the move towards free trade in books and the reductions in paper duties in the period contributed to an environment conducive to publishing in bulk at prices a growing number could pay. The great wood-engraving workshops of the Dalziel Brothers and Joseph Swain provided a seemingly inexhaustible supply of designs for publications on every subject. The use of wood-engraving as the chosen medium was brought to an inglorious end by about 1880 for several reasons, just one of which was the inexorable rise in photography. Many of these issues were examined in detail in a previous publication and hence they are not repeated here.[1]

The intention in this publication, in contrast, is to show what was produced by 31 artists in both books and magazines during the period and to pinpoint the exact date of the appearance of a large number of their designs. The critiques contained in the chapters are written to examine the artistic quality (or lack of it) in the work of each protagonist. It is also hoped that an excursion has been made through a large and often daunting body of work to assist fellow-explorers to pick their way along the winding path.

Several themes underline my thinking in this book. I have attempted to provide a balance between the celebrated Pre-Raphaelite artists and the less well-known, though to me, equally rewarding Idyllic School artists. In the chapters devoted to High Victorian artists and other artists I have included illustrators who I felt, sometimes for subjective reasons, could not be omitted. My stress on the magazines has also been a deliberate one. Bulky and awkward to examine though they are, they often provided a vehicle for some of the very best work, and for some artists it is only possible to study them properly through the periodical literature. I also mention when possible the texts which the illustrations accompanied, for it is essential, in my opinion, not to forget that all the designs discussed and listed here were first and foremost meant to be looked at as complementing a poem or a story.

It is the highly imaginative nature of so many of these illustrations, coupled with an essential equality between image and text which so distinguishes the productions of these artists. These two features are the hallmarks of the entire phenomenon which was the Sixties.

Note

1 *Victorian Illustrated Books 1850–1870 – The Heyday of Wood-Engraving*, 1994.

1

The Pre-Raphaelites: The inner circle

Dante Gabriel Rossetti, John Everett Millais, William Holman Hunt,
Ford Madox Brown, Edward Burne-Jones

This loose group of artists, with the charismatic and mercurial figure of Rossetti at its head, was largely responsible for the great changes which took place in black and white illustration of literature in England in the 1850s and 1860s. They followed illustrators such as Horsley, Maclise, Mulready, Gilbert and Tenniel who were already active during the previous decades. The work of these predecessors was marked by a delicacy of approach, coupled with light printing and an unspoken but clearly apparent subservience to the text. A typical example is Goldsmith's *The Vicar of Wakefield* of 1843 illustrated by Mulready.[1] Here is a celebrated series of drawings, many of which though delightful, are crowded with figures sometimes with little attempt made to suggest character or emotion.

Another strand of illustration at this period was to be found in the ubiquitous and modest Annuals which were so much a feature of elegant drawing-rooms from the 1820s until the late 1850s. These were frequently a vehicle for new poetry and prose and were almost invariably illustrated with steel-engravings after paintings by artists such as Turner, Bonington, Prout and Stanfield. In general, new illustrations were not commissioned for the Annuals since the engravings which they contained were almost without exception made after popular works exhibited at the Royal Academy and other important centres in London.[2]

A further variety of illustration was popular in the 1840s and it was one which was to continue for some years into the period under discussion. This was a style, largely comic in intent and feeling, which grew out of the single-sheet tradition of satirical prints begun in the late eighteenth century by Gillray and Rowlandson and continued by Isaac and George Cruikshank, Robert Seymour and Hablot Knight Browne (Phiz). Phiz and George Cruikshank were distinguished illustrators in this style especially of the works of Dickens, Charles Lever and Harrison Ainsworth.[3] It was out of this background that the Pre-Raphaelite illustrators emerged.

The Pre-Raphaelites and in particular Rossetti came to recognize illustration, at least for a time, as equal in importance to painting. Since they saw themselves essentially as literary artists they turned to illustration as a means of conveying the narrative element which was so central a feature of their work. They brought to illustration a 'high seriousness' coupled with an intellectually rigorous outlook which led to designs of nobility and distinction. Their bold, confident approach to their art led to more heavily printed and defined illustrations than those of their predecessors, which by their very strength were on an equal footing with the text. Their devotion to medievalism in all its forms meant that the Moxon Tennyson (1857) was an ideal

vehicle for their talents and preoccupations. With the exception of Millais, these artists were happier to illustrate poetry which dealt with a remote and imaginary past entirely removed from contemporary life. Such an emphasis in illustration was not without its drawbacks, however. Only Millais proved commercially minded enough to work sufficiently quickly to satisfy magazine editors with deadlines to meet, and hence the laborious and lengthy dedication of Rossetti, Brown and Hunt to their projects, admirable though it was, meant that their illustrations were relatively few in number.

Stylistically also these artists changed illustration completely. While their predecessors were usually content with conventional figure groupings and generalized facial expression, so in contrast, the Pre-Raphaelites tended to use a small number of figures or indeed a single one in their designs. They often liked to employ a large and dominant figure in the foreground as in 'The Maids of Elfen-Mere' (1855) (Plate 1.1) and they also made a conscious use of contortion both in feature and pose. A typical example (also by Rossetti) can be seen in his celebrated depiction of Saint Cecilia in 'The Palace of Art' (The Moxon Tennyson, 1857) (Plate 1.2).

Dante Gabriel Rossetti (1828–82)

As has already been stated it was Rossetti who led the great change in both the style and the feeling in English illustration at this period. This is especially remarkable since he made no more than ten significant illustrations and these appeared in just four books between 1855 and 1866. It is almost certain that he made no designs for the magazines.

Stylistically he was influenced by the German Nazarene artists notably Peter Cornelius and Friedrich Overbeck, but more importantly what he gained from a knowledge of these artists was something of their obsession with medieval themes and an almost religious intensity of approach. The first illustration which marked so fundamental a shift from what preceded it was 'The Maids of Elfen-Mere' mentioned above, which appeared in William Allingham's *The Music Master* of 1855, together with several immature designs by Arthur Hughes and another somewhat stronger one by Millais. This drawing remains one of the most outstanding Rossetti ever made, with its heady mixture of sensuality and disquiet. It was influential on the young Burne-Jones who wrote:

> it is I think the most beautiful drawing for an illustration I have ever seen, the weird faces of the maids of Elfinmere [sic], the musical timed movement of their arms together as they sing, the face of the man, above all, are such as only a great artist could conceive.[4]

Two years later Rossetti made just five designs for the celebrated edition of Tennyson's *Poems* known as the Moxon Tennyson after the publisher. One of the most extraordinary of these was the 'Saint Cecilia' which Tennyson saw as having little to do with his poem, a criticism cogently echoed by a later commentator who remarked: 'Tennyson's St. Cecilia is asleep. Rossetti's swoons in erotic, submissive ecstacy'[5] (Plate 1.2). Another design for 'The Palace of Art' shows again a blend of medievalism coupled with a strong central figure, this time unconventionally with her back to the viewer (Plate 1.6).

In 1862 Rossetti provided a frontispiece and a title-page illustration to his sister Christina's

Goblin Market (Plates 1.7 and 1.8) and in 1866 he again contributed two designs for her *The Prince's Progress* (Plates 1.9 and 1.10). These books are important not merely because of the presence of the sensual drawings which complement the poetry so aptly, but on account of a wholeness in book design rare during this period. Both are true first editions, containing new designs made specifically for them, and, in addition, Rossetti designed the bindings in a chaste medieval manner sensitively reflecting the contents. Such a guiding hand linking text, illustration and binding was most unusual in an era often criticized for creating illustrated books artificially. As one critic put it when discussing Thornbury's *Historical and Legendary Ballads and Songs*, 1876: 'Beautiful though its pictorial contents are the Thornbury volume is a disgraceful piece of book cobbling, which helps to show once again that throughout the period and beyond it the conception of a book as a unit was virtually non-existent.'[6] No such accusation can be levelled at these two productions and they remain outstanding examples of trade books which, unusually, possess a clarity of purpose and execution today only found in the precious realms of the private press.

Rossetti made no further designs which were published within our period, largely because he turned to other things, but more significantly because of his dissatisfaction with the way his drawings were engraved. He particularly disliked the work of the Dalziel Brothers, the engraving firm which so dominated the entire period and he frequently made outbursts disparaging their efforts. In 1856 he wrote to William Allingham while he was working on his designs for the Moxon Tennyson: 'But these engravers! What ministers of wrath! Your drawing comes to them, like Agag, delicately, and is hewn in pieces before the Lord Harry.'[7] Rossetti was reflecting the feelings of several other artists and it seems likely that, with the exception of Millais, this was a major reason for the relatively small number of illustrations produced by members of this group. However, it should also be stressed that few of these artists understood fully the technique of wood-engraving and the difficulties which their drawings frequently presented to the much maligned engravers.

Rossetti: Checklist of illustrated books

1855 William Allingham: *The Music Master*

1857 Alfred Tennyson: *Poems* (the Moxon Tennyson)

1862 Christina Rossetti: *Goblin Market*

1866 Christina Rossetti: *The Prince's Progress*

1888 William Allingham: *Flower Pieces and other Poems*

1889 Richard C. Jackson: *The Risen Life*

John Everett Millais (1829–96)

Millais is by a long way both the most prolific and the most varied of the artists in this particular group. He also differs from those around him because his period of production of original

illustrations was of greater length, with the earliest appearing in 1852. He was still producing work of striking originality almost 30 years later,[8] and therefore spans the age in a manner unequalled by any other illustrator under consideration. Millais was also, in every sense of the word, a more 'commercial' artist than his rivals. He could work quickly which meant he was able to meet the deadlines set by the magazine editors for whom he worked, and he was equally adept at illustrating poetry or prose either newly written or reprinted.

He was also something of a chameleon in that he possessed a remarkable ability to alter his style to suit the particular text upon which he was engaged. Millais could draw appropriately in an 'ancient' style for the series of poems from Norse mythology which appeared in the early years of *Once a Week*, and yet could also provide designs entirely appropriate to the historical novels of Harriet Martineau which were published in the pages of the same magazine. His understanding and feeling for contemporary life is perhaps best seen in the important series of designs which he made for Trollope's novels, while he reached a level of nobility and spirituality in *The Parables of Our Lord* (1863–4), which is arguably his greatest achievement as an illustrator (Plates 1.13, 1.14, 1.15, 1.16 and 1.17). In addition he did not disdain the special skills needed to draw for children, as is apparent in the tender and apparently artless designs for Leslie's *Little Songs for me to Sing* (1865). Also notable are his drawings for a girls' book, Tytler's *Papers for Thoughtful Girls* (1863) (Plates 1.18, 1.19 and 1.20).

Millais's central position and significance in illustration cannot be overstressed and his substantial body of work would make a subject in itself. In recent years, however, two studies have appeared which deal critically with important aspects of Millais as an illustrator.[9]

In the magazines Millais made several major contributions. In the earliest issues of *The Cornhill Magazine* in 1860 he illustrated Trollope's *Framley Parsonage* and in 1862–3 turned his attention to the same novelist's 'The Small House at Allington'. For the latter he provided full-page designs and numerous delightful initial letter vignettes. Also in 1862 came a drawing of real Pre-Raphaelite intensity 'Irene' which was well engraved by Joseph Swain.

In *Good Words* in 1862 Millais produced 12 entirely appropriate designs in his 'modern' style for Dinah Mulock's (Mrs Craik) 'Household Story' 'Mistress and Maid', while in complete contrast his drawing for 'Highland Flora' reflected his Scottish connections as well as a genuine sense of the tragic. In the following year in the same magazine came 12 of his long awaited designs for *The Parables of Our Lord* and in 1864 he made a few further contributions of lesser interest. After this he was curiously absent from the pages of *Good Words* until his single design for William Black's 'Macleod of Dare' in 1878.

1862 also saw a single large full-page design entitled 'Christmas Story-Telling' which seems to have been presented as a separate item with the *Illustrated London News* in the Christmas issue. A touched proof can be found in the Dalziel Archive in the British Museum.

There are three designs in *London Society* in 1862 and 1864 and the lovely 'The Sighing of the Shell' to a poem by George Macdonald in *The Argosy* appeared in June 1866.

It was in *Once a Week* that Millais made many of his finest designs and he began working for this remarkable magazine at its inception in 1859. Especially noteworthy during this year are 'The Grandmother's Apology' which accompanied Tennyson's poem on 16 July and 'The Plague of Elliant' to a text translated from the Breton by Tom Taylor which appeared on 15 October. The largest and in many ways the most sustained of Millais's projects here was for the historical

novels of Harriet Martineau. In 1862 he illustrated 'Sister Anna's Probation' and 'The Anglers of the Dove' and in 1863 came 'The Hampdens' and 'Son Christopher'. This group of designs makes an instructive parallel with the drawings of modern life which Millais made for the Trollope novels in the *The Cornhill Magazine*. A particularly successful drawing was the one which appeared at the opening of 'Sister Anna's Probation' on 15 March 1862. Here is a sensitive portrayal of mother and daughter sitting together, which undoubtedly would encourage a reader to pursue the story. Millais made one later design for *Once a Week* which should not be ignored. This is the grimly haunting 'Death Dealing Arrows' which was published on 25 January 1868.

The designs Millais made for Trollope's *Phineas Finn, The Irish Member*, which were published in the short-lived *Saint Paul's Magazine* during Trollope's equally brief editorship (1867–8), do not show this artist at his best. Perhaps he found the story's political setting less to his taste than those of the other Trollope, such as *Framley Parsonage*, novels which dealt more with domestic life and the Church.

Millais's contributions to book illustration are quite as varied and rewarding as those he made for the magazines. The earliest I have been able to identify is the etched frontispiece to Wilkie Collins's *Mr Wray's Cash-Box* which was published in 1852 (Plate 1.11). This snippet of modern life showing the lover's pockets agreeably and realistically sagging with the weight of their contents, predates the more celebrated 'The Maids of Elfen-Mere' (Rossetti) in *The Music Master* by three years, and shows that Millais was trying to make stylistic changes to illustration at this early date. Perhaps it is unsurprising that he also provided an illustration for Allingham's book which complemented Rossetti's masterpiece.

Only recently discovered is the frontispiece to Anderson's *The Pleasures of Home*, a delightful design which amusingly hints at the contradictions inherent in the title. The book appears to be datable to either 1855 or 1856. The single steel-engraved design 'When first I met thee' which appeared in an uncommon edition of Moore's *Irish Melodies* shows Millais at the height of his powers both as a draughtsman and as a storyteller.

In the following year he made his memorable drawings for the Moxon Tennyson. An outstanding example is 'St Agnes' Eve' where Dalziel has miraculously depicted the breath showing in the chill night air. In the same year, in Willmott's *The Poets of the Nineteenth Century*, comes the drawing made for Coleridge's 'Love'. One can only agree with the perceptive comment of Forrest Reid who remarked:

the drawing ... is, I think, the most moving and impassioned he ever made ... This picture of two figures clinging together in a darkened landscape, with the great white moon rising between the branches of the trees, strikes us indeed as being in no way inferior to the work of Coleridge himself.[10]

In 1858 Millais supplied two important etchings for *Passages from the Poems of Thomas Hood*, ('The Bridge of Sighs' and 'Ruth') a single design of the 'Finding of Moses' for *Lays of the Holy Land from Ancient and Modern Poets*, and two splendidly accomplished and confident drawings for Mackay's *The Home Affections Pourtrayed by the Poets*. 'The Border Widow' conveys a sense of anguish and despair powerfully and simply.

During 1861 Millais began to supply a small number of steel-engraved frontispieces to volumes

in Hurst and Blackett's *Standard Library*. These are mostly single figures and two of the most memorable are for Dinah Mulock's (Mrs Craik) *Nothing New* (1861–2) and for Hugo's *Les Misérables* (1864). Although steel-engraving as a medium was far less important than wood-engraving at this period, Millais showed that he was equally at home designing for either. 1862 saw the publication in two volumes of Trollope's *Orley Farm*, a work which had originally appeared in parts, and in 1864 the book edition of *The Small House at Allington* first printed in the pages of *The Cornhill Magazine*. It is fortuitous that the bibliographical complexities inherent in the publication of Trollope's novels have been so excellently dealt with in a standard work which usefully also mentions the illustrations.[11] Although Trollope himself thought especially highly of Millais's efforts for *Orley Farm* they are perhaps not as satisfactory as a group as the drawings he made earlier for *Framley Parsonage*. Although fewer in number, the latter must rate as the most cogent and intelligent works Millais made for Trollope.

1864 was also the year of the publication of all 20 of the designs Millais had made over six years for *The Parables of Our Lord* (Plates 1.13, 1.14, 1.15, 1.16 and 1.17). He clearly found the project a daunting one, and wrote to the Dalziels to explain his feelings: 'I can do ordinary illustration as quickly as most men, but these designs can scarcely be regarded in the same light.'[12] The results amount to achievements of memorable simplicity and strength, and they led an early critic to speak from the heart: 'It is difficult to speak dispassionately of this book. ... there is much that is not merely the finest work of a fine period, but that may be placed amongst the finest of any period.'[13] During this year several good designs from the *The Cornhill Magazine* were reprinted, from the wood and on better paper, in a lavish anthology of illustrations by several artists entitled the *Cornhill Gallery*. Two years later a volume dedicated to Millais alone was published, and although an interesting and desirable volume, it is curious in its choice of illustrations, since so many of the most clearly excellent ones were omitted.[14]

In 1866 Millais sensitively illustrated a book for girls by Jean Ingelow entitled *Studies for Stories from Girls' Lives* and after this date, with the occasional exception, both the number and interest of his book designs declined markedly. However, two books from this later period deserve notice. Thackeray's *The Memoirs of Barry Lyndon* of 1879 contains several drawings of a power reminiscent of the Sixties, while *Leslie's Songs for Little Folks* [1883] has, as a frontispiece, a rapt design of a nun gazing from a convent window. This frontispiece was evidently made nearly 30 years earlier and was, inexplicably, held over until its somewhat incongruous appearance in this book for children. The original drawing dated 1854 was exhibited in the Arts Council exhibition devoted to Millais in 1979 (Cat. no. 30, illustrated p.42).

Millais: Checklist of illustrated books

1852 W. Wilkie Collins: *Mr Wray's Cash-Box*

1855 William Allingham: *The Music Master ...*

1855–6 John Anderson: *The Pleasures of Home*

1856 Thomas Moore: *Irish Melodies*

1857 Alfred Tennyson: *Poems* (The Moxon Tennyson)
R.A. Willmott (ed.): *The Poets of the Nineteenth Century*

1858 Anthology: *Lays of the Holy Land from Ancient and Modern Poets*
 Thomas Hood: *Passages from the Poems of Thomas Hood*
 Charles Mackay (ed.): *The Home Affections Pourtrayed by the Poets*

1861 [Dinah Mulock (Mrs Craik)]: *John Halifax, Gentleman*
 [Dinah Mulock (Mrs Craik)]: *Nothing New*
 [Julia C. Stretton]: *The Valley of a Hundred Fires*

1862 Anthology: *Passages from Modern English Poets*
 Anthony Trollope: *Orley Farm*

1863 [Dinah Mulock (Mrs Craik)]: *Mistress and Maid*
 Sarah Tytler (Henrietta Keddie): *Papers for Thoughtful Girls*
 William Wordsworth: *Wordsworth's Poems for the Young*

1864 Anthology: *The Cornhill Gallery*
 Matthew Browne (William Brighty Rands): *Lilliput Levée*
 W. Wilkie Collins: *No Name*
 Victor Hugo: *Les Misérables*
 J.E. Millais: *The Parables of Our Lord*
 Anthony Trollope: *Rachel Ray*
 Anthony Trollope: *The Small House at Allington*

1864–5 *Dalziel's Arabian Nights' Entertainments*

1866 Daniel Defoe: *Robinson Crusoe*
 Jean Ingelow: *Studies for Stories from Girls' Lives*
 J.E. Millais: *Collected Illustrations*

1867 Charles Mackay (ed.): *A Thousand and One Gems of Poetry*
 J.E. Millais: *Twenty-Nine Illustrations by John Everett Millais*

1868 J.W. Goethe: *Egmont*

1869 H. Cholmondely Pennell: *Puck on Pegasus*
 Anthony Trollope: *Phineas Finn*

1871 Matthew Browne (William Brighty Rands): *Lilliput Lectures*
 Henry Leslie: *Henry Leslie's Musical Annual*

1873 F.C. Burnand: *Mokeanna!*

1874 Anthology: *Dawn to Daylight*

1875 S.C. Hall: *An Old Story*

1877 Henry Frith: *Routledge's Holiday Album for Boys*
 Mrs Semple Garrett: *Our Little Sunbeam's Picture-Book*

1878 Henry Frith: *Little Valentine*

1879 W.M. Thackeray: *The Memoirs of Barry Lyndon*

1882 Anthony Trollope: *Kept in the Dark*

1883 Henry Leslie: *Leslie's Songs for Little Folks*

n.d. ? *c.*1856 John Sullivan: *Wace, ses Oeuvres* (unpublished?)

William Holman Hunt (1827–1910)

Although Hunt produced few illustrations, his designs are of great interest and some are of the highest quality. 'My Beautiful Lady' which appeared in *The Germ* in January 1850 shows two designs etched on one plate and both are entirely Pre-Raphaelite in feeling. However, Hunt did not return to illustration for ten years when he contributed three designs to *Once a Week* in 1860. Both 'Witches and Witchcraft' and 'Temujin' (Plates 1.21 and 1.22) reveal an interest in contortion both in facial appearance and in the pose of the figure which was so recurrent a theme in the designs of the Pre-Raphaelite artists. 'At Night', (Plate 1.23) on the other hand, is a far simpler and more tender design which possesses a sweetness and a directness not unlike that to be found in the illustrations of Millais at this period.

'Go and Come' (Plate 1.24) which was published in *Good Words* in 1862 shows Hunt combining a monumentality of form with a sense of rapid movement in the figure in the background harvesting the wheat. This atmosphere of Biblical gravity and dignity found a ready echo in 'Eliezer and Rebekah at the Well' made for *Dalziel's Bible Gallery* in 1863 but it was not published until 1881. 'The Eve of St Agnes' which appeared in the Christmas supplement of *The Queen*, though poorly engraved as Forrest Reid observed, remained entirely Pre-Raphaelite in its intensity. Hunt's last magazine illustration is the slight but charming 'Born at Jerusalem' which appeared in *Good Words* on 9 October 1878. The text was by Mrs Craik (Dinah Mulock) and the baby was Hunt's daughter, born on 20 September, whom he named Gladys Mulock Holman Hunt.

Hunt's first book illustrations appeared in 1857 in the Moxon Tennyson for which he made seven designs. Among the finest are the two which he made for 'The Ballad of Oriana' (Plates 1.29 and 1.30) which show at its most developed and accomplished, his feeling for medievalism. The memorable design for the 'The Lady of Shalott' (Plate 1.31) caused one commentator to praise especially the interpretative skill of the engraver: 'the magic web of her hair which she weaves surrounds her, flowing crazily through the whole design, changing as it goes from black to white and back to black again.'[15]

Two years later came the frontispiece to *Days of Old* (Plate 1.32), a strong design which successfully combines the monumental with the natural.[16] Then, in 1861, Hunt made two contrasting drawings for Mrs Gatty's *Parables from Nature*. 'Active and Passive' uses the haunting figure of a grave digger in the lower foreground emerging from a grave, which makes a potent contrast with the sailor behind examining the sundial. 'The Light of Truth' remains a moving night scene despite Harral's mediocre engraving (Plates 1.33 and 1.34).

In 1862 Hunt provided a delicate title-page design for *The Pilgrim's Progress* (Plate 1.35), a

striking steel-engraved frontispiece to Dinah Mulock's *Studies from Life*, and a distinguished drawing for 'The Lent Jewels' which appeared as a frontispiece to Willmott's *English Sacred Poetry* (Plate 1.36). Five years elapsed before he contributed arguably his tenderest drawing, of a girl at prayer, in Watts's *Divine and Moral Songs for Children*. Reproduced by the experimental and short-lived graphotype process, this design illustrated 'A Morning Song of Praise' and with great delicacy suggests the light of dawn flooding in through the window.[17]

Hunt was to produce just a few scattered designs for books during the following years. In 1874 he made two little-known frontispieces for the second edition of Farrar's *The Life of Christ* and in 1878 came a steel-engraved frontispiece to Yonge's *The Story of the Christians and Moors of Spain*, which was clearly made earlier for some other project, and was simply employed for this book when the opportunity arose (Plate 1.37).

Hunt: Checklist of illustrated books

1857 Alfred Tennyson: *Poems* (the Moxon Tennyson)

1859 Anonymous: *Days of Old*

1861 Margaret Gatty: *Parables from Nature*

1862 John Bunyan: *The Pilgrim's Progress*
[Dinah Mulock (Mrs Craik)]: *Studies from Life*
R.A. Willmott (ed.): *English Sacred Poetry*

1867 Isaac Watts: *Divine and Moral Songs for Children*

1870 Anthology: *The Piccadilly Annual*

1873 Anthology: *Routledge's Sunday Album for Children*

1874 F.W. Farrar: *The Life of Christ*

1878 Charlotte M. Yonge: *The Story of the Christians and Moors of Spain*

1881 Anthology: *Dalziel's Bible Gallery*

1894 Anthology: *Art Pictures from the Old Testament*

Ford Madox Brown (1821–93)

While Brown is one of the least productive illustrators of this group, his designs, few in number though they may be, are on occasion works of real interest and power. The earliest to appear in a periodical is 'Cordelia' an etching which was published in *The Germ* No. 3 in 1850 (Plate 1.38). It is not a particularly distinguished effort though there is a genuine attempt to delineate the contrasting characters of Cordelia, Goneril and Regan. Nineteen years later he provided 'The Traveller' in *Once a Week* which was an adequate though not outstanding drawing (27 February 1869). However, in 1871 Brown made his most memorable and sensual designs for D.G.

Rossetti's poem 'Down Stream' which appeared in a short-lived magazine entitled *The Dark Blue* (Plates 1.39 and 1.40). Starkly engraved by the little known C.M. Jenkin, the main drawing shows a brawny and lustful scene of a remarkable and most un-Victorian frankness. It is amazing that such a work managed to be published at this time without censorship or restraint. Additionally Brown provided a tailpiece, which in comparison is of less distinction.

In book illustration, Brown's greatest achievement was 'The Prisoner of Chillon' to the poem by Byron which appeared in Willmott's *The Poets of the Nineteenth Century* in 1857 (Plate 1.41). Brown spent a remarkable length of time on this drawing, for which he required a dead body in order to study the gradual process of decomposition. In his diary he recorded his painstaking approach to the project:

> Out shopping, then to University hospital to ask John Marshall about a dead boddy. He got the one that will just do. It was in the vaults under the disecting room. When I saw it first, what with the dim light, the brown and parchment like appearance of it & the shaven head, I took it for a wooden simulation of the thing. Often as I have seen horrors I really did not remember how hideous the shell of a poor creature may remain when the substance contained is fled. Yet we both in our joy at the obtainment of what we sought declared it to be a lovely & a splendid corps.[18]

It seems that Brown devoted no less than 28 hours to this aspect of the drawing, and such dedication, though praiseworthy, reveals the hopelessly uncommercial attitude to illustration of some of these artists, which ensured that their contributions to the genre remained inevitably few and far between.

In 1868 Brown contributed three designs for *Lyra Germanica* translated by Catherine Winkworth. The most successful of these was 'He that soweth …' which accompanied a poem by Baron Friedrich Ludwig von Hardenberg (1772–1801) who wrote under the pseudonym *Novalis*.

The following year Brown returned to the poetry of Byron and made some six designs for an edition published in 1870 by Moxon. The two other drawings were by Brown's son Oliver Madox Brown and all of these were reproduced by steel-engraving (Plates 1.42, 1.43, 1.44, 1.45, 1.46 and 1.47). The wood-engraved head and tailpieces although relatively inconsequential are probably also by Brown, and may be compared stylistically with the one he made for Rossetti's 'Down Stream' in *The Dark Blue* (see above). Most of these Byron subjects Brown later worked up as oil paintings.

Finally come the three powerful designs for the *Bible Gallery* (1881) which were probably made *c.*1864–5. 'Elijah and the Widow's Son' (Plate 1.49) is one of the most memorable, and Brown successfully combines a dramatic feeling with a real sense of a blazingly hot day.

Brown: Checklist of illustrated books

1857 R.A. Willmott (ed.): *The Poets of the Nineteenth Century*

1868 Catherine Winkworth (trans.): *Lyra Germanica*

1870 Lord Byron (edited by W.M. Rossetti): *Poetical Works*

1881 Anthology: *Dalziel's Bible Gallery*

1894 Anthology: *Art Pictures from the Old Testament*

Edward Burne-Jones (1833–98)

Burne-Jones was the least prolific illustrator of this inner group of Pre-Raphaelite artists and indeed produced only eight published designs during the period covered by this study. The well-known drawings produced in the 1890s for William Morris and the Kelmscott Press, though begun in the Sixties (see below), seem to belong in character to the more self-conscious era of 'the book beautiful' and were published by what was essentially a private press.

Burne-Jones made just two designs for magazines and both appeared in *Good Words*: 'King Sigurd, the Crusader' in 1862 and 'The Summer Snow' the following year (Plates 1.51 and 1.52). The latter is perhaps the finer showing a 'stunner' wistfully reading in a garden wearing the enormous skirt which proved so fertile a fashion for many other illustrators of the time, most notably Millais. The fact that the drawing is given to 'Christopher Jones' in the index to the magazine points up the general unreliability of the indices of so many of the periodicals under discussion. This lovely design is important because it is almost the only one in which the artist's true and best-known style is immediately discernible. In the tiny number of designs for books it is possible to see Burne-Jones experimenting with differing manners resulting in an almost equal mixture of success and failure.

1857 saw the steel-engraved frontispiece, and title-page design and the wood-engraved tailpiece for Archibald Maclaren's *The Fairy Family* (Plates 1.53, 1.54 and 1.55). Despite the naïve charm of these, his earliest illustrations, Burne-Jones was clearly embarrassed by them, and never formally acknowledged that they were his work. Even when the book appeared as a reprint in 1874 his name was not attached to them. The large number of drawings for this project have been eloquently discussed by John Christian (see Select bibliography) and the same writer remarked that: 'The project foundered because the style in which the drawings were begun and the new attitude to illustration introduced by the Pre-Raphaelites were ultimately irreconcilable.'[19] These drawings were also the subject of an exhibition at the Pierpont Morgan Library, New York, in 1994.

In 1861 Burne-Jones made a single drawing which appeared 20 years later in *Dalziel's Bible Gallery*. Entitled 'The Parable of the Burning Pot' (Plate 1.56) and accompanying verses from Ezekiel, it was probably engraved in 1863, although the ill-fated volume did not appear until 1881. In 1863 he made a number of designs which were specifically intended for the project but only this one attained publication. Stylistically the image owes much to the work of Simeon Solomon whose work he admired especially at this time.

In 1865 he contributed a Nativity to Mrs Gatty's *Parables from Nature* (Plate 1.57) and in 1868 came his last design in the period, which was the single title-page illustration to William Morris's *The Earthly Paradise*. Morris was writing his poems in 1865 and discussed an illustrated edition with Burne-Jones the same year but the scheme never reached fruition; only this illustration appeared in the first edition published by F.S. Ellis. It seems likely that the block was cut by

Morris himself or by one of his staff.[20] The three lute-playing figures look forward to Burne-Jones's more developed medieval style which was to prove so suitable for the much later and grander Kelmscott Press editions.

Burne-Jones: Checklist of illustrated books

1857 [Archibald Maclaren]: *The Fairy Family*

1865 Margaret Gatty: *Parables from Nature*

1868 William Morris: *The Earthly Paradise*

1881 Anthology: *Dalziel's Bible Gallery*

1894 Anthology: *Art Pictures from the Old Testament*

Notes

1 Published by John Van Voorst and reprinted in 1855. Thirty-five designs engraved by John Thompson.

2 *The Anniversary* for 1829 contains a dedication: 'To the President and members of the Royal Academy this volume is most respectfully inscribed'. For further information see Frederick W. Faxon *Literary Annuals and Gift Books*, reprint of 1912 edition, Pinner, 1973. This, however, has little to say about the illustrations in the annuals.

3 For an excellent survey of this type of illustration see J.R. Harvey *Victorian Novelists and their Illustrators*, 1970.

4 *Oxford and Cambridge Magazine*, 1856, no. 6.

5 William Vaughan *German Romanticism and English Art*, 1979, p.158.

6 Percy Muir *Victorian Illustrated Books*, 1971, p.139.

7 Oswald Doughty and John Robert Wahl (eds) *Letters of Dante Gabriel Rossetti*, Oxford, 1965, vol. 1, 1835–60, p.310. The letter is undated but was postmarked 18 December 1856.

8 W. Wilkie Collins *Mr Wray's Cashbox*, 1852. W.M. Thackeray *The Memoirs of Barry Lyndon*, 1879.

9 *The Parables of Our Lord*, reprint with an introduction by Mary Lutyens, New York, 1975. N. John Hall *Trollope and His Illustrators*, 1980.

10 Forrest Reid *Illustrators of the Eighteen Sixties*, 1928. Quoted from the reprint, New York, 1975, p.67.

11 Michael Sadleir *Trollope – A Bibliography*, 1928. Reprinted Folkestone, 1964, 1977.

12 British Library, Dept of MSS, Add.38974, f.194, 195.

13 Gleeson White *English Illustration 'The Sixties' 1855–70*, 1897. Quoted from the reprint, Bath, 1970, p.119.

14 *Millais's Collected Illustrations*, Alexander Strahan, 1866.

15 Robin de Beaumont 'Collector's Progress' p.15 in publication, cited in note 1 of the Introduction, p.xviii.

16 Signed in monogram and dated 1858. Although Hunt's name is not mentioned in the book, the design is referred to in the advertisements at the back of Thomas Hughes's *The Scouring of the White Horse*, 1859, a work illustrated by Richard Doyle.

17 Graphotype was a technique which involved the use of a block made of chalk. The artist traced his design in reverse on to the block, filled in the lines with special ink made of glue and lampblack, and then the untouched chalk was removed with brushes of fitch-hair and the whole surface treated with silicate. The method was admired on account of its autographic nature since it removed the need for a wood-engraver to interpret the artist's design. Its complexity and the advance of photography meant that its life was a brief one. For a contemporary notice see J. Carpenter, 'Concerning the Graphotype' in *Once a Week*, 16 February 1867, pp.181–4 and for a more recent discussion see Geoffrey Wakeman *Victorian Book Illustration*, Newton Abbot, 1973, pp.95–8.

18 Entry for 13 March 1856, p.167 in *The Diary of Ford Madox Brown*, edited by Virginia Surtees, New Haven and London, 1981.

19 Exhibition, London, Hayward Gallery and elsewhere *Burne-Jones*, 1975–6, p.80.

20 It now seems almost certain that the block was cut by Morris himself. See Brenda Rix in *The Earthly Paradise – Arts and Crafts by William Morris and his Circle from Canadian Collections*, exhibition catalogue, Toronto, Art Gallery of Ontario and elsewhere, 1993, p.243 no. K: 5.

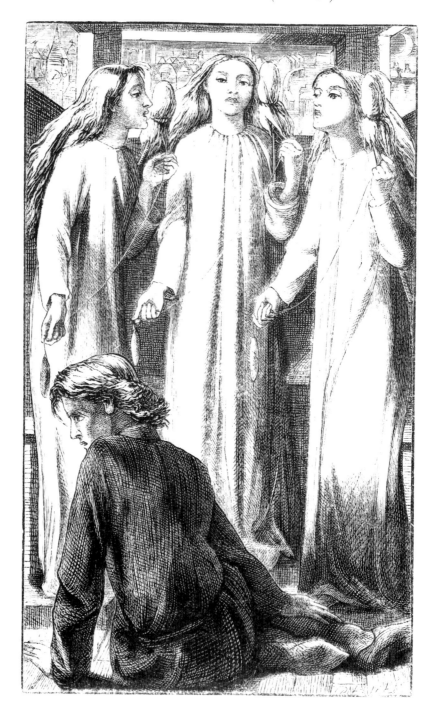

PLATE 1.1
The Maids of Elfen-Mere

PLATE 1.2
The Palace of Art

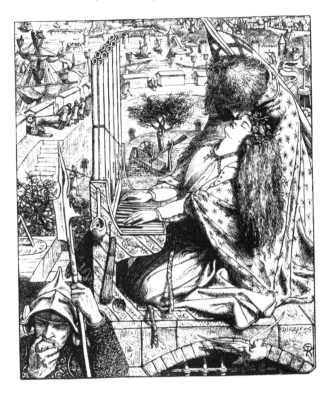

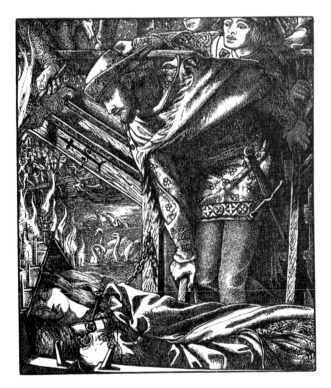

PLATE 1.3
The Lady of Shalott

PLATE 1.4
Mariana in the South

PLATE 1.5
Sir Galahad

16

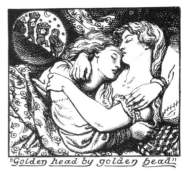

PLATE 1.8
Golden head by golden head

PLATE 1.6
The Palace of Art

PLATE 1.7
Buy from us with a golden curl

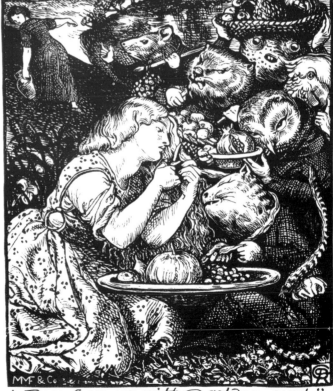

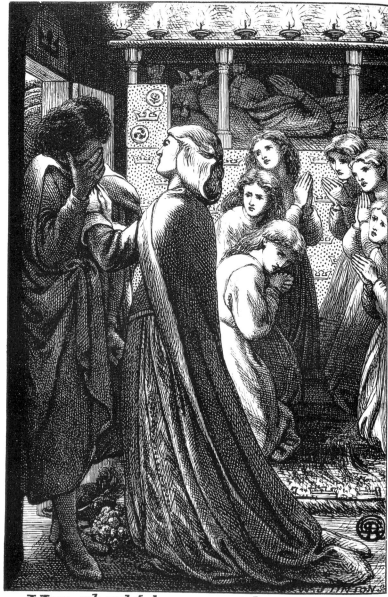

You should have wept her yesterday

PLATE 1.9

You should have wept her yesterday

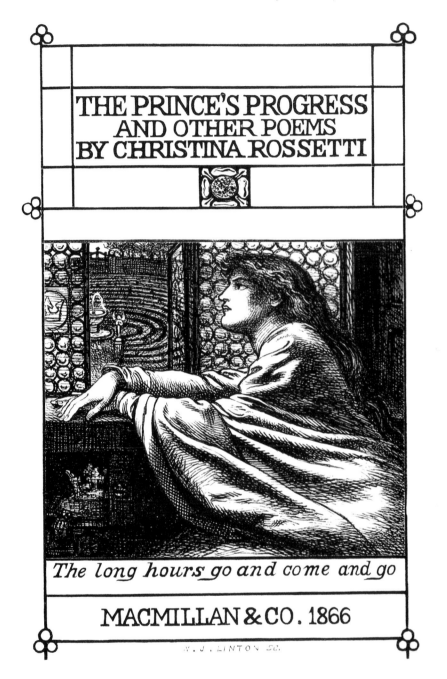

PLATE 1.10
The long hours go and come and go

PLATE 1.11
Untitled

PLATE 1.12
Untitled

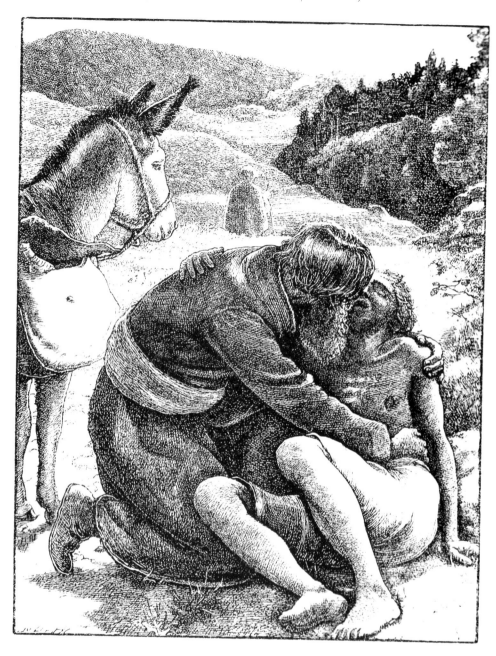

PLATE 1.13
The Good Samaritan

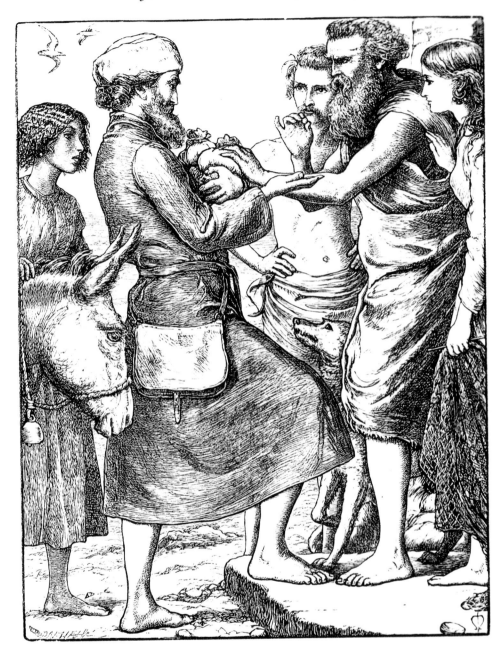

PLATE 1.14
The Pearl of Great Price

PLATE 1.15
The Sower

PLATE 1.16
The Prodigal Son

PLATE 1.17
The Pharisee and the Publican

PLATE 1.18
Cis Berry's arrival

PLATE 1.19
Dame Dorothy

PLATE 1.20
Herr Willy Koenig

PLATE 1.21
Witches and Witchcraft

PLATE 1.22
Temujin

PLATE 1.23
At Night

PLATE 1.24
Go and come

PLATE 1.25
Recollections of the Arabian Nights

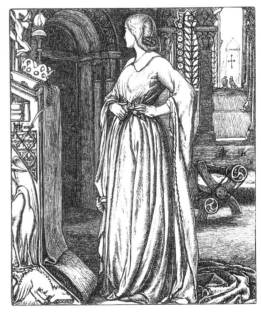

PLATE 1.26
Recollections of the Arabian Nights

PLATE 1.27
Godiva

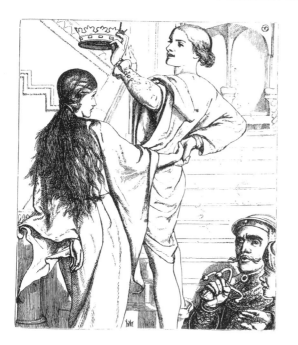

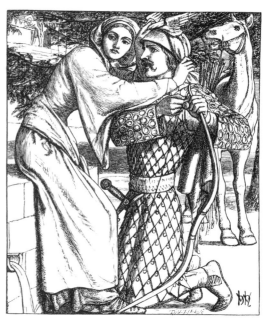

PLATE 1.28
The Beggar Maid

PLATE 1.29
The Ballad of Oriana

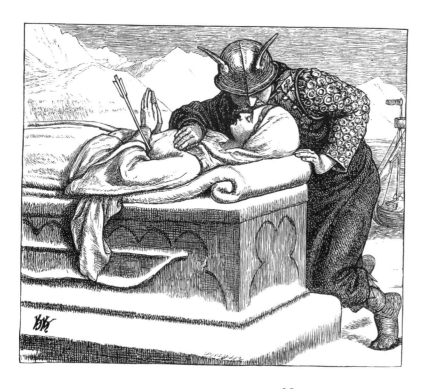

PLATE 1.30
The Ballad of Oriana

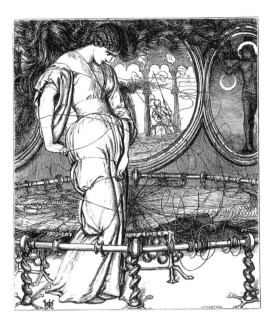

PLATE 1.31
The Lady of Shalott

PLATE 1.32
Untitled

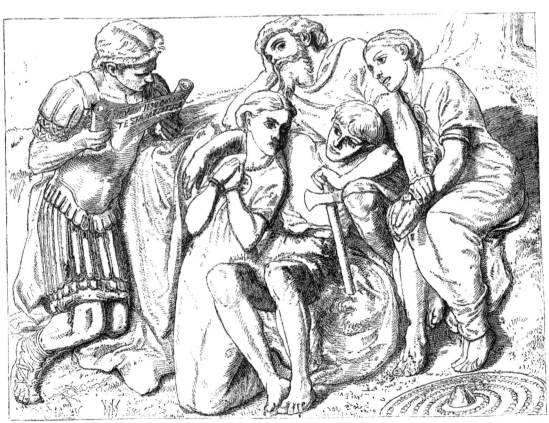

PLATE 1.33
Active and Passive

PLATE 1.34
The Light of Truth

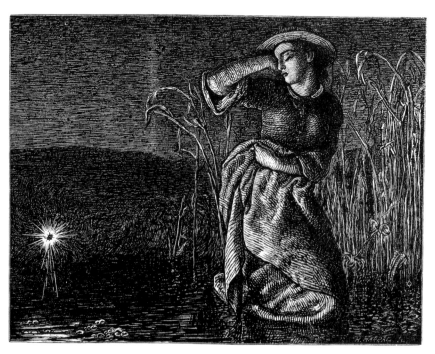

THE

PILGRIM'S PROGRESS

FROM THIS WORLD
TO THAT WHICH IS TO COME

DELIVERED UNDER THE SIMILITUDE OF A

DREAM

Wherein is discovered
the manner of his setting out, his Dangerous Journey,
and Safe Arrival at the Desired Country

By JOHN BUNYAN

CAMBRIDGE
Printed at the *University Press* for
Macmillan and Co. Cambridge and *London*
1862

PLATE 1.35
Untitled

PLATE 1.36
The Lent Jewels

PLATE 1.37
Untitled

PLATE 1.38
Cordelia

PLATE 1.39
Down Stream

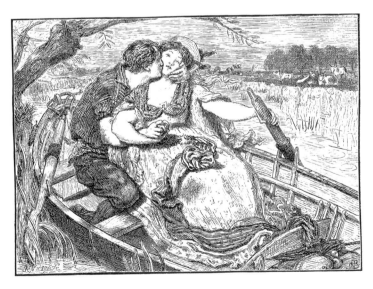

PLATE 1.40
Down Stream

PLATE 1.41
The Prisoner of Chillon

PLATE 1.42
Untitled

PLATE 1.43
Childe Harold's Pilgrimage

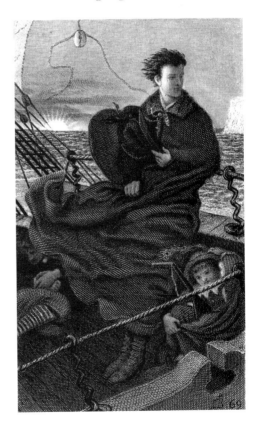

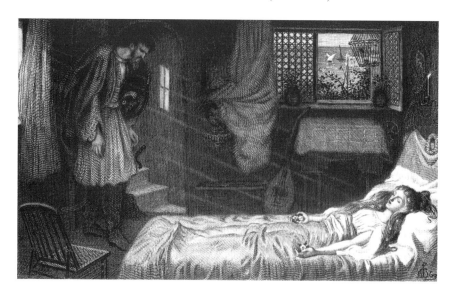

Plate 1.44
The Corsair

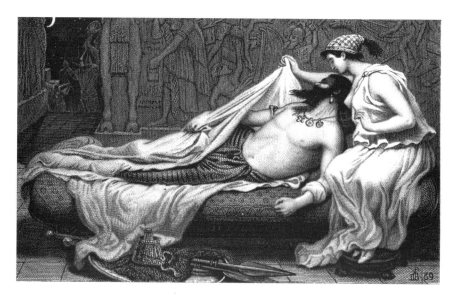

Plate 1.45
Sardanapalus

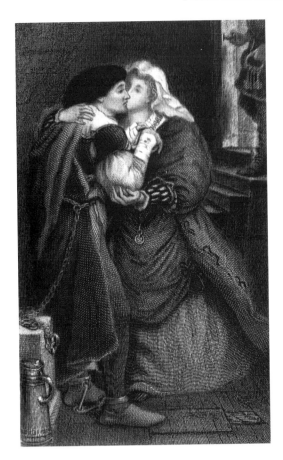

PLATE 1.46
The Two Foscari

PLATE 1.47
Don Juan

PLATE 1.48
Joseph's Coat

PLATE 1.49
Elijah and the Widow's Son

PLATE 1.50
The Death of Eglon

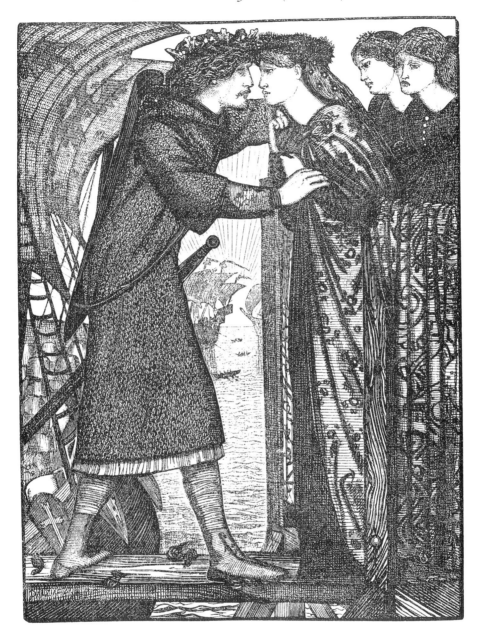

PLATE 1.51
King Sigurd, the Crusader

PLATE 1.52
The Summer Snow

PLATE 1.53
Untitled

LONDON LONGMAN & C° 1857.

PLATE 1.54
Untitled

PLATE 1.55
Untitled

PLATE 1.56
The Parable of the Burning Pot

PLATE 1.57
The Deliverer

2

The Pre-Raphaelites: The outer circle

Frederick Sandys, Arthur Hughes, Simeon Solomon, Henry Hugh Armstead,
Joseph Noel Paton, Frederic Shields, Matthew James Lawless

This chapter is devoted to a number of artists who, in my opinion, share with those of the central group certain characteristics either in subject-matter or style or indeed both, but who were themselves never formally part of the Pre-Raphaelite Brotherhood. All, however, were closely associated with their ideas and beliefs and hence are grouped together.

Frederick Sandys (1832–1904)

Sandys was arguably one of the most interesting and genuinely talented of all the black and white illustrators under discussion, but paradoxically he was also one of the least productive, making no more than 30 designs in all. His finest work appeared in the periodicals rather than in books, and his highly wrought and sometimes febrile manner was better suited to poetry than to prose.

Although Sandys was entirely individual in his approach to illustration, the influence of German art on his style and his subject-matter is unmistakable. Alfred Rethel (1816–59) was the contemporary artist whose repeated themes of death, frequently depicted in oppressive medieval settings, had a great appeal for mid-Victorian illustrators such as Sandys, while echoes of his work can also be observed in the designs of Shields and Lawless. 'Der Tod als Freund' (Death the Friend) was a woodcut published by Rethel in 1851 which was widely circulated in England, and was highly influential. 'Until her Death' (*Good Words*, 1862) (Plate 2.1) looks not only to Rethel but also, with its barely suppressed sexuality, beyond to the German Renaissance and artists such as Dürer and Hans Sebald Beham. The pose of the figure here is a direct quotation from Dürer's 'Melencolia' (1514) while there is also no doubt that Sandys had seen and admired Brown's 'The Prisoner of Chillon' of 1857. Sandys also made regular use of a pronounced central figure, which was a favourite device of the Pre-Raphaelites, in illustrations such as 'From my Window' and 'The Waiting Time' (Plates 2.3 and 2.4).

Sandys recognized the sensuality of a woman sucking her own hair which he employed with great power to accompany 'If' by Christina Rossetti in *The Argosy* in March 1866 (Plate 2.6). A reduced detail of the design appeared on the title page of the bound volume of the magazine for Midsummer 1866. It was a motif he repeated in 'Helen and Cassandra' (Plate 2.7) which was published just a month later in *Once a Week* (28 April 1866).

The majority of Sandys's designs were published in *Once a Week* between 1861 and 1866 while

'Danae in the Brazen Chamber' (Plate 2.8) which was intended originally for the same periodical did not appear until 1888. Drawn to accompany a poem by Swinburne, the appearance of the male genitalia was considered unsuitable for publication by the publishers and editor of *Once a Week*.[1] When it made its belated appearance it was in the *Century Guild Hobby Horse*. Several of his most successful drawings, notably 'From my Window', 'Rosamond, Queen of the Lombards', 'The Old Chartist' and 'Harald Harfagr' were published in *Once a Week* (Plates 2.3, 2.9, 2.10 and 2.12) but two of his very finest appeared in less expected surroundings.

'Amor Mundi', arguably his greatest drawing, appeared in the short-lived and obscure *The Shilling Magazine* (June 1865) (Plate 2.15). Composed to accompany the poem by Christina Rossetti it reflects strongly the sickly odour of death suggested in the text. 'The Waiting Time' was published in another little-known periodical, *Churchman's Family Magazine* in July 1863 (Plate 2.4). This extraordinary image shows the depression of a female weaver in a Lancashire mill during the shortage of raw cotton caused by the American Civil War. Perhaps nowhere during this period was a sense of total despair more starkly conveyed. While the handful of drawings made for the *Cornhill* are of less interest than those in *Once a Week*, 'Cleopatra' (September 1866) to a poem by Swinburne is a splendidly voluptuous confection.

Sandys made a handful of drawings for books and, of these, the two for Willmott's *English Sacred Poetry* of 1862 are the most distinguished. 'Life's Journey' is a drawing of immense power, while remarkably in 'The Little Mourner' he avoids sentimentality to produce a design which is both touching and memorable. In 1865 comes the curious and exotic frontispiece to Meredith's *The Shaving of Shagpat* (Plate 2.18) and in the following year a further frontispiece (again steel-engraved) for Dinah Mulock's (Mrs Craik) *Christian's Mistake*. Finally in the long delayed *Bible Gallery* of 1881 is the single 'Jacob hears the voice of the Lord' which, though strongly drawn, looks more like the work of Leighton than of Sandys and to tell the truth is not very interesting (Plate 2.19). If anything it reveals that Sandys was wise to confine himself largely to the poetical rather than the biblical.

Sandys: Checklist of illustrated books

1862 R.A. Willmott (ed.): *English Sacred Poetry*

1865 George Meredith: *The Shaving of Shagpat*

1866 [Dinah Mulock (Mrs Craik)]: *Christian's Mistake*
 Anthology: *Pictures of Society Grave and Gay*

1867 Anthology: *Idyllic Pictures*
 Anthology: *Touches of Nature*

1876 Walter Thornbury (ed.): *Historical and Legendary Ballads and Songs*

1881 Anthology: *Dalziel's Bible Gallery*

1894 Anthology: *Art Pictures from the Old Testament*

Arthur Hughes (1832–1915)

Hughes, who was born in the same year as Sandys, was an industrious illustrator whose work was invariably competent and frequently charming. While he clearly lacked the comprehensive and varied skills of Millais and was no equal to the intense sensibility of Sandys he was an unrivalled illustrator for children, and was also responsible for a single masterpiece for adults, *Enoch Arden* (1866). Stylistically, Hughes's designs display a flowing, rhythmic line and rounded harmonious forms. His facial types are somewhat generalized in both women and children, and unlike Rossetti or Sandys he rarely makes a feature of contortion of faces or forms. To call his work charming is intended as a compliment and not a stricture, for he knew where his true abilities lay and he made the most of them.

In *Good Words* in 1869 Hughes contributed two designs for 'Carmina Nuptiale' which show him at his most poetic, while 'Fancy', which appeared in the same magazine the following year, is a powerful image. In 1871 Hughes made two drawings 'Go little letter, Apace, apace' and 'The Mist and the Rain' which were originally intended for a book with verses by Tennyson and music by Arthur Sullivan. In the event this potentially interesting collaboration was abandoned, and the illustrations were cut down for inclusion in the magazine. 'The Dial', made also for *Good Words* in the same year, is a magnificent and memorable design and repeats a favourite motif of the Victorian illustrators, that of the sundial denoting the transitory nature of human existence.[2] 'Will O' the Wisp', which accompanied a poem by Robert Buchanan, appeared in *Good Words* in 1872 and had been made several years earlier for inclusion in Willmott's *The Poets of the Nineteenth Century* (1857) but was not used.[3] It was first published in Milton's *Comus* in 1858.

Hughes continued to make designs for *Good Words* and 'Looking Back' (1873) is a reprinted drawing which made its first appearance entitled 'Blessing in Disguise' in *The Sunday Magazine* on 1 December 1868. Here the image has been cut down removing both the name of the engraver (Dalziel) and Hughes's own monogram. The cavalier re-use of designs by publishers who often provided new titles for them as here, means that it is difficult to be certain whether every drawing discussed is in truth making its very first appearance. In the case of popular and very productive artists such as Hughes and Millais it is little short of impossible.

As an illustrator for children Hughes made his greatest contributions in *Good Words for the Young* to the stories of the editor, George Macdonald. His masterpiece is undoubtedly 'At the Back of the North Wind' which appeared from November 1868 until October 1870 and was published in book form in 1871 (Plates 2.20, 2.21, 2.22 and 2.23). Hughes's gossamer-light designs lift the story far from the commonplace and have helped to ensure its survival as a classic for children. Hughes made numerous drawings for this distinguished periodical and for its far duller and equally short-lived successor, *Good Things for the Young of All Ages*. It is much to the credit of the publisher, Alexander Strahan, who owned *Good Words for the Young* that this fecund collaboration between Hughes and Macdonald took place. He saw the importance of illustration in his magazines which included *Good Words* and *The Sunday Magazine* and in appointing Macdonald to the editorship ensured that it would be an organ of high quality both from a literary and a visual perspective. Several of the stories were reprinted in book form after initial publication in the magazine. 'Ranald Bannerman's Boyhood' which is second in importance only to 'At the Back of the North Wind', appeared as a book in 1871. It had been serialized between

November 1869 and October 1870.

Hughes also made several fine designs for the rather tedious writings of Matthew Browne (William Brighty Rands) in the same magazine. An outstanding composition is 'Trade' (1 February 1871) which is a wonderfully understood drawing with a boy feeding another with an apple in the foreground. In December the same year Hughes provided a drawing for a poem by Macdonald 'The Wind and the Moon', which is a densely worked and highly surreal composition and most uncharacteristic of the artist.

Hughes made a couple of drawings for *London Society*. The first 'The Farewell Valentine' (February 1865) is a lovely image, but it is difficult to credit so feeble a work as 'Not Mine' (July 1870) to Hughes at all. Nevertheless, it is clearly assigned to him in the index. It is a point to be noted that the indices to the illustrated periodicals are frequently unreliable and sometimes inaccurate, and should always be approached with a healthy caution.

Some of Hughes's earliest designs for magazines are to be found in *The Queen* (1861) and *The Welcome Guest* (1858). Those in the latter may be compared in style with the drawings the artist made for Allingham's *The Music Master* (1855).

Three of Hughes's drawings for Tennyson's *Enoch Arden* appeared in *The Shilling Magazine* in December 1865, and it seems were intended as some sort of puff for the book itself. Although the book bears the date 1866, the catalogue at the back is dated December 1865 which suggests that these illustrations appeared concurrently with the book to help ensure good sales during the Christmas season.

The relatively small number of drawings Hughes made for *The Sunday Magazine*, another periodical from Strahan's stable, are among his very finest. This was a journal intended for the Sabbath and the essentially religious sentiments of the literary offerings clearly struck a chord in Hughes's imagination. 'My Heart' (October 1870) to a poem by George Macdonald is a timeless design of an angel weaving, while 'Tares and Wheat' (March 1871) is a miraculous image of a sower and Satan. Also of note is 'Daria' (March 1872) which depicts a beautiful Roman girl, eventually a Christian convert and martyr, who declared while still a pagan, that she will never love until she finds a man who has died to prove his love for her. The poem is by Dora Greenwell.

Although Hughes made numerous designs for book illustration, some of his most successful undertakings remain those for Macdonald's stories for children mentioned above, which made their initial appearance in the magazines.

His earliest independent book illustrations are some slight and scarcely formed fantasies for Allingham's *The Music Master* (1855) and others in a similar vein for Willmott's *The Poets of the Nineteenth Century* (1857). In 1866 he produced arguably not only his best book but one of the most noteworthy of the entire period. This was *Enoch Arden* by Tennyson which achieved fame at the time on account of the sympathy of the illustrator for a genuinely important work of literature (Plates 2.24, 2.25 and 2.26). As a contemporary critic acutely pointed out this was 'a remarkable and valuable example of aptitude on the part of an artist to illustrate a particular poem'.[4]

Hughes's other important illustrated book is Thomas Hughes's *Tom Brown's Schooldays* (1869). Although scarcely read today, this classic for children, by an author unrelated to the illustrator, first appeared to acclaim, on 24 April 1857. In this form it was unillustrated and by November

the same year it had reached its fifth edition. The edition with illustrations by Hughes and Sydney Prior Hall (1842–1922) was published by Macmillan in 1869 and Hughes, who provided the majority of the illustrations, revealed a real understanding and feeling for the text. Several of the full-page designs are somewhat lacking in characterization, but Hughes was at his best in the delightful initial letter designs which begin each chapter. This edition has been much reprinted.[5] The tone and nature of Hughes's work in this book were perceptively crystallized by Gordon Ray who wrote: 'This is still Hughes's best book for those who prefer the sturdy to the eerie.'[6]

Hughes also illustrated two books by Christina Rossetti – *Sing-Song* (1872) (Plates 2.27 and 2.28) and *Speaking Likenesses* (1874) – but both of these, to my mind, show Hughes at his least vigorous and most conventional. The undeniably charming figure groups are somewhat lifeless and look forward to his later and increasingly vapid works such as *Babies' Classics* (1904). A noteworthy though scarcely known book with more interesting and potent designs is Jean Ingelow's *The Shepherd Lady* published by Roberts Brothers in Boston in 1876 (Plates 2.29, 2.30, 2.31 and 2.32).

Hughes: Checklist of illustrated books

1855 William Allingham: *The Music Master*

1857 R.A. Willmott (ed.): *The Poets of the Nineteenth Century*

1866 Alfred Tennyson: *Enoch Arden*
Thomas Woolner: *My Beautiful Lady*

1867 George Macdonald: *Dealings with the Fairies*

1868 George Macdonald: *England's Antiphon*
Revd F.W. Farrar: *Seekers after God*
[Thomas Hughes]: *Tom Brown's Schooldays* (*Golden Treasury* edition)
F.T. Palgrave: *Five Days Entertainments at Wentworth Grange*

1869 [Thomas Hughes]: *Tom Brown's Schooldays* (Macmillan edition)

1870 Mrs George Macdonald: *Chamber Dramas for Children*
Anthology: *National Nursery Rhymes and Nursery Songs*

1871 Henry Bramley and John Stainer (eds): *Christmas Carols New and Old*
Matthew Browne (William Brighty Rands): *Lilliput Lectures*
Henry Kingsley: *The Boy in Grey*
George Macdonald: *At the Back of the North Wind*
George Macdonald: *Ranald Bannerman's Boyhood*

1872 Matthew Browne (William Brighty Rands): *Lilliput Legends*
T.G. Hake: *Parables and Tales*
George Macdonald: *The Princess and the Goblin*
Christina Rossetti: *Sing-Song*

1873 George Macdonald: *Gutta Percha Willie*

Simeon Solomon (1840–1905)

Although Simeon Solomon can hardly be described as a copious illustrator, his designs, despite their limitations in range and in subject-matter, are of a real power, nobility and distinction. His art is suffused with his Judaism and he had an unique insight into Jewish spirituality which no other artist under discussion could match. His intensity, which is apparent in all the Jewish subjects which he drew, is frequently softened by the inclusion of elements from the natural world, such as birds and flowers. Sir William Richmond, who was a fellow student with Solomon at the Royal Academy Schools, recognized that when he remained true to his background he was a great artist, but once he strayed from this tradition his art was somehow damaged and even emasculated: 'Unfortunately Solomon departed from his simple genius to accept an artificial and neurotic vein of late and debased Roman Art; the result was, he was no longer sincere; whereas when he consented to be a Jew, no more highly interesting personal work has ever been done.'[7] Solomon's facial style owes a good deal to Rossetti and also, on occasion, to Hughes while the statuesque nature of his figures bears comparison with Hunt, Leighton and Poynter.

Solomon made a handful of designs for the magazines. In 1862 he provided 'The Veiled Bride' to *Good Words* which unsurprisingly is close in style and feeling to his drawings for *Dalziel's Bible Gallery*, many of which were made in this same year (Plates 2.33 and 2.34). Two further contributions on Jewish subjects were made by him for *Once a Week* (also in 1862) but it was the series of ten designs which he made for *The Leisure Hour* in 1866 which establish him as an outstanding illustrator (Plates 2.35, 2.36, 2.37, 2.38 and 2.39). Depicting 'Jewish Ceremonies and Customs' these indifferently engraved and printed drawings appeared from February to December. Notwithstanding these technical drawbacks, each image possesses a sense of the dramatic and profoundly spiritual which Solomon recognized in his faith. That he was able to convey such an atmosphere to a largely Christian audience is remarkable. His final magazine illustration is 'The End of a Month' which appeared accompanying a poem by Swinburne in *The Dark Blue* in April 1871. Curiously his name beneath the image is misspelt 'Salaman'.

In 1858 the artist contributed a very fine design 'The Haunted House' to *Passages from the Poems of Thomas Hood* but his next book illustrations did not appear until 1881 when some six were published in *Dalziel's Bible Gallery*. A further 14 were first printed in *Art Pictures from the Old Testament* in 1894. These 20 drawings, once again on Jewish themes, together with those made for *The Leisure Hour* are the most rewarding and significant illustrations which he made.

Solomon: Checklist of illustrated books

1858 Thomas Hood: *Passages from the Poems of Thomas Hood*

1881 Anthology: *Dalziel's Bible Gallery*

1894 Anthology: *Art Pictures from the Old Testament*

Henry Hugh Armstead (1828–1905)

Armstead made very few designs but all are powerful with sculptural figures and a dramatic narrative element. He was clearly influenced by the leading Pre-Raphaelite artists and it is a matter of regret that he is so difficult to evaluate. His six designs for the magazines are mostly admirable with one of the best being 'A Song which none but the redeemed can sing'. This was published in *Good Words* in July 1861 and accompanied a poem by Dora Greenwell. His last design for magazines was 'Statues of Moses, St Peter, St Paul and David' which was published in the same periodical ten years later.

Among his nine book illustrations, outstanding is his single contribution to *Poems* by Eliza Cook (1861). Entitled 'The Trysting-Place' this is a haunting image which echoes appropriately the lines in the poem:

> There's a Cavalier that rideth on a
> white and bony hack;
> There's one beside his bridle with a
> spade upon his back; (Plate 2.40)

The four designs Armstead made the following year for Willmott's *English Sacred Poetry* are of interest (Plates 2.41, 2.42 and 2.43), but those he contributed to *Dalziel's Bible Gallery* (1881) which he made probably about 1862 also are better (Plate 2.44). Here he is at his most persuasive in the two crowded scenes rather than the ones with just two figures. Compared to Solomon's treatments of similar subjects in the same volume, Armstead looks somewhat unsure of his compositions and even a little awkward in the drawing.

Armstead: Checklist of illustrated books

1861 Eliza Cook: *Poems*

1862 R.A. Willmott (ed.): *English Sacred Poetry*

1867 Anthology: *Touches of Nature*

1881 Anthology: *Dalziel's Bible Gallery*

1894 Anthology: *Art Pictures from the Old Testament*

Joseph Noel Paton (1821–1901)

Although Paton's designs were dismissed somewhat curtly by Forrest Reid as 'correct and careful' I think more highly of them, mainly on account of the major contribution which he made to Aytoun's *Lays of the Scottish Cavaliers* (1863)[8] (Plates 2.45, 2.46, 2.47, 2.48 and 2.49). Paton was, like the main Pre-Raphaelites, an essentially literary artist and a true storyteller. He became a close friend of Millais when both were studying at the Royal Academy Schools in 1843 and remarkably seemed able to maintain a cordial relationship both with him and with Ruskin, even after the traumatic breakdown of the latter's marriage to Effie. Paton remained devoted to allegory throughout his career, and his somewhat obsessional concern with accuracy led to a telling remark recorded by Lewis Carroll in his diary. After seeing Paton's picture *The Quarrel of Oberon and Titania* at the Scottish National Gallery Carroll exclaimed: 'We counted 165 fairies!'[9]

Paton produced four designs for periodicals – two for *The Cornhill Magazine* in 1864 and two for *The Sunday Magazine* the following year. Of these, perhaps the strongest and most striking is 'Lux in tenebris' which was well engraved by Swain in the May 1864 issue of the *Cornhill*.

Paton made a small number of designs for books throughout the period covered by this study, and two works containing steel-engraved illustrations after his designs are unjustifiably neglected. *The Dowie Dens o' Yarrow* (1860) and *The Rime of the Ancient Mariner* (1863) are large-scale volumes and arguably somewhat archaic both in design and in feeling. Nevertheless, both show a developed sense of composition and bear detailed study. What is noteworthy about them is the feeling that in atmosphere they belong to a period about 20 years earlier. They should be compared with *Prometheus Unbound* (1844) which contains 12 outline engravings, clearly influenced by Retzsch.

In 1863 came two not very interesting drawings for Kingsley's *The Water Babies*, but in the same year Paton, with his brother Waller, produced in *Lays of the Scottish Cavaliers* a book of greatest importance. The bulk of the designs are by Paton himself, and as Solomon was happiest with Jewish subjects, so Paton reveals here his mastery of Scottish ones. The book is Pre-Raphaelite in nature but suffused with a Scottish flavour. The designs possess a grimness and a grandeur close to Frederic Shields and they also look forward to the macabre drawings of another Scottish illustrator of a later period, William Strang.

Paton never produced anything else as remarkable in illustration as the *Lays...* but the terrifying design of the demon drink which he made for Hall's *An Old Story* (1875) is an unexpected late image and one well worth looking up.

Paton: Checklist of illustrated books

1860 Anon: *The Dowie Dens o' Yarrow*

1863 W.E. Aytoun: *Lays of the Scottish Cavaliers*
 S.T. Coleridge: *The Rime of the Ancient Mariner*
 Charles Kingsley: *The Water Babies*
 Dinah Mulock (Mrs Craik): *The Fairy Book*

1864 William Allingham (ed.): *The Ballad Book*

1866 Anthology: *Gems of Literature*

1867 Mrs S.C. Hall: *The Prince of the Fair Family*

1869 H.C. Pennell: *Puck on Pegasus*

1870 [Lady Augusta Noel]: *The Story of Wandering Willie*

1873 S.C. Hall: *The Trial of Sir Jasper*

1874 Elsie Strivelyne: *The Princess of Silverland*

1875 William Ballingall: *Classic Scenes in Scotland by Modern Artists*
 S.C. Hall: *An Old Story*

1878 John Brown: *Rab and his Friends*

Frederic Shields (1833–1911)

Shields like Paton produced very little as an illustrator, but nearly all is of great interest. Stylistically he may be compared most closely with Sandys and indeed with Rethel. However, in contrast to Sandys, Shields was at his most successful with prose rather than with poetry, and his work lacks almost entirely the brooding sexual undertones which are so much a feature of Sandys's productions.

The few designs which Shields made for *Once a Week* in 1861, 1864 and 1867 are unremarkable and it is on just two books that his reputation as an illustrator rests. In 1863 he contributed six small designs to Defoe's *History of the Plague of London 1665* and the following year saw the publication of *Illustrations to Bunyan's Pilgrim's Progress*, a book virtually without letterpress (Plates 2.50, 2.51, 2.52, 2.53, 2.54, 2.55, 2.56, 2.57, 2.58 and 2.59). It is in the Bunyan illustrations in particular, that the influence of Alfred Rethel is especially apparent. In 1849 the German artist had published *Auch ein Totentanz* (Another Dance of Death) which comprised six large woodcuts in which he managed to combine a backward glance at earlier treatments of the subject notably by Holbein and Nikolaus Manuel Deutsch (1484–1530), with a contemporary and populist approach. Shields made conscious use of several of Rethel's devices here, including steep precipices dropping away in the foreground, large figures, heavily shadowed, in the foreground and even a similar somewhat Germanic script.

Shields wrote revealingly of the influence of the Pre-Raphaelites and especially Rossetti in the Moxon Tennyson on his work for the Bunyan:

> The year 1860 formed a turning-point in my career, for then, having before heard much of Rossetti ... I fell in with the edition of Tennyson's poems which contains some designs from his hand. Those, burning with imaginative fervour of invention, appealed to forces hitherto held in subjection within me, and at this juncture a door was opened to put to trial their capacity, in a proposition from the late Mr. Henry Rawson, of the *Manchester Examiner*, to illustrate 'The Pilgrim's Progress' ... In my enthusiasm, and fearful lest this first

chance of serious design should slip my grasp, I undertook the larger designs at two pounds each, the smaller at half the price. The period occupied by this commission ... brought me again to bread and water, which I grudged not, my soul's desires being filled whilst I drank deep of Bunyan's divine dream.[10]

The Defoe drawings in contrast are admirable in their way but their small scale does not permit them very much scope to make an impact on the reader.

Shields: Checklist of illustrated books

1856 [Oliver Ormewood]: *The Greyt Eggshibishun e Lundun*

1863 Daniel Defoe: *History of the Plague of London 1665*

1864 John Bunyan: *Illustrations to Bunyan's Pilgrim's Progress*

Matthew James Lawless (1837–64)

Lawless is a sad example of a real but undeveloped talent curtailed by premature death. His interest in medieval subjects and his accomplished fine line place him in the circle of Sandys, though he rarely approaches that master in strength or in refinement. Lawless's ability was to draw memorable single figures, usually female, of nobility and distinction and it is also remarkable that he usually manages to avoid slipping into the trap of mawkishness, towards which he sometimes sailed perilously close.

In his brief career Lawless appeared surprisingly frequently in the magazines. His moving 'One Dead' (Plate 2.60) appeared in *Churchman's Family Magazine* in September 1863 and is among the finest things he did, as is 'Rung into Heaven' which was published in *Good Words* in the previous year. Both these admirable drawings manage by a whisker to avoid excess sentimentality. *London Society* published a number of characteristic Lawlesses, nearly all of which were well engraved by Walter Barker. Outstanding are 'Surreptitious Correspondence' of November 1862 and the haunting 'Expectation' which was published posthumously in April 1868 but which is dated 1862 in the block. The text beneath the image reads: 'Drawn by the late M.J. Lawless'. A further good design similarly labelled was 'An Episode in the Italian War' which did not attain publication in the magazine until August 1870.

Once a Week, however, is by far the most rewarding magazine in which to study Lawless as a draughtsman, because he made more drawings for this publication than for any other. His earliest appeared on 17 December 1859 to 'Sentiment from The Shambles' and while the first two illustrations look somewhat amateur, the third reveals the artist beginning to find his own entirely individual style. In April 1860 come three designs for 'The Head Master's Sister' and the image on p.389 must rank as one of the finest illustrations the artist ever made. 'The Betrayed' (Plate 2.61) (4 August 1860) to a poem by Sarah Bolton is a monumental image, while of comparable quality, though arguably even more mesmeric, are the two illustrations to 'Oenone' (29 December 1860). In April 1861 Lawless made two drawings for 'Effie Gordon' by B.S.

Montgomery which show the artist at his most consciously medieval in both feeling and execution. Lawless continued to draw for *Once a Week* with distinction over the next two years and notable examples are 'The Dead Bride' (19 April 1862), 'Heinrich Frauenlob' (3 October 1863) (Plate 2.63) and 'Broken Toys' (5 December 1863). This poignant, simple and moving work was his penultimate contribution to the magazine and shows him moving towards a sparer style which he did not live to perfect.

As a contributor of original illustrations for books Lawless was much less productive. In 1861 he provided three designs for Catherine Winkworth's translation of *Lyra Germanica*. While two of the drawings are comparatively slight, the third on p.47 of a woman convulsed with weeping is a masterpiece, sensitively engraved by Swain (Plates 2.65 and 2.66). Lawless also made a contribution to *Passages from Modern English Poets* in 1862 and in the same year come several important designs for Formby's *Pictorial Bible and Church History*, expertly chronicled by Forrest Reid.[11]

Although this concludes the listing of Lawless's book designs, those which he made for magazines can be more conveniently sampled in certain of the anthologies which reprint, invariably on better paper and usually from the original blocks, drawings from the periodicals. *Pictures of Society* (1866) contains several of his drawings from *London Society* and *Churchman's Family Magazine* while *Touches of Nature* (1867) re-publishes some of his work from *Good Words* and *The Sunday Magazine*. Some of the finest images from *Once a Week* can be found in Thornbury's *Historical and Legendary Ballads and Songs* (1876).

Lawless: Checklist of illustrated books

1861 Catherine Winkworth (trans.): *Lyra Germanica*

1862 Anthology: *Passages from Modern English Poets*
Revd. H. Formby: *Pictorial Bible and Church History*

1866 Anthology: *Pictures of Society*

1867 Anthology: *Touches of Nature*

1870 Anthology: *The Piccadilly Annual*

1876 Walter Thornbury: *Historical and Legendary Ballads and Songs*

1877 Mrs Sale Barker: *Routledge's Holiday Album for Girls*

Notes

1 The design should have appeared in *Once a Week* on p.672 in 1867. It was finally published in *Century Guild Hobby Horse*, vol. iii in October 1888.

2 For another and comparable example of the genre see Hunt's 'Active and Passive' in Mrs Gatty *Parables from Nature*, 1861, facing p.93.

3 I am indebted for this information to Mr Leonard Roberts given verbally 14 May 1991.

4 Anonymous review in *Athenaeum*, 23 December 1865.

5 A recent edition, which includes Hughes's designs, is in the Oxford *World's Classics* series (1989) with a useful introduction and notes on the text and the illustrations by Andrew Sanders.

6 Gordon N. Ray *The Illustrator and the Book in England from 1790 to 1914*, 1976, p.111.

7 Quoted by Bernard Falk from A.M.W. Stirling *The Richmond Papers* in *Five Years Dead*, 1937 p.321.

8 Forrest Reid, *Illustrators of the Eighteen Sixties*, 1928. Quoted from the reprint, New York, 1975, p.254.

9 M.H. Noel-Paton and J.P. Campbell *Noel Paton 1821–1901*, Edinburgh, 1990, p.21.

10 Henry C. Ewart (ed.) *Toilers in Art*, 1891, pp.162–3.

11 Reid, *Illustrators*, p.55.

PLATE 2.1
Until her Death

Plate 2.2
Sleep

PLATE 2.3
From my Window

PLATE 2.4
The Waiting Time

"Yet she was all so queenly in her woe."

PLATE 2.5
Yet she was all so queenly in her woe

66

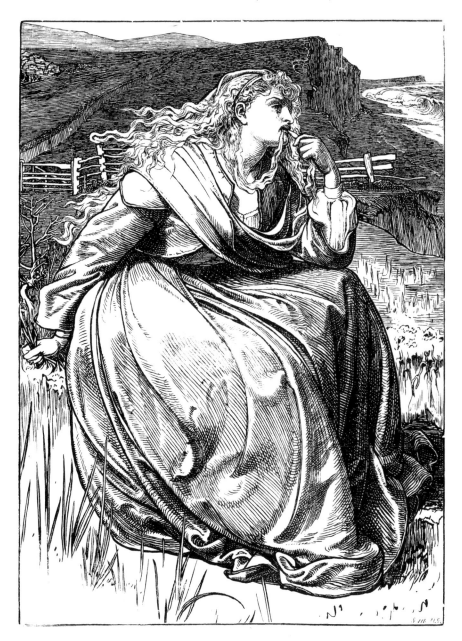

PLATE 2.6
If

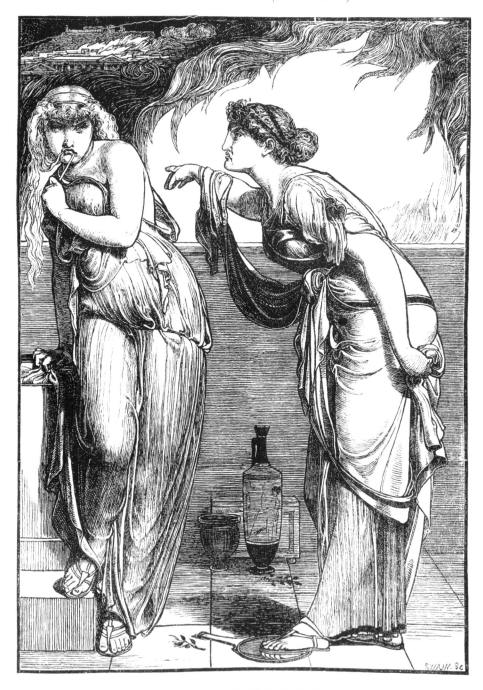

HELEN AND CASSANDRA.—BY F. SANDYS. [See p. 451.

PLATE 2.7
Helen and Cassandra

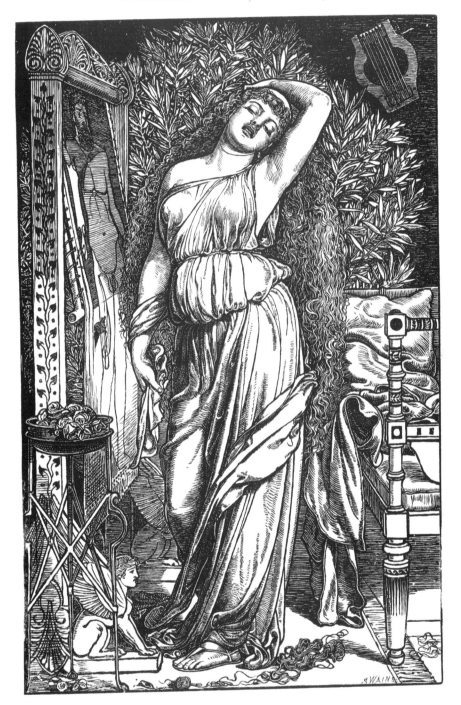

PLATE 2.8
Danae in the Brazen Chamber

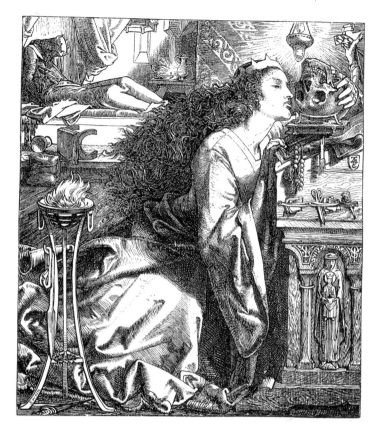

PLATE 2.9
Rosamond, Queen of the Lombards

PLATE 2.10
The Old Chartist

PLATE 2.11
The three statues of Aegina

PLATE 2.12
Harald Harfagr

PLATE 2.13
The King at the Gate

PLATE 2.14
Jacques de Caumont

PLATE 2.15
Amor Mundi

LEGEND OF THE PORTENT.

PLATE 2.16
Legend of the Portent

Plate 2.17
Manoli

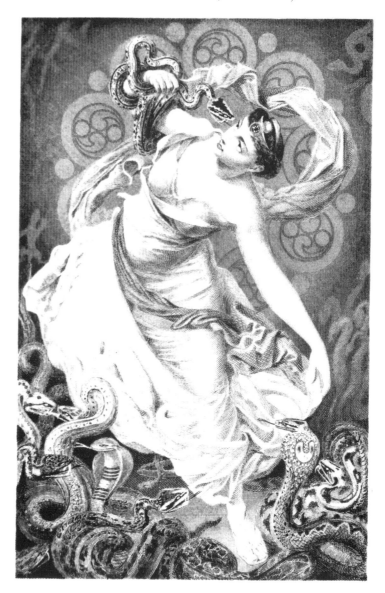

PLATE 2.18
Bhanavar among the serpents of Lake Karatis

PLATE 2.19
Jacob hears the Voice of the Lord

PLATE 2.20
Untitled

PLATE 2.21
Untitled

Plate 2.22
Untitled

Plate 2.23
Untitled

PLATE 2.24
Untitled

PLATE 2.25
Untitled

PLATE 2.26
Untitled

PLATE 2.27
Untitled

PLATE 2.28
Lullaby, O lullaby

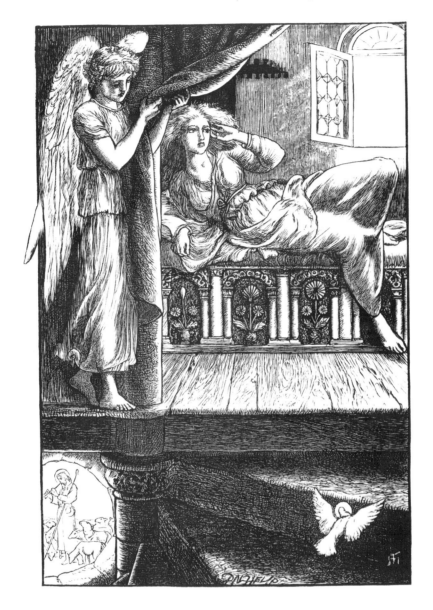

PLATE 2.29
The Dear white lady in yon tower …

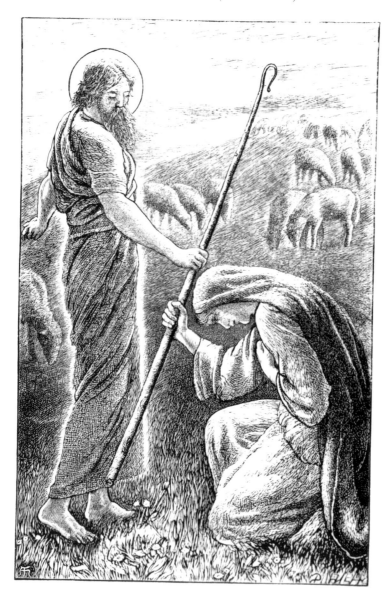

Plate 2.30
Take now this crook

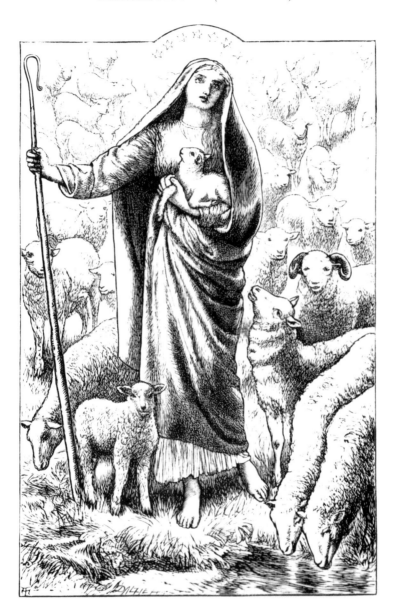

Plate 2.31
On Sunny slopes …

PLATE 2.32
Above the Clouds

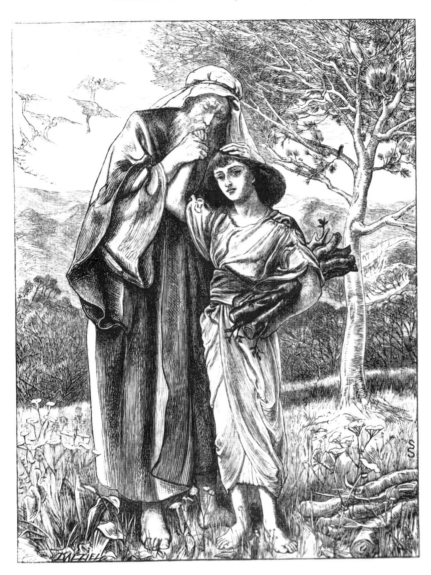

PLATE 2.33
Abraham and Isaac

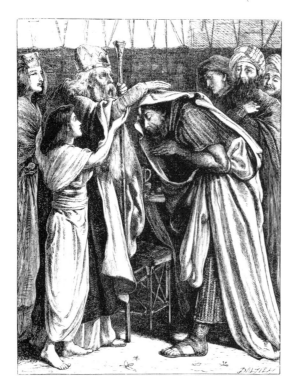

PLATE 2.34
Melchizedek blesses Abraham

PLATE 2.35
The Circumcision

90

Plate 2.36
The Eve of the Jewish Sabbath

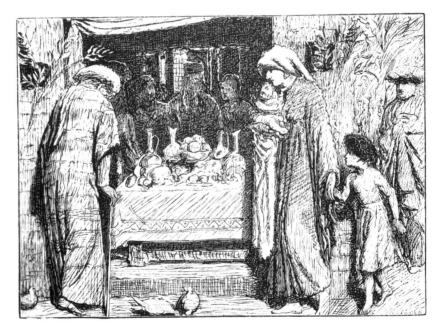

Plate 2.37
The Feast of Tabernacles

PLATE 2.38
The rejoicing of the Law

PLATE 2.39
The Week of Mourning

PLATE 2.40
The Trysting-Place

PLATE 2.41
A Dream

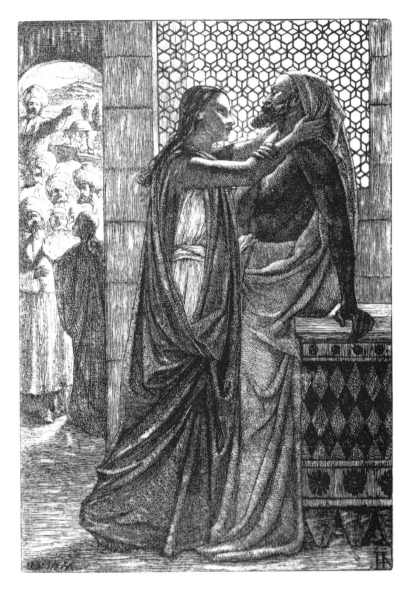

PLATE 2.42
The dead man of Bethany

PLATE 2.43
Evening Hymn

PLATE 2.44
The Fall of the Walls of Jericho

PLATE 2.45
The Execution of Montrose

PLATE 2.46
The Heart of the Bruce

PLATE 2.47
The Widow of Glencoe

PLATE 2.48
Blind Old Milton

PLATE 2.49
Hermotimus

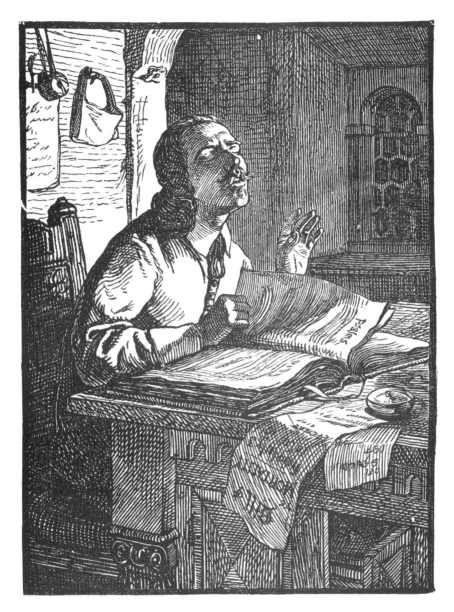

PLATE 2.50
The Decision of Faith

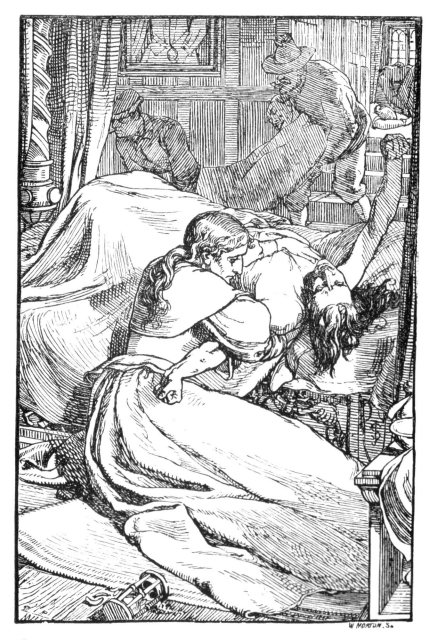

Plate 2.51
The Plague-Stricken House

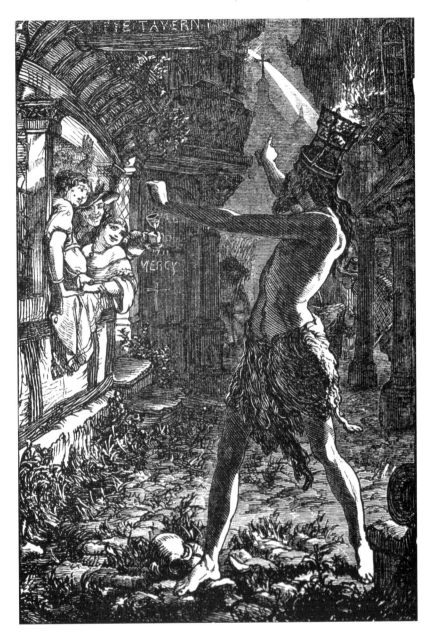

PLATE 2.52
Solomon Eagle

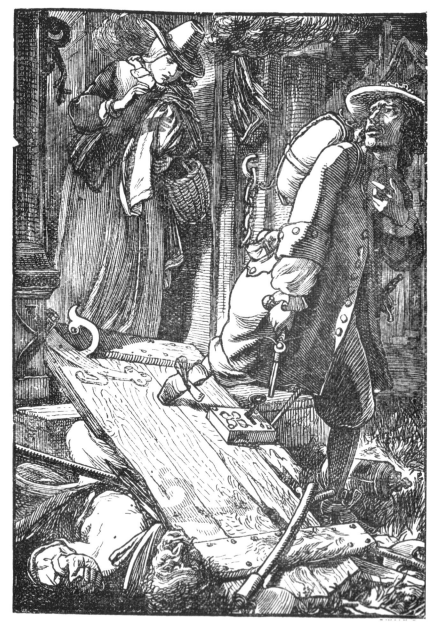

PLATE 2.53
Imprisoned family escaping

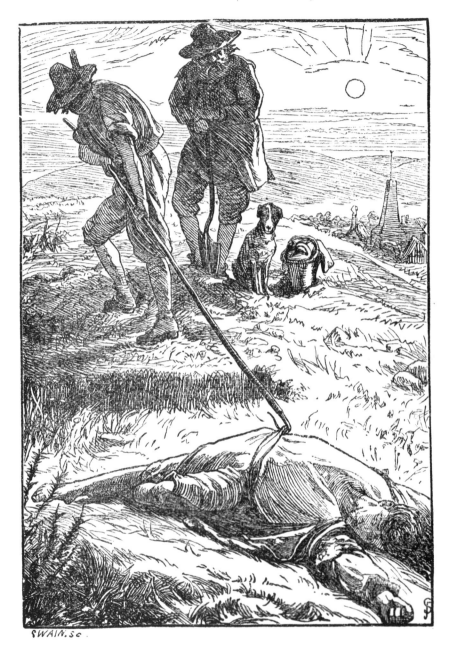

SWAIN.sc.

PLATE 2.54
Fugitive found dead by rustics

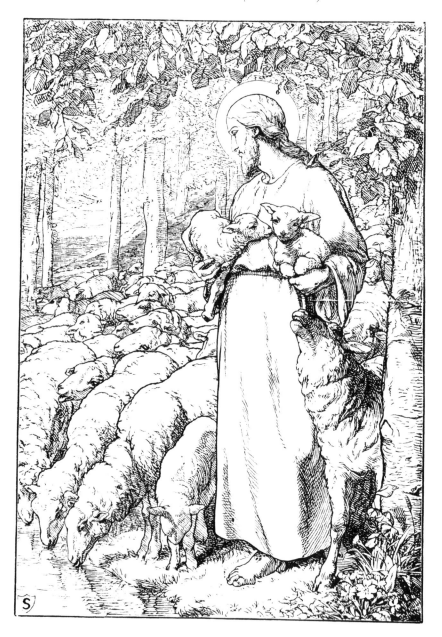

PLATE 2.55
The Good Shepherd

PLATE 2.56
Apollyon

PLATE 2.57
Mercy making garments

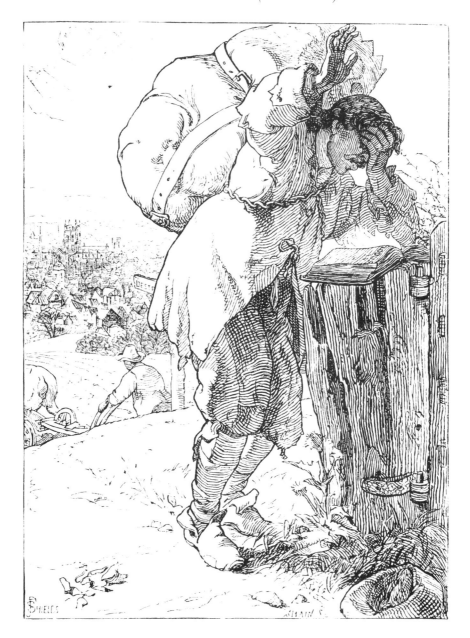

PLATE 2.58
Christian reading

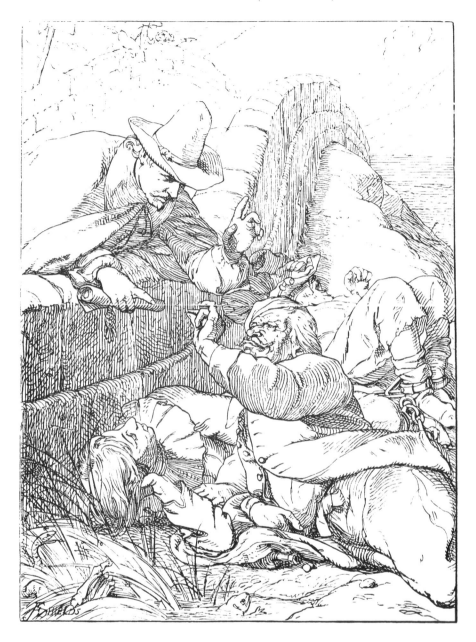

PLATE 2.59
Christian, Sloth, Simple etc

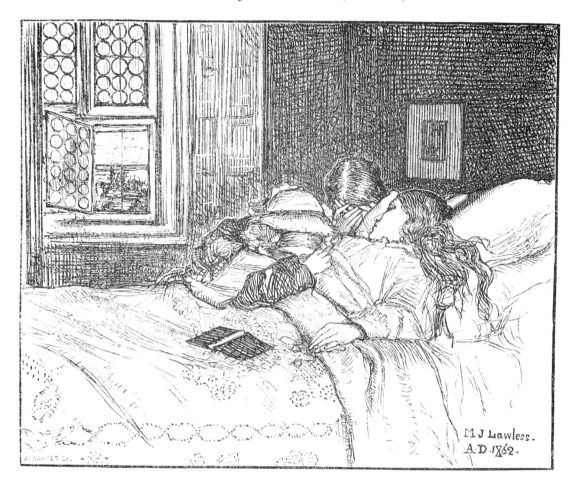

PLATE 2.60
One Dead

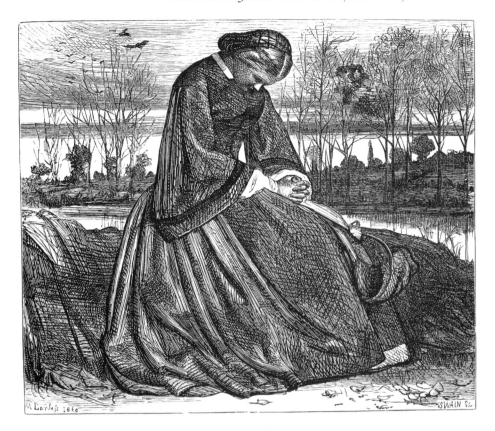

PLATE 2.61
The Betrayed

PLATE 2.62
Dr. Johnson's Penance

111

PLATE 2.63
Heinrich Frauenlob

PLATE 2.64
Faint Heart never won Fair Ladye

PLATE 2.65
Untitled

PLATE 2.66
Untitled

3

The Idyllic School

George du Maurier, George John Pinwell, Frederick Walker, Arthur Boyd Houghton,
John William North, John Dawson Watson, John Pettie, Robert Barnes, William Small

Almost without exception the Pre-Raphaelite artists wished to be known primarily as painters or poets rather than as illustrators, and it is remarkable that Millais who shared such ideas continued to illustrate for most of his career. As already mentioned the majority of the others swiftly turned away from the pressures and drudgery imposed on them by insatiable publishers, editors and engravers. As the number of Pre-Raphaelite designs declined and their contributors became ever more desultory, so another loose grouping of artists arose to take their place. Known as the Idyllic School these practitioners, in general, possessed a more pragmatic approach to the art of illustration, and several realized that the genre was the one to which their talents were best suited, and indeed saw it as a career. They were interested in Pre-Raphaelite ideas and had imbibed some of them, but they also made subtle changes in emphasis which on occasion led them close to the sentimental and even the banal.

The term 'Idyllic' may have come about from an anthology of designs taken from *The Quiver*. Entitled *Idyllic Pictures* and published in 1867 it contained drawings by several leading practitioners notably Pinwell, Houghton, Robert Barnes and William Small, as well as Sandys who perhaps does not fit so neatly into the group. Forrest Reid was probably the first to use the term critically when he wrote of Walker's drawings for *Denis Duval* in *The Cornhill Magazine*: 'he may clothe his figures in the costume of a bygone age, but the drawings themselves breathe precisely the same idyllic Victorian spirit as his modern illustrations.'[1]

Although it should be stressed that 'Idyllic' is used for convenience rather than strict accuracy, it seems to crystallize several characteristics which these artists shared. They were less interested in a 'remote past', a dreamy medieval world peopled by knights, swooning mistresses and tales of legend far from reality or everyday life which the Pre-Raphaelites perfected. Instead they created scenes which were more earthbound but, at their best, were no less poetic or intense. They often depicted a harmonious rural life with decent but poor people apparently leading simple, noble existences far from urban squalor.

In their own way, although they concentrated more on contemporary mores, their treatment of them was as unrealistic and imagined as anything the Pre-Raphaelites ever created. It cannot be said that, in this vein, these illustrators dealt with social issues, until the arrival of *The Graphic* which was founded in 1869. Here Pinwell, Fildes and most notably Houghton, with his *Graphic America*, turned away from Idyllic scenes to subjects of current interest. Again with the exception of Houghton these artists lacked the unashamed sensuality of Sandys and their greatest strengths

were those of understatement, directness and a genuine sincerity. In addition, there was almost invariably present a strong moral and religious feeling in their work.

George du Maurier (1834–96)

Du Maurier, more than any other of these artists, seems to have had a foot both in the camp of the Pre-Raphaelites and in that of the Idyllics. His work as a *Punch* artist, for which today he is best known, does not concern us here, since in the first ten years of his career he was determined to make his living as a contributor to the leading non-comic periodicals. He set his sights on *Once a Week* and wrote to his mother in April 1861: 'I am very anxious to be kept on O.A.W [*Once a Week*] as it is the swellest thing out and gets one known, and the more carefully I draw the better it will be for me in the end ... '[2] At this date it is clear du Maurier was determined to be seen as a serious practitioner, and was influenced by German artists notably Rethel and Adolph Menzel, as Tom Armstrong noted:

> Du Maurier used to practise methods of execution about this time with pen and brush, and I remember his careful copy of a portion of one of Rethel's famous woodcuts, *Death the Friend*, and also portions of Menzel's work in the life of Frederick the Great. This book, of which Charles Keene was the first among us to own a copy, impressed English draughtsmen on wood very much.[3]

Du Maurier, who knew several of the Pre-Raphaelites, and was a lifelong friend of Millais and an admirer of Sandys, perhaps unsurprisingly drew in a number of styles. While he could be Pre-Raphaelite and Idyllic by turns, he also showed his comic abilities regularly, as well as a melodramatic turn of mind, especially in his work for thrillers such as 'The Notting Hill Mystery' which appeared in *Once A Week* (1862–3). Always present is a remarkable facility in drawing, a skill which he was to squander after the Sixties on innumerable saccharine fancies almost entirely for *Punch*.

In *The Cornhill Magazine* du Maurier made arguably his most distinguished contributions to illustration. His first was 'The Cilician Pirates', a striking drawing of genuine drama, which appeared in April 1863, and in September of the same year came ten charming vignettes to 'How we slept at the Châlet des Chèvres'. Here is the artist at his lightest and most delicate, and he also displays an innate feeling for the story.

As Millais and Houghton were able to tailor their styles to the text, so, at least during this period, was du Maurier their equal. In August 1864 Mrs Gaskell's *Wives and Daughters* began to be serialized in the magazine, and he provided all the illustrations as well as initial letter designs at the beginning of each chapter (Plates 3.1 and 3.2). The quality of this series is such that it can only really be compared with Millais's drawings for Trollope. A thorough reading of the text ensured the artist's sympathy with the protagonists in the novel, and this, coupled with superb engraving by Swain, meant that the interpretation is outstanding. Indeed du Maurier clearly admired Gaskell and he provided illustrations for several of her works. It would be a service to re-publish all his drawings for her writings, since nowhere else is his work so at one with the

text. *Wives and Daughters* was concluded in January 1866, and although he continued to draw for the magazine he never again attained so exalted a level of achievement. The 24 designs he made for 'Against Time' between October 1869 and September 1870 are not inspired and reveal a sad decline into tedium.

The artist only made two drawings for *Good Words* but both are remarkable. 'A Time to Dance' appeared in October 1861 and 'Under the Elm', a late Pre-Raphaelite essay, was not published until 1872. The few designs he made for the *Graphic* are not of particular interest, but the group of drawings in *The Leisure Hour* show him at the height of his powers. Some 27 illustrations accompanied G.E. Sargent's 'Hurlock Chase', and although they lack the poetic distinction of the Gaskell designs, the whole is a wonderfully sustained achievement. The following year the same magazine published a smaller number of drawings for 'The Awdries and their friends' which though good are at a slightly lower level of interest. Unfortunately, the paper in this magazine and the quality of printing are both poor.

Du Maurier made numerous drawings in his lighter playful manner for *London Society*, some of which are of excellent quality. The artist is at his happiest in 'Mr Punch's Representative' which was published in the Christmas number in 1864 to illustrate 'Christmas in the Streets' and 'A "Wrinkle" for the Coast Guard' of the following year. Nearly all du Maurier's contributions to this magazine were capably engraved by Thomas Robinson.

Once a Week shows the artist at his most varied and interesting. Perhaps his loveliest drawing here is 'Non Satis' (November 1860), showing him at his most consciously Pre-Raphaelite, while 'On her Death-bed' of 1861 possesses an uncharacteristic intensity, closest in feeling to Sandys. Particularly rewarding is the series to 'The Notting Hill Mystery' (1862–3) which is done with great panache in the artist's best 'waxed-moustache' melodramatic thriller style. However, even better are the drawings for Mrs Braddon's 'Eleanor's Victory' (1863). These rich and varied designs, many containing dramatic lighting effects, produce a *'tour de force'* which is highly original and successful. Du Maurier returned with equal skill to impressions of light in 'Philip Fraser's Fate' the following year. Some notable designs also appeared in *The Sunday at Home* and 'In the right pocket' of 1864 is notable and close in style to the drawings for Mrs Gaskell on which du Maurier was engaged in the loftier pages of *The Cornhill Magazine* at about the same period.

While du Maurier was a frequent provider of illustrations for books at this period, nothing in his serious manner can compare in importance or scope with the designs already mentioned for *Wives and Daughters*. The *Cornhill* illustrations were reprinted in two volume book form in 1866. The relatively small number of drawings the artist made for several other of Mrs Gaskell's writings are at a similar level of interest. *Sylvia's Lovers* (1863), (Plates 3.3 and 3.4) *Cranford* (1864) and *North and South* (1867) are all noteworthy and it is perhaps surprising that du Maurier's name appears nowhere in these books, although his initials are usually on the blocks. Fortunately he was engraved here by the almost invariably scrupulous Swain, who always permitted his designs to come through clearly and with definition.

Just one other book, Jerrold's *The Story of a Feather* of 1867, which the artist also illustrated single-handed is of significance (Plates 3.5 and 3.6). It is a model of outstanding comic invention and facility. If anything it is in the initial letters that du Maurier excelled, and quite correctly a perceptive critic labelled them 'exquisite'.[4]

Although du Maurier made some pleasing designs for Shirley Brooks's *Sooner or Later* in 1868, his artistry was already in decline. The seeds of this were sown in *The History of Henry Esmond* (Plates 3.7 and 3.8) and *Lucile*, also published the same year, and by 1874 it was complete, as the absurdly sentimental drawings for Montgomery's *Misunderstood* bear witness. The *Esmond* drawings are far better than those for *Lucile* but they display a descent into blandness which is depressing. Of even less interest were the wretched illustrations for one of Hardy's weaker novels, *The Hand of Ethelberta*, in 1877.

Du Maurier: Checklist of illustrated books

1861 Henry Dalton: *The Book of Drawing Room Plays*

1863 Mrs Gaskell: *Sylvia's Lovers*

1864 Alfred Elwes: *Luke Ashleigh*
 Mrs Gaskell: *Cranford*
 Mrs Gaskell: *A Dark Night's Work*
 Baroness Tautphoeus: *Quits*
 Revd L.B. White (ed.): *English Sacred Poetry of the Olden Time*

1865 Anthology: *Our Life Illustrated by Pen and Pencil*
 Mrs Gaskell: *Cousin Phyllis*
 Mrs Gaskell: *The Grey Woman*
 Mrs Gaskell: *Lizzie Leigh and other Tales*

1866 [R.H. Barham]: *The Ingoldsby Legends*
 John Foxe: *Book of Martyrs*
 Mrs Gaskell: *Wives and Daughters*
 Adelaide Procter: *Legends and Lyrics*

1867 Anthology: *The Attractive Picture Book*
 Mrs Gaskell: *North and South*
 Andrew Halliday (ed.): *The Savage-Club Papers*
 Douglas Jerrold: *The Story of a Feather*
 Isaac Watts: *Divine and Moral Songs* (Nisbet edition)

1868 Shirley Brooks: *Sooner or Later*
 Owen Meredith: *Lucile*
 Mrs Prosser: *The Awdries and their Friends*
 W.M. Thackeray: *The History of Henry Esmond*

1869 Lope de Vega: *Castelvines y Monteses*

1870 J.F. Waller: *Pictures from English Literature*

1873 F.C. Burnand: *Mokeanna!*
 Baroness Tautphoeus: *At Odds*

1874 Florence Montgomery: *Misunderstood*
 Clement Scott: *Round about the Islands*

1875 W. Wilkie Collins: *The Frozen Deep*
 W. Wilkie Collins: *The Moonstone*
 W. Wilkie Collins: *Poor Miss Finch*
 W. Wilkie Collins: *The New Magdalen*
 Elizabeth Lynn Linton: *Patricia Kemball*

1876 Jemmett Browne: *Songs of Many Seasons*

1877 H. Cholmondely Pennell: *Pegasus Re-Saddled*
 Thomas Hardy: *The Hand of Ethelberta*

1878 Charles and Mary Lamb: *Tales from Shakespeare*

1879 W.M. Thackeray: *Ballads*

1882 Charles Reade: *Foul Play*

George John Pinwell (1842–75)

Although it is undoubtedly true that Pinwell's art was limited in range and subject-matter, and on numerous occasions his technique was uncertain and even inadequate, he remains one of the truest exponents of Idyllicism. He is the poet of the figure in everyday dress, in the same way as J.W. North is the lyricist of the Idyllic landscape. Pinwell's hooded and introverted creations rarely look out directly at the viewer, and more frequently hide their features by turning away or sheltering beneath hats. It is the use of such devices that gives so many of his compositions a sense of remoteness, and even mystery, which can be memorable. He fully understood the medium of wood-engraving and his drawings, though frequently unimpressive judged simply as works of draughtsmanship, improve markedly when engraved on the block. Pinwell excelled at drawing women and children, and in a less theatrical way than du Maurier was a master of light and shade.

His single contribution to *The Argosy* was an unusual but powerful drawing of Napoleon seen from behind. Published in 1866, it accompanied a poem by William Allingham entitled 'Cape Ushant'. Although he only made a few designs for *The Cornhill Magazine*, one of those for 'Out of the Forest' in August 1870, is a magnificent piece. The artist produced far more for *Good Words*, and of the individual drawings, one of the finest was to Dora Greenwell's poem 'A Christmas Carol 1863' published in 1864. However, perhaps the most sustained and rewarding group of illustrations were the 12 which he made for George Macdonald's 'Guild Court' which, well engraved by Dalziel, ran through the magazine in 1867. In 1868 Pinwell illustrated 'Una and the Lion' by Florence Nightingale, and here he showed great ability in his handling of a crowded graveside scene. This was in a journalistic style which he was to repeat in his work a few years later in *The Graphic*. He continued to contribute regularly to the magazine for the next few years, and produced another of his noble female figure drawings for 'Margaret in the Xebec'

by Jean Ingelow in April 1870.

In 1871 Pinwell's contributions to *Good Words* dropped both in number and interest, and the only one of note, 'Toddy's Legacy', was spoilt by slapdash engraving. For the next four years he was absent from its pages, until he illustrated in its entirety, a novel once more by Jean Ingelow, 'Fated to be Free' in 1875. These 35 designs reveal a great decline in quality and execution and are evidently the work of a sick and dying man. One of the blocks is dated 1874 while another even has the artist's monogram engraved in reverse. Pinwell died on 8 September 1875 and there is an irony in the fact that the final drawing on page 832 is of 'Valentine on his deathbed'. With the single design for *The Sunlight of Song*, where the block is dated 1875, this was probably his last drawing, and he may never have seen it published.

Pinwell made just one drawing for *Good Words for the Young* – 'A Tradition of the Black Rock' – which is a design of typical strength and power, and it is perhaps a little strange that he did no more work for this distinguished juvenile publication. Although he did illustrate a small number of books for children, especially at the beginning of his career, such as *The Happy Home* (1864) and *Hacco the Dwarf* (1865) he seems more comfortable and successful drawing for adults. Though a consummate delineator of youth his best drawings in this vein appear in books intended for adults.

Pinwell did little for *The Graphic* but two of his drawings here are outstanding. 'The Lost Child' (8 January 1870) is a fine composition matched only by 'The Sisters' (6 May 1871), which is also in his most mature style. The few designs he made for *London Society* are not particularly distinguished, and the best to 'The Courtship of Giles Languishe', is ruined by poor printing.

The artist began providing designs for *Once a Week* in January 1863. His first drawing, 'The Saturnalia' (31 January 1863), is an ambitious and complex drawing, and not entirely successsful. His next few contributions are of average interest only, until the touching image to 'The Strong Heart' (4 July 1863). On 5 September 1863 came 'Waiting for the Tide', which is one of Pinwell's lovely wistful women, drawn with real feeling. 'The Sirens' (21 November 1863) (Plate 3.9) is uncharacteristically erotic, but none the less an interesting departure. In 1864 a fine drawing was to 'Horace Winston' (13 February) while 'Proserpine', published in the following week's issue, is a strange and unearthly concept but less successful as a composition being overcrowded. Throughout 1864 his contributions to the magazine were regular but not particularly distinguished, and in April 1865 came 'Dido'. It is difficult to believe that so dreadful a drawing is really by the artist. Nevertheless, from time to time he did lapse both in quality of design and even in matters of taste. As *Once a Week* cut back on the number of illustrations in the mid-1860s, largely on the grounds of cost, so Pinwell's appearances in its pages decline. However, of note is a haunting image 'Come buy my pretty windmills' (30 March 1867), and a moving study of youth and age, 'A Seat in the Park', which was published on 26 June 1869.

The Quiver contains much of the finest work Pinwell did for all periodical literature. 'Echoings from Faded Flowers' (December 1865) is a masterpiece, while the drawing he made for Walter Thornbury's 'The Lost Opportunity' in March 1866 is a sensitive image of three angels standing at the deathbed of an old man. Several other drawings made in 1866 are of similar high quality and 'Margaret' which appeared in November the same year is made all the simpler and more powerful by the way in which the artist hides the features of both the male and female figures. Almost all the drawings in 1867 show the artist at his best, while one of his last contributions to

'The Burden of the Bells' (May 1868) manages just to avoid sentimentality, and yet succeeds in conveying grief by posture even more than by facial expression. Although *The Sunday at Home* is rarely a periodical of distinction, Pinwell's few designs for it are well worth seeking out.

Pinwell's work for *The Sunday Magazine* is of similar quality and perhaps even greater variety than that which he gave to *The Quiver*. In 'The House of God' (November 1864), the artist returns to a favourite theme, that of youth and age, and makes a telling contrast between the old woman and the two young children in church. 'Think on the Poor' (1 November 1865) is another typical use of juxtaposition – in this instance not of youth and age but of a rich woman sitting with a poor one. The broken chair in the foreground makes a powerful point, and Pinwell returns to contrast once again, this time in slightly lighter vein; 'Remonstrance' (2 April 1866) is delightful in the way the figure of the elderly woman at prayer is set against the playful cat in the foreground. The artist is at his most sculptural and monumental in 'The Gang Children' (1 October 1868) to a poem by Dora Greenwell. However, his greatest achievement in this magazine and arguably one of his most important as an illustrator is the group of drawings he made for 'The Crust and the Cake'. The story ran through the magazine from 1 October 1868 until 1 September 1869, and it is fair to say that all that is best about Pinwell's art can be appreciated from its pages. In addition to the large designs, the numerous vignettes are especially rewarding. A final drawing and a great one was made for 'The Lighthouse-keeper's story'. This posthumous piece appeared in the magazine's Christmas story in 1876.

While Pinwell was a frequent illustrator of magazines it is perhaps somewhat surprising that he was far less productive in his work for books. His two earliest books for children which have already been mentioned, *The Happy Home* and *Hacco the Dwarf*, both by Henrietta Lushington, are significant only because they show him searching for a style. His designs in them are, at this stage, awkward and immature. In 1865 his work develops in *Dalziel's Arabian Nights' Entertainments* and most importantly, in the same engravers' edition of Goldsmith. *Dalziel's Illustrated Goldsmith* is significant since it is the only large undertaking the artist undertook alone. This costume piece, to which Pinwell was temperamentally and artistically unsuited, is a disappointment, although Reid was probably correct when he remarked: 'The *Goldsmith* is one of the big books of the period, and establishes Pinwell's reputation as a first-rate illustrator.'[5] It was left to a more recent commentator to evaluate the book justly when he wrote: 'Not, in fact, a book about which one can be enthusiastic, despite a handful of pretty things. Certainly not, as White thought, Pinwell's "masterpiece".'[6]

In 1866 Pinwell illustrated *Gil Blas* which showed him handling a costume story with more confidence, and he also produced some notable designs for Buchanan's *Ballad Stories of the Affections*. However, by far his most outstanding and memorable drawings appear in *A Round of Days* (1866) and *Wayside Posies* the following year (Plates 3.10, 3.11, 3.12, 3.13, 3.14, 3.15, 3.16 and 3.17). Here his abilities are aided by excellent printing on good quality paper and it is fair to say that in these two works all that is quintessentially 'Idyllic' in the artist's work can be fully appreciated. A design such as 'The Island Bee', from *Wayside Posies*, shows him as a master of grace and understatement in the depiction of woman and child. Millais saw the essence in Pinwell's work when he remarked perceptively: 'no man could produce work like his who was not a man of exquisite taste and refined poetic feeling.'[7] It was, however, left to a later critic to get to the very heart of Pinwell's work, when he wrote:

All the designs that he made for Buchanan's *Wayside Posies* (1867), one of Dalziel's 'Fine Art Books', are full of detailed observation of country utensils and buildings. The old door, the heavy mallet, apples in a loft or water in the mill–pond, are given quite as much attention and prominence as the figures in these scenes. All are lit with diffused, reflected light, which gives his work its unmistakeable atmosphere. But he is not sentimental; the human figures are set out in a severely detached way: they have something of the generalisation of a type. But they are portrayed with every circumstance of their life.[8]

At almost the same level are some of his contributions to *The Spirit of Praise* (1867) (Plates 3.18 and 3.19). In Jean Ingelow's *Poems* (1867) and Buchanan's *North Coast and other Poems* (1868) there are further excellent examples of this artist at his best, while, also in 1868, comes the fine frontispiece to *It is Never too Late to Mend* and the interesting and powerful drawings he made for Dickens's *The Uncommercial Traveller*. This last volume is especially important since it shows Pinwell moving towards a harder, more journalistic style in draughtsmanship, and one which he was to employ in the *Graphic* soon after. The book is also noteworthy since the elderly man in 'Leaving the Morgue' (facing p.107) is quite clearly a portrait of Dickens himself.[9]

After 1868 Pinwell's contributions to books drop severely both in number and in interest. His last illustration in *The Sunlight of Song* (1875) shows him in obvious decline, but making an attempt to embrace the interest in things Oriental which was popular at the time. 'The Spies bringing the grapes' made for *Dalziel's Bible Gallery* in the Sixties was not published until its appearance in the useful collection, *Art Pictures from the Old Testament*, in 1894. It is a strangely inelegant drawing, and though interesting, shows that Pinwell was not really suited to so overtly a religious undertaking.

Pinwell: Checklist of illustrated books

1864 Matthew Browne (William Brighty Rands): *Lilliput Levée*
 Henrietta Lushington: *The Happy Home*

1865 Anthology: *Our Life Illustrated by Pen and Pencil*
 Dalziel's Arabian Nights' Entertainments
 Oliver Goldsmith: *Dalziel's Illustrated Goldsmith*
 Henrietta Lushington: *Hacco the Dwarf*

1866 Anthology: *A Round of Days*
 Anthology: *The Spirit of Praise*
 Robert Buchanan: *Ballad Stories of the Affections*
 Tobias Smollett (Translated from Le Sage): *The Adventures of Gil Blas*

1867 Anthology: *Golden Thoughts from Golden Fountains*
 Anthology: *Touches of Nature*
 Robert Buchanan (ed.): *Wayside Posies*
 Jean Ingelow: *Poems*

1868 Robert Buchanan (ed.): *North Coast and other Poems*
 Charles Dickens: *The Uncommercial Traveller*
 Charles Reade: *It is Never too Late to Mend*

1870 Anthology: *National Nursery Rhymes*

1871 Henry Leslie: *Henry Leslie's Musical Annual*

1872 Matthew Browne (William Brighty Rands): *Lilliput Legends*
 Norman Macleod: *Character Sketches*

1874 Anthology: *Picture Posies*

1875 Anthology: *The Sunlight of Song*

1876 Jean Ingelow: *Fated to be Free*
 Walter Thornbury (ed.): *Historical and Legendary Ballads and Songs*

1877 Sarah Doudney: *Stories of Girlhood*

1882 Anthology: *English Rustic Pictures*

1894 Anthology: *Art Pictures from the Old Testament*

Frederick Walker (1840–75)

Walker, though in his day one of the most popular illustrators of the Sixties, seems now a more difficult and elusive artist to evaluate justly. That he was an accomplished watercolourist has never been at issue, but on looking once again at his illustrations, it is sometimes far from easy to see why he was so especially admired by the critics and the public in his own time. His work is always delicate and sensitive, but at least to this commentator, it appears also to lack both power and profundity. He was a better draughtsman than Pinwell but a more conventional one, and he possessed nothing of the latter's sense of mystery and the quality perceived in Pinwell by no less an artist than Van Gogh: 'He was such a poet that he saw the sublime in the most ordinary, commonplace things.'[10]

If Walker lacked poetry, his true skills lay in a workmanlike approach and a real understanding of contemporary life and the art of wood-engraving. Du Maurier saw the virtues of Walker's work when he wrote of him in *The Magazine of Art* in August 1890: 'He was the first to understand, in their "inner significance", the boot, the hat, the coat sleeve, the terrible trousers, and, most difficult of all, the masculine evening suit. Even Millais and Leech, who knew the modern world so well, could not beat him at these.' Such a clear and fair view was echoed by Reid who wrote:

There is little imagination in Walker's work; he possessed the type of mind for which the poetic is indistinguishable from the sentimental; therefore we like him best when he contents himself with reproducing charming aspects of ordinary domestic life – a pretty girl

shelling peas, or an old woman lifting the kettle from the hob.[11]

In May 1861 Walker made his first contribution, entitled 'Nurse and Doctor', to *The Cornhill Magazine*. This was for the editor Thackeray's 'Philip' and the charming story of how the two men met is admirably related by Reid (p.141) and hence does not bear re-telling here. Walker took over the designs for this novel since Thackeray realized that his own were not up to the job. Facing 'Nurse and Doctor', the initial letter drawing is indeed by Thackeray, and the two make a useful comparison. 'Philip' established Walker as an important illustrator and 'Comfort in Grief' (December 1861) is a design of power and monumentality. The 'Philip' designs ran through the magazine until August 1862. In March 1864 Walker began to illustrate another novel by Thackeray 'Denis Duval', which the author left unfinished at his death. Walker is at his most beguiling in several of these designs and 'Evidence for the Defence' is a good example. From July 1866 until January 1867 Walker illustrated Anne Thackeray's 'The Village on the Cliff', and of these 'A Vacarme' which appeared in December 1866 finds an echo in du Maurier's concept of Svengali in his novel *Trilby* published in 1894. Walker was fortunate to have his designs in *The Cornhill* engraved by the reliable Swain who does full justice to the artist's fine drawings for 'Jack the Giant-Killer' which appeared from December 1867 until January 1868.

The series of eight illustrations Walker made for 'Oswald Cray' by Mrs Henry Wood appeared in *Good Words* in 1864. These are excellent designs and show that Walker was a natural storyteller. 'In the November Night' which is one of the very best of the eight, the artist delicately contrasts Oswald and Jane Allister with the other figures. That of the woman looking out of a door, hands on hips, is a particularly successful composition.

Walker contributed to *Once a Week* almost from the beginning, and although his early essays are tentative, he begins to find his own style in 'Tenants at number twenty-seven', which was published on 19 May 1860. His contributions improved regularly until the two for 'The Magnolia, for London, with Cotton' (2 March 1861) which display him at his most characterful. On 29 June came 'Jessie Cameron's Bairn' which is a wonderfully understood and feeling study of a baby. From October to December 1861 Walker illustrated 'The Settlers of Long Arrow' and these 11 designs are among his most sustained and remarkable achievements. The drawings are full of life and variety and it seems that at last he is getting into his stride. Another rewarding group is to 'The Prodigal Son' (April to July 1862). Walker continued to illustrate for *Once a Week* until 1863 and, three years later, he contributed a single drawing to the magazine. This beautiful and fluent design, 'The Vagrants' (Plate 3.20) illustrates no text, and with it Walker signalled his farewell to this periodical. Walker exhibited a watercolour of the same subject at the Royal Academy in 1868. The few other magazine illustrations Walker made to such organs as *Everybody's Journal*, *The Argosy* and *The Leisure Hour* are of little more than documentary interest.

I have been unable to see a copy of Michael Scott's *Tom Cringle's Log* to which it seems, Walker contributed in 1861, but the other book of the same year, *The Twins and their Stepmother*, is not a work of great significance. However, the two novels by Dickens illustrated by the artist in the following year, *Hard Times* and *Reprinted Pieces* are both noteworthy and the quality of Walker's designs here make one regret that he was never commissioned to undertake the work for any further novels by that author. 'A child in prayer' (Plate 3.21) in Willmott's *English Sacred Poetry* (1862) reveals a genuinely religious sense which is echoed in another equally fine design

in *English Sacred Poetry of the Olden Time* (1864), where the models for 'A Teacher's Knowledge and a Saviour's Love', were apparently members of Walker's own family, with Cookham church in the background.[12]

However, in common with Pinwell, it is in the two greatest Idyllic books of the period, *A Round of Days* (1866) and *Wayside Posies* (1867) (Plates 3.22, 3.23 and 3.24) that Walker shows his truest distinction. In the former, the illustration to Tom Taylor's poem 'Broken Victuals' (Plate 3.25) draws a tender contrast between the little girl and the elderly man, while 'The bit o'garden' (Plate 3.26) in the latter, is full of lovingly observed detail. The delightful dog is a favourite and often repeated Walker device. Although Walker made some other contributions to books after this date, nothing can approach his contributions to these volumes in quality and interest.

'Broken Victuals' mentioned above, shows Walker's passion for the details of everyday objects, and it was this quality which the engraver Joseph Swain remarked upon when he observed: 'In working out the minutest detail Walker was painfully conscientious. This was even shown in the backgrounds of his illustrations, most of which were drawn on the blocks from nature, the majority of them being scenes at Cookham or in the immediate vicinity.'[13] Perhaps more than anyone else, Swain recognized that among Walker's greatest strengths was his real understanding of the art of the engraver, which he himself had learnt when apprenticed with Charles Green and John William North to J.W. Whymper.

Walker: Checklist of illustrated books

1860 Sir J. Eardley-Wilmot: *Reminiscences of the late Thomas Assheton Smith Esq*

1861 Anonymous: *The Twins and their Stepmother*
Michael Scott: *Tom Cringle's Log*

1862 Charles Dickens: *Hard Times*
Charles Dickens: *Reprinted Pieces*
R.A. Wilmott (ed.): *English Sacred Poetry*

1863 W.M. Thackeray: *Roundabout Papers*

1864 L.B. White (ed.): *English Sacred Poetry of the Olden Time*

1865 Mrs Phebe Lankester: *Marian and her Pupils*

1866 Anthology: *A Round of Days*
Mrs Henry Wood: *Oswald Cray*

1867 Anthology: *Touches of Nature*
Robert Buchanan (ed.): *Wayside Posies*
Anne Thackeray: *The Story of Elizabeth*
Anne Thackeray: *The Village on the Cliff*
Frederick Walker: *Twenty-Seven Illustrations by Frederick Walker*

Arthur Boyd Houghton (1836–75)

Houghton is arguably the greatest member of the Idyllic group, in the same way that Millais may be considered the most distinguished of the Pre-Raphaelite illustrators. Like Millais, Houghton possessed remarkable facility and an ability to draw in different styles to suit the various texts he was asked to illustrate. He was also immensely productive, and his *oeuvre* in both magazine and book illustration, is probably larger than any other artist under discussion. His draughtsmanship is always lucid and never slipshod, and, if he has a weakness, it is his illustrations of children's books, where he never seems entirely happy. When it comes to depicting children in books for adults it is a different matter, and on one occasion, his drawings come close to genius. In *Home Thoughts and Home Scenes* his images of children are some of the most dark and disturbing of any book, not just in British, but in all illustration. If his style here may be termed 'domestic' then another, of which he was also a master, may be called his 'orientalist' manner.

This he uses frequently, but nowhere to better effect than in *Dalziel's Arabian Nights' Entertainments*, almost certainly his most accomplished achievement in this vein. Yet Houghton also excelled as a journalist, in a way unmatched by any of those around him. 'Graphic America', entombed in the unwieldy volumes of *The Graphic*, constitutes a genuinely important body of work and demands re-publication. Finally, Houghton was a poet, and though perhaps less intense than Pinwell, could match him because of the variety of his vision which is shown to good advantage in *A Round of Days* and *North Coast*, to name but two.

For *The Argosy* Houghton made two designs, with 'The Vision of Sheik Hamil' (1866) being a noble drawing, in the artist's most developed oriental style. In the Christmas number of *Entertaining Things*, in January 1862, the untitled illustration to 'The Maid of the Woolpack' is a curiously uneven drawing of surreal quality. While the face of the girl has a haunting beauty the rest of the design is awkward.

Houghton was a regular and a distinguished contributor to *Good Words*, from 1862. Two of his typically disconcerting studies of children appear in this year, and these are 'My Treasure' and 'About Toys'. In 1863 comes another in similar vein entitled 'Childhood'. In his more poetic manner are four of his loveliest designs which appeared on 1 September 1866. Well engraved by Linton they accompany a poem called 'Harvest', and are respectively entitled 'Reaping', 'Binding', 'Carrying' and 'Gleaning'. Two years later, Houghton once more was able to demonstrate his versatility, with eight illustrations to the 'The Krilof Fables', translated from the

Russian by William Ralston. Somehow Houghton managed to convey the Slavonic nature of the texts in a compelling group of small designs. These were reprinted in the book issued the following year, with some excellent animal studies by J.B. Zwecker. Although Houghton continued to illustrate for *Good Words* up to 1872, nothing else he contributed matched these extraordinary drawings.

In the early years of *Good Words for the Young*, Houghton made a number of designs, but in general he was never at his best when designing for children.

In *The Graphic*, between 1870 and 1872, comes arguably his most distinguished and sustained achievement for periodical literature – 'Graphic America' (Plates 3.27 and 3.28). Houghton saw the emerging nation with a clear and unflinching eye, and what he drew was uncompromising but unfailingly truthful. In more than 60 designs he ranged over most aspects of contemporary life in the country, and apparently neither liked nor approved of much he saw. These creations are far more than the work of a jobbing journalist, and they go beyond mere travelogue. At the same time as he was engaged on this project, he made a small number of equally telling drawings of European life for the same periodical. One of the best was 'Early Morning in Covent Garden Market – Shelling Peas', which was published on Christmas Day 1870. In contrast is 'The Commune or Death – Women of Montmartre' (10 June 1871), which is one of the greatest and most powerful drawings the artist ever made, showing the women marching through the streets carrying banners. In all his work for *The Graphic* Houghton revealed a mature and confident understanding of politics on the world stage.

Houghton made a few designs for *London Society*, with one of the most characteristic being 'Finding a Relic', which was published in July 1862. In October 1867 he made two drawings for 'A Spinster's Sweepstake and what came of it' which are in his frequently repeated Anglo-Indian style. He had been born in India and always showed a feeling for, and an innate understanding of, the country.

Perhaps a little surprisingly *Once a Week* employed Houghton sparsely, and just for two years between 1865 and 1867. However, of note is 'The Queen of the Rubies' (17 February 1866) which is a very sensual design. It aptly illustrates the lines: 'a beautiful dark-eyed maiden fastened by a light chain to a stake in the ground'.

The Quiver published several of Houghton's loveliest drawings, especially of domestic scenes. A good example is 'But you will gather the children round … ' of September 1866, while another is 'Baby Loo to You … ' published in November of the same year. In complete and startling contrast comes 'From morn till weary night he toiled, dejected' (April 1867), a drawing clearly influenced by Sandys, with a Pre-Raphaelite attention to detail and a consciously wrought medievalism. However, Houghton was also capable of poor work. His three designs for 'An Hour's Revenge, and what came of it' (July 1868) are of a wretched nature, matched only by the mediocre engraving.

The Sunday Magazine was an important vehicle for Houghton's talents, and highlights especially his variety in style and grasp of different subjects. He showed how sensitively he could sustain a lengthy narrative, with the 12 illustrations he made for Sarah Tytler's 'The Huguenot Family in the English Village'. Well engraved by the Dalziels, this appeared between October 1866 and September 1867. Also in September 1867, Houghton produced the memorable 'A lesson to a King', which was one of the finest works he did for this periodical. His drawings of

Biblical subjects such as 'Paul's Judges' (1 November 1867) are worthy but dull. More successful was the unusual group scene at the deathbed of George Herbert entitled 'George Herbert's Last Sunday' (1 April 1868). Two further designs demand comment: 'The Good Samaritan' (1 June 1868) is a work full of genuine compassion, which can stand comparison with Millais's interpretation of the same subject; and 'Miss Bertha' (1 March 1869) which is another moving image, of a humble East End weaver's room with Bertha tenderly nursing the child, Nettie.

Although Houghton's contributions to *Tinsley's Magazine* were few in number they are well worth looking up. For 'The Story of a Chignon' in December 1867 he made two designs on one block – the upper depicting a man falling on his dead lover, is a fine drawing. 'The Return from Court' published in May 1868 is one of the stately women at which the artist excelled.

Houghton was as productive for books as he was for the magazines. The earliest volume to which he contributed, appears to be Wilkie Collins's *After Dark*, published in 1862. After an interval of three years he is entirely in his stride, and in 1865 produced two of his masterpieces – *Dalziel's Arabian Nights' Entertainments* and *Home Thoughts and Home Scenes* (Plates 3.29, 3.30 and 3.31). Both achievements reveal him at the height of his powers, not only in draughtsmanship, but also in imagination. In the former he is at his most sensual and exotic, especially in so steamy a design as 'Queen Labe unveils before King Beder' (Plate 3.32). The latter is an extraordinary book, since the drawings of the children show them as heavy visaged, frequently frightened and rarely carefree. They seem to hint at a real unease at the centre of the Victorian psyche, and although ostensibly about children, the work itself is definitely a far more complex and disturbing volume than the innocent title might suggest. The poetry, all by leading women poets such as Jean Ingelow and Dora Greenwell, is also overdue for revaluation.

Robinson Crusoe, a book I have failed to see, was apparently also published in 1865, but the few excellent designs seem to be those reprinted in *Warne's Picture Book* of some three years later (Plates 3.33, 3.34, 3.35 and 3.36). The books specifically aimed at children such as *Ernie Elton* (1865) and *Ernie at School* (1867), both by Elizabeth Eiloart, are surprisingly diffident essays in the genre – perhaps the only one which he did not master.

1866 was another remarkably productive year for Houghton. His most notable contributions to publications which he did not tackle alone were for *A Round of Days* and Buchanan's *Ballad Stories of the Affections* (Plates 3.37 and 3.38). The major book which he did illustrate single-handed was *Don Quixote* (Plates 3.39, 3.40 and 3.41). Reid found the 100 designs disappointing and wrote:

> Better fifty full-page designs than a hundred small and frequently scrappy sketches. There are, of course, lovely things in the *Don Quixote* – one or two portraits of Rozinante especially are in the artist's best manner – but the standard set by *The Arabian Nights* was a high one, and it cannot, to my thinking, be claimed that the *Don Quixote* comes anywhere near it.[14]

Despite so acute a comment, the modern reader might find *Don Quixote* a more rewarding volume than Reid suggests. The drawings seem to me to show him drawing with a vigour and drama which suit the brilliance of the text admirably. The book also has the advantage of being printed on far better paper than that employed for the *Arabian Nights' Entertainments*.

Houghton made some new and equally interesting drawings for G.F. Townshend's sanitized

edition of *The Arabian Nights' Entertainments*, while the few designs for Jean Ingelow's *Studies for Stories* and Sarah Tytler's *Citoyenne Jacqueline* are at a similarly high level. The frontispiece and title-page illustration for the latter, though small, are delicate and distinguished. One or two charming designs are also to be found in a diminutive volume *Stories told to a Child* (1865) by Jean Ingelow where for once Houghton seems happier in illustrating for children (Plate 3.42).

In 1867 reprinted designs by Houghton were included in the important anthologies *Touches of Nature* and *Idyllic Pictures*. The best new work which he did was for the Chandos edition of Longfellow's *Poetical Works* and *Poems* by Jean Ingelow. In the latter the outstanding group made for 'Songs of Seven' is especially notable. *Golden Thoughts from Golden Fountains* also contains some excellent drawings, while the frontispiece to *Our Mutual Friend* is striking.

In 1868 come further fine drawings for Buchanan's *North Coast* with less interesting ones for the children's books *Barford Bridge* and *The Boys of Beechwood*. By 1869 Houghton's book designs had declined in number to a trickle, but *Krilof and his Fables*, now handsomely reprinted in book form by Strahan from *Good Words*, reminded the readers of the versatility of this artist.

After this date Houghton's illustrations dwindled still further and his sporadic contributions to *Christian Lyrics* (1871 or 1872) and *St. Abe and his Seven Wives* are really only of interest to the curious. 'The Chronicles being read to the King' for *Dalziel's Bible Gallery* (1881) was probably made in about 1863–4. Though good of its kind, it reveals that religious subjects were not a first priority for Houghton, and the composition and its feeling suggests the atmosphere of the *Arabian Nights' Entertainments* more than the Bible. However, one little-known but potent Bible design, 'Moses brings water from the Rock', made for the otherwise undistinguished *The Child's Bible* (1868–9), deserves to be noted.

Houghton: Checklist of illustrated books

1862 W. Wilkie Collins: *After Dark*

1865 *Dalziel's Arabian Nights' Entertainments*
 Anthology: *Home Thoughts and Home Scenes*
 Daniel Defoe: *Robinson Crusoe*
 Elizabeth Eiloart: *Ernie Elton*
 [Elizabeth Eiloart]: *Patient Henry*
 Jean Ingelow: *Stories told to a Child*
 Mrs Phebe Lankester: *Marian and her Pupils*
 R. and C. Temple: *The Temple Anecdotes*
 A.B. Thompson: *The Victorian History of England*
 G.F. Townshend (ed.): *The Arabian Nights' Entertainments*

1866 Anthology: *A Round of Days*
 Revd H.C. Adams: *Balderscourt*
 Anne Bowman: *The Boy Pilgrims*
 Robert Buchanan: *Ballad Stories of the Affections*
 M. de Cervantes: *Don Quixote*
 Charles Dickens: *Hard Times* and *Pictures from Italy*

John Foxe: *Book of Martyrs*
Jean Ingelow: *Studies for Stories*
Sarah Tytler: *Citoyenne Jacqueline*

1866–8 Tom Hood (ed.): *Cassell's Illustrated Penny Readings*

1867 Anthology: *Golden Thoughts from Golden Fountains*
Anthology: *Idyllic Pictures*
Anthology: *The Spirit of Praise*
Anthology: *Touches of Nature*
Charles Dickens: *Our Mutual Friend*
Elizabeth Eiloart: *Ernie at School*
Andrew Halliday (ed.): *The Savage-Club Papers*
Jean Ingelow: *Poems*
H.W. Longfellow: *Poetical Works* (Chandos edition)

1868 Anthology: *Warne's Picture Book*
Revd H.C. Adams: *Barford Bridge*
Robert Buchanan: *North Coast and other Poems*
H.W. Dulcken: *Old Friends and New Friends*
Elizabeth Eiloart: *The Boys of Beechwood*

1868–9 *The Child's Bible*

1869 Charles Camden: *The Boys of Axelford*
W.R.S. Ralston (trans.): *Krilof and his Fables*
L.Valentine (ed.): *The Nobility of Life*

1870 Anthology: *National Nursery Rhymes*

1871 or 1872 [Lucy Fletcher] (ed.): *Christian Lyrics* (Chandos Poets)

1872 Robert Buchanan: *St. Abe and his Seven Wives*

1874 Anthology: *Dawn to Daylight*
Anthology: *Picture Posies*

1875 A. and E. O'Shaughnessy: *Toyland*

1878? Lord Byron: *Poetical Works*

1881 Anthology: *Dalziel's Bible Gallery*

1894 Anthology: *Art Pictures from the Old Testament*

John William North (1842–1924)

Although North is gradually becoming recognized as a leading watercolourist of the Idyllic

school, he is yet to be seen also as perhaps the most distinguished landscape illustrator of the entire period.[15] He was a friend both of Walker and Pinwell, and shared with them the city dweller's longing for a tranquil country existence. This he regularly betrayed in his drawings of Halsway Court in Somerset, which proved an inspiration to all three, and indeed appears frequently in both *A Round of Days* and *Wayside Posies* (Plates 3.43, 3.44, 3.45 and 3.46). His illustrative style is marked by a clean line as well as a feeling for textures in trees, water and sky. He was also an expert in suggesting differences in climate and temperature – ideas very difficult to convey via the medium of wood-engraving.

North dedicated himself in illustration to landscape, a genre which hitherto had been dominated by the ubiquitous Birket Foster. While Foster is always accomplished and on occasion even memorable as in *Pictures of English Landscape* (1863), his work is done very much to a formula. His compositions invariably contain elements such as a child, a church or an old man which, when repeated, become merely tedious. North, in contrast, is a sensitive and understated draughtsman of both landscape and seascape, and he is the only one of these artists who can be seen as a poet of landscape. He has been overlooked as an illustrator largely because he did not produce many works, and what he did achieve is scattered and hence difficult to evaluate as a whole.

In the magazines North made a single contribution to *Aunt Judy's Magazine* in 1874, and two to *Good Words* in 1863 and 1866. Of the few drawings he made for *Once a Week*, 'The Lake' of 1867, is a notable and enduring image. In *The Sunday Magazine* in February 1865 came perhaps his best drawing for the periodicals. 'Winter', which illustrated a text by the editor of the magazine, Thomas Guthrie, is a memorable image of two children, with a threshing machine in a field as the background. Unfortunately the impact of the composition is lessened because of the surprisingly deficient engraving by Swain. One further good drawing for the same magazine is 'The Weary Day is at its Zenith still' (1 May 1867), which is a typically expansive view of hilly landscape.

If North was only studied with reference to what he did in the magazines we should take little notice of him, as it is in book illustration that his best and most consistent work is to be found. He provided two sensitive frontispieces to Holme Lee's two-volume novel, *In the Silver Age* in 1864, and in the same year made some only average drawings for *English Sacred Poetry of the Olden Time* and *The Months Illustrated by Pen and Pencil*. In 1865 came some similar work for *Our Life Illustrated by Pen and Pencil*. The following year, however, saw *A Round of Days*, a volume of the highest significance for North, even though he made so few drawings for it. In a design such as 'The Home Pond' he expresses everything that he felt about the Idyllic approach to landscape. The highly wrought block and the attention to detail must have been a nightmare to engrave, but the result is a conspicuous triumph. 'The Old Shepherd', in another vein, accurately, but with no trace of sentimentality, conveys the chill of the frosty scene. *Wayside Posies* of 1867 is the most important book to which North contributed. In his 19 drawings he displays his talents in great variety. 'At the grindstone' makes a useful contrast with 'On the Shore', while 'Spring' reveals North as an intense artist in the understanding of climate. This ability to suggest temperature and atmosphere is further shown in 'Reaping'. 'A vagrant's song' is another important design which also includes several fine figure studies.

In the same year North made further memorable designs for Jean Ingelow's *Poems*, most

notably for 'Requiescat in Pace' and 'The Four Bridges'. Nothing else that North did in illustration approaches the consistently high level he reached in these two volumes. Jean Ingelow's *Songs of Seven*, was never seen in book form by Forrest Reid though he knew the proofs in the Dalziel Archive in the British Museum. The book was finally re-discovered in 1976 by Robin de Beaumont, having been published by Roberts Brothers in Boston, in 1866.[16]

North: Checklist of illustrated books

1864 Anthology: *The Months Illustrated by Pen and Pencil*
 Holme Lee: *In the Silver Age*
 Revd L.B. White (ed.): *English Sacred Poetry of the Olden Time*

1865 Anthology: *Our Life Illustrated by Pen and Pencil*

1866 Anthology: *A Round of Days*
 Anthology: *The Spirit of Praise*
 Jean Ingelow: *Songs of Seven*

1867 Anthology: *Golden Thoughts from Golden Fountains*
 Anthology: *Touches of Nature*
 Revd Robert Baynes (ed.): *The Illustrated Book of Sacred Poems*
 Robert Buchanan (ed.): *Wayside Posies*
 Jean Ingelow: *Poems*
 H.W. Longfellow: *Poetical Works* (Chandos Poets)

1871 Edward Whymper: *Scrambles amongst the Alps*

1874 Anthology: *Picture Posies*

John Dawson Watson (1832–92)

Watson was an illustrator of real and varied gifts. Although almost forgotten today, he worked in a number of styles in much the same way as Houghton. He rarely approached Houghton's power and sensuality but, nevertheless, his skills were not inconsiderable. He was a particularly fine figure draughtsman especially with adults but his children sometimes have a tendency towards over-sweetness. He was very highly thought of not least by his engravers, the Dalziels, who wrote:

> In the early days of our connection with him [Watson] often spoke of what he called his 'fatal facility', and no doubt that gift told to his detriment. His art was no trouble to him: and this was the root of a certain indolence shown in his later productions which, generally speaking, were far inferior to what might have been expected from his natural powers – though his work was at all times full of tender refinement, beauty and sympathetic feeling. … During the sudden rage that sprung up for water colour drawings his work was much sought after by the dealers. We remember him on one occasion speaking of this eagerness

for his pictures, and saying: 'I believe if I were to spit upon a piece of paper and smear it over with my hand they would declare it beautiful, and have a scramble who was to buy it.[17]

Watson illustrated frequently both in books and in the magazines, and it is worth noting that some of his best designs may be found in the poorer and cheaper periodicals aimed at the working classes. It would be incautious to draw any definite conclusions from his contributions to *The British Workman* or *The Servants' Magazine*, but their presence might suggest a need by Watson to earn his living by publishing wherever he could, and perhaps, a developed social conscience.

The artist made some large and striking drawings for the first named periodical. One of the best is 'Preparing for the Flower Show – A sketch in St. George's Bloomsbury', well engraved by Knight, which was published in August 1863. This was re-used as the cover for the volume for the following year, where it was printed in colour. Watson appears to have severed his connection with this journal towards the end of 1865. In *Churchman's Family Magazine* 'Sunday Evening' of February 1863, is one of the artist's tenderest drawings, which was intended as the frontispiece to this number. For his religious work Watson often employed a gaunt ascetic line, clearly influenced by German artists, notably Retzsch. This somewhat cold grandeur is seen at its most pronounced in his two major books, *The Pilgrim's Progress* and *Robinson Crusoe*, but it also appears regularly in the magazines. It can be very moving as in 'Her arms are wound about the tree' which was published in the same magazine in April 1863. An untitled design in *The Friendly Visitor* (1 February 1867) is a lovely image of an elderly couple at prayer with an inattentive child in the pew in front. Then again Watson excels with 'The Empty Cradle' (1 May 1867), which depicts a weeping bereaved mother. It is remarkable that in such scenes Watson almost always manages to avoid excess sentimentality.

Watson illustrated for *Good Words* from its earliest issues. His first contribution is the magnificent 'The Toad', for a story adapted from Victor Hugo, which was published in January 1861. In 1863 came another memorable drawing, 'A Pastoral'. 'The Aspen' of the same year was rightly praised by Reid who termed it: 'a thing positively steeped in poetry.'[18]

Watson made just a handful of drawings for *The Graphic*, but they are almost all of interest and distinction. Like Houghton, Watson was versatile, and could turn himself into a journalist when required. 'Duck Shooting in the North' (12 February 1870) is a design of such power that it dispels any idea that Watson could only draw successfully the soft or sentimental side of life. 'The favourite of the Regiment' (22 October 1870) is similarly a strong composition of a soldier bending over the body of his dead comrade. Watson even apes Houghton with great aplomb, with an American scene, 'The Fugitives from Chicago' (4 November 1871). Of the three designs the artist made for *The Infant's Magazine*, 'A ramble in the fields' (June 1866) is in his best style.

London Society contains Watson's finest drawings for periodical literature (Plates 3.47, 3.48, 3.49 and 3.50). The tender 'Spring Days' of February 1862 to a poem by Keats, was followed in March by 'Ash Wednesday', perhaps the noblest illustration he ever made. The man bent in sorrow with his face hidden is a concept both of grandeur and directness. Almost equal to it is 'Romance and a curacy' (June 1862). Watson drew for the magazine throughout 1862 and 1863, almost always at a high level, though nothing else reaches the standard of the two designs just

mentioned. 'Given Back on Christmas Morn', which was published in the Christmas number of *London Society* in 1866, was, however, their equal. It is a powerful drawing of a mother fervently praying at the bedside of her sick child. In November 1868 comes the fine 'The Oracle', and this was followed by an even more distinguished piece, 'The Two Voices', to a poem by Robert Buchanan. This appeared in the Christmas number the same year. Although Watson continued to work for *London Society* until 1870, only the charming 'Bringing home the May' and the noble 'Second Blossom' both published in 1869 are really worth looking up. The few designs the artist made for *Once a Week* are of surprisingly little interest.

The Quiver might have been expected to be a fertile hunting-ground for rewarding drawings by Watson. In the event, however, most of his work for this periodical is dull, and several of his designs are, frankly, poor. 'The last country walk we took ... ' (December 1866) is spoilt by wretched engraving, while 'With that he laughed upon my fallen pride' (October 1867), is merely melodramatic. Even more surprising is the coarseness of 'And Wisdom then and there they slew' (December 1867). However, the second drawing to 'Sowing in Tears' (February 1868) possesses real power and is further distinguished by a creative use of light and shade. In July the same year comes 'Pass sweetly to thy rest' which is arguably Watson's most notable contribution to the magazine. Neither *The Sunday Magazine* nor *Tinsley's Magazine* contain much of interest for the Watson enthusiast, but the fine single design 'She threw her trembling arms ... ' in *The Servants' Magazine* (March 1869) is well worth finding. Finally the illustrations to 'Phemie Keller' in *The Shilling Magazine* (June–December 1865) are mostly of the highest quality. According to Gleeson White (p.65) there should be eight designs in all, but in the copy examined I found just seven.

Watson's first illustrated books appeared in 1861. The few designs for Eliza Cook's *Poems* are either peopled by his rather chubby children who possess a generalized sweetness close both to Robert Barnes and Ludwig Richter, or are of somewhat greater interest such as 'Sunshine'. Here the artist shows a sensitive understanding of elderly people. *The Pilgrim's Progress* of the same year is an important work being entirely illustrated by Watson (Plate 3.51). The book is a sustained though perhaps a rather forbidding achievement. The figure drawing is invariably of a high standard and some of the designs are genuinely memorable. If Watson's interpretations of Bunyan are not always inspired, they are never less than accomplished and genuinely felt.

In *English Sacred Poetry* of 1862 Watson made a varied group of drawings. 'Time and the Year' (Plate 3.52) is a masterly medieval scene, while 'Moonlight' is an expertly lit vignette with a poetic sense of mystery. In contrast, however, the artist seems much less comfortable with the period designs for Gray's *Elegy* in the same volume. 1862 also saw some notable designs by Watson for Bennett's *Poems*, and still more, this time for a book for girls, *The Heroines of Domestic Life*. In the following year his most significant book designs were for the otherwise wretchedly illustrated *The Flower of Christian Chivalry*. Here 'The last sleep of Savanarola' is in his most rapt religious style.

In 1864 comes *The Golden Harp*, probably the most successful book for children that Watson illustrated (Plate 3.53). The work was shared with Thomas Dalziel and Joseph Wolf and several of Watson's designs are winners. Outstanding are the frontispiece 'Charity', and 'The Song of the Seed-Corn'. The point about Watson's drawings here, is not that they are masterpieces, but that they entirely suit the small scale of the volume, and hence would have been likely to appeal to

children. *Robinson Crusoe* of the same year should be considered with *The Pilgrim's Progress* published four years earlier. Again all the illustrations were given to Watson, and in some ways the project is a greater success, taken as a whole. As before, it was in the single figure drawings, that the artist is most in command – a typical example being 'Crusoe returns thanks for his deliverance.'

In 1865 the few drawings for *Dalziel's Arabian Nights' Entertainments* revealed that oriental subjects did not suit Watson. In 1866 he made an unimportant appearance in *Ballad Stories of the Affections*, but far more impressive were the three quality drawings for Dora Greenwell's 'A Life in a Day' in *A Round of Days*. After this date Watson's contributions to books fall off markedly in interest, although there are one or two good things both in *Golden Thoughts from Golden Fountains* (1867), and in *The Bridal Bouquet* (1873).

Watson was not a genius, but in all his work there is a sincerity of purpose and a dedication to his task, which means that nothing he did was shoddy. If his most sustained achievements were in the two books by Bunyan and Defoe, his most inspired were in the individual designs he made scattered throughout the magazines.

Watson: Checklist of illustrated books

1861 Anonymous: *Eildon Manor: A Tale for Girls*
 John Bunyan: *The Pilgrim's Progress*
 Eliza Cook: *Poems*
 Norman Macleod: *The Gold Thread*
 [D. Richmond]: *Accidents of Childhood*
 [D. Richmond]: *The Maze of Life*

1862 William C. Bennett: *Poems*
 Mrs Octavius Freire Owen: *The Heroines of Domestic Life*
 D. Richmond: *Through Life and for Life*
 R.A. Willmott (ed.): *English Sacred Poetry*

1863 Anthology: *The Boys' and Girls' Illustrated Gift Book*
 J.H. Burrow: *The Adventures of Alfan*
 M. Grylls: *Helen and her Cousins*
 Mrs W.R. Lloyd: *The Flower of Christian Chivalry*

1864 Anthology: *The Child's Picture Scrap Book*
 Daniel Defoe: *The Life and Adventures of Robinson Crusoe*
 H.W. Dulcken: *The Golden Harp*
 L.B. White (ed.): *English Sacred Poetry of the Olden Time*

1865 Anthology: *Our Life Illustrated by Pen and Pencil*
 Dalziel's Arabian Nights' Entertainments
 Mrs Phebe Lankester: *Marian and her Pupils*
 Samuel Rogers: *The Pleasures of Memory*
 Henry Southgate: *What Men Have Said about Woman*

1866 Anthology: *A Round of Days*
 Robert Buchanan: *Ballad Stories of the Affections*
 John Foxe: *Book of Martyrs*
 Adelaide Procter: *Legends and Lyrics*
 [S.B. and A.B. Warner] (Elizabeth Wetherell and Amy Lothrop): *Ellen Montgomery's Bookshelf*

1866–8 Tom Hood (ed.): *Cassell's Illustrated Penny Readings*

1867 Anthology: *Golden Thoughts from Golden Fountains*
 Anthology: *Touches of Nature*
 Robert Baynes (ed.): *The Illustrated Book of Sacred Poems*
 Maria Louisa Charlesworth: *Ministering Children – A Sequel*
 Andrew Halliday (ed.): *The Savage-Club Papers*

1868 William Cowper: *Table Talk and other Poems*
 H.W. Dulcken: *Old Friends and New Friends*
 [Anna Bartlett Warner]: *The Word – The Star out of Jacob*

1869 Revd Thomas Pelham-Dale: *Life's Motto*
 L. Valentine (ed.): *The Nobility of Life*

1870 Anthology: *The Child's Book of Song and Praise*
 J.F. Waller: *Pictures from English Literature*

1871 W.M.L. Jay: *Without and Within*

1872 Anthology: *Aunt Bessie's Picture Book*
 Anthology: *Household Tales and Fairy Stories*
 Anthology: *Little Lily's Picture Book*

1873 Anthology: *Lyrics of Ancient Palestine*
 Henry Southgate: *The Bridal Bouquet*

1874 Anthology: *Picture Posies*

1875 W.C. Bennett: *Baby May and Home Poems*

1876 Anthology: *Mama's Return and other Tales*
 Anthology: *Master Jack and other Tales*

1877 Anthology: *Aunt Emma's Picture Book*
 Mrs Sale Barker: *Routledge's Holiday Album for Girls*
 G. Christopher Davies: *Wildcat Tower*
 H. Frith: *Routledge's Holiday Album for Boys*

1878 Anthology: *The Large-Picture Primer*

1879 Anthology: *Little Laddie's Picture Book*
 Anthology: *Little Lassie's Picture Book*

Anthology: *A Picture Book for Laddies and Lassies*

n.d. Anthology: *Popular Nursery Tales and Rhymes*
 Mrs Sale Barker: *Flowers in May* (*c.*1874)

John Pettie (1839–93)

Although Pettie can only be described as an occasional illustrator, what he did produce is of the highest distinction and hence cannot be ignored. I place him with the Idyllic School, but with so small a body of work it is difficult to be entirely confident how to judge him. His figure drawing both of children and adults was outstanding, and in the juxtaposition of youth and age (a recurrent theme for several illustrators in the period) he has no peer.

It is in the early years of *Good Words* that it is possible to see Pettie at his best. In 1862 both 'What sent me to sea' and 'The Country Surgeon' (Plates 3.54 and 3.55) are examples of his mature draughtsmanship, and he matched these the following year, with 'The Monks and the Heathen' and the tender 'The Passion Flowers of Life'. Also from 1863 is 'Kalampin', arguably an even more moving piece comparing old and young. The contrast between the elderly man's gnarled fingers and the tiny hand of the child is exquisitely handled.

While the two illustrations for *Good Words for the Young* are of no more than documentary interest, the two designs Pettie made for *The Sunday Magazine* are at the same high level as his work in *Good Words*. The first for 'The Occupations of a Retired Life' was published on 1 December 1867, and the second for 'Philip Clayton's first-born', appeared on 1 October the following year.

Pettie's book designs though equally few, are rewarding. Both *The Postman's Bag* (1862) and Wordsworth's *Poems for the Young* (1863) (Plates 3.56 and 3.57) were aimed at children and are full of delicacy and charm. In 1872, in Norman Macleod's *Character Sketches*, the final *Sunday Magazine* illustration was reprinted, without any mention of Pettie's authorship. I have sought in vain for evidence of Pettie's involvement in *Pen and Pencil Pictures from the Poets* (1866) which is referred to by Reid.[19]

Pettie: Checklist of illustrated books

1862 Jan de Liefde: *The Postman's Bag*

1863 W. Wordsworth: *Wordsworth's Poems for the Young*

1872 Norman Macleod: *Character Sketches*

Robert Barnes (1840–95)

Although Barnes can be over-sentimental on occasion, he is of importance largely because he may be seen as almost invariably true to the Idyllic vein. He is rarely profound, but his best work is tender and even distinctive. He rarely strays outside rural life, and within these narrow

confines, his designs can be harmonious and, from time to time, moving. Like Watson, some of Barnes's best work is entombed in the working-class magazines, where he contributes some notable and unusually large drawings. In compass and range, however, he does not approach the former. His most important book is *Pictures of English Life* (1865).

The *Band of Hope Review* includes some large-scale designs by Barnes. Typical is 'Falling Leaves' (1 December 1865), which is splendid of its kind, though undeniably sentimental. 'Father! Don't Go' (1 March 1867) is a powerful and deeply felt drawing of a father carrying his little tear-stained daughter, and is perhaps Barnes's most successful work in this magazine. In contrast 'Act of Bravery at Godalming' is little more than cheap melodrama. *The British Workman* also has some fine work by Barnes within its rarely thumbed pages. 'Christmas Tree' (1 December 1865) is well handled and once more on a grand scale, with admirable engraving by John Knight. Equally successful is the noble 'Father Stirling' (1 August 1867), and this is matched by 'Jack's Christmas Present' (2 December 1867). The few drawings Barnes made for *Cassell's Magazine* are well worth examining, and he is at his most tender in 'Our interview was interrupted by the entrance of Mrs Allonby' (1870).

The Cornhill Magazine is a major source of good work by the artist. In February 1864 he was entrusted with illustrating 'Margaret Denzil's History' (Plate 3.58). He not only supplied the full-page designs but also provided the delightful initial letter illustrations. 'To Go – or stay?' (July 1864), well engraved by Swain, is one of Barnes's loveliest drawings. The large group of designs he made for Charles Reade's 'Put Yourself in his Place' between March 1869 and July 1870 must rank as his most sustained piece of work, and it is a pity that these important images remain almost unknown. It is also curious that Barnes did so little for *The Cornhill*, and that there was a gap of five years from 1864 to 1869, when he is entirely absent from its pages.

The two designs made for *The Cottager in Town or Country* (1864 and 1865) are again large and striking, and in similar vein is the single contribution to *The Day of Rest*. 'Seeking the blessed land' (25 December 1872) is a powerful complement to the poem by Dora Greenwell. Barnes made numerous drawings for *The Friendly Visitor* between 1867 and 1869, but none is particularly noteworthy. Better are the few in *Golden Hours*, especially the three to 'The Farm of the Lowenberg' (April to June 1868). Of a similar high standard are the nine for 'Alfred Hagart's Household' which appeared, again engraved by Swain, in *Good Words* in 1865. Barnes's works for *The Infant's Magazine* possess a superficial charm but little more. In contrast 'The strange things which happened at our Christmas Party' (*London Society*, Christmas 1865), notwithstanding the triteness of the title, is a tender design.

There are also one or two rewarding drawings in *Once a Week*. Outstanding here is 'Lost for Gold' (14 April 1866), which shows Mary yearning for her lover who left her 20 years before: 'To make you a fortune'. The few drawings in *The Quiver* are all excellent. 'That's a neat article, now ... ' (May 1869) is a good household interior, with one of Barnes's delightful, if ubiquitous children. Finally, in *The Sunday Magazine* are two reliable groups of drawings – the first for 'Kate the Grandmother' and the second for 'Annals of a Quiet Neighbourhood'.

Barnes's work for books though extensive is not of outstanding interest. Only in *Pictures of English Life* (1865) (Plates 3.59, 3.60, 3.61, 3.62 and 3.63) is it possible to see the artist at his Idyllic if limited best, and it would be of little value to discuss all his other books in detail. Everything that he had to say about rustic family life can be seen in these ten large drawings. It

is a major book because it is so entirely Idyllic in spirit.

Reid wrote: 'Barnes would have been the right man to illustrate George Eliot's earlier novels; he would have been the wrong man to illustrate the novels of Mr Hardy.'[20] Interestingly Barnes did illustrate *The Mayor of Casterbridge* in *The Graphic* in 1886 – a task for which he was entirely unsuited. However, he was far more successful with Eliot's *Silas Marner* and *Scenes of Clerical Life* [1868]. Both books contain fine examples of his work.

Barnes: Checklist of illustrated books

1863 May Beverley: *Romantic Passages in English History*

1864 Anthology: *The Months Illustrated by Pen and Pencil*
Mrs Barbauld: *Hymns in Prose*

1865 Anthology: *Our Life Illustrated by Pen and Pencil*
Anthology: *Pictures of English Life*
[Mrs C.E. Bowen]: *Sybil and her Live Snow-ball*

1866 [Mrs C.E. Bowen]: *How Paul's Penny Became a Pound*
[Mrs C.E. Bowen]: *How Peter's Pound Became a Penny*
John Foxe: *Book of Martyrs*
Jean Ingelow: *Studies for Stories*
Isaac Watts: *Divine and Moral Songs for Children*
Mrs Henry Wood: *Oswald Cray*

1867 Anthology: *Touches of Nature*
John G. Watts (Sel.): *Little Lays for Little Folks*

1868 Mrs C.E. Bowen: *Jack the Conqueror*
William Cowper: *Table Talk and other Poems*
[Lucy Fletcher] (ed.): *Christian Lyrics*
[Jane and Ann Taylor]: *Original Poems*

1870 Anthology: *The Child's Book of Song and Praise*
J.F. Waller: *Pictures from English Literature*

1871 J. Templeton Lucas: *Prince Ubbely Bubble's New Story Book*

1873 Mrs C.E. Bowen: *Ben's Boyhood*

1874 Anthology: *Dawn to Daylight*

1876 Mrs D.P. Sanford: *Frisk and his Flock*

1877 Sarah Doudney: *Stories of Girlhood*
Mrs Semple Garrett: *Our Little Sunbeam's Picture-Book*

1878 G.S. Cautley: *A Century of Emblems*

1879 Mary Boyd: *Grace Ashleigh's Life Work*

1880 [Ruth Buck]: *Thoughtful Joe*
 Mary Russell Mitford: *Children of the Village*
 Hesba Stretton: *In Prison and Out*

n.d. George Eliot: *Scenes of Clerical Life*
 George Eliot: *Silas Marner*
 Mrs H. Paull: *Horace Carleton*

William Small (1843–1929)

Since 1928, when Reid devoted several pages to Small's work, his name and his immensely varied talents have fallen into almost total obscurity. It seems extraordinary that such a gifted artist could have slipped so far from critical scrutiny to be all but unknown today. However, it should be noted that: 'he became the highest paid illustrator of his time, earning sixty guineas for each drawing for the *Graphic*'.[21] At his best Small drew with real character, a fine line, sincere and direct in feeling. He was an expert illustrator for children but could tackle adult prose and poetry with equal success and competence. In his treatment of poetry he sometimes approached Millais and Houghton in power.

Why then has his star fallen from the sky? Two possible explanations come to mind. His copious nature means that there is almost too much work easily to come to terms with, and his drawings are very widely scattered. It is frequently the case that a large body of work can suggest the drudge more than the poet. Secondly, Small lived on for many years beyond the Sixties, and he attempted to adapt his style to the new possibilities offered by photography, when wood-engraving was superseded in the 1880s. In his wash drawings of this later period, his strength as a fluent and sometimes lyrical draughtsman, was obscured and his reputation sullied. In his versatility, and also, on occasion in terms of style, he may be compared, not unfavourably, with Watson and Houghton.

In the magazines there is a great deal worthy of notice by Small. In *The Argosy* from December 1865 until November 1866, he provided 12 illustrations to 'Griffith Gaunt' by Charles Reade. Meticulously engraved by Swain, these designs are among the greatest and most moving that the artist ever made. That showing Mrs Gaunt at prayer, kissing the crucifix, is arguably the most potent.

In *The Boy's Own Magazine* throughout 1866, Small contributed a first-rate group of drawings for 'Ralph de Walden'. Entirely suited to the story, they manage to be both powerful and affecting. In *Cassell's Illustrated Family Paper* in 1865 come the illustrations to 'Bound to the Wheel', an important series, notable for strong designs well matched to the text. Some four years later, for the same publication now re-named *Cassell's Magazine*, Small illustrated Wilkie Collins's 'Man and Wife'. The project evidently did not appeal, since, almost without exception, the drawings are wretched. He was more at home in *The Children's Hour*, where his talent for drawing for children was much in evidence. A typical example is 'Horace Hazelwood' (April to September 1866), which was later re-published in book form. The engraving by J. Williamson

is also sympathetic. The two drawings in *The Friendly Visitor* are both notable. 'Lame Robie's Christmas Guest' (1 December 1868) is a memorable piece showing the child seated with his crutches, while equally compelling is 'The Sunset of Life' (1 May 1869). Here Small draws with real tenderness an elderly couple looking out of a window at a haymaking scene.

Good Cheer, which was the title used for the extra Christmas numbers of *Good Words*, is a fertile area for good designs by the artist. One successful group was made for 'The Neap Reef' (1871) but these are surpassed by the drawings done for 'La Bonne Mere Nannette' the following year. These distinguished compositions were expertly engraved by W.J. Palmer and W.H. Hooper.

Small made a considerable number of drawings for *Good Words*, but he never bettered his first, 'Lilies' (1866), a design of monumental substance. Less poetic, though admirable in their way, are the large number of designs and chapter heading vignettes for Mrs Craik's 'The Woman's Kingdom', which ran through the magazine during 1868.

Small made just one design for *Good Words for the Young*. It is 'My little gipsy cousin' which was published on 1 March 1871. This depiction of a nursing mother, sitting barefoot and dejected on the ground, is probably the greatest drawing the artist ever made, and is, arguably, one of the finest by any illustrator of the entire period.

Small, like Houghton, revealed himself to be an acute journalistic illustrator in the pages of *The Graphic*. Especially notable are 'Grouse Shooting' (13 August 1870) and the six designs for 'The Western Highlands, Connemara' (August to September 1871).

Yet another facet of Small's artistic personality was demonstrated in *London Society*. His two drawings for 'Up and Down Moel Vammer' (February to March 1871) of men about town, show that on occasion Small could take on du Maurier and compete with him on equal terms.

More variety is apparent in the pages of *Once a Week*. In 'The Stag-Hound' (17 March 1866) Small makes the incident where the dog 'seized the traveller by the jowl' exciting and terrifying at the same time. In complete contrast is the beautiful 'Larthon of Inis-Huna' where the children possess a sweetness worthy of Arthur Hughes. In *The People's Magazine* Small illustrated 'Up and Down the Ladder' (June to October 1867), yet another fine group of drawings several of which are reminiscent of du Maurier.

The Quiver also contains important work by Small. 'Dead and alone, by the trysting-stone' (December 1865) is a haunting drawing of a dead woman lying with a withered wreath on her head, while the five designs for 'The Deeper Depth' (March to May 1866) are all works of genuine potency, apparently drawn from life. 'From broken steel and bleeding clay ... ' (January 1867), shows the artist successfully tackling a historical subject in this influential scene of the aftermath of battle. Returning to more Idyllic matters 'Over the border – of Middlesex' in the same issue, is a rustic view of a horse and trap with a steam train in the background. In the light of such drawings it is surprising that Small was never employed to illustrate Hardy, for he surely would have been an ideal candidate.

The two series in *The Sunday at Home*, 'The Fortune of the Granbys' (1866) and 'Blind John Netherway' (1867) are both excellent, with Small revelling in telling the story. However, the printing and paper quality in this periodical leave a great deal to be desired.

The Sunday Magazine is yet another organ with good drawings by the artist. '"Wind me a summer crown", she said' (1 October 1866) is an inspired image of a girl, seen from behind,

sitting on the ground and gazing at a fountain, while 'Perfect Peace' (1873) is another intense composition of a woman at prayer in an extensive landscape.

If Small was industrious as a magazine illustrator, he was equally active in his work for books. In his poetic vein he was at his best in Buchanan's *Ballad Stories of the Affections* (1866), and the same poet's *North Coast and other Poems* of two years later. However, arguably the most significant book of poetry to which Small made a major contribution was Milton's *Ode on the Morning of Christ's Nativity* (1868) (Plate 3.64). Here in the exalted company of Albert Moore, as well as several other artists, Small produced a number of designs which were highly appropriate to such a major text.

Some of Small's designs for magazines can be sampled in the anthologies *Touches of Nature* (1866) and *Idyllic Pictures* (1867), where they benefit from better quality printing, presumably from the original blocks and on good quality paper. Small's work for children can be seen in a number of books, but the most sustained and consistent is probably in Watts's *Divine and Moral Songs* (1866) (Plates 3.65 and 3.66). Some charming drawings for children also appear in *The Washerwoman's Foundling* (1867), *On the Way* by A.L.O.E. (1868) and the same author's *Marion's Sundays* (1864). Also notable in this style are *Exiles in Babylon* (1864) and *Little Lays for Little Folk* (1867) (Plates 3.67, 3.68 and 3.69).

It seems curious that Small was apparently rarely entrusted with a major text to illustrate single-handed. Perhaps he preferred to make contributions with others to various projects, and felt happier only illustrating children's books on his own account. One little-known book for adults which he did illustrate alone, was George Eliot's *Adam Bede* (n.d.). The few designs are of such high quality that they make one wish that more commissions of this kind might have been put his way.

Small: Checklist of illustrated books

1864　Anonymous: *The Basket of Flowers*
　　　A.L.O.E.: *Marion's Sundays*
　　　A.L.O.E.: *Exiles in Babylon*

1865　Anonymous: *Tom Ilderton*
　　　Barbara Hoole (Mrs Hofland): *William and his Uncle Ben*
　　　William Wordsworth: *Poetical Works*

1866　Anthology: *Pen and Pencil Pictures from the Poets*
　　　Anthology: *The Spirit of Praise*
　　　Robert Buchanan: *Ballad Stories of the Affections*
　　　John Foxe: *Book of Martyrs*
　　　Jean Ingelow: *Studies for Stories*

1866–8　Tom Hood (ed.): *Cassell's Illustrated Penny Readings*

1867　Anthology: *Golden Thoughts from Golden Fountains*
　　　Anthology: *Idyllic Pictures*
　　　Anthology: *Touches of Nature*

Robert Baynes (ed.): *The Illustrated Book of Sacred Poems*
Cassell's History of England
Elizabeth Eiloart: *Johnny Jordan and his Dog*
William Gilbert: *The Washerwoman's Foundling*
Bishop Heber: *Heber's Hymns*
H.W. Longfellow: *Poetical Works* (Chandos edition)
Walter Thornbury (ed.): *Two Centuries of Song*
Isaac Watts: *Divine and Moral Songs*
John G. Watts: *Little Lays for Little Folk*

1868 Anonymous: *Tom Butler's Trouble*
Anthology: *The Book of Elegant Extracts*
A.L.O.E.: *On the Way*
Aunt Susan (Mrs Prentiss): *Little Susy's Six Birth-days*
Robert Buchanan: *North Coast and other Poems*
H.W. Longfellow: *Poetical Works* (Nelson edition)
John Milton: *Ode on the Morning of Christ's Nativity*
Charles Reade: *Christie Johnstone*

1870 Anthology: *National Nursery Rhymes*
Anthology: *Favourite English Poems and Poets*
A.L.O.E.: *Precepts in Practice*
J.F. Waller: *Pictures from English Literature*

1872 Matthew Browne: *Lilliput Legends*

1874 Anthology: *Dawn to Daylight*

1875 Anthology: *The Sunlight of Song*
Mrs Prosser: *The Door without a Knocker*

1876 Walter Thornbury: *Historical and Legendary Ballads and Songs*

1877 Anthology: *Aunt Emma's Picture Book*
Mrs Sale Barker: *Routledge's Holiday Album for Girls*
Mrs Semple Garrett: *Our Little Sunbeam's Picture-Book*
Sarah Doudney: *Stories of Girlhood*
[J.A. Sidey]: *Alter Ejusdem*

1879 Anthology: *Little Laddie's Picture Book*
Anthology: *Little Lassie's Picture Book*
Anthology: *A Picture Book for Laddies and Lassies*

1880 John Bunyan: *The Pilgrim's Progress*

1881 Anthology: *Dalziel's Bible Gallery*

1894 Anthology: *Art Pictures from the Old Testament*

n.d. George Eliot: *Adam Bede*
 Robert Hope-Moncrief: *Horace Hazelwood*

Notes

1 Forrest Reid, *Illustrators of the Eighteen Sixties*, 1928. Quoted from the reprint, New York, 1975, p.134.
2 Daphne du Maurier (ed.), *The Young George du Maurier – A Selection of his letters, 1860–1867*, 1951, p.36.
3 Thomas Armstrong, 'Reminiscences of George du Maurier' in *Thomas Armstrong C.B. A Memoir*, edited by L.M. Lamont, 1912, pp.159–60. Kugler's *Life of Frederick the Great* appeared with some 500 wood-engraved designs by Menzel in an English translation in 1844.
4 Percy Muir, *Victorian Illustrated Books*, 1971, p.122.
5 Reid, *Illustrators*, p.161.
6 Muir, *Victorian Illustrated*, p.141.
7 Quoted from George and Edward Dalziel, *The Brothers Dalziel – A Record*, 1901. Reprint 1978, p.220.
8 Basil Gray, *The English Print*, 1937, p.140.
9 I am indebted to Lionel Lambourne for kindly pointing this out to me (verbal information, 1993).
10 Quoted from Rodney Engen, *Dictionary of Victorian Wood Engravers*, Cambridge, 1985, p.207.
11 Reid, *Illustrators*, p.134.
12 Walker is buried in the churchyard at Cookham.
13 Henry C. Ewart (ed.), *Toilers in Art*, 1891, p.178.
14 Reid, *Illustrators*, p.196.
15 See the catalogue of an exhibition held at the Yale Center for British Art and elsewhere, *Victorian Landscape Watercolors*, 1992, by Scott Wilcox and Christopher Newall, pp.55–6 for a discussion of North as a watercolourist.
16 Robin de Beaumont, Catalogue Nine, Spring 1985, p.33 no.191.
17 Dalziel and Dalziel, *The Brothers*, pp.173–4.
18 Reid, *Illustrators*, p.167.
19 Reid, *Illustrators*, p.204.
20 Reid, *Illustrators*, p.257.
21 Rodney Engen, *Dictionary of Victorian Wood Engravers*, 1985, p.240.

PLATE 3.1
Molly's New Bonnet

PLATE 3.2
Vae Victis

PLATE 3.3
"I may die" he said …

PLATE 3.4
What ails yo at me? …

PLATE 3.5

Patty at her mother's bedside

PLATE 3.6
The stolen watch

PLATE 3.7
Beatrix

PLATE 3.8
Reconciliation

PLATE 3.9
The Sirens

153

PLATE 3.10
At the threshold

PLATE 3.11
The Shadow

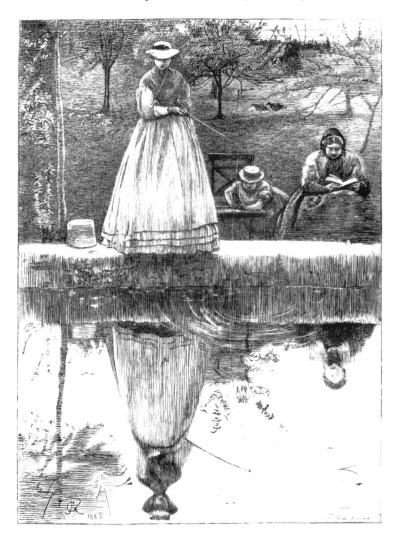

PLATE 3.12
Shadow and Substance

PLATE 3.13
The Swallows

PLATE 3.14
The Journey's End

PLATE 3.15
King Pippin

PLATE 3.16
By the Dove-cot

PLATE 3.17
The Island Bee

PLATE 3.18
Prayer is the Christian's vital breath

PLATE 3.19
God hears thy sighs and counts thy tears

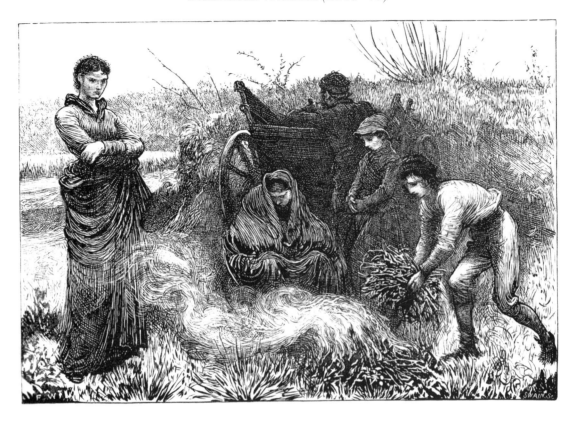

PLATE 3.20
The Vagrants

PLATE 3.21
A child in prayer

PLATE 3.22
Autumn Days

Plate 3.23
Rain

PLATE 3.24
Where the wind comes frae

PLATE 3.25
Broken Victuals

PLATE 3.26
The bit o' garden

PLATE 3.27
Crossing a Canon

PLATE 3.28
Buffalo Hunting – Camping out

PLATE 3.29
Camaralzaman commands Giondar to put the princes to death

PLATE 3.30
Noah's Ark

PLATE 3.31
The Chair Railway

PLATE 3.32
Queen Labe unveils before King Beder

CRUSOE ON THE RAFT.

PLATE 3.33
Crusoe on the raft

PLATE 3.34
Crusoe meets Friday

CRUSOE MEETS FRIDAY.

PLATE 3.35
Crusoe and the Spaniard

CRUSOE AND THE SPANIARD.

PLATE 3.36
Crusoe and his family

CRUSOE AND HIS FAMILY.

PLATE 3.37
Helga and Hildebrand

Plate 3.38
How Sir Tonne won his bride

PLATE 3.39
Rosinante fell …

PLATE 3.40
Hold, base-born rabble …

178

PLATE 3.41
Sancho Panza was conducted …

PLATE 3.42
The Golden Opportunity

PLATE 3.43
The Home Pond

PLATE 3.44
At the grindstone

PLATE 3.45
The visions of a city tree

PLATE 3.46
Glen-Oona

PLATE 3.47
Spring Days

PLATE 3.48
Ash Wednesday

PLATE 3.49
Romance and a Curacy

PLATE 3.50
A Summer's Eve in a Country Lane

PLATE 3.51
Giant Despair beats the Pilgrims

PLATE 3.52
Time and the Year

PLATE 3.53
Maley and Malone or the Evils of Quarreling

PLATE 3.54
What sent me to sea

PLATE 3.55
The Country Surgeon

PLATE 3.56
Address to a child during a boisterous winter evening

PLATE 3.57
The Cottager to her infant

PLATE 3.58
A Surprise

PLATE 3.59
Charity

PLATE 3.60
The shy child

PLATE 3.61
The race down the hill

PLATE 3.62
The sick child

PLATE 3.63
The Cottage Door

PLATE 3.64
But Peaceful was the night

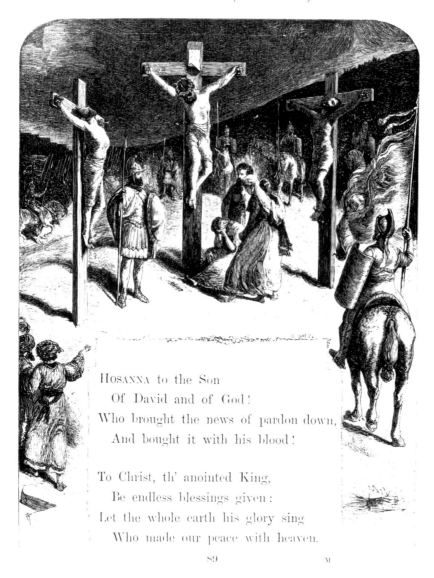

Hosanna to the Son
 Of David and of God!
Who brought the news of pardon down,
 And bought it with his blood!

To Christ, th' anointed King,
 Be endless blessings given:
Let the whole earth his glory sing
 Who made our peace with heaven.

89 M

PLATE 3.65
Hosanna to the Son …

SONG IV.

THE THIEF.

WHY should I deprive my neighbour
 Of his goods against his will?
Hands were made for honest labour,
 Not to plunder, or to steal.

'Tis a foolish self-deceiving
 By such tricks to hope for gain:
All that's ever got by thieving
 Turns to sorrow, shame, and pain.

101

PLATE 3.66
The Thief

PLATE 3.67
The Monarch's Fall

THE ENGLISH GIRL

SPORTING on the village green,
The pretty English girl is seen ;
Or beside her cottage neat,
Knitting on the garden seat.

Now, within her humble door,
Sweeping clean her kitchen floor ;
While upon the wall, so white,
Hang her coppers, polish'd bright.

PLATE 3.68
Knitting on the garden seat

THE SAND CASTLE.

THE tide is out, and all the strand
 Is glistening in the summer sun ;
Let 's build a castle of the sand—
 Oh ! will not that be glorious fun ?

With walls and outworks wide and steep,
 All round about we'll dig a moat,
And in the midst shall be the keep,
 Where England's flag may proudly float.

PLATE 3.69
The Sand Castle

PLATE 3.70
Joy

PLATE 3.71
The joys of harvest we have known

4

The High Victorians

Frederic Leighton, Edward John Poynter, George Frederick Watts, Frederick Richard Pickersgill

This chapter is devoted to four artists who in style and artistic interests were far removed from those who may be termed 'Pre-Raphaelite' or 'Idyllic'. Leighton, Poynter, Watts and Frederick Pickersgill were first and foremost painters, not illustrators and all worked in a grand manner. Academic in feeling and exalted in tone, they took their themes from history and classical antiquity. One critic has accurately defined them as Neo-Classical painters, remarking on the classical revival in painting:

> By the nature of its subject matter it was specially attractive to the academic mentality. As a branch of High Art it was not far removed from historical painting: it was concerned with lofty idealism and its themes were a subject of scholarship ... Such themes required a wide range of classical learning, an alert eye for new archaeological discovery and a painting technique to match the subject.[1]

While three of these artists were only occasional illustrators, Pickersgill was a surprisingly copious contributor. All, however, made a notable contribution to the illustration of the period, and hence deserve consideration here. Stylistically, they shared such skills as impeccable draughtsmanship and a consistent nobility of feeling.

Frederic Leighton (1830–96)

Leighton's work as a periodical illustrator was restricted to *The Cornhill Magazine*. In 1860 came 'The Great God Pan' (Plate 4.1) to a poem by Elizabeth Barrett Browning, and two more for the same poet's 'Ariadne at Naxos'. Seven years later he made two, not to be despised drawings, for Adelaide Sartoris's 'A Week in a French Country-House'. A book edition containing both these images was published the same year.

In 1862–3 Leighton drew his most important illustrations to George Eliot's 'Romola' also for the *The Cornhill Magazine* (Plates 4.2, 4.3, 4.4, 4.5 and 4.6). Useful critical comment has already been made on these designs, and little can be added except to stress the significance of the project.[2] Leighton contributed an unusually large number of designs for this, the only novel by Eliot to be illustrated in its first printing. As well as the full-page illustrations, he made numerous

initial letters, which are among the happiest of all the images he provided. Since he worked closely in collaboration with the author (hardly a common occurrence at the time) it might be thought that the increased number of designs came about at the author's insistence. However, it is more likely that the editor of *The Cornhill* saw the larger circulation of the heavily illustrated rival, *Good Words*, and encouraged Leighton to attempt to give his periodical the edge. Successful though both novel and illustrations were, the expense was prohibitive, and the magazine never again carried as many illustrations as during the publication of 'Romola'. Although invariably finely drawn, Leighton's drawings here may be thought a little austere, but in this they suit so learned a tale admirably. In 1880 a limited edition was published in two volumes in which all the designs reappeared well printed from the wood.

As an illustrator of books, which did not derive from periodical publication, Leighton's contributions are of less importance. His frontispiece to Mary Boyle's *Woodland Gossip* (1864) is little more than a curiosity, but the designs for *Dalziel's Bible Gallery* (1881) should not be overlooked (Plate 4.7). Although they possess little in the way of warmth, they are undeniably grand and occasionally powerful as in 'Samson carrying the Gates'.

Leighton: Checklist of illustrated books

1864 Mary Louisa Boyle: *Woodland Gossip*

1867 Frederic Leighton: *Twenty-Five Illustrations by Frederic Leighton Designed for The Cornhill Magazine*
Adelaide Sartoris: *A Week in a French Country-House*

1880 George Eliot: *Romola*

1881 Anthology: *Dalziel's Bible Gallery*

1886 Mrs J.White: *My Face is my Fortune*

1894 Anthology: *Art Pictures from the Old Testament*

Edward John Poynter (1836–1919)

Poynter was a more productive illustrator than might be expected and also on occasion both interesting and inventive. He worked for several periodicals and most of his contributions are worth examination.

Of the three designs in the *Churchmans' Family Magazine* for 'The Painter's Glory', the second full-page image, which is dated in the block 1862, is the finest. In *London Society* the group devoted to 'Lord Dundreary' is not without merit, but more interesting is the entirely untypical 'I can't thmoke a pipe' of October 1862 and the fine 'A Sprig of Holly', which was published in the Christmas number in 1864. Poynter's best work in the magazines, however, appears in *Once a Week*. He contributed two drawings to 'A Dream of Love' in the autumn of 1862, and the second of these, of the sleeping girl, is especially striking. 'Ducie of the Dale' (18 April 1863) is a work of real charm, while in 'the Ballad of the Page and the King's Daughter' (6 June 1863)

Poynter produced a composition both complex and moving.

The 'Persephone' which appeared in Jean Ingelow's *Poems* of 1867 is a notable piece, not least on account of the artist's consummate handling of the diaphanous dress, but it is in *Dalziel's Bible Gallery* (1881) that Poynter shows his distinction as a book illustrator (Plates 4.8 and 4.9). His drawings here possess a drama and a variety entirely absent from Leighton's contributions to the same project. While there is a languid sensuality bordering on abandon in his depiction of 'Miriam' in 'Moses strikes the Rock', Poynter reveals an understanding and a feeling for the moment which is intensely affecting. In several of his other designs in this book there is a perception of the text and a sympathy for meaning which eludes several of the other artists.

Poynter: Checklist of illustrated books

1867 Jean Ingelow: *Poems*

1869 L. Valentine (ed.): *The Nobility of Life*

1872 H, E.M. (Emily Marion Harris): *Echoes*

1873 John Keats: *Endymion*

1881 Anthology: *Dalziel's Bible Gallery*

1894 Anthology: *Art Pictures from the Old Testament*

George Frederick Watts (1817–1904)

Although Watts made only three illustrations, all for *Dalziel's Bible Gallery* (Plates 4.10 and 4.11) they are distinctive in style and intense in feeling. 'Noah's Sacrifice' is especially noble. Reid suggested, perhaps correctly, that Watts could not master the medium of wood-engraving and he quotes a letter that the artist wrote to the Dalziels complaining at their criticism of his Noah: 'my object is not to represent the phrenological characteristics of a mechanical genius, but the might and style of the inspired patriarch ... '[3] On the evidence of just these few designs it is a matter of regret that Watts could not be persuaded to persevere as an illustrator. However, it may be closer to the mark to suggest that Watts did not really wish to master the skill of drawing for the engraver since it was as a painter not an illustrator, that he wanted to be chiefly renowned.

Watts: Checklist of illustrated books

1881 Anthology: *Dalziel's Bible Gallery*

1894 Anthology: *Art Pictures from the Old Testament*

Frederick Richard Pickersgill (1820–1900)

Pickersgill was a distinctive illustrator whose work has been almost entirely neglected. He was

especially influenced stylistically by the German outline illustrators of the 1830s and 1840s, most notably Johann Schnorr von Carolsfeld, F.A.M. Retzsch and Wilhelm Kaulbach, and he was a consummate draughtsman in their manner. He differed from them, however, in the way he softened his compositions, that makes his best work rounder and warmer than theirs which so frequently seems cold and even forbidding. Pickersgill is also a remarkable practitioner, since he appeared to be almost unaffected by the ideas of the Pre-Raphaelites and others at work during the period. He was illustrating in 1870 in much the same way as he had been in the 1840s, and his work is consistently reliable and perhaps somewhat conventional. Nevertheless, everything he produced in illustration is marked by care and conviction, and it is for just such underrated virtues that he warrants exploration and revaluation.

His small number of periodical designs are scattered far and wide, and on the whole he is rarely at his best in the magazines. Perhaps the loveliest drawing he made in this context appeared in the Christmas number of *London Society* in 1862 to 'The Wishing Well'.

Although Pickersgill began his career as an illustrator in the early 1840s, it was an aborted project of 1850 which brought him into early contact with the influential Dalziels.[4] In this year they commisssioned him to illustrate *The Life of Christ*, but unfortunately the project foundered, and, in the event, Pickersgill completed only six designs. These notable, though somewhat static images were to be echoed stylistically throughout the artist's long career. There are several fine drawings in Bryant's *Poems* (?1854) and others in Montgomery's *Poems* (1860), Moore's *Lalla Rookh* (1860) (Plate 4.12) and Willmott's *English Sacred Poetry* (1862). In general Pickersgill was to contribute the occasional piece to a number of books, and he avoided single-handed illustration almost entirely.

In 1870 Dean Henry Alford provided a text, *The Lord's Prayer*, to a small group of independently made designs by the artist (Plates 4.13 and 4.14). Despite the unconventional order, with the illustrations preceding the text, the book is a marked success, displaying Pickersgill's draughtsmanship and sincerity at their most mature. These works were only to be equalled by the potent drawings made for *Dalziel's Bible Gallery* (1881). To my mind, Pickersgill's few drawings here, are almost the most distinguished in an exalted company, and his rather archaic style suits the subject-matter completely. 'Rahab and the Spies' is a masterpiece both in the monumentality of the figures and in the typically deft handling of light and shade – quite as fine is 'Jacob blessing Ephraim and Manasseh' (Plate 4.15) in the same volume.

Pickersgill: Checklist of illustrated books

1850 F.R. Pickersgill: *Six Compositions from the Life of Christ*

1854 M. F. Tupper: *Proverbial Philosophy*

?1854 W.C. Bryant: *Poems*

1856 Revd T.J. Judkin: *By-Gone Moods*

1857 R.A. Willmott (ed.): *The Poets of the Nineteenth Century*

1858 Anthology: *Lays of the Holy Land*
 Charles Mackay (ed.): *Home Affections Pourtrayed by the Poets*

John Milton: *Comus*
Thomas Moore: *Poetry and Pictures*
Edgar Allan Poe: *Poetical Works*

1859 James Thomson: *The Seasons*

1860 Anthology: *Poems and Pictures*
James Montgomery: *Poems*
Thomas Moore: *Lalla Rookh*

1862 R.A. Willmott (ed.): *English Sacred Poetry*

1864 Anthology: *Favourite Poems by Gifted Bards*
Anthology: *Jewels Gathered from Painter and Poet*

1865 Anthology: *Beauties of Poetry and Gems of Art*

1866 Anthology: *Pictures of Society*

1867 Revd Robert Baynes (ed.): *The Illustrated Book of Sacred Poems*
Charles Mackay (ed.): *A Thousand and One Gems of Poetry*

1870 Anthology: *The Child's Book of Song and Praise*
Anthology: *Favourite English Poems and Poets*
Henry Alford: *The Lord's Prayer*

1874 Anthology: *Dawn to Daylight*

1881 Anthology: *Dalziel's Bible Gallery*

1894 Anthology: *Art Pictures from the Old Testament*

Notes

1 Jeremy Maas, *Victorian Painters*, 1988 (Revised edition), p.178.
2 Hugh Witemeyer, *George Eliot and the Visual Arts*, 1979, pp.157–70.
3 Forrest Reid, *Illustrators of the Eighteen Sixties*, 1928. Quoted from the reprint, New York, 1975, p.207.
4 Examples of Pickersgill's work in the 1840s can be found in S.C. Hall (ed.), *The Book of British Ballads* (Second Series), 1844, and Philip Massinger, *The Virgin Martyr*, 1844.

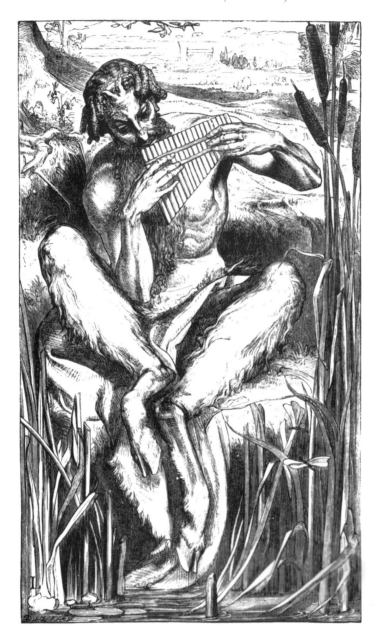

PLATE 4.1
The Great God Pan

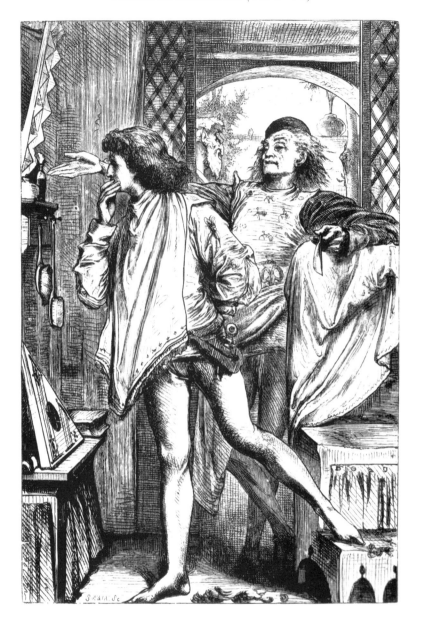

Plate 4.2
Suppose you let me look at myself

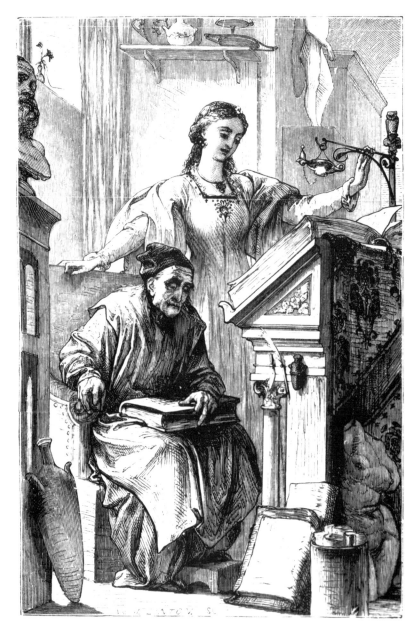

Plate 4.3
The blind scholar and his daughter

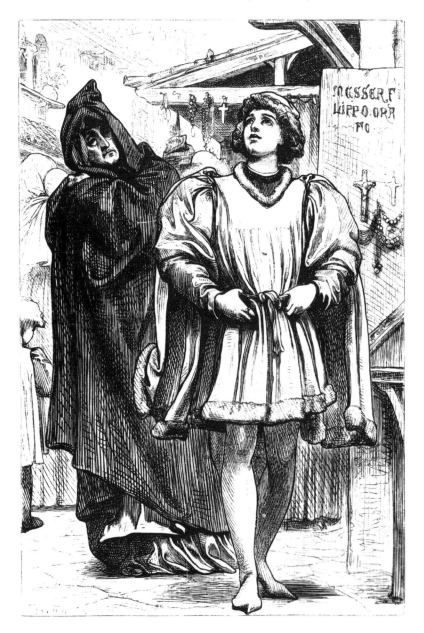

PLATE 4.4
A recognition

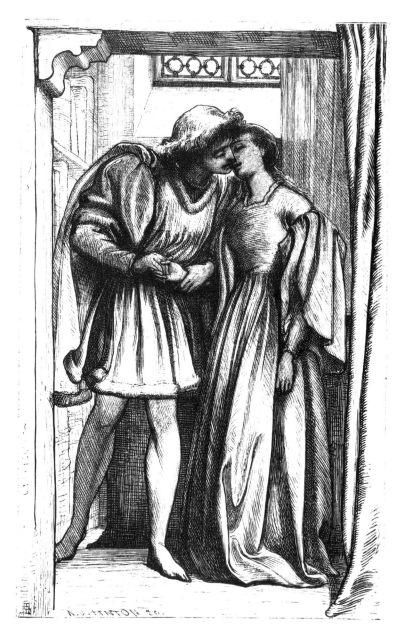

PLATE 4.5
The first kiss

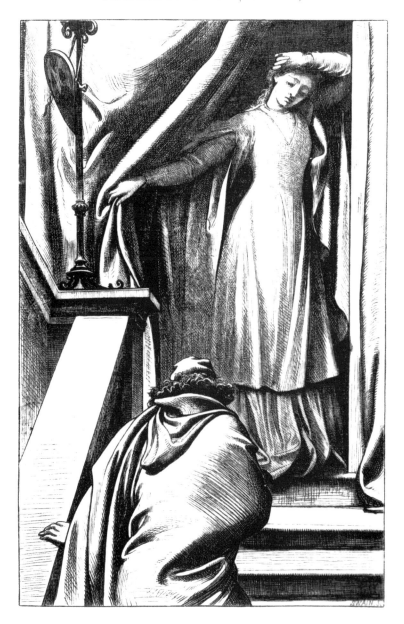

PLATE 4.6
Coming Home

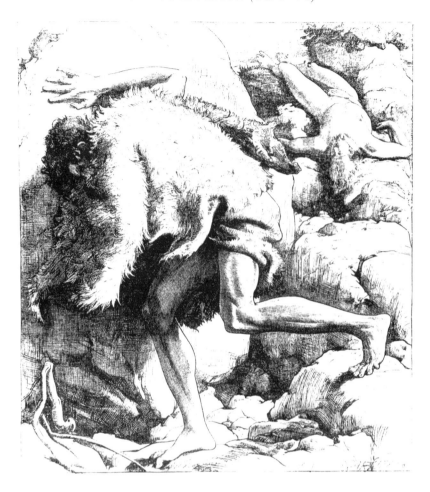

PLATE 4.7
Cain and Abel

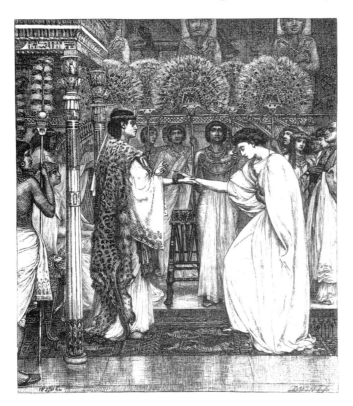

PLATE 4.8
Pharaoh honours Joseph

PLATE 4.9
Joseph distributes Corn

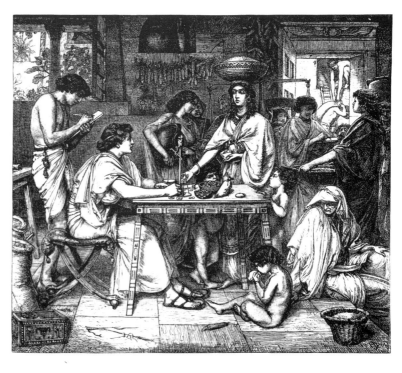

221

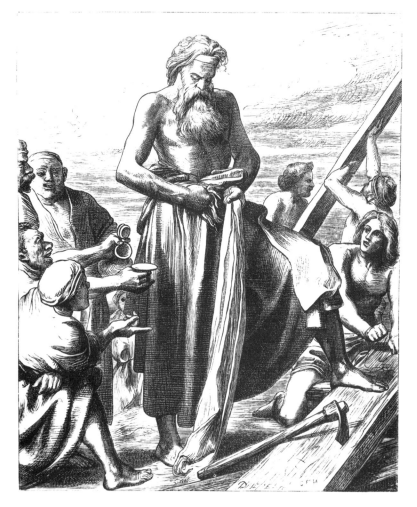

PLATE 4.10
Noah building the Ark

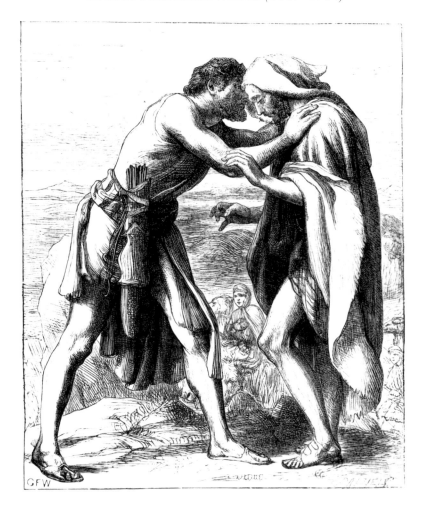

PLATE 4.11
Esau meeting Jacob

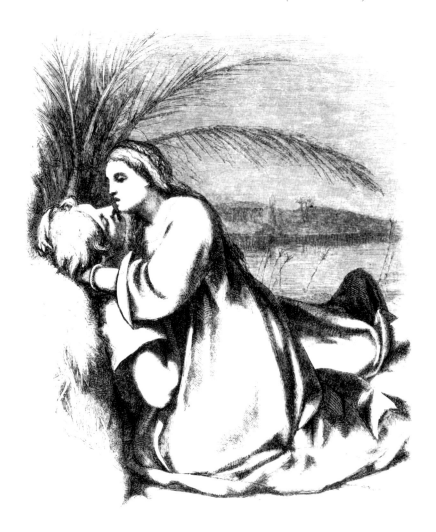

PLATE 4.12
There – Drink my tears …

PLATE 4.13
Then knelt down the Holy one …

PLATE 4.14
So the strong one yielded …

PLATE 4.15
Jacob blessing Ephraim and Manasseh

5

Other artists

Thomas Morten, Charles Henry Bennett, Charles Samuel Keene, James Abbott McNeil Whistler, James Mahoney, Samuel Luke Fildes

Several artists, who cannot be ignored in a survey of this nature, do not fit into any of the categories explored in previous chapters. They seem individuals who demand consideration as such, and their importance is a key to the richness and variety in illustrative style which is a hallmark of the period. Keene and Bennett can be seen to be, not only consummate comic artists, but also capable of work of real profundity. The virtually ignored Morten and Mahoney are equally worthy of pursuit, while Fildes points to the end of Sixties illustration, with his move towards social realism and inspirational journalism.

Thomas Morten (1836–66)

Morten committed suicide at the age of 30, and any reputation he retains rests almost entirely on his *Gulliver's Travels* which appeared a year before his death (Plates 5.1, 5.2, 5.3). Morten was an eclectic, whose borrowings, according to one critic, were nothing short of plagiarism. In this instance the clear source was John Gordon Thompson, who had tackled the same work a little earlier.[1] The truth of such unacknowledged usage of another man's designs is irrefutable, but Morten's treatment makes his book a memorable triumph, in clear contrast to the workmanlike mediocrity of his predecessor. What Morten was doing had honourable precedents with artists such as Gillray and Rowlandson, who frequently worked up the suggestions of amateurs like Bradyll and Wigstead into some of their greatest images. The crucial and tragic difference was that Morten, uncertain of his own style, evidently used the work of other practitioners without their permission. Nevertheless, in this major book and in some of the periodical designs, Morten reveals a fine line, a true sense of whimsical design, and, on occasion, a touch of poetry. His version of Swift is one of the most compelling of all editions of the classic, and can be compared favourably with that by Grandville of 1838.

Between May and July 1866, Morten made a small number of drawings for *Aunt Judy's Magazine*. All are competent, while 'He brings it thee ... ' (June) is a fine piece indeed. The single design in *Beeton's Annual* for 1866, to a story called 'The Arms of the de Forgerons' shows his mastery of the grotesque and the fantastic. It was during the work for 'The Lion in the Path' in *Cassell's Illustrated Family Paper* that Morten took his life, and after 3 November the drawing was undertaken by another hand. However, these late designs show a sad decline in his abilities, and

are of little merit. In contrast the few drawings for the *Churchman's Family Magazine* show the artist at his best. 'The Bell-Ringer's Christmas Story' (December 1863) is a work of real distinction, while 'The Twilight Hour' (June 1864) is one of his greatest images. The woman gazing wistfully out of a window is worthy of Millais, and it is no coincidence that Morten's monogram deliberately apes that of the more celebrated protagonist.

The drawings by the artist in *Entertaining Things*, *Everybody's Journal* and *Every Boy's Magazine* need not detain us, but it is a different matter when examining the pages of *Good Words*. 'Cousin Winnie' (1863) possesses a lyricism worthy of Arthur Hughes, while 'The Spirit of Eld' of the same year is one of the artist's noblest and most memorable creations.

London Society, for which Morten did a large amount of work, is also a repository of several good works. 'The Widow's Wail' (March 1862) relates to a poem by Thomas Hood as well as a recent mining disaster, and is a piece of genuine strength, while 'Pictures in the clouds' (October 1863) is a design of great beauty. 'Love and Pride' (July 1865) reveals Morten's mastery of figure drawing but after this date nothing quite reaches this level of attainment. In November and December 1866, and again in December 1869, a few drawings were published in the magazine poignantly marked, 'Drawn by the late T. Morten'.

Morten put some of his best work into *Once a Week*, no doubt inspired by the exalted galaxy of artistic talent which this remarkable periodical commanded all too briefly. 'Macdhonuil's Coronach' (28 January 1865) is a magnificent drawing of the forsaken Ellen yearning for her Ian, but arguably even finer, is 'The Dying Viking' (3 March 1866), one of the artist's most haunting drawings and worthy of Sandys at his best (Plate 5.4). 'The Curse of the Gudmunds' (11 August 1866) is another admirable composition depicting the white elf hugging her elfin child to her.

While the designs Morten made for *The Quiver* are all of a fair standard perhaps the most interesting is 'Ah me! ah me! 'tis a common tale ... ' which reveals a peculiarly summary manner of drawing, using a number of zigzag lines. This points to a stylistic development which Morten sadly was never able to continue.

Although nothing in books approaches *Gulliver's Travels* in importance, there are one or two items of interest. The artist provided a notable illustration to 'The Merchant and the Genie' in *Dalziel's Arabian Nights' Entertainments* (1865), and the little known *Golden Hair*, published in the same year, is also worth investigating (Plate 5.5). 'Chamber Music' in *Two Centuries of Song* (1867) has a superficial charm but also reveals that the artist had little sympathy for costume pieces.

Morten: Checklist of illustrated books

1861 Geraldine Stewart: *The Laird's Return*

1862 [Joseph Johnson]: *Clever Girls of Our Time*

1865 *Dalziel's Arabian Nights' Entertainments*
Tom Hood: *Jingles and Jokes for Little Folks*
Jonathan Swift: *Gulliver's Travels*
Sir L. Wraxhall: *Golden Hair*

1866 Anthology: *A Round of Days*
 John Foxe: *Book of Martyrs*
 Adelaide Procter: *Legends and Lyrics*

1867 Anonymous: *Woman's Strategy*
 Walter Thornbury (ed.): *Two Centuries of Song*
 Isaac Watts: *Divine and Moral Songs* (Nisbet edition)

?1867 *Cassell's History of England*

1870 Anthology: *The Piccadilly Annual*

Charles Henry Bennett (1829–67)

Bennett like Walker, Pinwell, Houghton and Morten, was a tragically short-lived artist. While much of his work was devoted to comic illustration, especially for *Punch*, as well as in innumerable books for children, he also occasionally turned his considerable skills to serious books aimed at adults. While *Quarles's Emblems* (1861) is a major achievement, his *The Pilgrim's Progress* illustration (1860) is an unjustly neglected masterpiece (Plates 5.6, 5.7, 5.8 and 5.9). Bennett was essentially a brilliant draughtsman with a tendency towards the grotesque and caricature. He was unfailingly inventive in design, and unlike almost all of the other illustrators of the time, frequently supplied both the drawings and the texts to his publishers. He was succeeded after his death at *Punch* by the better known Ernest Griset, but an examination of the large oeuvre of Bennett reveals the Englishman to be more than Griset's equal in almost every department.

Although Bennett did comparatively little work for periodicals there are several excellent examples of his grotesques to be found in their pages. One of the best, 'Mr Timothy Hoggins' Christmas Dream' was published posthumously in *The British Juvenile* on 1 December 1868. Typically original, are the 12 drawings Bennett made for 'Young Munchausen', in *Every Boy's Magazine* throughout 1864.

London Society contains a number of consistently amusing caricature heads, notably 'Fellows' (June 1865), where the artist is merciless in poking fun at the pompous members of learned societies. Also excellent is the series devoted to 'The Swell' which appeared three years earlier (Plates 5.10 and 5.11). The use of the caricature head, as a device, was employed with graver effect in *The Pilgrim's Progress* of 1860. In the grotesque vein further fine drawings are 'Nest-building Apes' in *Once a Week* (19 July 1862), and 'Christmas Dreams' in *The Queen* (Christmas supplement, 21 December 1861).

Turning now to the books, it is no exaggeration to say that especially among those for children, there are almost no failures. Outstandingly original are *The Faithless Parrot* and *The Frog Who Would A Wooing Go* (both 1858), which are equalled and indeed excelled by *The Sorrowful Ending of Noodledoo …* (1865). *The Pilgrim's Progress* (1860) contains a perceptive preface by Charles Kingsley who evidently saw what Bennett was attempting to do and fairly evaluated his achievement:

For that Bunyan drew mostly from life there can be little doubt. He may have been now and then, like all true poets, an idealiser, out of several personages compounding one. But the very narrowness of his characters, when considered together with their strong individuality, makes it more probable that he accepted certain persons whom he actually knew in life, as fair types of the fault which he was exposing.

On this method, therefore, Mr Bennett has constructed the great majority of his ideal portraits. Believing that the ideal is best seen in the actual, the universal in the particular, he has boldly drawn, as far as he could, from life. I say boldly; for to do this is to do no less than to run his knowledge of human nature against Bunyan's. But by no other method, surely, was success attainable; and if he has fallen short, he has fallen short on the right road.[2]

Bennett fell short but rarely, and almost all his work is worthy of study and examination. What Kingsley saw as a real knowledge of human beings and their weaknesses, is also apparent even in Bennett's most light-hearted and ostensibly superficial productions. His art is complex and sometimes profound, and it is a mistake to pigeon-hole him as simply an illustrator for children. He was indeed a master of the genre, but unlike many of his competitors he had a good deal more to say both artistically and psychologically. Among the purely juvenile works some of his most rewarding images are to be found in his animals which are inevitably full of life and vigour.

Bennett: Checklist of illustrated books

1857 Aesop: *Fables of Aesop and Others …*
 C.H. Bennett: *Shadows*

1858 C.H. Bennett: *Birds, Beasts and Fishes*
 C.H. Bennett (ed.): *Old Nurse's Book of Rhymes, Jingles and Ditties*
 C.H. Bennett: *The Faithless Parrot*
 C.H. Bennett: *The Frog Who Would A Wooing Go*
 C.H. Bennett: *The Sad History of Greedy Jem*

1859 Anon: *Games and Sports for Young Boys*
 C.H. Bennett: *Proverbs with Pictures*
 J.C. Brough: *The Fairy Tales of Science*

1860 C.H. Bennett: *The Nine Lives of a Cat*
 C.H. Bennett and R.B. Brough: *Shadow and Substance*
 John Bunyan: *The Pilgrim's Progress*
 Henry Morley: *Fables and Fairy Tales*

1861 Anon: *Games of Skill and Conjuring*
 Henry Morley: *Oberon's Horn*
 Francis Quarles: *Quarles' Emblems*
 W.H. Wills (Sel.): *Poets' Wit and Humour*

1863 C.H. Bennett: *London People: Sketched from Life*
 C.H. Bennett: *The Book of Blockheads*

C.H. Bennett: *Nursery Fun – The Little Folks Picture Book*
C.H. Bennett: *The Story that Little Breeches Told*
Henrietta Wilson: *The Chronicles of a Garden*

1864 Revd John Allan: *John Todd and How He Stirred his own Broth Pot*
Paul de Musset: *Mr Wind and Madam Rain*
Darcy W. Thompson: *Nursery Nonsense*

1865 C.H. Bennett: *The Sorrowful Ending of Noodledoo ...*
C.H. Bennett: *The Surprising ... Adventures of Young Munchausen*
Darcy W. Thompson: *Fun and Earnest*

1867 C.H. Bennett: *Lightsome and the Little Golden Lady*

1868 Mark Lemon: *Fairy Tales*

1871 William Sangster: *Umbrellas and their History*

1872 C.H. Bennett and R.B. Brough: *Character Sketches*

1877 Henry Morley: *The Chicken Market and other Fairy Tales*

1878 Anthology: *The Shilling Funny Nursery Rhymes*

Charles Samuel Keene (1823–91)

Lionel Lindsay wrote a survey of Keene's work in 1934 which he called *Charles Keene – The Artists' Artist*. This was a highly appropriate title for a man admired by Degas, Sickert, William Rothenstein and Roger Fry, among many others. Keene was, above all, a supremely gifted draughtsman, a natural storyteller in black and white, and a more varied performer than his voluminous work for *Punch* might suggest. He was greatly influenced by German art and especially by the master of the vignette in illustration, Adolph Menzel. The two artists became friends and exchanged drawings, and apparently the German artist became a subscriber to *Punch* entirely on account of Keene's presence in its pages.[3] What Keene so admired in Menzel and also in Millais, was a sharpness of outline, combined with clarity and strength within a small space.

Keene was at his best with comic tales, but he also illustrated books for boys, works of travel and instruction, novels and poetry. While he is rarely profound or moving, his drawings are rewarding and invariably executed with a vivacity which can be memorable.

In *The Cornhill Magazine*, Keene's only contributions were a full-page design and an initial letter to George Eliot's short story, 'Brother Jacob', published in July 1864 (Plate 5.12). Typically Keene judged the story with care, and produced a piece that was entirely appropriate. In *London Society*, clearly an organ that appealed to him, Keene was frequently on top form. Despite Horace Harral's unsympathetic engraving 'Our Christmas Turkey' in the Christmas number of 1868 and 'In the Solent' (July 1870) show him in his most characteristically jovial style.

It was in *Once a Week*, however, that Keene made the majority of his periodical contributions of the kind with which this study is chiefly concerned. The 15 drawings for Charles Reade's *A*

Good Fight, appeared between July and October 1859, and are all admirable. When the work was eventually completed later, it bore its more familiar title, *The Cloister and the Hearth*, although the reprint in book form, by Chatto and Windus in the mid-1880s, contained only eight of Keene's designs from the original magazine issue. Arguably even more important, were the 40 illustrations for George Meredith's 'Evan Harrington', which was published between February and October 1860. Time and again, both here and throughout *Once a Week*, it is the consistency of invention and draughtsmanship in Keene, which is so striking.

Keene drew regularly during the early years of *Once a Week* and there are few disappointments. Two outstanding designs were made for 'the Mazed Fiddler' (2 February 1861), while that for 'Nips Daimon' (24 May 1862) is a ghostly and macabre scene of a skeleton riding on a sledge. This was to a story set in Montreal. Between June and December 1862, Keene supplied a number of masterly images for Mrs Henry Wood's, 'Verner's Pride', but after this date, the frequency of his contributions began to decline. Finally, after a long interval came 'The Old Shepherd on his pipe' (July 1867) which is a great drawing, with a cat of which Steinlen might have been proud.

Keene was drawing for books well before the 'sixties, and although not included in the Index of illustrated books, there should be at least a mention of his early essay in illustration, *Robinson Crusoe* of 1847 (Plates 5.13 and 5.14). *The Book of German Songs* (1856) (Plates 5.15 and 5.16) is a significant work by Keene, for the vignette designs it contains show more clearly than anywhere else the debt he owed to Menzel. Keene made numerous appearances in books throughout the period, but the most important are two which he illustrated single-handed: *The Cambridge Grisette* (1862) (Plates 5.17 and 5.18) and *Mrs Caudle's Curtain Lectures* (1866). Both reveal the artist at his most accomplished and light-hearted, and, for the student, the essence of his art may be found in these unpretentious, apparently artless productions. Here also may be sensed a partial retreat from the hard Germanic outline to a softer, though no less incisive style of drawing. Keene's greatness was as a consummate draughtsman, who excelled when he was untrammelled by the need to convey a serious message. For a substantial sampling of his *Punch* designs the anthology, *Our People* (1881), is ideal.

Keene: Checklist of illustrated books

1853 Captain B.F. Bourne: *The Giants of Patagonia*

1856 H.W. Dulcken (trans. and ed.): *The Book of German Songs*

1858 Sir Colin Campbell: *Narrative of the Indian Revolt*
Thomas Hood: *Passages from the Poems of Thomas Hood*

1859 Alfred Baring Garrod: *The Nature and Treatment of Gout*

1860 Mary Gillies: *The Voyage of the Constance*
Captain Mayne Reid: *The Boy Tar*

1861 John G. Edgar: *Sea Kings and Naval Heroes*
William Kingston: *Jack Buntline*
Catherine Winkworth (trans.): *Lyra Germanica*

1862 Anonymous: *Eyebright*
 Anthology: *Passages from Modern English Poets*
 Frank Freeman: *Paul Duncan's Little by Little*
 R.A. Willmott (ed.): *English Sacred Poetry*
 Herbert Vaughan: *The Cambridge Grisette*

1864 F.C. Burnand: *Tracks for Tourists*
 Mark Lemon (ed.): *The Jest Book*
 Mark Lemon: *Legends of Number Nip*

1865 Margaret Gatty: *Parables from Nature*
 Tom Taylor (trans.): *Ballads and Songs of Brittany*

1866 Douglas Jerrold: *Mrs Caudle's Curtain Lectures*
 Adelaide Procter: *Legends and Lyrics*

1867 Anthology: *Touches of Nature*

1868 Charles Reade: *Double Marriage*

1870 Anthology: *Favourite English Poems and Poets*

1876 Walter Thornbury (ed.): *Historical and Legendary Ballads and Songs*

1879 W.M. Thackeray: *Roundabout Papers …*

1881 Anthology: *Our People*

James Abbott McNeil Whistler (1834–1903)

Whistler made just six designs for wood-engravings, which were published in *Once a Week* and *Good Words* in 1862. In addition were the two etched works in *Passages from Modern English Poets* which appeared the same year. So small a group makes evaluation of his contribution to illustration a difficult one, but there can be no argument with Reid's assesssment:

> Had we nothing of Whistler's but his six wood engravings I think we might still claim that he was a great artist. They do not display all his qualities, of course, but they display his poetic imagination, his feeling for decoration, his beauty of line, his sense of composition, and that impeccable taste which in him, as Arthur Symons has said was carried to the point of genius.[4]

In *Good Words*, the two drawings to 'The Trial Sermon' (Plates 5.19 and 5.20) entirely echo Reid's view, and reveal also something of the fluency and sketchy nature of his draughtsmanship. This mastery of line, which must have presented many problems to the engraver to interpret, is perhaps even more marked in the *Once a Week* drawings. 'The Major's Daughter' (21 June 1862), is a scene of a girl on a ship staring pensively at the horizon, while the curiously entitled 'The

Relief Fund in Lancashire' (26 July 1862), is a masterpiece. In style and execution it is unlike any other wood-engraving of the period. It was intended to accompany an address by Tennyson, concerning the plight of the starving Lancashire weavers, but, in the event, the poet was not well enough to contribute. Fortunately, Whistler's image remained in place.[5] Both his last two designs for the magazine are of a similar standard – 'The Morning before the Massacre of St. Bartholomew' being of a poignant tenderness which is matched by 'Count Burkhardt' (Plates 5.21 and 5.22). The two designs for *Passages from Modern English Poets* are fine, though to my mind have little to do with illustration, and may be regarded, like many of the images in this book, as essentially separate prints intended to stand alone as works of art.

Whistler's illustrations possess such an interest and an individuality that they cannot be ignored.

Whistler: Checklist of illustrated books

1862 Anthology: *Passages from Modern English Poets*

1876 Walter Thornbury (ed.): *Historical and Legendary Ballads and Songs*

James Mahoney (1847–79)

Little is known about the life of Mahoney, apart from what can be gleaned from the Dalziels' record and from Reid. The consensus seems to have been that he was a difficult man to work with, largely because of his frequent bouts of drunkenness. However, he made a substantial contribution to the illustration of the period, and the drawings which he made for three novels by Dickens are notable. He also produced some fine designs for numerous periodicals. His qualities are awkward to judge because he was frequently uneven, and, on occasion, could be both shoddy and commonplace. He also made many designs for cheap literature, such as the publications of the Society for Promoting Christian Knowledge (SPCK) which remain obscure, and this, coupled with poor printing on worse paper, has meant that his talents have tended towards relegation and critical oblivion. As a draughtsman he was at his best with modern life subjects, often of a rough nature, and hence his success with Dickens and Wilkie Collins. Stylistically he owes something both to Watson and Keene, although he lacks the poetry of the former and the sheer technical ability of the latter.

The two designs for *The Argosy* are both good, with 'Bell from the North' (September 1866), showing the artist in unusually tender mood (Plates 5.23, 5.24 and 5.25). In 1874, in the rarely rewarding *The Day of Rest*, Mahoney provided six illustrations to 'Cassy' by Hesba Stretton, and some of these small drawings have a genuine charm and quality. In *Good Words* there are several workmanlike, if not outstanding works, over a number of years. In 1872 he made some 36 drawings for 'At his gates' by Mrs Oliphant, and although the full-page designs are adequate but uninspired, Mahoney excels in most of the delightful initial letter designs. The numerous appearances by Mahoney in *Good Words for the Young* make little impact, especially when compared with those of Arthur Hughes, which so dominate the early years of this magazine. However, those for 'The Travelling Menagerie' (January to October 1872) are worth the effort of looking up.

In *The Leisure Hour* Mahoney's most sustained effort came in 'The Great Van Broek Property' (January to June 1866), while 'Finding the body of William Rufus' (24 November 1866) is a splendidly ghoulish historical composition. The designs in *London Society* are of average interest only, but there is better work to be found in *The People's Magazine*. 'The Sea King's Burial' (5 January 1867), is a surprisingly noble image, and, equally fine, is 'Robin's Wife' (1 June 1867), which depicts a woman weeping at her baby's grave. Also to be mentioned, is the distinguished 'How Amyas Threw his sword into the Sea' (2 November 1867). The single design in *The Quiver* – 'But for dreary musing one needs little light' (February 1868) – is an uncharacteristically poetic drawing of a girl gazing out of a window.

In *The Sunday at Home* there are 13 illustrations to 'The Old Manor House' (October to December 1865). This is a good series with examples of the clever light effects of which the artist was evidently so fond. However, on the debit side, it should be remarked that his depictions of feet often make them look more like paws.

From November 1867 until September 1868 in *The Sunday Magazine* Mahoney provided a large number of illustrations for 'The Occupations of a Retired Life'. This is an excellent opportunity to sample the artist's work in a group, and there are some fine illustrations. However, it is also possible to see his erratic nature, for the good and the less happy designs make uneasy companions.

Turning to the books, Mahoney illustrated several in 1865 and 1866, working especially for the SPCK, and although these are rarely of great interest they reveal something of his activity and employment at this period. The frontispiece and title page for Trollope's, *The Three Clerks*, show him at his best during these years.

It was, however, during the next decade, that Mahoney's most important book illustrations were made, all for the *Household Edition* of Dickens. In 1871 came *Oliver Twist*, in 1873 *Little Dorrit* (Plates 5.26 and 5.27), and in 1875 *Our Mutual Friend*. At last Mahoney seems to have found his wholly individual voice, and notwithstanding the mediocre paper and unpleasing appearance of this series, these works, which he undertook single-handed, are his major achievements. In *Oliver Twist* the figures of Sikes and Fagin are drawn with a remarkable perception, and on frequent occasions, Mahoney produces scenes as dramatic and exciting as the story itself. Equally sympathetic is the work for *Little Dorrit* and *Our Mutual Friend*, and in both, there is a happy marriage of image and text which is extremely rare in the period. Indeed, it is this equal partnership between author and illustrator which, in these three instances, is so memorable and continually rewarding.

Although Mahoney did nothing else in book illustration of equal significance to the Dickens novels, there is something of the same sense of drama and a feeling for narrative in three works by Wilkie Collins, all belonging to 1875. They are *The Frozen Deep*, *Basil*, and *Hide and Seek*. Although each book contains only a small number of drawings all show that Collins was a writer with whom Mahoney felt in tune.

Mahoney: Checklist of illustrated books

1865 Anonymous: *The Gold Stone Brooch*
 Anonymous: *The Schoolmaster's Warning*

Anonymous: *Stories on the Commandments*
Anonymous: *Stories on my Duty towards God*
Anonymous: *The Trial of Obedience*
Ruth Buck (Mrs Joseph Lamb): *The Carpenter's Family*
George G. Perry: *History of the Crusades*
Jonathan Swift: *Gulliver's Travels* (A. & C. Black edition)
Anthony Trollope: *The Three Clerks*

1866 Anonymous: *The Gold Chain*
Anonymous: *The Secret Fault*
Anonymous: *Tom Barton's Trial and other Stories*
Mrs W.H. Coates: *The Beautiful Island*
Alfred H. Engelbach: *The Wreck of the Osprey*
Alfred H. Engelbach: *Victor Leczinski*

1866–8 Thomas Hood (ed.): *Cassell's Illustrated Penny Readings*

1867 Anthology: *Touches of Nature*
Walter Scott: *Poetical Works* (Chandos Poets)

1868 Anonymous (A.E.W.): *Mary Ashford*

1869 Anonymous: *Helen's Trouble*
Charles Camden: *The Boys of Axelford*
Edward Howe: *The Boy in the Bush*
L.Valentine (ed.): *The Nobility of Life*

1870 Anthology: *The Cycle of Life*
Anthology: *National Nursery Rhymes*

1871 Henry Bramley and John Stainer (eds): *Christmas Carols*
Charles Dickens: *Oliver Twist*
Edward Whymper: *Scrambles amongst the Alps in the Years 1860–69*

1872 Jean Ingelow: *The Little Wonder-Horn*

1873 Anthology: *Lyrics of Ancient Palestine*
Charles Camden: *The Travelling Menagerie*
Charles Dickens: *Little Dorrit*

1875 Anthology: *The Sunlight of Song*
W. Wilkie Collins: *Basil*
W. Wilkie Collins: *The Frozen Deep*
W. Wilkie Collins: *Hide and Seek*
Charles Dickens: *Our Mutual Friend*

1877 Frederick Scarlett Potter: *Frank Newitt's Fortunes*

1878 [M.D.]: *A Bonfire and What Came of it*

1879 Miss A.C. Chambers: *Annals of Hartfell Chase*

n.d. Anonymous: *Alice Gray*

Samuel Luke Fildes (1844–1927)

Fildes marks the beginning of the end of the movement in illustration known as the 'Sixties'. Although some of his magazine illustrations are remarkable, and almost all competently drawn, he developed into a practitioner more concerned with social realism and journalism, than one with much in common with the other artists considered in this survey. His work for *The Graphic*, though powerful and intense, is a world away from that created by Rossetti, Pinwell or Leighton. Like Herkomer, Fildes seems a much more modern artist than almost all the other illustrators under discussion. It is hardly surprising that he was greatly admired by Van Gogh. It is also important to note that Fildes only began to illustrate in the magazines in the last years of the 1860s, and by this time the main organs for artists such as *Once a Week*, *Good Words* and the *The Cornhill Magazine* were turning away from illustration, largely on account of the spiralling costs.

In *Cassell's Magazine* Fildes made just a few contributions. The finest of these is 'O! Wind, Wind, loud moaning o'er the land', which was published in December 1869. This is an image of a yearning woman gazing sadly into the distance. Equally admirable are the large cover designs the artist made for *The Cottager and Artisan*, which was the successor to *The Cottager in Town or Country*. The title was changed in 1865. Perhaps Fildes's most successful cover is 'The Harvest of the Sea' (September 1867), though almost as good and full of character is 'Cabby' (March 1869). The few drawings for *Good Words* are of interest (Plates 5.28 and 5.29) but those made for *The Graphic* are of the first importance. The most celebrated is 'Houseless and Hungry' (4 December 1869) where the artist shows his commitment in dealing with social issues, but equally moving is 'One Touch of Nature, makes the whole world kin' (22 April 1871).

In *The Mark*, which was the Christmas number of *The Quiver* in 1868, there is an impressive Fildes design to 'Poor Margaret' and in *The Quiver* itself are several further drawings well worth investigation. 'Where fearful fevers rage ... ' (February 1868) is a great drawing of a sick-bed scene executed with real tenderness, while the two for 'Three Chapters in a Painter's life' reveal perhaps something of the qualities which made Van Gogh collect so avidly this illustrator's wood-engravings.

Once a Week is particularly rewarding, for Fildes appears here with almost more variety and interest than in any other of the periodicals. 'The Goldsmith's Apprentice' (22 June 1867), is a touching and memorable design, and this is matched by 'Cassandra' (21 September 1867). In more realist style is 'Salmon Fishing in North Wales' (10 October 1868), while in complete contrast is 'Daphne' (14 November 1868). Here is Fildes uncharacteristically producing a design which is almost entirely Pre-Raphaelite in feeling. In 'Led to Execution', however (3 July 1869) we see a drawing, though late in the period, clearly reminiscent of the medievalism of Lawless.

'The Farmer's daughter' (*The Sunday Magazine*, 1 July 1868), is a lovely image while 'Found dead on the Embankment' in the Christmas number of the *World* (12 December 1878), is an extremely late example of Fildes's uncompromising *Graphic* style.

Fildes's book illustrations, with the notable exception of *The Mystery of Edwin Drood*, seem to me of far less interest than the work he did for the magazines. In this single book, however, he showed that he was entirely at one with the text, and there are some undeniably fine designs. In their strength and even occasionally in terms of style, they may be usefully compared with the drawings made by Mahoney for the *Household Edition* of Dickens, which began publication the following year. In total and depressing contrast *Lord Kilgobbin* (1877) must rank as one of the most tedious and disappointing of Fildes's essays in illustration. It had appeared originally in *The Cornhill Magazine* in 1870–2. However, the work done by the artist in Foxe's *Book of Martyrs* (1866) is worth investigating (Plate 5.30).

Fildes: Checklist of illustrated books

1866 John Foxe: *Book of Martyrs*

1866–8 Thomas Hood (ed.): *Cassell's Illustrated Penny Readings*

1868 Charles Reade: *Peg Woffington*

1869 Charles Reade: *Griffith Gaunt*

1870 W. Wilkie Collins: *The Law and the Lady*
Charles Dickens: *The Mystery of Edwin Drood*
Victor Hugo: *By Order of the King*
J.F. Waller: *Pictures from English Literature*

1877 Charles Lever: *Lord Kilgobbin*

1879 Charles Dickens: *The Mystery of Edwin Drood* (*Household Edition*)
W.M. Thackeray: *Men's Wives*

Notes

1 Allan R. Life 'That Unfortunate Young Man Morten' in *Bulletin* of the John Rylands Library, Manchester, vol. 55, 1972–3, p.383.

2 First edition, 1860, Preface, p.ix.

3 Simon Houfe, 'Charles Keene and the Artists' in exhibition catalogue, *Charles Keene, The Artists' Artist*, Christie's, London, 1991, pp.24–7.

4 Forrest Reid, *Illustrators of the Eighteen Sixties*, 1928. Quoted from the reprint, New York, 1975, p.108.

5 The supply of cotton had almost ceased at this date because the American Civil War prevented supplies reaching England and appalling hardships were suffered in the Lancashire mill towns.

PLATE 5.1
I observed a huge creature walking after them in the sea

PLATE 5.2
It was the most violent exercise that I ever underwent

PLATE 5.3
He did me the honour to raise it gently to my mouth

PLATE 5.4
The Dying Viking

PLATE 5.5
Who may you be, stranger?

PLATE 5.6
Discontent

Plate 5.7
The Jury

Plate 5.8
Christiana

PLATE 5.9
Mrs Bat's-Eyes and Mrs Know-Nothing

PLATE 5.10
Ode to the Swell

PLATE 5.11
Ode to the Swell

Plate 5.12
Mother's Guineas

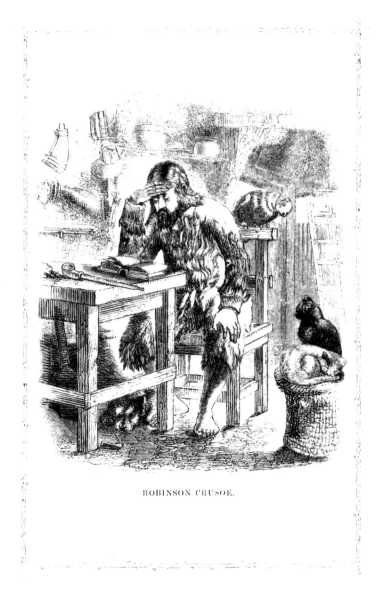

ROBINSON CRUSOE.

PLATE 5.13
Untitled

PLATE 5.14
Untitled

PLATE 5.15
A Battle Prayer

PLATE 5.16
The Hussites before Naumburg

PLATE 5.17
Untitled

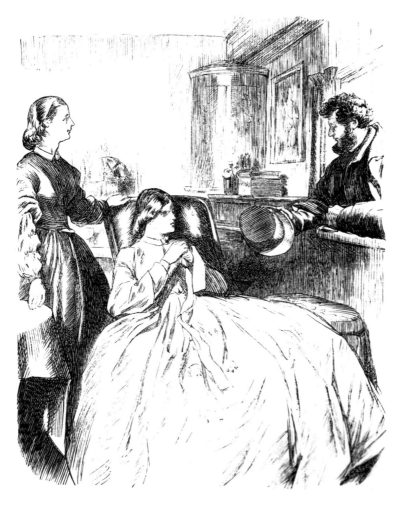

THE BOUDOIR-BAR.

PLATE 5.18
The Boudoir-Bar

PLATE 5.19
The Trial Sermon

PLATE 5.20
The Trial Sermon

PLATE 5.21
The Morning before the Massacre of St. Bartholomew

PLATE 5.22
Count Burkhardt

PLATE 5.23
Autumn Tourists

PLATE 5.24
Bell from the North

PLATE 5.25
The love of years

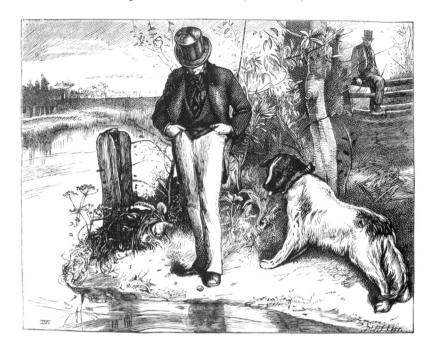

PLATE 5.26
As Arthur came over the stile …

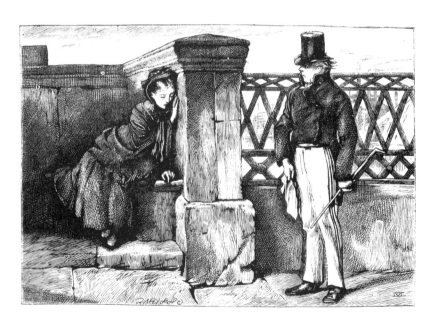

PLATE 5.27
And so he left her …

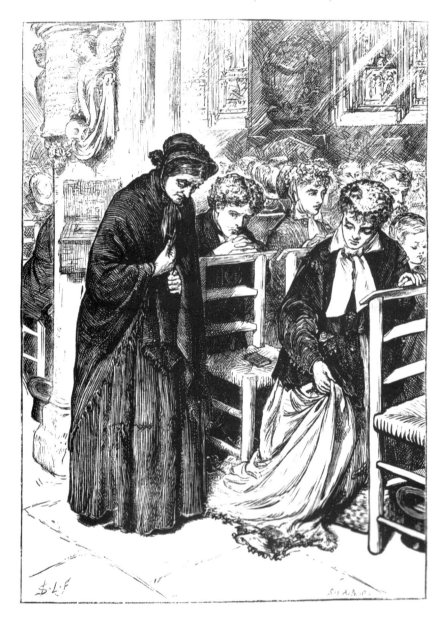

Plate 5.28
In the Choir

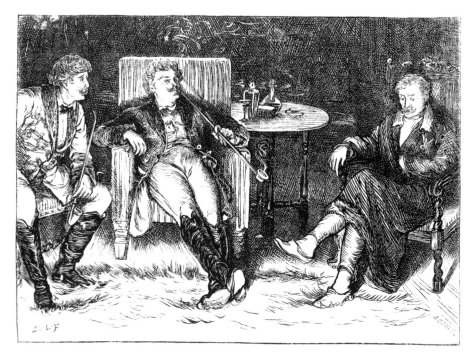

PLATE 5.29
The Captain's Story

PLATE 5.30
As he went, he kept intently reading his book

The illustrated magazines

The magazines and periodicals, to which almost all the artists in this survey contributed, are of crucial importance in any understanding of the illustration of the period. They were the organs which enabled them to make a living, and for the greatest such as Millais or Leighton they proved the springboard to the better paid and higher status occupation of oil painting. To study certain artists such as Sandys, Fildes and Lawless one may look in vain for book illustrations since most of their finest work appears in the magazines. The periodicals also reveal just how unsuited most of the Pre-Raphaelites were to produce regular work to deadlines, while several of the Idyllic illustrators, notably Houghton and Pinwell, were in contrast consistently professional in their approach. However, the sheer bulk of the volumes and the huge numbers of designs can be daunting. The fact that most of the covers and advertisements have been removed from the bound yearly volumes means that much information has been lost. Frequently it has proved impossible to ascertain the exact date of a design because such details were only included on the discarded covers. This is especially true in the case of *Good Words*.

In the Index of illustrated books will be found a number of the highly important anthologies and gift books which reprinted designs that had first appeared in the magazines. The best known are *The Cornhill Gallery*, *Millais's Illustrations*, *Touches of Nature*, *Pictures of Society Grave and Gay*, *Idyllic Pictures* and Thornbury's *Historical and Legendary Ballads and Songs*. These collections are significant because they are usually well printed on good paper from the original blocks, and they provide a convenient way of sampling the works of the artists. However, they do not invariably include all the best designs, and by removing the drawings from their original settings the context of their first appearances is lost. Additional confusion is caused by the habit of re-titling the designs in these books, generally in order to correspond vaguely with prose or verse which they were never intended to accompany. In the view of this commentator it is important to return to the magazines themselves, to judge how appropriate each design is in relation to the text for which it was originally made.

The Index of magazine illustrations is preceded by an annotated list of all the periodicals examined, with some brief comments as to the contents and chief illustrators. Some artists who are not discussed in the text of the book are also included here. In certain cases the years of importance are given, though this does not imply that other years have not been checked. In the Index itself, where no engraver is mentioned, this denotes that there is no name visible in the block. 'Engraver not ascertained' suggests that initials or a device are visible but cannot be made

out with certainty. The period covered is in line with the rest of the book – roughly 1860–80 and within the entry for each artist the magazines are arranged alphabetically. The date of each design is followed by its title, the text and author (where significant), its page reference and the engraver's name (if known). For some major projects such as *Wives and Daughters* (du Maurier) and *Romola* (Leighton), every illustration is separately indexed. For those considered of less significance the style is normally 'Thirty illustrations to ... '.

After Work
A penny monthly. It boasted: 'Not a page is likely to be dull or unprofitable.' Notable for a good design by Small in 1877 and a few by other artists including Mary Ellen Edwards.

Animal World
Contains designs by Barnes and Small reprinted from other magazines such as *The Band of Hope Review* and *The Graphic*. I have declined to wade through it.

The Argosy December 1865–November 1867
Sandys, Houghton, Small, Mahoney, Millais, Walker.

Aunt Judy's Magazine 1866–74
A sixpenny monthly edited by Margaret Gatty which began in May 1866.
Morten, North.

The Band of Hope Review 1861–8
Barnes.

Beeton's Annual 1866
A single design by Morten.

The Boy's Own Magazine
A sixpenny monthly edited by S.O. Beeton.
Small.

The British Juvenile
A penny monthly first published on 1 July 1866. From the same stable as *The British Workman* it was later subtitled 'Temperance in all things'.
Bennett (1866), Barnes (1879).

The British Workman January 1862–December 1868
Barnes, Watson.

Cassell's Christmas Annual 1866
Also entitled *My Pale Companion* it cost a shilling and appears to have appeared only once.
Small.

Cassell's Illustrated Family Paper 28 January 1865–9 March 1867
In March 1867 the name changed to *Cassell's Magazine* (q.v.) and readers were informed on 9 March (p.448) that: 'The Illustrations will be by the best artists'.

Cassell's Magazine March 1867–September 1871
A penny weekly or sixpenny monthly.
Watson, Fildes, Pinwell, Small, Barnes, Charles Green, Mary Ellen Edwards, Morten.

The Children's Hour 'A Magazine for the Young of the Fold' 1865–70
Published in Edinburgh, it began in October 1865.
Small.

Churchman's Family Magazine January 1863–December 1864
A significant though short-lived magazine.
Watson, Morten, Pickersgill, Armstead, Millais, Barnes, Poynter, Sandys, Lawless.

The Cornhill Magazine January 1860–December 1871
A major periodical both from the artistic and literary points of view. I have not indexed this magazine beyond volume 22 (July–December 1870) although it should be noted that here and in the following volumes may be found du Maurier's designs for 'The Adventures of Harry Richmond' and Fildes's for 'Lord Kilgobbin'. Both series are tedious and under-powered.
Millais, Walker, du Maurier, Hughes, Barnes, Paton, Leighton, Sandys, Pinwell, Fildes, Mary Ellen Edwards.

The Cottager in Town or Country 1861–9
Barnes, Fildes.

The Dark Blue March 1871–February 1873
Brown, Solomon.

The Day of Rest 25 December 1872–27 June 1874
Mahoney, Barnes.

Entertaining Things January 1861–May 1862 (all published)
A short-lived venture which described itself on its title page as: 'A Magazine of thoughtful and intellectual amusement'.
Du Maurier, Houghton, Morten.

Every Boy's Magazine 1862–6
A sixpenny monthly published by Routledge. In 1866 it was called *Routledge's Magazine for Boys*.
Morten, du Maurier, Bennett, Houghton.

Everybody's Journal 1 October 1859–28 January 1860
Incorporated after its first 18 issues into the *London Journal*.
Morten, Walker.

Friendly Visitor January 1867–December 1869
A penny monthly originally started in 1824 by Revd W. Carus Wilson. Subtitled 'A Magazine for the Aged' it was published at this period by the proprietors of *The British Workman*.
Barnes, Watson, Small.

The Germ 1850
By the third number the title was changed to *Art and Poetry*.
Hunt, Brown.

Golden Hours January–December 1868
Barnes, Houghton.

Good Cheer 1867–76
The Christmas numbers of *Good Words*.
Pinwell, Pettie, Small, Millais, Mahoney, North.

Good Things for the Young of all Ages 1873–7
The less distinguished successor to *Good Words for the Young*.
Hughes.

Good Words 1860–8
An important magazine begun in Edinburgh by Alexander Strahan and then moved to London. The richest year for illustration was 1862.
Orchardson, du Maurier, Millais, Sandys, Walker, Houghton, Lawless, Keene, Armstead, Whistler, Solomon, Morten, Pettie, Watson, Mahoney, Fildes, Fraser, Wolf, J. Leighton, W. Simpson, Thomas Dalziel, John Lawson.

Good Words for the Young 1868–72
Arguably the finest magazine for children published at this time and edited by George Macdonald.
Hughes, Mahoney, Houghton, Small.

The Graphic 1869–73
Houghton, Watson, Small, Pinwell, Fildes, Walker, du Maurier.

The Infant's Magazine 1 January 1866–1 November 1869
A penny monthly for young children. In 1869 some numbers appeared translated into Spanish clearly intended for export.
Barnes, Small.

The Leisure Hour 1861, 1864–6
Walker, du Maurier, Solomon.

London Society February 1862–December 1871
A distinguished periodical especially in its early years.
Watson, Bennett, Pickersgill, Walker, Morten, Houghton, du Maurier, Millais, Lawless, Poynter, Barnes, Hughes, Keene, Small. Marcus Stone.

Once a Week July 1859–June 1871
Arguably the most remarkable illustrated magazine of the period for both the quality and variety of its illustrators.
Millais, Keene, Lawless, H.K. Browne (Phiz), Leech, Tenniel, Walker, du Maurier, Sandys, Morten, Whistler, Poynter, Pinwell, Barnes, Houghton, Small, North, Fildes, Helen Paterson (later Allingham), Walter Crane.

The People's Magazine 5 January 1867–28 December 1867
A sixpenny monthly which could also be purchased in weekly parts. Published by the Society for Promoting Christian Knowledge.
Mahoney, Small.

The Queen September–December 1861
By 1863 the magazine was virtually unillustrated and in July 1863 it was amalgamated with *The Lady's Newspaper*.
Hunt, Hughes, Bennett.

The Quiver November 1865–September 1869
The Christmas number of this magazine was called *The Mark*.
Small, Pinwell, Sandys, Morten, Houghton, Watson, Fildes.

The Round Robin 1872
The annual volume of *Merry and Wise* (*Old Merry's Monthly*).
Watson.

Saint Paul's Magazine October 1867–September 1868
Important only for Millais's designs for *Phineas Finn* by Trollope who was the editor at this time.

The Servants' Magazine 1867–9
A penny small format monthly published by S.W. Partridge.
Barnes, Watson.

The Shilling Magazine 1865
I have been unable to see the issues after 1865 (the magazine apparently continued until May 1866) but these may well have included the designs by Small mentioned by Gleeson White.
Sandys, Watson.

The Sunday at Home 1863–7
Pinwell, du Maurier, Mahoney, Small, Charles Green.

The Sunday Magazine October 1864–August 1873
A sevenpenny monthly also available in weekly numbers for a penny. Published in London, Edinburgh and Dublin it was edited by Thomas Guthrie.
Pinwell, Barnes, Paton, North, du Maurier, Houghton, Armstead, Small, Mahoney, Shields, Watson, Pettie, Fildes, Hughes.

Tinsley's Magazine August 1867–July 1869
Houghton, Watson.

The Welcome Guest 1 May 1858–22 December 1858
Two early designs by Hughes.
1860–1. Bennett, Houghton, Morten. For additional details see Appendix.

Index of magazine illustrations

This index is arranged alphabetically by artist name and by magazine title within each artist's name. Numbered items are arranged chronologically within each magazine title.

2. 2 October 1865 – 'The Fisherman's Return', p.40. Engraved by J.Cooper.

3. 1 December 1865 – 'Christmas Tree', p.45. Engraved by John Knight.

4. 1 January 1866 – 'A Credit to Her Mother', p.52.

5. 2 July 1866 – 'Thomas Brown: A dialogue on Sunday Morning', text by George Mogridge ('Old Humphrey'), p.73. Engraved by John Knight.

6. 1 August 1867 – 'Father Stirling', p.125. Engraved by John Knight.

7. 2 December 1867 – 'Jack's Christmas Present', p.141.

8. 2 March 1868 – 'The Oiled Feather', p.153. Engraved by John Knight.

CASSELL'S MAGAZINE

1. 1870 – 'A Face', to poem by Alsager Hay Hill, p.237.

2. 1870 – 'Our interview was interrupted by the entrance of Mrs Allonby', to 'Mrs Allonby', facing p.302. Engraved by Frederick Wentworth.

3. 1870 – 'Run from your churches – scarce a league away ...', to 'The Lord's Prayer in May Fair', to poem by Alsager Hay Hill, facing p.424. Engraved by Frederick Wentworth.

CHURCHMAN'S FAMILY MAGAZINE

1. March 1863 – Two illustrations to 'The Maystoke Chorister', pp.289 and 293. Engraved by R.S. Marriott.

THE CORNHILL MAGAZINE

1. February 1864 – 'At Parting', to 'Margaret Denzil's History', facing p.138. Engraved by Swain. The initial letter on p.138 is possibly not by Barnes. It bears a monogram which does not appear to be his but I cannot identify it with certainty.

2. April 1864 – 'At the Stile', to 'Margaret Denzil's History', facing p.494. Engraved by Swain. Also an initial letter illustration on p.494.

3. May 1864 – 'The Two Faces', to 'Margaret Denzil's History', facing p.585. Engraved by Swain. Also an initial letter illustration on p.585.

4. June 1864 – 'My Baby', to 'Margaret Denzil's History', facing p.719. Engraved by Swain. Also an initial letter illustration on p.719.

5. July 1864 – 'To go – or stay?', to 'Margaret Denzil's History', facing p.76. Engraved by Swain. Also an initial letter illustration on p.76.

6. August 1864 – Initial letter illustration to 'Margaret Denzil's History', p.233. Since Barnes was illustrating this story it seems sensible to attribute this unsigned drawing to him.

7. September 1864 – 'A Surprise', to 'Margaret Denzil's History', facing p.257. Engraved by Swain. Also an initial letter illustration on p.257.

8. October 1864 – Initial letter illustration to 'Margaret Denzil's History', p.477. See the note to the illustration also given to Barnes on p.233 of this magazine for the same year.

9. March 1869 to July 1870 – Thirty-four illustrations to 'Put yourself in his place', text by Charles Reade; vol 19: pp.257, facing 257, 385, facing 385, 513, facing 513, 641, facing 641; vol 20: pp.1, facing 1, 129, facing 129, 257, facing 257, 385, facing 385, 513, facing 513, 641, facing 641; vol 21: pp.1, facing 1, 129, facing 129, 257, facing 257, 385, facing 385, 513, facing 513, 641, facing 641; vol 22: pp.1, facing 1. Engraved by W. Thomas.

THE COTTAGER IN TOWN OR COUNTRY

1. 1 March 1864 – 'The Prince of Wales Inspecting the Cottages on His Estate', design for the cover of the magazine. Engraved by Butterworth and Heath.

2. 2 January 1865 – 'How John Barton Came Home', frontispiece repeated as cover (printed on blue paper). Engraved by Butterworth and Heath.

THE DAY OF REST

1. 25 December 1872, Christmas number –
 'Seeking the blessed land', to poem by Dora
 Greenwell, p.9.

FRIENDLY VISITOR

1. 1 February 1867 – 'What! deny me a
 flower!', p.21.
2. 1 March 1867 – 'The Swiss Mother', p.33.
3. 1 July 1867 – 'A Crown; or Does it pay?',
 p.97.
4. 1 August 1867 – 'Pull out the staple!',
 p.117.
5. 1 January 1869 – 'The Debt is Paid', p.1.
 Engraved by John Knight.
6. 1 January 1869 – 'Please Sir, will you read
 it?', p.9. Engraved by John Knight.
7. 1 March 1869 – 'The sign-board with three
 words crossed out', p.32.
8. 1 April 1869 – 'The Windmill's Defect',
 p.49.
9. 1 May 1869 – 'The late Dr Oxley', p.73.
10. 1 July 1869 – 'Blind Mary of the Mountain',
 p.97.
11. 1 October 1869 – 'The Old Sailor and the
 Bible Reader', p.153.
12. 1 November 1869 – 'Father Hyacinthe',
 p.161.

GOLDEN HOURS

1. January 1868 – 'My Daisy', facing p.33.
 Engraved by Butterworth and Heath.
2. March 1868 – 'Our Pet Lambs', to poem by
 Netta Leigh, facing p.176. Engraved by
 Butterworth and Heath.
3. April to June 1868 – Three illustrations to
 'The Farm of the Lowenberg', text by Kate
 Vowell, facing pp.217, 289, 370. Engraved
 by Butterworth and Heath.

GOOD WORDS

1. 1864 – 'Grandmother's Snuff', facing p.411.
 Engraved by Swain.
2. 1864 – 'A Burn Case, Ma'am', to 'Keeping
 up the fire!', facing p.568. Engraved by
 Swain.

3. 1864 – 'A Lancashire Doxology', to poem
 by Mrs Craik, facing p.585. Engraved by
 Swain.
4. 1864 – 'Blessed to Give', facing p.641.
 Engraved by Swain.
5. 1864 – ' "It's all up" shouted Barker in
 Mark's ear', to 'Oswald Cray', text by Mrs
 Henry Wood, facing p.691. Engraved by
 Swain.
6. 1864 – 'The Organ-Fiend', to 'An
 Unneighbourly Act', facing p.697.
7. 1864 – 'He looked involuntarily at Sara …',
 to 'Oswald Cray', text by Mrs Henry
 Wood, facing p.761. Engraved by Swain.
8. 1864 – ' "I have sinned." she repeated
 several times by her son's bedside', to
 'Worth a Leg', facing p.809. Engraved by
 Swain.
9. 1864 – 'One single word of sympathy and
 Caroline burst into tears', to 'Oswald Cray',
 text by Mrs Henry Wood, facing p.827.
 Engraved by Swain.
10. 1865 – 'Alfred Hagart's Household', nine
 illustrations, facing pp.61, 151, 208, 308,
 365, 440, 516, 741, 809. All engraved by
 Swain.

THE INFANT'S MAGAZINE

1. June to October 1866 – Five illustrations to
 'My Mother', text by Ann Taylor, pp.89,
 105, 121, 129, 145. Engraved by John
 Knight.
2. 1 January 1868, no. 25 – Untitled cover
 illustration (printed in colour). Reprinted in
 black and white in 1 July 1868 in no. 31 of
 the same magazine p.101 and entitled 'Two
 little feet upon which baby stands'.
3. 1 December 1868, no. 36 – 'Preparing for
 Sunday', p.177 (cover).
4. 1 April 1869, no. 40 – 'Phoebe and the
 plums', p.49.
5. 1 May 1869, no. 41 – 'The Three T's',
 p.73.
6. 1 June 1869, no. 42 – 'Be Present at Our
 Table, Lord', p.89.
7. 1 July 1869, no. 43 – 'The Doll's Party',
 p.101.

8. 1 September 1869, no. 45 – 'The Spoiled Pinafore', p.129.

9. 1 October 1869, no. 46 – 'Having a nice ride (by Papa's leave)', p.145.

10. 1 October 1869, no. 46 – 'Please dress me', p.153.

11. 1 November 1869, no. 47 – 'Dolly's Carriage', p.161.

THE LEISURE HOUR

1. 24 December 1864 – 'Granny's Portrait', p.825. Engraved by Swain. This does not appear to illustrate any text.

LONDON SOCIETY

1. December 1862 – 'Dreaming Love and waking Duty', facing p.563. Engraved by R.S. Marriott.

2. March 1864 – 'Little Golden-Hair's Story', facing p.268. Engraved by R.S. Marriott.

3. Christmas number 1864 – 'Rose Married? Married! When? To whom?', to 'Cousin Tom', facing p.72. Engraved by W. Thomas.

4. Christmas number 1865 – 'The strange things which happened at our Christmas Party', facing p.24. Engraver's name indecipherable.

ONCE A WEEK

1. 27 February 1864 – 'The Moon's Wanderings', p.267. Engraved by Swain.

2. 12 March 1864 – 'The Officer', p. 322. Engraved by Swain.

3. 9 April 1864 – 'A legend of Northampton', p.434. Engraved by Swain.

4. 30 April 1864 – 'The Madonna Della Seggiola', p.518. Engraved by Swain.

5. 2 July 1864 – 'Our Bet', p.29. Engraved by Swain.

6. 14 April 1866 – 'Lost for Gold', to poem by C.F. Alexander, p.407. Engraved by Swain.

THE QUIVER

1. December 1867 – 'It wouldn't be in my interest, ma'am …', to 'One Trip More', p.177. Engraved by W. Thomas.

2. March 1869 – 'What, Bob, off again?', to 'The Smuggler's Fate', text by William

Kingston, p.377. Engraved by W. Thomas.

3. May 1869 – 'That's a neat article now …', to 'The Tallyman', p.521. Engraved by W. Thomas.

THE SERVANTS' MAGAZINE

1. January to March 1867 – Three illustrations to 'Lucy Bell's First Place', text by Nelsie Brook, pp.9, 33, 53.

2. 1 June 1867 – 'Value of Civility', p.121.

3. 1 April 1868 – 'The Nurse-Maid', p.77.

4. 1 October 1869 – 'The factory girl who really was thirteen', p.217.

5. 1 November 1869 – 'Mr Budgett …', p.241.

THE SUNDAY AT HOME

1. June 1864 – 'The Prince of Wales inspecting the cottages on his estate', printed on the rear cover of this issue as an advertisement for the monthly periodical *The Cottager in Town or Country*. q.v. Engraved by Butterworth and Heath.

THE SUNDAY MAGAZINE

1. October 1864 – 'Light in Darkness', to 'What a blind man can do', p.25. Engraved by Swain.

2. November 1864 – 'Our Children', p.97.

3. October 1864 to March 1865 – Twenty-one illustrations to 'Kate the Grandmother', pp.33, 40, 44, 48, 113, 120, 121, 125, 128, 161, 168, 169, 176, 241, 248, 249, 252, 353, 360, 425, 432. Engraved by Swain.

4. 1 August 1865 – 'Saturday Evening', p.861. Engraved by Swain.

5. 2 October 1865 – 'The Pitman to his Wife', to poem by Dora Greenwell, facing p.17. Engraved by Swain.

6. 1 November 1865 to 1 June 1866 – Seven illustrations to 'Annals of a Quiet Neighbourhood', facing p.73, 217, 281, 357, 430, 497, 569. Engraved by Swain.

7. 1 October 1868 – 'A Missionary in the East', p.57.

BENNETT, Charles Henry

THE BRITISH JUVENILE
1. December 1st 1868 – 'Young Timothy Hoggins' and 'Mr Timothy Hoggins' Christmas Dream', two designs on the same page, p.233. Engraver not ascertained.

EVERY BOY'S MAGAZINE
1. January 1864 to December 1864 – Twelve illustrations to 'Young Munchausen', facing pp. 17, 79, 145, 240, 289, 353, 421, 480, 547, 609, 673, 734. Engraved by Dalziel.

GOOD WORDS
1. September 1861 – 'Shades', p.522. Engraved by Dalziel.

LONDON SOCIETY
1. April 1862 – Four illustrations to 'The Swell. The Best of all Good Company', to poem by Thomas Hood, pp.211, 212, 213, 214.
2. June 1862 – Two illustrations to 'Mediums', pp.454, 455.
3. July 1862 – Three illustrations to 'Beadledom', pp.72, 74, 75.
4. September 1862 – ' "Paterfamilias" reading The Times.', facing p.233. Engraved by Dalziel.
5. October 1863 – Four illustrations to 'Shop', Between pp.374 and 383.
6. December 1863 – 'A quiet rubber', to 'A Whist Party', facing p.547. Engraved by Dalziel.
7. June 1865 – Eight illustrations to 'Fellows', pp.547, 548, 549, 550, 551, 554, 555, 556.
8. June 1867 – 'What's in the papers?', facing p.512. Engraved by Dalziel marked 'Drawn by the late C.H. Bennett'.

ONCE A WEEK
1. 22 October 1859 – 'The Song of the Survivor', p.350.
2. 19 July 1862 – 'Nest-building Apes', p.112. Engraver not positively identified. Signed JS, possibly Swain or ?

THE QUEEN
1. 21 December 1861, no.16 Christmas supplement – 'Christmas Dreams', four designs on pp.316 and 317. Engraver not ascertained.

BROWN, Ford Madox

THE DARK BLUE
1. October 1871, vol ii – 'Down Stream', to poem by D.G.Rossetti, facing p.211. Engraved by C.M. Jenkin. Also a tailpiece at the end of the poem on p.212.

THE GERM
1. March 1850 no. 3 – 'Cordelia', etching. For this third number the name of the magazine was changed to *Art and Poetry*.

ONCE A WEEK
1. 27 February 1869, new series, vol iii – 'The Traveller', to 'The Romance of Railway Stations', facing p.145. Engraved by Swain.

BURNE-JONES, Edward

GOOD WORDS
1. April 1862 – 'King Sigurd, the Crusader', p.248. Engraved by Dalziel.
2. May 1863 – 'The Summer Snow', facing p.380. Engraved by Dalziel.

DU MAURIER, George

THE CORNHILL MAGAZINE
1. April 1863 – 'The Cilician Pirates', facing p.530. Engraved by Swain.
2. June 1863 – 'A sorry jest', to 'Sybil's disappointment', facing p.720. Engraved by Swain.
3. July 1863 – 'The Night Before the morrow', to poem by William Smith, facing p.99. Engraved by Swain.
4. September 1863 – Ten illustrations to 'How we slept at the Châlet des Chèvres', pp.317–33. Engraved by Swain.

29. February 1868 – Two illustrations to 'My Neighbour Nelly', pp.210 and facing 210. Engraved by Swain.

30. April 1868 – Two illustrations to 'Lady Denzil', pp.429 and vignette facing 429. Engraved by Swain.

31. June 1869 – Two illustrations to 'The Courtyard of the Ours d'Or', facing p.726 and an initial letter vignette on p.726. Engraved by Swain.

32. August 1869 – Two illustrations to 'Sola', vignette on p.215 and facing p.215. Engraved by Swain.

33. September 1869 – Two illustrations to 'Mrs Merridew's Fortune', vignette on p.327 and facing p.327. Engraved by Swain.

34. October 1869 to September 1870 – Twenty-four illustrations to 'Against Time', vol. xx: pp. 471, facing 471, 621, facing 621, 734, facing 734; vol. xxi: pp.105, facing 105, 233, facing 233, 362, facing 362, 483, facing 483, 611, facing 611, 731, facing 731; vol. xxii: pp.99, facing 99, 129, facing 129, 319, facing 319.

ENTERTAINING THINGS

1. December 1861 – To 'The Nocturnal Sketch', text by George J. Knox, p.353.

2. January 1862 (Christmas number) – To 'The Maniac Passenger', text by Tom Southee, p.17.

EVERY BOY'S MAGAZINE

1. February 1863 – To 'Aboul Cassim's Shoes', text by C.S. Chettnam, p.94. Engraved by Dalziel.

2. October 1863 – 'The Pacha's Pet Bear', p.577. Engraved by Dalziel.

GOOD WORDS

1. October 1861 – 'A Time to Dance', p.579. Engraved by Dalziel.

2. 1872 – 'Under the Elm', p.605. Engraved by Swain.

THE GRAPHIC

1. 13 May 1871 – 'Battledoor and Shuttlecock', p.437.

2. 22 July 1871 – 'The Eton and Harrow Cricket Match at Lords – The Lookers on', p.77.

3. 5 August 1871 – 'The Rival Grandpas and Grandmas', p.137.

4. 25 December 1871 (Christmas number) – 'Before Dinner – The March Past', p.10. Engraved by Horace Harral.

5. 14 September 1872 – 'A Musical Rehearsal', p.241.

THE LEISURE HOUR

1. 2 July 1864 to 31 December 1864 – Twenty-seven illustrations to 'Hurlock Chase', text by G.E. Sargent, pp.417, 433, 449, 465, 481, 497, 513, 529, 545, 561, 577, 593, 609, 625, 641, 657, 673, 689, 705, 721, 737, 753, 769, 785, 801, 817, 833. Engraved by Thomas Robinson.

2. 7 January 1865 to 1 April 1865 – Thirteen illustrations to 'The Awdries and their friends', pp.1, 17, 33, 49, 65, 81, 97, 113, 129, 145, 161, 177, 193. Engraved by Thomas Robinson.

3. 16 December 1865 to 23 December 1865 – Two illustrations to 'The Graemes of Glenmavis', pp.785, 801. Engraved by Thomas Robinson.

LONDON SOCIETY

1. August 1862 – 'Jewels – A sketch at the International Exhibition', facing p.105. Engraved by Swain. Du Maurier contributes two further illustrations to 'The Great Ex.' on pp.107, 110. The first is engraved by Swain and the second by Horace Harral.

2. September 1862 – 'A "Kettle-Drum" in Mayfair', facing p.203. Engraved by Swain.

3. November 1862 – 'Oh, sing again that simple song', facing p.433. Engraved by Horace Harral.

4. December 1862 – Three illustrations to 'Up Snowdon and down on Bangor Bard', pp.481, 483, 489. Engraved by W. Barker and Swain.

5. 1862, Christmas number – 'A Christmas Fire-side Tale', p.14.

8. 30 March 1861 – 'A Night ride to the Guillotine', p.387.

9. 25 May 1861 – 'On her Death-bed', to poem by A.J. Munby, p.603.

10. 21 September 1861 – Two illustrations to 'Recollections of an English Gold Mine', pp.356, 361.

11. 12 October 1861 – 'Monsieur the Governor', p.445.

12. 19 October 1861 – 'Of a man who fell among thieves', p.463. Engraved by Swain.

13. 9 November 1861 – 'Sea-Bathing in France', p.547. Engraved by Swain.

14. 21 December 1861 – 'The Poisoned Mind', p.722.

15. 28 December 1861 – 'The Hotel Garden', p.24.

16. 28 December 1861 to 11 January 1862 – Three illustrations to 'The Admiral's Daughter', pp.1, 29, 57. Engraved by Swain.

17. 11 January 1862 – 'The Change of Heads', p.71.

18. 18 January 1862 – 'The latest thing in ghosts', p.99.

19. 8 March 1862 – Two parallel images on one page, 'Metempsychosis', p.294. Engraved by Swain.

20. 29 March 1862 – 'Per l'Amore d'Una Donna', p.390.

21. 12 April 1862 – 'A Parent by Proxy', p.435. Engraved by Swain.

22. 31 May 1862 – 'Three Score and Ten', p.644.

23. 2 August 1862 – 'Miss Simms', p.166.

24. 23 August to 20 September 1862 – Five illustrations to 'Santa; or, a Woman's Tragedy', pp.225, 253, 281, 309, 337. Engraved by Swain.

25. 25 October 1862 – 'Only', p.490.

26. 15 November 1862 – 'The Cannstatt Conspirators', p.561. Engraved by Swain.

27. 29 November 1862 to 17 January 1863 – Seven illustrations to 'The Notting Hill Mystery', pp. 1, 57, 85, 617, 645, 673, 701. Engraved by Swain.

28. 7 March to 3 October 1863 – Sixteen illustrations to 'Eleanor's Victory', text by Miss Braddon, pp.295, 351, 407, 463, 519, 575, 631, 687; continued in vol.ix: pp.15, 71, 127, 183, 239, 295, 351, 407. Engraved by Swain.

29. 20 June 1863 – 'Out of the Body', p.701.

30. 20 February 1864 – 'The Veiled Portrait', p.225. Engraved by Swain.

31. 12 March 1864 – 'The Uninvited', p.309. Engraved by Swain.

32. 2 April 1864 – 'My Aunt Tricksy', p.393. Engraved by Swain.

33. 16 April 1864 – 'The Old Corporal', p.462.

34. 30 April and 7 May 1864 – Two illustrations to 'Detur Digniori', pp.505, 533.

35. 9 and 16 July 1864 – Two illustrations to 'Philip Fraser's Fate', pp.57, 85. Engraved by Swain.

36. 6 January 1866 – 'Little Bo-Peep', frontispiece to vol. i, new series. Engraved by Swain.

37. 1 September 1866 – 'Lady Julia', p.239. Engraved by Swain.

38. 27 October 1866 – 'The Nymph's Lament', to poem by Andrew Marvell, an extra illustration on toned paper, facing p.476. Engraved by Swain.

39. 4 January to 20 June 1868 – Ten illustrations to 'Foul Play', text by Charles Reade and Dion Boucicault, pp.12, 57, 140, 179, 247, 269, 313, 421, 465, 530. Engraved by Swain.

PUNCH

1. 28 February 1863 – 'The White Witness Back-Hairs the Lady Bettina', to 'Mokeanna!', text by F.C. Burnand, p.81. See also Index of illustrated books.

THE SUNDAY AT HOME

1. 15 August 1863 – 'Sunday at Home and Sunday from Home', p.513. Engraved by Whymper. This design is attributed to du Maurier, an attribution shared by Gleeson White (p.84).

2. 2 to 30 January 1864 – Five illustrations to 'The Artist's Son', pp.1, 17, 33, 49, 65. Engraved by Thomas Robinson.

3. 12 and 19 November 1864 – Two illustrations to 'John Henderson's Siller and Gowd', pp.721, 737.

4. 17 December 1864 – 'In the right pocket', to 'The Strange Hammer', p.801. Engraved by Thomas Robinson.

THE SUNDAY MAGAZINE

1. December 1864 – 'I see plainly that you, like your brothers, think only of self', to 'Every one for himself', p.200. Engraved by Swain.

FILDES, Samuel Luke

CASSELL'S MAGAZINE

1. *c*.July 1868 – 'Woodland Voices', p.137. Engraved by W. Thomas.

2. December 1869 – 'O! Wind, Wind, loud moaning o'er the land', to 'Sonnet' – poem by Hope Douglas which is on p.16, facing p.8.

3. 1870 – 'Oh love! oh love! This music', to 'The Song', facing p.191. Engraved by William Hollidge.

THE COTTAGER AND ARTISAN

1. September 1867 – 'The Harvest of the Sea', cover design. Engraved by W. Thomas.

2. 1 March 1869 – 'Cabby', cover design. Engraved by W. Thomas.

3. 1 July 1869 – 'Thinking of Home', cover design. Engraved by W. Thomas.

GOOD WORDS

1. 1 August 1867 – 'In the Choir', to poem by Isabella Fyvie, facing p.537. Engraved by Swain.

2. 1868 – 'The Captain's Story' to 'Strange but not untrue', p.169. Engraved by Swain.

THE GRAPHIC

1. 4 December 1869 – 'Houseless and Hungry', p.9.

2. 11 March 1871 – 'Under Fire', p.220.

3. 22 April 1871 – 'One Touch of Nature makes the whole world kin', p.372.

4. 22 July 1871 – 'A Sketch at Her Majesty's Garden Party, Buckingham Palace', p.84.

5. 25 December 1871, Christmas number – Three illustrations to 'Miss or Mrs', text by Wilkie Collins, pp.3, 19, 23.

6. 18 January 1873, supplement to *The Graphic* – 'The Emperor Napoleon III after Death'. Photographed by W. and D. Downey.

7. 8 November 1873 – 'The Bashful Model', double page spread on pp.440, 441.

THE MARK – The Christmas Number of *The Quiver*

1. 1868 – 'Why, yes it is, it really is — our poor Margaret', to 'Poor Margaret', text by Clara Balfour, facing p.41. Engraved by W. Thomas.

ONCE A WEEK

1. 22 June 1867 – 'The Goldsmith's Apprentice', p.723. Engraved by Swain.

2. 3 August 1867 – 'The Child-Queen', to poem by Walter Thornbury, p.135. Engraved by Swain.

3. 7 September 1867 – 'From Victor Hugo', p.285. Engraved by Swain.

4. 21 September 1867 – 'Cassandra', to poem by J. Mew, p.345. Engraved by Swain.

5. 2 May 1868 – 'The Orchard', p.396. Engraved by Swain.

6. 10 October 1868 – 'Salmon Fishing in North Wales', p.292. Engraved by Swain.

7. 14 November 1868 – 'Daphne', p.398. Engraved by Swain.

8. 30 January 1869 – 'The Duet', facing p.57. Engraved by Swain.

9. 13 March 1869 – 'The Juggler', facing p.189. Engraved by Swain.

10. 12 June 1869 – 'Hours of Idleness', facing p.474. Engraved by Swain.

11. 3 July 1869 – 'Led to Execution', facing p.541. Engraved by Swain.

12. 10 July 1869 – 'Basking', facing p.563. Engraved by Swain.

THE QUIVER (See also *The Mark*)
1. February 1868 – 'Where fearful fevers rage…', to 'Charity', p.377. Engraved by W. Thomas.
2. March 1868 – Two illustrations to 'Three Chapters in a Painter's Life', pp.417, 433. Engraved by W. Thomas.
3. February 1869 – 'It was from Sir Samuel Delamere', p.281. Engraved by W. Thomas.
4. March 1869 – 'Caesar and his Roman Legions drank them in the vanished ages', to 'By the Ravensbarne near Catford Bridge', text by Matthias Barr, facing p.397.

THE SUNDAY MAGAZINE
1. 1 July 1868 – 'The Farmer's Daughter', p.656. Engraved by Swain.

THE WORLD
1. 12 December 1878, Christmas number – 'Found dead on the Embankment', text by F.D. Finlay, double-page spread between pp.16 and 17. Engraved by Froment.

HOUGHTON, Arthur Boyd

THE ARGOSY
1. May 1866 – 'The Vision of Sheik Hamil', to poem by Isa Craig, pp.500–3. Usually placed as the frontispiece to vol. I of the magazine which is entitled 'Midsummer Volume 1868'. Engraved by Swain.
2. December 1866 – 'The Knight-Errant of Arden', to poem by James Leslie, either frontispiece or facing p.30. Engraved by Dalziel.

ENTERTAINING THINGS
1. January 1862 (Christmas number) – To 'The Maid of the Woolpack', text by Andrew Halliday, p.1.

EVERY BOY'S MAGAZINE
1. January 1866 to December 1866 – Eight illustrations to 'Barford Bridge', text by Revd H.C. Adams, facing pp.1, 66, 130, 258, 321, 385, 449, 577. Engraved by Dalziel.

GOLDEN HOURS
1. December 1868 – 'The Oriental Bride', to 'An Eastern Wedding', text by Netta Leigh, facing p.859. Engraved by Butterworth and Heath.

GOOD CHEER – The Christmas Number of *Good Words*
1. 25 December 1867 – 'The Banishment of the Scotch Fairies', p.16. Engraved by Dalziel.
2. 25 December 1867 – 'Memory's offering', facing p.58. Engraved by Dalziel.
3. 25 December 1868 – 'Young Tom's Grey Hair', p.43. Engraved by Dalziel.

GOOD WORDS
1. 1862 – 'My Treasure', p.504. Engraved by Dalziel.
2. 1862 – 'On the Cliffs', p.624. Engraved by Dalziel.
3. 1862 – 'True or False?', to poem by Adelaide Procter, p.721. Engraved by Dalziel.
4. 1862 – 'About Toys', p.753. Engraved by Dalziel.
5. 1863 – 'St. Elmo', facing p.64. Engraved by Dalziel.
6. 1863 – 'A Missionary Cheer', facing p.548. Engraved by Dalziel.
7. 1863 – 'Childhood', facing p.636. Engraved by Dalziel.
8. 1866 – 'The Voyage', facing p.521. Engraver not ascertained.
9. 1 September 1866 – Four illustrations entitled 'Reaping' 'Binding' 'Carrying' 'Gleaning', to poem 'Harvest' which appears on p.600, placed between pp.592 and 593. Engraved by Linton.
10. 1867 – 'Omar and the Persian', facing p.105. Engraved by Dalziel.
11. 1867 – 'Making Poetry', facing p.248. Engraved by Dalziel.
12. 1 January 1868 – 'The Victim', to poem by Tennyson which appears on p.17, usually bound after the title page of the volume. Engraved by Dalziel.

13. 1868 – Eight illustrations to 'A Russian Fabulist – The Krilof Fables', in the first English translation by William Ralston, p.41(2), p.217(3), p.416(3). The other illustrations to this text were by J.B. Zwecker. Engraved by Dalziel. See also Index of Illustrated Books.

14. 1868 – Three illustrations to 'The Church in the Cevennes', pp.56, 57. Engraved by Dalziel.

15. 1868 – 'Discipleship', to poem by George Macdonald, p.112.

16. 1868 – 'The Pope and the Cardinals', p.305. Engraver not ascertained.

17. 1868 – 'The Gold Bridge', p.321. Engraved by Dalziel.

18. 1868 – 'The traveller replied, "It is well; take my coat also, O my friend" ', to 'The Two Coats', p.432. Engraved by Dalziel.

19. 1868 – Six illustrations 'How it all happened', p.480, 481 and facing p.484. Engraved by Dalziel. The full-page illustration is sometimes bound earlier in the volume.

20. 1868 – 'Dance my children', to poem by Norman Macleod, the editor of *Good Words,* facing p.568. Engraved by Dalziel.

21. 1868 – 'A Russian Farm-yard', p.760. Engraved by Dalziel.

22. 1869 – 'Noblesse Oblige', facing p.71. The index does not mention Houghton, giving the entire series to F.A. Fraser, but this block is clearly signed 'Houghton'. Engraved by Dalziel.

23. 1871 – 'Baraduree Justice', p.464. Engraved by Dalziel.

24. 1872 – 'The Black Fast', p.377.

GOOD WORDS FOR THE YOUNG

1. 1 April to 1 May 1868 – Two illustrations to 'The Merry Cobbler of Bagdad', text by M. Percival Fripp, pp.337, 368. Engraved by Dalziel.

2. 1 November 1868 – To 'Cockie Lockie's Journey', p.49. Engraved by Dalziel. The three other illustrations to this story are by Thomas Dalziel.

3. 1 December 1868 – 'The Musicians' and 'The Talking Idol', to 'Lessons from Russia', text by William Ralston, pp.100, 101. Engraved by Dalziel.

4. 1 January 1869 – Two illustrations to 'The Boys of Axelford', text by Charles Camden, pp.145, 148. Engraved by Dalziel.

5. 1 November 1869 – 'The Two Nests', p.13. Engraved by Dalziel.

6. 1 November 1868 – To 'Keeping the "Cornucopia" ', p.33. Engraved by Dalziel.

7. 1 November 1870 – 'Don Jose's Mule Jacintha', to poem by M. Betham-Edwards, p.28. Engraved by Dalziel.

THE GRAPHIC

1. 11 December 1869 – ' "Night Charges" on their way to the Court', p.33. Engraved by W. Thomas.

2. 5 March 1870 to 1 July 1870 vol. I
9 July 1870 to 23 July 1870 vol. II
14 January 1871 to 17 June 1871 vol. III
29 July 1871 to 25 December 1871 vol. IV
17 February to 9 March 1872 vol. V
30 November 1872 vol. VI
22 February 1873 vol. VII
Sixty-six illustrations to 'Graphic America', vol. I: pp.321(2), 324, 345(3), 348, 365(2), 368, 369(2), 393(3), 396, 417, 420, 436, 437(2), 465, 488, 489, 512(3), 513, 533, 536(3), 556, 557; vol. II: pp.40(2), 41, 57(2), 60, 88(2), 89(2); vol III: pp.28, 32(2), 204, 221, 569(2); vol IV: pp.116(2), 117, 136, 227, 260, 300, 445, 448, 616, 645; vol. V: pp.145, 220; vol VI: pp.512–13(1); vol VII: p.185. Engraved by Hooper, Wentworth, F.J.K., Swain, W.L. Thomas, Horace Harral, W. Measom et al.

3. 17 September 1870 – 'The Raid on "The Useless Mouths" in Paris', p.273. Engraved by Swain.

4. 24 December 1870 – 'Morning in the Avenue de Paris, Versailles', pp.612, 613, a double-page spread.

5. 25 December 1870 – 'Early Morning in Covent Garden Market – Shelling Peas', p.713.

6. 31 December 1870 – 'Buried Quick and Unburied Dead', p.645.

7. 8 April 1871 – 'The Paris Mob – A Barricade in Paris', p.313. Engraved by Horace Harral.

8. 3 June 1871 – 'Paris under the Commune – Women's Club at the Boule Noire …', p.520. Engraved by Horace Harral.

9. 10 January 1871 – 'The Commune or Death – Women of Montmartre', p.541.

10. 22 July 1871 – 'Serenading the Imperial Prince of Germany before the German Embassy', p.73.

11. 23 September 1871 – 'The Courts Martial at Versailles', p.293.

12. 2 December 1871 – 'Witchcraft in 1871', p.540.

13. 10 February 1872 – 'A Hair-Dressing Exhibition', p.133.

14. 17 February 1872 – 'The Grand Duke Alexis of Russia under Niagara Falls', p.141.

15. 9 March 1872 – 'A leaf from an artist's note book on Thanksgiving Day', p.213. This illustration is not related to *Graphic America*.

16. 11 May 1872 – 'Sketches in London – Before the Bar', p.439.

17. 29 June 1872 – 'Our London Children – A Plea for a Day in the Country', p.616.

18. 3 August 1872 – 'Stanley on his way to the Coast', p.104.

19. 5 October 1871 – 'Taking the Waters at Baden-Baden', p.317.

20. 26 October 1872 – 'Orphans – A Sketch in the City', p.377.

21. 30 November 1872 – 'Between Decks on an Emmigrant Ship – Feeding Time', pp.512 and 513, a double-page spread.

22. 28 December 1872 – 'Our Artist's Christmas Entertainment', p.605.

23. 4 January 1873 – 'Dancing in the New Year – A Welcome to 1873', pp.8 and 9, a double-page spread.

LONDON SOCIETY

1. July 1862 – 'Finding a Relic', Facing p.89. Engraved by Dalziel.

2. August 1866 – 'Ready for Supper – A sketch at the Lady Mayoresse's Juvenile Ball', to 'Mansion House Hospitalities', pp.136–40, a larger engraving than usual which is folded in order to accommodate it in the confines of the magazine facing p.97. Engraved by Dalziel.

3. Christmas number 1866 – 'The Christmas Tree', facing p.81. Engraved by Dalziel.

4. October 1867 – Two illustrations, to 'A Spinster's Sweepstake and what came of it', facing p.377 and on p.383. Engraved by Dalziel.

5. November 1868 – 'The Turn of the Tide', facing p.458. Engraved by Dalziel.

ONCE A WEEK

1. 15 April 1865 – 'The Old King dying', p.463.

2. 12 August 1865 – 'The Portrait', p.210.

3. 18 November 1865 – 'King Solomon and the Hoopoes', p.603. Engraved by Swain.

4. 16 December 1865 – 'The Legend of the Lockharts', p.715.

5. 30 December 1865 – 'Leila and Hassan', p.769. Engraved by Swain.

6. 17 February 1866 – 'The Queen of the Rubies', text by Newel Herbert, p.177. Engraved by Swain.

7. 21 April 1866 – 'A Turkish Tragedy', text by T.C. Moore, p.448.

8. 25 August 1866 – 'A Dead man's Message', to poem by Edwin Arnold, p.211.

9. 22 to 29 December 1866 and 5 January 1867 – Three illustrations to 'The Mistaken Ghost', text by Cornelia Crosse, pp.15, 687, 723. Engraved by Swain.

10. 9 March 1867 – 'A Hindoo Legend', p.273. Engraved by Swain.

11. 8 June 1867 – 'The Bride of Rozelle', p.663. Engraved by Swain.

THE QUIVER

1. May 1866 – 'One half he wrapped about the wretch, the other he donned again', to 'St Martin. A Legend', text by Digby Starkey, facing p.532. Engraved by W.L. Thomas.

2. June 1866 – 'Yon waves shall wash us down', to 'The Captain', p.585. Engraved by W. Thomas.

3. July and August 1866 – Two illustrations to 'Other People's Windows', pp.664, 737. Engraved by C. P. and G., presumably Cassell, Petter and Galpin, the publishers of *The Quiver*.

4. July 1866 – 'Wee Rosie Mary', facing p.676.

5. August 1866 – '... the thieves forced lock and grate', to 'Sowing and Reaping', text by Walter Thornbury, p.729. Engraved by C. P. and G.

6. September 1866 – 'But you will gather the children round ...', to 'Golden Hours', p.777. Engraved by C. P. and G.

7. September 1866 – 'Wins back the day, and – dies', to 'To the Death', p.809. Engraved by C. P. and G.

8. November 1866 – 'Baby Loo to You', facing p.88. Engraved by C. P. and G.

9. April 1867 – 'From morn till weary night he toiled, dejected', to 'The Artist', p.456.

10. November 1867 – 'Jones and other men had ... annoyed him whenever he sat down to read the Bible', to 'Faithful and Brave', p.97.

11. July 1868 – Three illustrations to 'An Hour's Revenge and what came of it', pp.705, 721, 737. Engraved by W.Thomas

THE SUNDAY MAGAZINE

1. February 1865 – 'One hand on a vase of water bore ...', to 'Friar Ives at Acre', p.384. Engraved by Dalziel.

2. 1 October 1866 – 'A Proverb Illustrated', facing p.33. Engraved by Dalziel.

3. 1 October 1866 to 1 September 1867 – Twelve illustrations to 'The Huguenot Family in the English Village', text by Sarah Tytler, pp.5, 77, 177, 224, 292, 364, 433, 508, 580, 651, 723, 798. Engraved by Dalziel.

4. 1 November 1866 – 'Heroes', to poem by M.B. Smedley, facing p.129. Engraved by Dalziel.

5. 1 January 1867 – 'Oh they sung sweet and they sung sour ...', to 'Luther the Singer', facing p.256. Engraved by Dalziel.

6. 1 February 1867 – 'The Martyr', facing p.345. Engraved by Dalziel.

7. 1 March 1867 – 'The last of the Family', to poem by Isabella Fyvie, facing p.393. Engraved by Dalziel.

8. 1 September 1867 – 'A lesson to a King', to 'A Clear Conscience', facing p.817. Engraved by Dalziel.

9. 1 October 1867 – 'Augustine addressing his flock at Hippo', to 'Pictures from Church History', p.57. Engraved by Dalziel.

10. 1 October 1867 – 'The Tribes go up to give thanks to the name of the Lord', to 'The Three Great Feasts of Israel', text by Charles Hole, facing p.67. Engraved by Dalziel.

11. 1 November 1867 – 'Paul's Judges', text by W. Fleming Stevenson, p.88.

12. 1 November 1867 – 'Sunday Songs from Sweden', to poem by Gilbert Tait, p.112. Engraved by Dalziel.

13. 1 November 1867 – 'Conveying the poor fever-stricken patients to the little hospital', to 'The Charcoal Burners', facing p.118. Engraved by Dalziel.

14. 1 December 1867 – 'On the appointed day the Israelites brought their lamps ...', to 'The Feast of the Passover', p.185.

15. 1 January 1868 – 'The Poor Man's Shuttle', p.273.

16. 1 February 1868 – 'The Feast of Pentecost', p.296. Engraved by Dalziel.

17. 1 February 1868 – 'The Lord is witness against you this day ...', To 'Samuel the Ruler', text by Thomas Guthrie (editor of *The Sunday Magazine*), p.337. Engraved by Dalziel.

18. 1 April 1868 – 'Mr George sat up, called for one of his musical instruments and sang ...', to 'George Herbert's Last Sunday', text by Sarah Tytler, p.424. Engraved by Dalziel.

19. 1 May 1868 – 'Baden-Baden', p.520. Engraved by Dalziel.

20. 1 June 1868 – 'The Good Samaritan', p.552. Engraved by Dalziel.

21. 1 June 1868 – 'The Church of the Basilicas', p.561.

22. 1 July 1868 – 'Joseph's Coat', p.616. Engraved by Dalziel.

23. 1 August 1868 – 'St Paul Preaching …', to 'St Paul and the Sisterhood at Philippi', p.681. Engraved by Dalziel.

24. 1 September 1868 – 'The Parable of the Sower', p.777. Engraved by Dalziel.

25. 1 October 1868 – 'One of the women seized the uplifted arm of the executioner …', to 'The Wisdom of Solomon', p.16. Engraved by Dalziel.

26. 1 October 1868 – 'The Jews in the Ghetto of Rome', p.44. Engraved by Dalziel.

27. 1 November 1868 – 'The man of war makes obeisance to the man of God', to 'Rehoboam, the foolish man', text by Thomas Guthrie (the editor of *The Sunday Magazine*), p.85. Engraved by Dalziel.

28. 1 November 1868 – 'The King cuts the parchment roll into strips, and throws it into the fire', to 'Three Generations of Jewish Patriotism', p.125. Engraved by Dalziel.

29. 1 December 1868 – 'A Sunday in the Bush', p.161. Engraved by Dalziel.

30. 1 March 1869 – 'Miss Bertha', p.384. Engraved by Dalziel.

31. 1 May 1869 – 'More about Miss Bertha', p.513. Engraved by Dalziel.

32. 1 July 1869 – 'The Babylonian Captivity', p.633. Engraved by Dalziel.

33. 1 July 1869 – 'John Baptist', to poem by E.H. Bickersteth, p.641. Engraved by Dalziel.

34. 1 September 1869 – 'Samson', p.760. Engraved by Dalziel.

35. 1 October 1869 – 'My Mother's Knee', p.17. Engraved by Dalziel. Although given to Houghton in the index, it is hard to believe that this mediocre and unsigned drawing is by the artist.

36. 1 October 1869 – 'Design for a group of statues of St Paul's companions', to 'Barnabas', p.33.

37. 1 November 1869 – 'Sunday at Aix Les Bains', p.88. Engraved by Dalziel.

38. 1 November 1869 – 'Achsah's Wedding Gifts', p.104. Engraved by Dalziel.

39. 1 July 1870 – 'Sister Edith's Probation', p.600. Engraved by Dalziel.

40. 1 November 1870 – 'The Woman that was a Sinner', to poem by George Macdonald, p.104. Engraved by Dalziel.

41. 1 May 1871 – 'The Withered Flower', p.512. Engraved by Dalziel.

42. April 1872 – 'In Babylon', p.576. Engraved by Dalziel.

TINSLEY'S MAGAZINE

1. December 1867 – 'The Story of a Chignon', facing p.544.

2. March 1868 – 'For the King', facing p.149.

3. May 1868 – 'The Return from Court', facing p.377.

THE WELCOME GUEST

1. According to Hogarth, checklist p.44 no.27b I, 1831: (see Select Bibliography) Exhibition catalogue, London V&A 1975, p.330 has one illustration by Houghton. There I found instead 'The Country Curate's Story', a poem by Robert Buchanan.

HUGHES, Arthur

THE CORNHILL MAGAZINE

1. November 1863 – 'At the Brook', to 'Margaret Denzil's History', facing p.582. Engraved by Swain.

GOOD CHEER

1. 25 December 1868 – 'A will of her own', the monogram appears to be that of Hughes but it is indistinct and the drawing is not very characteristic, p.27. Engraved by Dalziel.

GOOD THINGS FOR THE YOUNG OF ALL AGES

1. January 1873 – To 'A Secret About A Poor Hunchback', text by Charles Camden, p.17. Engraved by Dalziel.

2. January 1873 – To 'The Wonderful Organ',

text by Marianne Beaufort, p.24. Engraved by Dalziel.

3. January 1873 to October 1873 – Ten illustrations to 'Sinbad in England', text by William Gilbert, facing p.25, pp.80, 129, 193, 256, 320, 432, 481, 592, 641. Engraved by Dalziel.

4. January 1873 – Two illustrations to 'Henry and Amy', pp.72, 73. Engraved by Dalziel.

5. January 1873 – 'My Daughter', to poem by Matthew Browne (William Brighty Rands), p.136. Engraved by Dalziel.

6. November 1873 – To 'Sweetheart', p.1. This illustration is reprinted from *Good Words for the Young*.

7. November 1873 – Three illustrations to 'Cottage Songs For Cottage Children', text by George Macdonald, pp.24, 25(2). Engraved by Dalziel.

GOOD THINGS – THE ENGLISH BOY'S AND GIRL'S MAGAZINE

1. January to ?May 1877 – Four illustrations to 'The Princess and Curdie', text by George Macdonald, pp.1, 193, 257, 321. Engraved by Dalziel. No artist is mentioned in the volume. According to Leonard Roberts, all are reprints except p.193 which is new.

GOOD WORDS

1. 1864 – 'At the Sepulchre', facing p.728. Engraved by Swain.

2. 1869 – Two illustrations to 'Carmina Nuptiale', pp.625, 688. Engraved by Dalziel.

3. 1 November 1870 – 'Fancy', to poem by Jean Ingelow, p.777

4. 1 December 1870 – 'The Mariner's Cave', to poem by Jean Ingelow, p.865. Engraved by Dalziel.

5. 1871 – 'Go little letter, Apace, apace', song using poem 'The loves of the Wren' by Tennyson with music by Sullivan, p.33.

6. 1871 – 'The Mist and the Rain', facing p.113. Another song using a poem by Tennyson and music by Sullivan from the same collection as the above mentioned illustration. Both designs were made for a

proposed book with Tennyson's text and Sullivan's music. The project was abandoned and the illustrations cut down for publication in this magazine.

7. 1871 – 'The Dial', facing p.183.

8. 1871 – 'The Mother and the Angel', p.648. Engraved by Dalziel.

9. 1872 – 'Will o' the Wisp', to poem by Robert Buchanan, p.49.

10. 1872 – 'The Carpenter', to poem by George Macdonald, p.97. Engraved by Dalziel.

11. 1872 – Two illustrations to 'Vanity Fair', to poem by Robert Buchanan, pp.128, 129. Engraver not ascertained.

12. 1872 – 'The Man with Three Friends', to poem by Dora Greenwell, p.241. Engraved by Dalziel.

13. 1873 – 'Looking Back', p. 640. This is a reprint of a design entitled 'Blessing in Disguise' which appeared in *The Sunday Magazine* on 1 December 1868, p.156. Here the engraving is reduced in size removing the name of the engraver (Dalziel) and Hughes's own monogram.

GOOD WORDS FOR THE YOUNG

1. 1 November 1868 to 1 October 1870 – Seventy-six illustrations to 'At the Back of the North Wind', text by George Macdonald, vol. I: pp.16(2), 17(2), 113(2), 116(2), 180(2), 181(2), 296(2), 297(2), 388(2), 389(2), 440(2), 441(2), 540(2), 541(2); vol II: pp.24(2), 25(2), 84(2), 85(2), 148(2), 152(2), 204(2), 205(2), 244, 245, 248, 249, 300(2), 301(2), 377(2), 380, 381, 424(2), 425(2), 472(2), 473(2), 528(2), 529(2), 588(2), 589(2), 664(2), 665(2). Engraved by Dalziel.

2. November 1868 to 1 March 1870 – Two illustrations to 'Lilliput Revels', pp.37, 286. Engraved by Dalziel.

3. 1 March 1869 to 1 July 1870 – Fourteen illustrations to 'The Boy in Grey', text by Henry Kingsley, vol. I: pp.240, 241, 284, 285, 337, 340, 408, 409, 520, 521; vol II: pp.440, 441, 488, 489. Engraved by Dalziel.

4. 1 November 1869 to 1 October 1870 – Thirty-six illustrations to 'Ranald Bannerman's Boyhood', text by George Macdonald, pp.1, 5, 8, 57, 61, 64, 113, 117, 120, 169, 172, 176, 225, 228, 232, 281, 284, 285, 337, 341, 344, 393, 396, 400, 449, 452, 456, 505, 508, 509, 561, facing p.562(2), 617, 620, 621. Engraved by Dalziel.

5. 1 November 1870 to 1 June 1871 – Thirty-one illustrations to 'The Princess and the Goblin', text by George Macdonald, pp.4(2), 5(2), 68(2), 69(2), 132(2), 133(2), 188(2), 189(2), 280(2), 281(2), 300(2), 301(2), 360(2), 361, 416(2), 417(2). Engraved by Dalziel.

6. 1 November 1870 – 'The Black Showman and the White Showman', p.17. Engraved by Dalziel.

7. 1 November 1870 – 'Government', to 'A Lilliput Lecture on Government', text by Matthew Browne, p.33. Engraved by Dalziel.

8. 1 December 1870 – 'Science', to 'A Lilliput Lecture on Science and Philosophy', text by Matthew Browne, p.72. Engraved by Dalziel.

9. 1 December 1870 – 'Barbara Petlamb', text by Matthew Browne, facing p.100. Engraved by Dalziel.

10. 1 January 1871 – 'Mercy', to 'A Lilliput Lecture on Justice, Mercy, Charity', text by Matthew Browne, p.145. Engraved by Dalziel.

11. 1 January 1871 – 'The Pedlar's Diamond', p.172. Engraved by Dalziel.

12. 1 February 1871 – 'Trade', to 'A Lilliput Lecture on Trade', text by Matthew Browne, p.201. Engraved by Dalziel.

13. 1 February 1871 – 'The Whisper', text by Matthew Browne, p.225. Engraved by Dalziel.

14. 1 March to 1 April 1871 – Two illustrations to 'King Arthur's Great Boar Hunt', pp.249, 329. Engraved by Dalziel.

15. 1 March 1871 – 'Lock and Key', text by Matthew Browne, p.264. Engraved by Dalziel.

16. 1 April 1871 – 'Little Keeper', text by Matthew Browne, p.321. Engraved by Dalziel.

17. 1 June 1871 – 'Handsome is that Handsome does', text by Matthew Browne, p.449. Engraved by Dalziel.

18. 1 August 1871 – 'Let be and you will see', text by Matthew Browne, p.537. Engraved by Dalziel.

19. 1 September 1871 – 'Helpfulness', text by Matthew Browne, p.585. Engraved by Dalziel.

20. 1 October 1871 – 'The Nephew of Charlemagne', text by Matthew Browne, p.641. Engraved by Dalziel.

21. 1 December 1871 – 'The Wind and the Moon', to poem by George Macdonald, p.80.

22. January to October 1872 – Twenty-four illustrations to 'Innocent's Island', text by Matthew Browne, pp.120, 121, 123, 124, 183, 184, 185, 186, 216, 217(2), 219, 256(2), 257(2), 376, 377, 416, 417, 504, 505, 552, 553. Engraved by Dalziel.

23. January to October 1872 – Eight illustrations to 'The History of Gutta-Percha Willie', text by George Macdonald, pp.153, 232, 288, 321, 361, 424, 464, 520. The first illustration, although given to Hughes in the index, is quite clearly signed by F.A. Fraser. Engraved by Dalziel.

LONDON SOCIETY

1. February 1865 – 'The Farewell Valentine', facing p.181. Engraved by W. Thomas.

2. July 1870 – 'Not Mine', facing p.51. Engraved by W. Thomas. In the British Library copy the poem appears in the December number, p.501, but the illustration is normally bound as stated above.

THE QUEEN

1. 21 December 1861, no. 16, Christmas supplement – 'Hark the Herald Angels Sing'

and 'Born on Christmas Eve and Died on Christmas Eve', two illustrations on p.297.

THE SHILLING MAGAZINE

1. December 1865, vol. VIII – Three illustrations to 'Enoch Arden' poem by Tennyson, pp. 434, 435, 436. An interesting example of a 'flyer' of Hughes' illustrations which appeared here in advance of the book publication. The catalogue at the rear of the book is dated December 1865, and the book itself is dated 1866. This suggests that the book appeared concurrently with this issue of the magazine and certainly in time for the Christmas trade of 1865.

THE SUNDAY MAGAZINE

1. 1 December 1868 – 'Blessing in Disguise', p.157. Engraved by Dalziel.
2. 1 October 1870 – 'My Heart', to poem by George Macdonald, facing p.10. Engraved by Dalziel.
3. 1 February 1871 – 'The First Sunrise', p.302.
4. 1 March 1871 – 'Tares and Wheat', text by Hugh Macmillan, p.353.
5. September 1871 – 'Sunday Musings', to poem by Gerald Massey, p.24. Engraved by Dalziel.
6. March 1872 – 'Daria', to poem by Dora Greenwell, based on Calderon's play *Los Dos Amantes del Cielo*, p.473. Engraved by Dalziel.
7. *c*.March 1872 – 'Night and Day', p.505.

THE WELCOME GUEST

1. 16 October 1858 – 'Girolamo at the Tentmaker's Door', to 'The Tentmaker's Story', text by Robert B. Brough, p.393. Engraved by Samuel Machin Slader.
2. 1858, Christmas number – To 'The Wedding-Rings of Shrimpington-Super-Mare', text by various authors including G.A. Sala, Adelaide Proctor and Augustus Mayhew, p.12. Engraved by Samuel Vincent Slader.

HUNT, William Holman

THE GERM

1. January 1850, no.1 – 'My Beautiful Lady', etching, with two designs on one plate.

GOOD WORDS

1. 1862 – 'Go and come. – The Sun is high in Heaven, the harvest but begun.', p.32. Engraved by Dalziel.
2. 1878 – 'Born at Jerusalem', text by Mrs Craik, p. 473. Subject was Hunt's daughter Gladys Mulock Holman Hunt, born 20 September 1876. Mulock was Mrs Craik's maiden name. See also her *Studies from Life* for which Hunt made a steel-engraved frontispiece design. The engraving is dated 9 October 1876.

ONCE A WEEK

1. 12 May 1860 – 'Witches and Witchcraft', p.438. Engraved by Dalziel.
2. 21 July 1860 – 'At Night', p.102. Engraved by Swain.
3. 1 December 1860 – 'Temujin', p.630. Engraved by Swain.

THE QUEEN

1. 21 December 1861 – Christmas supplement no. 16 – 'The Eve of St. Agnes', text beneath reads 'Drawn by W. Holman Hunt', p.293. The illustration is signed W.H.H. in the block.

KEENE, Charles

THE CORNHILL MAGAZINE

1. July 1864 – 'Mother's Guineas', to 'Brother Jacob', text by George Eliot, facing p.1. Engraved by Swain. Also an initial letter illustration on p.1.

GOOD WORDS

1. 1862 – 'Her Majesty, Nannerl the Washerwoman', p.536. Engraved by Dalziel.

LONDON SOCIETY

1. 1865, Christmas number – 'What came of killing a rich uncle one Christmas time', text

by Mark Lemon, facing p.3. Engraved by Horace Harral. A second illustration (unsigned on p.5) is also presumably by Keene.

2. 1866, Christmas number – Two illustrations to 'How I lost my whiskers', p.27, facing p.31. Engraved by Horace Harral.

3. 1867, Christmas number – Two illustrations to 'An Actor's Holiday', text by Mark Lemon, pp.18, 24. Engraved by Horace Harral.

4. March 1868 – Two illustrations to 'Tomkins' Degree supper and how it ended', p.224, facing p.232. Engraved by Horace Harral.

5. 1868, Holiday number – Two illustrations to 'Smoking Strictly Prohibited', p.49, facing p.56. Engraved by Horace Harral.

6. 1868, Christmas number – Two illustrations to 'Our Christmas Turkey', p.44, facing p.46. Engraved by Horace Harral.

7. 1869, Holiday number – To 'The Three Names', frontispiece and p.1. Engraved by Horace Harral.

8. 1869, Holiday number – 'Lady Nelly the Flirt', facing p.32. Engraved by Horace Harral.

9. 1869, Christmas number – Two illustrations to 'A Coat with a Fur Lining', text by Mark Lemon, p.1, facing p.6. Engraved by Horace Harral.

10. July 1870 – 'In the Solent', to 'Heiress Hunting', p.1. Engraved by Horace Harral.

11. 1870, Christmas number – Two illustrations to 'The Gipsy Model', pp. 39, 45. Engraved by Horace Harral.

ONCE A WEEK

1. July to October 1859 – Fifteen illustrations to 'A Good Fight', text by Charles Reade, pp.11, 31, 51, 71, 91, 111, 131, 151, 171, 191, 211, 231, 251, 254, 273.

2. 23 July 1859 – Two illustrations to 'Guests at the Red Lion', pp.61, 65. Engraved by Swain.

3. 20 August 1859 – 'A fatal gift', p.141.

4. 10 September 1859 – Two illustrations to

'Uncle Simkinson and Mrs Mountelphant', pp.201, 203.

5. 19 November to 3 December 1859 – Three illustrations to 'Benjamin Harris and his wife Patience', pp.427, 449, 471. Engraved by Swain.

6. 10 December 1859 – 'The Foundation of my Picture Gallery', p.483. Engraved by Swain.

7. 31 December 1859 – Two illustrations to 'Where is the Other?', pp.1, 5. Engraved by Swain.

8. 14 January 1860 – 'The Return of the Firefly', p.54. Engraved by Swain.

9. 4 February 1860 – 'A Night on the Ice', p.111. Engraved by Swain.

10. 11 February to 13 October 1860 – Forty illustrations to 'Evan Harrington or He would be a Gentleman', text by George Meredith, vol. ii: pp.133, 138, 155, 177, 182, 199, 221, 243, 265, 268, 287, 309, 331, 353, 375, 403, 431, 459, 487, 515, 543, 571, 599; vol. iii: pp.1, 29, 57, 85, 113, 141, 145, 169, 197, 225, 253, 281, 309, 337, 365, 393, 421.

11. 12 May 1860 – 'Mr Lorquison's Story', text by F.C. Burnand, p.458.

12. 6 October 1860 – 'A score of years ago', p.416. Engraved by Swain.

13. 24 November 1860 – 'The Emigrant Artist', p.608. Engraved by Swain.

14. 15 December 1860 to 5 January 1861 – Four illustrations to 'Sam Bentley's Christmas', pp. 19, 45, 687, 712. Engraved by Swain.

15. 2 February 1861 – Two illustrations to 'The Mazed Fiddler', pp.155, 158.

16. 16 March 1861 – Two illustrations to 'In Re Mr Bubb', pp.330, 332 Engraved by Swain.

17. 30 March 1861 – 'The Beggar's Soliloquy', to poem by George Meredith, p.378.

18. 20 April 1861 – 'Mundic and Barytes', p.466.

19. 4 May 1861 – 'A Model Strike', p.519.

20. 11 May 1861 – 'The Two Norse Kings – A

Yorkshire Legend', p.547. Engraved by Swain.

21. 22 June 1861 – 'The Revenue Officer's Story', p.713. Engraved by Swain.

22. 6 July 1861 – 'The Painter-Alchemist', p.43. Engraved by Swain.

23. 3 August 1861 – 'Adalieta', p.266. Engraved by Swain.

24. 24 August 1861 – 'Business with Bokes', p.251.

25. 7 September to 5 October 1861 – Five illustrations to 'Lilian's Perplexities', text by A.W. Dubourg, pp.281, 309, 337, 365, 393. Engraved by Swain.

26. 14 December 1861 – 'The Patriot Engineer', to poem by George Meredith, p.686. Engraved by Swain.

27. 18 January to 8 March 1862 – Eight illustrations to 'The Woman I loved and the Woman who loved me', pp.85, 113, 141, 169, 197, 225, 253, 281. Engraved by Swain.

28. 15 March 1862 – 'My Schoolfellow's Friend', p.334.

29. 5 April 1862 – 'A Legend of Carlisle: The Scottish Gate', p.407. Engraved by Swain.

30. 24 May 1862 – 'Nips Daimon', p.603. Engraved by Swain.

31. 7 June 1862 – 'A mysterious supper-party', p.659. Engraved by Swain.

32. 28 June 1862 to 7 February 1863 – Seventeen illustrations, to 'Verner's Pride', text by Mrs Henry Wood, pp.15, 71, 127, 183, 239, 295, 351, 407, 463, 519, 575, 631, 687; vol. 8: pp.15, 71, 127, 183. Engraved by Swain.

33. 11 April 1863 – 'The March of Arthur', to poem translated from the Breton by Tom Taylor, p.434. Engraved by Swain.

34. 9 May 1863 – 'The Bay of the Dead', p.546. Engraved by Swain.

35. 30 May 1863 – 'My Brother's Story', p. 617. Engraved by Swain.

36. 4 July 1863 – 'The Viking's Serf', to poem by Walter Thornbury, p.42. Engraved by Swain.

37. 10 and 17 October 1863 – Two illustrations to 'The Heirloom', pp.435, 463. Engraved by Swain.

38. July 1867 – 'The Old Shepherd on his pipe', to poem by F.C. Burnand which was published 24 August 1867, frontispiece to vol. 4, new series. Engraved by Swain.

LAWLESS, Matthew James

CHURCHMAN'S FAMILY MAGAZINE

1. September 1863 – 'One Dead', facing p.275. Dated 1862 in the block. Engraved by W. Barker.

2. January 1864 – 'Harold Massey's Confession', facing p.65. Engraved by W. Barker.

GOOD WORDS

1. 1862 – 'Rung into Heaven', text by Horace Moule, p.153. Engraved by Dalziel.

2. 1862 – 'The Bands of Love', p.632. Engraved by Dalziel.

3. 1864 – 'The Player and the Listeners', facing p.169. Engraved by Dalziel.

LONDON SOCIETY

1. April 1862 – 'Beauty's Toilette. The Finishing Touch', facing p.265. Engraved by Dalziel.

2. September 1862 – 'The first night at the sea-side', p.220. Engraved by W. Barker.

3. October 1862 – 'A box on the ears and its consequences', to 'London Society in Paris', facing p.382. Engraved by W. Barker.

4. November 1862 – 'Surreptitious Correspondence', p.480. Engraved by W. Barker.

5. December 1863 – 'Honeydew', to 'Thoughts over a picture and a pipe', facing p.554. Engraved by W. Barker.

6. January 1864 – 'Not for you', facing p.85. Engraved by W.'Barker.

7. April 1868 – 'Expectation', published posthumously, p.361. Marked 'Drawn by the late M.J. Lawless'. The block is dated 1862 and is fully signed 'Lawless'. Engraved

by W. Barker.

8. August 1870 – 'An Episode in the Italian War', to poem which appears on p.192, p.97. Printed as being 'Drawn by the late M.J. Lawless'. Engraved by W.G.(not ascertained).

ONCE A WEEK

1. 17 December 1859 – Three illustrations to 'Sentiment from The Shambles', pp.505, 507, 509. Engraved by Swain.

2. 21 January 1860 – 'The Bridal of Galtrim', two images, p.88. Engraved by Swain.

3. 18 February 1860 – 'The Lay of the Lady and the Hound', p.164. Engraved by Swain.

4. 3 March 1860 – 'Florinda', p.220. Engraved by Swain.

5. 14 April 1860 – 'Only for something to say', p.352. Engraved by Swain.

6. 28 April 1860 – Three illustrations to 'The Head Master's Sister', pp.386, 389, 393. Engraved by Swain.

7. 5 May 1860 – 'The Secret that can't be kept', p.430. Engraved by Swain.

8. 9 June 1860 – 'A legend of Swaffham', p.549. Engraved by Swain.

9. 23 June 1860 – 'The lots upon the raft', p.620. Engraved by Swain.

10. 14 July 1860 – 'Pearl wearers and Pearl winners', to 'Oysters and Pearls', p.79. Although indexed as being by Lawless, there is almost nothing of him in this design. Engraved by Swain.

11. 4 August 1860 – 'The Betrayed', to poem by Sarah T. Bolton, p.155. Engraved by Swain.

12. 8 September 1860 – 'Elfie Meadows', p.304. Engraved by Swain.

13. 22 September 1860 – 'The Minstrel's Curse', p.351.

14. 8 December 1860 – 'My Angel's Visit', p.658. Engraved by Swain.

15. 29 December 1860 – Two illustrations to 'Oenone', pp.14, 15. Engraved by Swain.

16. 25 January 1861 – 'Dr. Johnson's Penance', to poem by Walter Thornbury, p.14. Engraved by Swain.

17. 16 February 1861 – 'Valentine's Day', p.208. Engraved by Swain.

18. 6 April 1861 – Two illustrations to 'Effie Gordon', to poem by B.S. Montgomery, pp.406, 407. Engraved by Swain.

19. 15 June 1861 – 'The Cavalier's Escape', to poem by Walter Thornbury, p.687. Engraved by Swain.

20. 5 October 1861 – 'The Montenegrins', p.420. Engraved by Swain.

21. 2 November 1861 – 'Twilight', to poem by Walter Thornbury, p.532. Engraved by Swain.

22. 16 November 1861 – 'King Dyring', p.575. Engraver not ascertained but block bears the monogram JS which may be that of John Sliegh.

23. 14 December 1861 – 'Fleurette', p.700. Engraver has same JS monogram as previous entry.

24. 8 February 1862 – 'What befel me at the Assises', p.194.

25. 19 April 1862 – 'The Dead Bride', to poem by Walter Thornbury, p.462. Engraved by Swain.

26. 11 October 1862 – 'The Lady Witch', p.434. Wood engraving. No engraver's name.

27. 20 October 1862 – 'The Two Beauties of the Camberwell Assemblies 1778', p.462. Engraved by Swain.

28. 30 May 1863 – 'The Linden Trees', p.644. Engraved by Swain.

29. 20 June 1863 – 'Gifts', p.712. Engraved by Swain.

30. 18 July 1863 – 'Faint Heart never won Fair Ladye', p.98.

31. 3 October 1863 – 'Heinrich Frauenlob', p.393. Engraved by Swain.

32. 5 December 1863 – 'Broken Toys', p.672.

33. 9 January 1864 – 'John of Padua', to an anonymous poem signed W.T. (probably Walter Thornbury), p.71. Signed with initials by the artist and dated 1863. Engraved by Swain.

LEIGHTON, Frederic

THE CORNHILL MAGAZINE

1. July 1860 – 'The Great God Pan', to 'A Musical Instrument', poem by Elizabeth Barrett Browning, facing p.84. Engraved by Dalziel.
2. December 1860 – 'Ariadne', to 'Ariadne at Naxos', to poem by Elizabeth Barrett Browning, two illustrations set within an elaborate architectural frame, facing p.674.
3. July 1862 – 'The Blind Scholar and his Daughter', to 'Romola', text by George Eliot, facing p.1. Engraved by W.J. Linton.
4. July 1862 – 'Suppose you let me look at myself', to 'Romola' by George Eliot, facing p.27. Engraved by Swain.
5. August 1862 – 'A recognition', to 'Romola' by George Eliot, facing p.145. Engraved by Swain. Also an initial letter on p.145.
6. August 1862 – 'Under the Plane-Tree', to 'Romola' by George Eliot, facing p.184. Engraved by W.J. Linton.
7. September 1862 – 'The First Kiss', to 'Romola' by George Eliot, facing p.289. Engraved by W.J. Linton. Also an initial letter on p.289.
8. September 1862 – 'The Peasant's Fair', to 'Romola' by George Eliot, facing p.311. Engraved by Swain.
9. October 1862 – 'The Dying Message', to 'Romola' by George Eliot, facing p.433. Engraved by W.J. Linton. Also an initial letter on p.433.
10. October 1862 – 'A Florentine Joke', to 'Romola' by George Eliot, facing p.450. Engraved by Swain.
11. November 1862 – 'The Escaped Prisoner', to 'Romola' by George Eliot, facing p.577. Engraved by W.J. Linton. Also an initial letter on p.577.
12. November 1862 – 'Niccoló at work', to 'Romola' by George Eliot, facing p.603. Engraved by Swain.
13. December 1862 – 'The Painted Record', to 'Romola' by George Eliot, facing p.721. Engraved by W.J. Linton. Also an initial letter on p.721.
14. December 1862 – 'Coming Home', to 'Romola' by George Eliot, facing p.726. Engraved by Swain.
15. January 1863 – 'You didn't think it was so pretty did you?', to 'Romola' by George Eliot, facing p.1. Engraved by Swain. Also an initial letter on p.1.
16. January 1863 – 'Escaped', to 'Romola' by George Eliot, facing p.29. Engraved by W.J. Linton.
17. February 1863 – 'Father, I will be guided', to 'Romola' by George Eliot, facing p.145. Engraved by Swain. Also an initial letter on p.145.
18. February 1863 – 'A scene in the Rucellai Gardens', to 'Romola' by George Eliot, facing p.153. Engraved by W.J. Linton.
19. March 1863 – 'The visible Madonna', to 'Romola' by George Eliot, facing p.282. Engraved by Swain. Also an initial letter on p.282.
20. March 1863 – 'A dangerous colleague', to 'Romola' by George Eliot, facing p.306. Engraved by W.J. Linton.
21. April 1863 – 'Monna Brigida's conversion', to 'Romola' by George Eliot, facing p.417. Engraved by Swain. Also an initial letter on p.417.
22. May 1863 – 'But will you help me?', to 'Romola' by George Eliot, facing p.553. Engraved by W.J. Linton. Also an initial letter on p.553.
23. May 1863 – 'Tessa at Home', to 'Romola' by George Eliot, facing p.569. Engraved by Swain.
24. June 1863 – 'Drifting away', to 'Romola' by George Eliot, facing p.681. Engraved by Swain. Also an initial letter on p.681.
25. July 1863 – 'Will his eyes open?', to 'Romola' by George Eliot, facing p.1. Engraved by Swain. Also an initial letter on p.1.
26. August 1863 – 'At the Well', to 'Romola' by George Eliot, facing p.129. Engraved by Swain. Also an initial letter on p.129.

27. February to April 1867 – Four illustrations to 'A Week in a French Country House', text by Adelaide Sartoris, the large drawings are entitled 'An evening in a French country house' and 'Drifting', p.192 (vignette), facing p.192, p.457 (vignette), facing p.457. Engraved by Swain.

MAHONEY, James

THE ARGOSY

1. August 1866 – 'Autumn Tourists', facing p. 217.
2. September 1866 – 'Bell from the North', to 'A London Lyric' poem by Robert Buchanan, facing p.289.
3. October 1866 – 'The love of years', to poem by M.B. Smedley, facing p.398.

THE COTTAGER AND ARTISAN

1. 2 September 1867 – 'The Old Cobbler and His Pupils', p.69. Engraved by Whymper.

THE DAY OF REST

1. 2 August 1873 – 'Jaspar the Monk', p.430. Engraved by Dalziel.
2. 8 November 1873 – 'Lest ye cut the angel's feet', p.603. Engraved by Dalziel.
3. 29 November 1873 – 'The Force of Truth', p.633. Engraved by Dalziel.
4. 3 January to 31 March 1874 – Six illustrations to 'Cassy', text by Hesba Stretton, pp.9, 26, 55, 152, 166(2). Engraved by Dalziel.

GOOD CHEER (Christmas number of *Good Words*)

1. 25 December 1867 – Two illustrations to 'Paul Falconer's Legacy', pp.45, 47. Engraved by Dalziel.
2. 25 December 1868 – 'Little Archie Big-Head', p.34. Engraved by Dalziel.
3. 25 December 1869 – 'Master Giles and his sister Betty', p.13. Engraved by Dalziel.

GOOD THINGS FOR THE YOUNG OF ALL AGES

1. October 1873 – 'The Old Mill', text by

Rona Lee, p.600. Engraved by Dalziel.

GOOD WORDS

1. 1868 – 'Yesterday and Today', p.672. Engraved by Dalziel.
2. 1 March 1869 Supplement – Two illustrations to 'A Supper in a Caravan', p.65 and facing p.71. Engraved by Dalziel.
3. 1869 – Five illustrations to 'The Staffordshire Potter', pp.169, 170(2), 172, 174. Engraved by Dalziel.
4. 1869 – Three illustrations to 'The Northampton Shoemaker', pp.760(2), 761. Engraved by Dalziel.
5. 1 February 1870 – 'The Dorsetshire Hind', p.97. Engraved by Dalziel.
6. 1 March 1870 – 'Ascent of Snowdon', to poem by Charles Turner, p.201. Engraved by Dalziel.
7. 1 October 1870 – 'Dame Martha's Well', to poem by Robert Buchanan, p.680. Engraved by Dalziel.
8. 1871 – 'German Miners', p.137. Engraved by Dalziel.
9. 1872 – Thirty-six illustrations to 'At his gates', text by Mrs Oliphant, pp.33, 40, 41, 105, 108, 113, 177, 182, 185, 249, 256, 257, 321, 325, 329, 393, facing p.393, 401, 465, facing p.465, 472, 541, 548, 549, 581, facing p.581, 589, 653, 660, 668, 725, 741, 744, 797, 806, 812. Engraved by Dalziel.
10. 1872 – 'Busy Margie', p.864.

GOOD WORDS FOR THE YOUNG

1. 1 January 1869 – 'The German Girl on St Thomas's Day', text by Sarah Tytler, p.152. Engraved by Dalziel.
2. 1 March 1869 – 'The Boys of Axelford', text by Charles Camden, p.228. Engraved by Dalziel.
3. 1 June 1869 – to 'Little Nat', text by G. Crockford, p.368. Engraved by Dalziel.
4. 1 June 1969 – 'The Three Kingdoms', to poem by J.E. Bendall, p.380. Engraved by Dalziel.
5. 1 August 1869 – 'Pepper's Drill', p.495.
6. 1 October 1869 – 'The Glass Merchant',

text by Norman G. Brown, p.572. Engraved by Dalziel.

7. 1 April 1870 – to 'About Philip', text by G. Crockford, p.328. Engraved by Dalziel.

8. 1 November 1870 to 1 September 1871 – Six illustrations to 'When I Was Young', text by Charles Camden, pp.36, 93, 156, 325, 512, 601. Engraved by Dalziel. The other illustrations are by E.F. Brewtnall.

9. December 1871 – to 'What we saw underground', text by Charles Camden, p.89. Engraved by Dalziel.

10. January to October 1872 – Ten illustrations to 'The Travelling Menagerie', text by Charles Camden, pp.136, 160, 209, 265, 305, 409, 448, 488, facing p. 544, 545. Engraved by Dalziel.

THE LEISURE HOUR

1. 6 May to 24 June 1865 – Eight illustrations to 'Adventures ashore and afloat', pp.273, 289, 305, 321, 337, 353, 369, 385. Engraved by Whymper.

2. 14 October 1865 – 'Among the Pennine Alps', p.641.

3. 6 January to 30 June 1866 – Twenty-six illustrations to 'The Great Van Broek Property', pp.1, 18, 33, 49, 65, 81, 97, 113, 129, 145, 161, 177, 193, 209, 225, 241, 257, 273, 289, 305, 321, 337, 353, 369, 385, 401.

4. 24 November 1866 – 'Finding the body of William Rufus', facing p.743. Engraved by Whymper.

LONDON SOCIETY

1. December 1868 – Two illustrations to 'Gossip from Egypt', pp.481, 509. Engraved by Whymper.

2. March 1869 – 'Officers and Gentlemen', facing p.284.

3. 1869, Holiday number – 'Holiday Hearts', to poem by Clement Scott, p.57. Engraved by Whymper.

4. 1869, Christmas number – Two illustrations to 'Mr. Dawbarn', facing p.48 and on p.51.

5. February 1870 – 'Sir Stephen's Question', to

'Matchmaking', facing p.112. Engraved by Whymper.

6. April 1870 – 'Going to the Drawing-Room', facing p.321.

7. July to August 1870 – Two illustrations to 'The Old House by the River', facing pp.67, 172.

ONCE A WEEK

1. 14 December 1867 – 'Zoë Fane', p.705. Engraved by Swain.

THE PEOPLE'S MAGAZINE

1. 5 January to 4 May 1867 – Twenty-one illustrations to 'Mr Wynyard's Ward', text by Holme Lee, pp.1, 17, 33, 49, 65, 81, 97, 113, 129, 145, 161, 177, 193, 209, 225, 241, 257, 273, 289, 305, 321.

2. 5 January 1867 – 'The Sea King's Burial', p.14.

3. 12 January 1867 – 'Lady Jane Grey refusing the crown', p.25.

4. 12 January 1867 – 'Home memories of Cowper', p.29.

5. 26 January 1867 – 'Rest', p.60.

6. 26 January 1867 – 'The Little Green Maiden', p.62.

7. 2 February 1867 – 'Popular Songs Illustrated', p.77.

8. 23 February 1867 – 'The Street Singer', p.125.

9. 2 March 1867 – 'Seeing is believing', p.133.

10. 16 March 1867 – 'The Battle of Hohenlinden', p.169.

11. 4 May 1867 – 'The Burial of Alaric', p.313.

12. 1 June 1867 – 'Robin's Wife', to poem by Fanny Wyvill, p.413.

13. 6 July 1867 – 'George III and the beggar', p.457.

14. 5 October to 28 December 1867 – Eleven illustrations to 'The Governor's Daughter', text by H. Sutherland Edwards, pp.657, 673, 689, 705, 721, 737, 753, 769, 785, 801, 817. Engraved by Whymper.

15. 2 November 1867 – 'How Amyas Threw his sword into the Sea', p.729.

THE QUIVER

1. February 1868 – 'But for dreary musing one needs little light', to 'Between the Lights', p.329. Engraved by W. Thomas.

THE SUNDAY AT HOME

1. 3 December 1864 – 'The Miller's books saved', to 'The Miller and his daughter', p.769. Engraved by Whymper.
2. 7 January to 28 January 1865 – Four illustrations to 'The Forty Acres', pp.1, 17, 33, 49. Engraved by Whymper.
3. 4 February to 25 February 1865 – Three illustrations to 'Fisher Bill', pp.65, 81, 113. The illustration on p.97 does not seem to be by Mahoney. Engraved by Whymper.
4. 8 July and 19 August 1865 – Two illustrations to 'The Two Voyages', pp.417, 513. Engraved by Whymper.
5. 7 October to 30 December 1865 – Thirteen illustrations to 'The Old Manor House', pp.625, 641, 657, 673, 689, 705, 721, 737, 753, 769, 785, 801, 817.
6. 3 August 1867 – 'James the First and the Daughter of Knox', p.521.

THE SUNDAY MAGAZINE

1. 1 August 1866 – 'A Visit to Marie, a French Heroine', facing p.753.
2. 1 September 1866 – 'Summer', placed as frontispiece to volume for 1866, to poem 'A Summer Hymn' by William Freeland on p.825.
3. 1 October 1867 – 'Sunday Songs from Denmark', to poem by Gilbert Tait, p.16. Engraved by Dalziel.
4. 1 November 1867 – to 'Love Days', Two illustrations on pp.136, 137.
5. 1 July 1868 – 'Just Suppose', text by Andrew Whitgift, p.649. Engraved by Dalziel.
6. 1 November 1867 to 1 September 1868 – Thirty-nine illustrations to 'The Occupations of a Retired Life', text by Edward Garrett, pp.119, 120, 128, 168, 169, 240, 241, facing p.244, 248, 312, 313, 320, 376, 377, facing p.381, 384, 440, 441, 448, facing p.449, 496, 497, facing p.503, 504, 568, 569, facing p.572, 576, 624, 625, facing p.628, 633, 688, facing p.688, 689, 696, 768, 769, and 771 which is used as a frontispiece to this volume. Engraved by Dalziel.
7. 1 October 1868 – 'The Centurion's Faith', to poem by Alan Brodrick, p.61. Engraved by Dalziel.
8. 1 January 1869 – 'A Christmas Evening in the Eighteenth Century', to poem by Isabella Fyvie, p.252. Engraved by Dalziel.
9. 1 April 1869 – 'Hoppety Bob and his class in the country', p.417. Engraved by Dalziel.
10. 1 July 1869 – 'How Roger Rolfe used his enemies', text by Isabella Fyvie, p.608. Engraved by Dalziel.
11. 1 August 1870 – 'A Sun-Dial in a Churchyard', to poem by George Jacque, p.704. Engraved by Dalziel.
12. 1 September 1870 – 'Passover Observances', p.736. Engraved by Dalziel.
13. 1 November 1870 – 'An afternoon with a sceptic', p.89. Engraved by Dalziel.
14. 1 January 1871 – 'Our Milkman's Mystery', text by James Pitt, p.216. Engraved by Dalziel.
15. 1 April 1871 – 'The Diet of Augsburg', p.417. Engraved by Dalziel.
16. December 1871 – 'Out of the History of a Ragged School', p.257. Engraved by Dalziel.

MILLAIS, John Everett

THE ARGOSY

1. June 1866 – 'The Sighing of the Shell', to poem by George Macdonald, facing p.64. Engraved by Dalziel.

CHURCHMAN'S FAMILY MAGAZINE

1. January 1863 to February 1863 – Two illustrations to 'The New Curate', facing p.15 and p.221. Engraved by Swain.

THE CORNHILL MAGAZINE

1. February 1860, vol. I – 'Unspoken

Dialogue', to poem by R. Monckton Milnes, facing p.194. Engraved by Dalziel.

2. April 1860 – 'Lord Lufton and Lucy Robarts', to 'Framley Parsonage', text by Anthony Trollope, facing p.449. Engraved by Dalziel.

3. June 1860 – 'Was it not a lie?', to 'Framley Parsonage' by Trollope, facing p.691. Engraved by Dalziel.

4. August 1860 – 'The Crawley Family', to 'Framley Parsonage' by Trollope, facing p.129. Engraved by Dalziel.

5. October 1860 – 'Lady Lufton and the Duke of Omnium', to 'Framley Parsonage' by Trollope, facing p.462. Engraved by Dalziel.

6. November 1860 – 'Last Words', to poem by Owen Meredith, facing p.513. Engraved by Dalziel.

7. January 1861 – 'Mrs Gresham and Miss Dunstable', to 'Framley Parsonage' by Trollope, facing p.48. Engraved by Dalziel.

8. February 1861 – 'Temptation', To 'Horace Saltoun', facing p.229. Engraved by Dalziel.

9. March 1861 – ' "Mark" she said "the men are here" ', to 'Framley Parsonage' by Trollope, facing p.342. Engraved by Dalziel.

10. April 1862 – 'Irené', facing p.478. Engraved by Swain.

11. July 1862 – 'The Bishop and the Knight', facing p.100. Engraved by Dalziel and dated 1862 on the block.

12. September 1862 – 'Please Ma'am, can we have the peas to shell?', to 'The Small House at Allington', text by Anthony Trollope, facing p.364. Engraved by Dalziel. Also an initial letter on p.364.

13. October 1862 – ' "And you love me!" said she', to 'The Small House at Allington' by Trollope, facing p.552. Engraved by Dalziel. Also an initial letter on p.552.

14. November 1862 – 'It's all the fault of the naughty birds', to 'The Small House at Allington' by Trollope, facing p.663. Engraved by Dalziel. Also an initial letter on p.663.

15. December 1862 – ' "Mr Cradell, your

hand" said Lupex', to 'The Small House at Allington' by Trollope, facing p.780. Engraved by Dalziel. Also an initial letter on p.780.

16. January 1863 – 'Why it's young Eames', to 'The Small House at Allington' by Trollope, facing p.56. Engraved by Dalziel. Also an initial letter on p.56.

17. February 1863 – 'There is Mr Harding coming out of the Deanery', to 'The Small House at Allington' by Trollope, facing p.214. Engraved by Dalziel. Also an initial letter on p.214.

18. March 1863 – 'And have I not really loved you?', to 'The Small House at Allington' by Trollope, facing p.349. Engraved by Dalziel. Also an initial letter on p.349.

19. April 1863 – 'Mr Palliser and Lady Dumbello', to 'The Small House at Allington' by Trollope, facing p.469. Engraved by Dalziel. Also an initial letter on p.469.

20. May 1863 – 'Devotedly attached to the young man', to 'The Small House at Allington' by Trollope, facing p.657. Engraved by Dalziel. Also an initial letter on p.657.

21. June 1863 – 'The Board', to 'The Small House at Allington' by Trollope, facing p.756. Engraved by Dalziel. Also an initial letter on p.756.

22. July 1863 – 'Won't you take some more wine?', to 'The Small House at Allington' by Trollope, facing p.59. Engraved by Dalziel. Also an initial letter on p.59.

23. August 1863 – 'And you went in at him on the station?', to 'The Small House at Allington' by Trollope, facing p.208. Engraved by Dalziel. Also an initial letter on p.208.

24. September 1863 – 'Let me beg you to think over the matter again', to 'The Small House at Allington' by Trollope, facing p.258. Engraved by Dalziel. Also an initial letter on p.258.

25. October 1863 – 'That might do', to 'The

Small House at Allington' by Trollope, facing p.385. Engraved by Dalziel. Also an initial letter on p.385.

26. November 1863 – ' "Mamma" she said at last, "It is over now, I'm sure" ', to 'The Small House at Allington' by Trollope, facing p. 513. Engraved by Dalziel. Also an initial letter on p.513.

27. December 1863 – 'Why on earth, on Sunday?', to 'The Small House at Allington' by Trollope, facing p.641. Engraved by Dalziel. Also an initial letter on p.641.

28. January 1864 – 'Bell, here's the inkstand', to 'The Small House at Allington' by Trollope, facing p.1. Engraved by Dalziel. Also an initial letter on p.1.

29. February 1864 – 'She has refused me and it is all over', to 'The Small House at Allington' by Trollope, facing p.232. Engraved by Dalziel. Also an initial letter on p.232.

30. April 1864 – Initial letter illustration, to 'The Small House at Allington' by Trollope, p.442. Engraved by Dalziel.

31. October 1864 – 'An Old Song', to 'Madame de Monferrato', facing p.434. Engraved by Dalziel. Also an initial letter on p.434.

GOOD WORDS

1. 1862 – 'Olaf the Sinner and Olaf the Saint', p.25. Engraved by Dalziel.

2. 1862 – Twelve illustrations to 'Mistress and Maid', text by Mrs Craik, pp.33, 97, 161, 225, 289, 353, 417, 481, 545, 609, 673 and frontispiece to the volume. Engraved by Dalziel.

3. 1862 – 'The Carrier Pigeon', to poem by Dora Greenwell, p.121. Engraved by Dalziel.

4. 1862 – 'Highland Flora', p.393. Engraved by Dalziel.

5. 1863 – Twelve illustrations to 'The Parables of Our Lord', pp.1, 81, 161, 241, 313, 385, 461, 533, 605, 677, 749, 821. Engraved by Dalziel. 'The Labourer in the Vineyard' (p.821) also appears as the frontispiece in bound volumes.

6. 1864 – 'O the Lark is singing in the sky', facing p.64. Engraved by Swain.

7. 1864 – 'A Scene for a Study', to poem by Jean Ingelow, facing p.160. Engraved by Swain.

8. 1864 – 'Polly', facing p.248. Engraved by Swain.

9. 1864 – 'The Bride of Dandelot', to poem by Dora Greenwell, facing p.304. Engraved by Swain.

10. 1864 – 'Prince Philibert', facing p.479. Engraved by Swain.

11. 1878 – 'Macleod of Dare', text by William Black, facing p.651. Engraved by Swain.

ILLUSTRATED LONDON NEWS

1. 20 December 1862 – 'Christmas Story-Telling', a full page design presented separately in the magazine. Engraved by Dalziel.

THE INFANT'S MAGAZINE

1. 1 November 1867, no. 23 – 'The Picture-Book', p.175. A reprint of the title-page vignette which first appeared in Wordsworth's *Poems for the Young* in 1863.

LONDON SOCIETY

1. August 1862 – 'Ah me! She was a winsome maid', to 'The Border Witch', facing p.181. Engraved by Dalziel.

2. 1862, Christmas number – ' "Yes Lewis" she said, "Quite satisfied" ', to 'The Christmas Wreaths of Rockton', facing p.65. Engraved by Swain.

3. September 1864 – 'Knightly Worth', to 'The Tale of a Chivalrous Life', facing p.193. Engraved by Dalziel. Sometimes placed as the frontispiece to the volume.

ONCE A WEEK

1. 2 July 1859 – 'Magenta', to poem by Tom Taylor, p.10. Engraved by Dalziel.

2. 16 July 1859 – 'The Grandmother's Apology', to poem by Tennyson, p.41. Engraved by Dalziel.

3. 23 July 1859 – 'On the water', p.70. Engraved by Dalziel.

4. 8 October 1859 – 'La Fille Bien Gardée', p.306. Engraved by Swain.

5. 15 October 1859 – 'The Plague of Elliant', to poem translated from the Breton by Tom Taylor, p.316. Engraved by Swain.

6. 5 November 1859 – 'Maude Clare', to poem by Christina Rossetti, p.382. Engraved by Swain.

7. 3 December 1859 – 'A Lost Love', p.482. Engraved by Dalziel.

8. 17 December 1859 – 'St. Bartholomew', p.514. Engraved by Dalziel.

9. 31 December 1859 – 'The Crown of Love', to poem by George Meredith, p.10. Engraved by Swain.

10. 7 January 1860 – 'A Wife', p.32. Engraved by Swain.

11. 4 February 1860 – 'The Head of Bran', to poem by George Meredith, p. 132. Engraved by Swain.

12. 10 March 1860 – 'Practising', to poem by Shirley Brooks, p.242. Engraved by Dalziel.

13. 16 June 1860 – 'Musa', p.598. Engraved by Dalziel.

14. 14 July 1860 – 'Master Olaf', p.63. Engraved by Swain.

15. 28 July 1860 – 'Violet', to poem by Arthur J. Munby, p.140. Engraved by Swain.

16. 25 August 1860 – 'Dark Gordon's Bride', to poem by B.S. Montgomery, p.238. Engraved by Swain.

17. 1 September 1860 – 'The Meeting', p.276. Engraved by Swain.

18. 6 October and 13 October 1860 – Two illustrations to 'The Iceberg', pp.407, 435. Engraved by Swain.

19. 3 November 1860 – 'A Head of Hair for Sale', p.519. Engraved by Swain.

20. 19 January 1861 – 'Iphis and Anaxarete', p.98. Engraved by Swain.

21. 26 January 1861 – 'Thor's hunt for his hammer', p.126. Engraved by Swain.

22. 17 August 1861 – 'Tannhäuser', p.211. Engraved by Swain.

23. 12 October 1861 – 'Swing Song', p.434. Engraved by Swain.

24. 4 January 1862 – 'Schwerting of Saxony', p.43. Engraved by Swain.

25. 1 February 1862 – 'The Battle of the Thirty', p.155. Engraved by Swain.

26. 22 February 1862 – 'The Fair Jacobite', p.239. Engraved by Swain.

27. 15 March to 12 April 1862 – Five illustrations to 'Sister Anna's Probation', text by Harriet Martineau, pp.309, 337, 365, 393, 421. Engraved by Swain.

28. 22 March 1862 – 'Sir Tristem', p.350. Engraved by Swain.

29. 10 May 1862 – 'The Crusader's Wife', to poem translated from the Breton by Tom Taylor, p.546. Engraved by Swain.

30. 31 May 1862 – 'The Chase of the Siren', to poem by Walter Thornbury, p.630. Engraved by Swain.

31. 14 June 1862 – 'The Drowning of Kaer – IS', to poem translated from the Breton by Tom Taylor, p.687. Engraved by Swain.

32. 5 July 1862 – 'Margaret Wilson', p.42. Engraved by Swain.

33. 12 July to 16 August 1862 – Five illustrations to 'The Anglers of the Dove', text by Harriet Martineau, pp.85, 113, 141, 169, 197. Engraved by Swain.

34. 19 July 1862 – 'Maid Avoraine', p.98. Engraved by Swain.

35. 16 August 1862 – 'The Mite of Dorcas', p.224. Engraved by Swain. Unusually this engraving seems an independent illustration unrelated to any story or poem.

36. 8 November 1862 – 'The Spirit of the Vanished Island', to poem by Mrs Acton Tindal, p.546. Engraved by Swain.

37. 6 December 1862 – 'The Parting of Ulysses', p.658. Engraved by Swain.

38. 20 December 1862 – 'Limerick Bells', to poem by Horace Moule, p.710. Engraved by Swain.

39. 3 January 1863 – 'Endymion on Latmos', p.42. Engraved by Swain.

40. 14 February to 18 April 1863 – Ten illustrations to 'The Hampdens', text by Harriet Martineau, pp.211, 239, 267, 281,

309, 337, 365, 393, 421, 449. Engraved by Swain.

41. 24 October 1863 – 'Hacho, the Dane; or the Bishop's Ransom', p.504. Engraved by Swain.

42. 24 October to 12 December 1863 – Eight illustrations to 'Son Christopher', text by Harriet Martineau, pp.491, 519, 547, 575, 603, 631, 659, 687. Engraved by Swain.

43. 25 January 1868 – 'Death Dealing Arrows', p.79.

PUNCH

1. 21 March 1863 – 'It is the Chapeau Blanc, the White Witness', to 'Mokeanna or the White Witness', text by F.C. Burnand, p.115. Engraver's name not visible. The story was also illustrated by du Maurier. It appeared in book form in 1873. See Index of Illustrated Books.

2. Almanack for 1865 – 'Mr Vandyke Brown, having left the Dress on the Lay Figure carefully arranged, goes out for his usual exercise, and this is how the Boys took advantage of his absence', page unnumbered. Engraved by Swain.

SAINT PAUL'S MAGAZINE

1. October 1867 to May 1869 – Twenty illustrations to 'Phineas Finn, The Irish Member', text by Anthony Trollope, vol. I: p.118, facing pp.247, 374, 509, 637, 751; vol. II: facing pp.113, 253, 376, 511, 638, 747; vol. III: pp.128, 233, 381, 503, 636, 738; vol. IV: pp.103, 256. Engraved by Swain and W. Thomas.

MORTEN, Thomas

AUNT JUDY'S MAGAZINE

1. May 1866 – 'Nights at the Round Table', facing p.48. Engraved by Horace Harral.

2. June 1866 – 'Kathleen …', to 'The Cousins and their Friends', facing p.70. Engraved by Horace Harral.

3. June 1866 – 'They heaped a great fire', to 'The Wives of Brixham', text by M.B. Smedley, facing p.81. Engraved by Horace Harral.

4. June 1866 – 'The little sick child …', facing p.102. Engraved by Horace Harral.

5. June 1866 – 'He brings it to thee…', to 'Frisk', facing p.121. Engraved by Horace Harral.

6. July 1866 – 'Daddy, don't lose heart again', to 'Little Johnny', facing p.150. Engraved by Horace Harral.

BEETON'S ANNUAL

1. 1866 – Untitled illustration to 'The Arms of the de Forgerons', text by W. Cosmo Monkhouse, facing p.314.

CASSELL'S ILLUSTRATED FAMILY PAPER

1. 1 September 1866 to 3 November 1866 – Ten illustrations to 'The Lion in the Path', pp.1, 17, 33, 49, 65, 81, 97, 113, 129, 145. Engraved by Cassell, Petter and Galpin. Morten committed suicide in September 1866. After 3 November the illustrations were undertaken by another hand and the engravings were entrusted to Linton.

CHURCHMAN'S FAMILY MAGAZINE

1. February 1863 – 'Discharged Cured', p.137. Engraved by R.S. Marriott.

2. March to May 1863 – Three illustrations to 'Black Peter's Conversion', facing pp.243, 432, 531. Engraved by Swain.

3. December 1863 – 'The Bell-Ringer's Christmas Story', to 'The Peal of Hope: the Bell-Ringer's Christmas Story', facing p.513. Engraved by Dalziel.

4. June 1864 – 'The Twilight Hour', to poem by Thomas Hood, facing p.553. Engraved by Dalziel.

ENTERTAINING THINGS

1. May 1861 to April 1862 – Seven untitled illustrations to 'Weatherbound', text by Tom Southee, pp. 65, 97, 128, 129, 161, 273, 385.

EVERYBODY'S JOURNAL

1. 1 October 1859 – An initial letter illustration to 'The Pearl Diver', text by Captain Mayne Reid, p.37.

7. 28 January 1865 – 'Macdhonuil's Coronach', to poem by William Black, p.161. Engraved by Swain.

8. 3 March 1866 – 'The Dying Viking', p.239. Engraved by Swain.

9. 21 April 1866 – 'King Erick', p.435. Engraved by Swain.

10. 11 August 1866 – 'The Curse of the Gudmunds', to poem by Elizabeth Harcourt Mitchell, p.155.

11. 15 September 1866 – 'On the Cliffs' p.308.

THE QUIVER

1. November 1865 – 'The old man leant his head on the mantle-piece and sobbed convulsively', to 'The Teacher of the Languages', p.1. Engraved by W. Thomas.

2. February 1866 – 'Flitting past in wintry weather …', to 'Hassan', text by D.P. Starkey, p.249. Engraved by J.D. Cooper.

3. February 1866 – 'And on my soul, I know not why there fell a bliss', to 'The Sea at Sunset, before a Storm', p.297. Engraved by J.D. Cooper.

4. May 1866 – 'Ah me! ah me! 'tis a common tale …', to 'Flowers from the Battle-Field', p.489. Engraved by W.J. Linton.

5. September 1866 – 'Calm and content I see thee, Walton', to 'Izaac Walton', poem by Walter Thornbury, p.825. Engraved by Cassell, Petter and Galpin.

NORTH, John William

AUNT JUDY'S MAGAZINE

1. 1874 – 'The Motion of the boat was so smooth …', to 'A Great Emergency', p.578.

GOOD CHEER (Christmas number of *Good Words*)

1. 25 December 1867 – Two illustrations to 'The Wounded Daisy', pp.48, 49. Engraver not ascertained.

GOOD WORDS

1. 1863 – 'Autumn Thoughts', facing p.743. Engraved by Dalziel.

2. 1866 – 'The Island Church', facing p.393. Engraved by Swain.

ONCE A WEEK

1. 24 December 1864 – 'The River', to poem by Julia Goddard, p.15.

2. 17 June 1865 – 'St Martin's Church, Canterbury', to 'Then and Now', p.713.

3. 28 July 1866 – 'Luther's Gardener', to poem by Walter Thornbury, p.99. Engraved by Swain.

4. 16 March 1867 – 'The Lake', p.303. Engraved by Swain.

THE SUNDAY MAGAZINE

1. February 1865 – 'Winter', text by Thomas Guthrie (editor of *The Sunday Magazine*), p.328. Engraved by Swain.

2. 1 January 1867 – 'Foundered at Sea', facing p.280. Engraved by Dalziel.

3. 1 May 1867 – 'The Weary Day is at its Zenith still', to 'Peace', text by Fanny Havergal, facing p.560. Engraved by Dalziel.

4. 1 June 1867 – 'Anita's Prayer', facing p.609. Engraved by Dalziel.

PATON, SIR Joseph Noel

THE CORNHILL MGAZINE

1. January 1864 – 'Ulysses', to 'Ulysses in Ogygia', poem by the artist, facing p.66. Engraved by Swain.

2. May 1864 – 'Lux in tenebris', to 'Blind Workers and Blind Helpers', p.617. Engraved by Swain.

THE SUNDAY MAGAZINE

1. January 1865 – 'Capture of the Slave Ship', p.289.

2. 1 June 1865 – Two images, 'Slavery' and 'Freedom', to 'The Song of the Freed Woman', poem by Isa Craig, printed separately between pp.672 and 673.

PETTIE, John

GOOD WORDS

1. July 1861 – Two illustrations, to 'Cain's Brand', pp.376, 422. Engraved by Dalziel.
2. 1862 – 'What sent me to sea', p.264. Engraved by Dalziel.
3. 1862 – 'The Country Surgeon', p.713. Engraved by Dalziel
4. 1863 – 'The Monks and the Heathen', text by Charles Kingsley, p.14. Engraved by Dalziel.
5. 1863 – 'The Passion Flowers of Life', facing p.141. Engraved by Dalziel.
6. 1863 – 'The Night-Walk over the Mill Stream', facing p.185. Engraved by Dalziel.
7. 1863 – 'Not Above his business', facing p.272. Engraved by Dalziel.
8. 1863 – 'The Harlequin Boy', facing p.417. Engraved by Dalziel.
9. 1863 – 'Kalampin', facing p.476. Engraved by Dalziel.
10. 1864 – 'The Child's Hospital', to 'Meadowside House', text by Mrs Craik, p.23.
11. 1878 – 'Macleod of Dare', text by William Black, frontispiece. Engraved by Dalziel.

GOOD WORDS FOR THE YOUNG

1. 1 December 1868 – Untitled vignette, to 'Hoity Toity', text by Charles Camden, p.89. Engraved by Dalziel.
2. 1 January 1869 – Untitled tailpiece, to 'The Boys of Axelford', text by Charles Camden, p.148.

THE SUNDAY MAGAZINE

1. 1 December 1867 – 'My sister held her for a moment …', to 'The Occupations of a Retired Life', p.176. Engraved by Dalziel.
2. 1 October 1868 – 'Philip Clayton's first-born', facing p.68. Engraved by Dalziel.

PICKERSGILL, Frederick Richard

THE BAND OF HOPE REVIEW

1. 1 August 1867 – 'Babyhood of a great painter', p.317. Engraved by Butterworth and Heath.

CHURCHMAN'S FAMILY MAGAZINE

1. June 1863 – 'The "Still Small Voice" – A Summer Evening Reverie', facing p.586. Engraved by Thomas Williams.
2. August 1863 – 'Archbishop Sancroft and the Earl of Aylesbury', to 'Life of Archbishop Sancroft', facing p.111. Engraved by W. Thomas.

THE INFANT'S MAGAZINE

1. 1 May 1869, no. 41 – 'Baby's Work', p.79. Engraved by G. Dalzill (*sic*).

LONDON SOCIETY

1. February 1862 – 'Tender words', to poem by Dryden, facing p.36. Engraved by Edmund Evans.
2. April 1862 – 'Private Theatricals – Arming for the Part', facing p.193. Engraved by Edmund Evans. The poem to which this illustration refers actually appears on p.257.
3. 1862, Christmas number – 'The Wishing Well: or Christmas Time at Langton Hall', facing p.28. Engraved by Edmund Evans.

PINWELL, George John

THE ARGOSY

1. April 1866 – 'For hours and hours he hardly moved …', to 'Cape Ushant', poem by William Allingham, facing p.409. Engraved by Swain.

CASSELL'S MAGAZINE

1. May 1868 – 'The Tide was at its flood', to 'Cleve Cliff', p.9. Engraved by W. Thomas.

CHURCHMAN'S FAMILY MAGAZINE

1. September 1863 – 'By the sea', p.257. Engraved by Swain.
2. March 1864 – 'March Winds', p.232. Engraver not ascertained.

THE CORNHILL MAGAZINE

1. August 1864 – 'Sull's Dismissal', to 'The Lovers of Ballyvookan', facing p.185.

Engraved by Dalziel. Also an initial letter illustration on p.185.

2. September 1864 – Initial letter illustration to 'The Lovers of Ballyvookan', p.311. Engraved by Dalziel.

3. August 1870 – Two illustrations to 'Out of the Forest', p.189 and facing p.189. Engraved by Swain.

GOOD CHEER (Christmas Number of *Good Words*)

1. 25 December 1867 – 'Billy Buttons', facing p.8. Engraved by Dalziel.

2. 25 December 1867 – Two illustrations to 'A Garden Party', text by Mrs Craik, p.56. Engraved by Dalziel.

3. 25 December 1868 – to 'Tween Decks', Initial letter illustration p.1 and full-page illustration p.7. Engraved by Dalziel.

4. 25 December 1868 – 'Peggy's Haven', p.19. Engraved by Dalziel.

GOOD WORDS

1. 1863 – 'Martyn Ware's Temptation', facing p.574. Engraved by Dalziel.

2. 1864 – 'A Christmas Carol 1863', to poem by Dora Greenwell, p.32. Engraved by Swain.

3. 1864 – Two illustrations to 'The Unkind Word', text by Mrs Craik, facing pp.427, 504. Engraved by Swain.

4. 1864 – ' "Friends!" exclaimed Molly, "Who'd have the likes of you for a friend?" ', to 'Malachi's Cove', text by Anthony Trollope, facing p.931. Engraved by Swain.

5. 1864 – 'Mourning', facing p.961.

6. 1 November 1866 – 'Bridget Dally's Change', facing p.753. Engraved by Dalziel.

7. 1867 – Twelve illustrations to 'Guild Court', text by George Macdonald, facing pp.6, 78, 146, 219, 292, 366, 438, 505, 577, 654, 751, 794. Engraved by Dalziel.

8. 1867 – 'A Bird in the hand is worth two in the bush', facing p.321. Engraved by Dalziel.

9. 1867 – 'The Cabin-boy', facing p.392. Engraved by Dalziel.

10. 1868 – Two illustrations to 'Notes on the Fire', pp.47, 49. Engraved by Dalziel.

11. 1868 – 'Much work for little pay', p.89. Engraved by Dalziel.

12. 1868 – 'In a Paris Pawnshop', p.233. Engraved by Dalziel.

13. 1868 – Three illustrations to 'Mrs Dubosq's Daughter', facing pp.317, 624, 688. Engraved by Dalziel. Four illustrations were listed in the index but only three found.

14. 1868 – 'Una and the Lion', text by Florence Nightingale, p.361. Engraved by Dalziel.

15. 1 June 1868 – Two illustrations to 'Lovely yet unloved', p.377 and between pp.328 and 329. Engraved by Dalziel.

16. 1 July 1868 – 'Hop-gathering', facing p.424. Engraved by Dalziel.

17. 1868 – 'The Quakers in Norway', p.504. Engraved by Dalziel.

18. 1 March 1870 – 'An ancient chess king dug from some ruins', to poem by Jean Ingelow, facing p.211. Engraved by Dalziel.

19. 1 April 1870 – 'Margaret in the Xebec', to poem by Jean Ingelow, p.280. Engraved by Dalziel.

20. 1 May 1870 – 'A Winter Song', to poem by Jean Ingelow, p.320. Engraved by Dalziel.

21. 1871 – 'What England has done for the sick and wounded', p.40. Engraved by Dalziel.

22. 1871 – 'The Devil's Boots', p.217.

23. 1871 – 'Toddy's Legacy', p.336. Engraved by Dalziel.

24. 1871 – 'Shall we ever meet again?', p.817. Engraved by Dalziel.

25. 1875 – Thirty-five illustrations to 'Fated to be Free', text by Jean Ingelow, pp.33, 41, facing p.43, 105, facing p.108, 113, 177, facing p.178, 185, 249, 257, facing p.262, 321, facing p.323, 328, facing p.393, 393, 401, 469, 476, facing p.478, 541, facing p.547, 549, 609, facing p.617, 617, 681, facing p.683, 689, 753, facing p.757, 760, 825, 823. Engraved by Swain.

GOOD WORDS FOR THE YOUNG

1. 1 March 1869 – 'A Tradition of the Black Rock', facing p.255. Engraved by Dalziel.

THE GRAPHIC

1. 8 January 1870 – 'The Lost Child', p.132. Engraved by Swain. Dated '69' on the block.
2. 6 May 1871 – 'The Sisters', p.416. Engraved by Dalziel.
3. 22 February 1873 – 'London Sketches – A Country Visitor', p.177.

LONDON SOCIETY

1. October 1863 – 'Wolsey's Estimate of the French Character', facing p.311.
2. October 1865 – 'The Courtship of Giles Languishe', p.384.
3. 1865, Christmas number – 'Three Remarkable Christmas Days', facing p.68. Engraved by Dalziel.
4. July and September 1867 – Two illustrations to 'Beautiful Miss Johnson', facing p.137 and 249. Engraved by Dalziel.
5. 1868, Holiday number – 'Off to the Seaside – or Somewhere', p.41. Engraved by Swain.

ONCE A WEEK

1. 31 January 1863 – 'The Saturnalia', p.154. Engraved by Swain.
2. 14 February 1863 – 'The Old Man at D.S.', p.197. Engraved by Swain.
3. 14 March 1863 – 'Seasonable Wooing', p.322. Engraved by Swain.
4. 28 March 1863 – 'A Bad Egg', p.392.
5. 25 April 1863 – 'A Foggy Story', p.477. Engraved by Swain.
6. 6 June 1863 – 'Blind', p.645.
7. 13 June 1863 – 'Tidings', p.700. Engraved by Swain.
8. 4 July 1863 – 'The Strong Heart', p.29. Engraved by Swain.
9. 11 July 1863 – 'Not a ripple on the Sea', p.57. Engraved by Swain.
10. 18 July 1863 – 'Laying a Ghost', p.85.
11. 22 August 1863 – 'The Fisherman of Lake Sunapee', p.225.
12. 5 September 1863 – 'Waiting for the Tide', p.281.
13. 26 September 1863 – 'Nutting', p.378. Engraved by Swain.
14. 21 November 1863 – 'The Sirens', p.616. Engraved by Swain.
15. 9 and 16 January 1864 – Two illustrations to 'Bracken Hollow', pp.57, 85. Engraved by Swain.
16. 16 January 1864 – 'The Expiation of Charles V', p.99. Engraved by Swain.
17. 23 and 30 January 1864 – Two illustrations to 'The Blacksmiths of Holsby', text by Louisa Crow, pp.113, 154. Engraved by Swain.
18. 6 February 1864 – 'Calypso', p.183. Engraved by Swain.
19. 13 February 1864 – 'Horace Winston', p.211. Engraved by Swain.
20. 20 February 1864 – 'Proserpine', p.239. Engraved by Swain.
21. 27 February 1864 – 'A Stormy Night', p.253. Engraved by Swain.
22. 5 March 1864 – 'Mistaken Identity', p.281.
23. 19 March 1864 – 'Hero', p.350. Engraved by Swain.
24. 2 April 1864 – 'The Vizier's Parrot', p.406. Engraved by Swain.
25. 23 April 1864 – 'A Pastoral', p.490. Engraved by Swain.
26. 14 May 1864 – 'A'Beckett's Troth', to poem by Robert Buchanan, p.574. Engraved by Swain.
27. 18 June 1864 – 'The Stonemason's Yard', p.701.
28. 25 June 1864 – 'Lord Oakburn's Daughters', p.26.
29. 12 November 1864 – 'Delsthorpe Sands', p.586. Engraved by Swain.
30. 10 December 1864 – 'The Legend of the Bleeding Cave at Pendine', p.699. Engraved by Swain.
31. 17 December 1864 – 'Rosette', to poem by W.J. Linton, p.713. Engraved by Swain.
32. 7 January 1865 – 'Followers not allowed', p.71. Engraved by Swain.
33. 21 January 1865 – 'Iliad', p.127. Engraved by Swain.
34. 29 April 1865 – 'Dido', p.527. Engraved by Swain.

35. 19 August 1865 – 'Achilles', to poem by G. Cotterill, p.239. Engraved by Swain.
36. 8 December 1866 – 'The Pastor and the Landgrave', p.631. Engraved by Swain.
37. 23 February 1867 – 'Joe Robertson's Folly', p.225. Engraved by Swain.
38. 30 March 1867 – 'Come buy my pretty windmills', facing p.362. Engraved by Swain.
39. 27 April 1867 – 'The Old Keeper's Story', p.483. Engraved by Swain.
40. 31 August 1867 – 'Evening-Tide', p.255. Engraved by Swain.
41. 26 June 1869 – 'A Seat in the Park', facing p.519. Engraved by Swain.

THE QUIVER
1. December 1865 – 'I turned them o'er in heedless haste – I'd seen them all before …', to 'Echoings from Faded Flowers', p.89. Engraved by Dalziel.
2. December 1865 – 'And they find a mad woman speaking to the speechless dead!', to 'Orphaned', p.105. Engraved by Dalziel.
3. March 1866 – 'One hapless hour he fell asleep', to 'The Lost Opportunity', poem by Walter Thornbury, p.329. Engraved by J.D. Cooper.
4. March 1866 – 'We would smile at all our early fears …', to 'The Sailor's Valentine', text by A.W. Butler, p.393. Engraved by J.D. Cooper.
5. May 1866 – 'He now began to enquire …', to 'The Two Sailor Boys', text by William Kingston, p.481. Engraved by Dalziel.
6. June 1866 – 'The little ones dance at their mother's knee …', to 'The Organ Man', p.617. Engraved by Cassell, Petter and Galpin.
7. November 1866 – 'I met her by the yard gate in her simple working dress', to 'Margaret', p.113. Engraved by Cassell, Petter and Galpin.
8. January 1867 – 'It contained my picture when I was a boy', to 'Home – A Christmas Story', p.24.
9. February 1867 – 'Will you go to church if father takes ninepence?', to 'Sally in our Alley', p.273.
10. February 1867 – 'Come out to look at the stranger who passed by', to 'Other People's Windows', p.305. Engraved by W. Thomas.
11. June 1867 – 'And charming it was …', to 'Frederica', p.561. Engraved by Swain.
12. July 1867 – 'She is gathering pears in the garden', to 'The Soldier of Foxdale', p.641.
13. November 1867 – 'Nor how a longing seized my soul', to 'A First Love', text by J.G. Watts, p.121.
14. December 1867 – 'And finally Mrs Goldbag brought some grapes …', to 'The Goldbags and the Penturbys', p.193. Engraved by W. Thomas.
15. January 1868 – 'He found the visitor standing before the kitchen fire', to 'The Story of an old Chess-Board', p.257. Engraved by W. Thomas.
16. April 1868 – 'And this woman carried a baby under her cloak', to 'The Village in a panic', p.449. Engraved by W. Thomas.
17. April 1868 – 'The golden coir began to pour over the edge of his turban', to 'The Golden Melon', p.481. Engraved by W. Thomas.
18. May 1868 – 'The living mother bending o'er the cot wherein her babe lay dead!', to 'The Burden of the Bells', text by D.P. Starkey, p.585. Engraved by W. Thomas.
19. August 1868 – 'There was hardly a patch that had not its associations', to 'The House that Jack Built', p.753. Engraved by W. Thomas.

THE SUNDAY AT HOME
1. 28 November 1863 – 'The German Band', p.753.
2. 12 March 1864 – 'The text for that day was "In the morning sow thy seed" ', to 'How to Use an Almanack', p.161.

THE SUNDAY MAGAZINE
1. November 1864 – 'The House of God', p.145.
2. November 1864 – 'Young Tom Dibble's

way of using his strength', to 'Two Ways of Using Strength', p.152. Engraved by Swain.

3. 1 May 1865 – 'Only a Lost Child', p.592. Engraved by Swain.

4. 1 November 1865 – 'Oft lift up the latch of chill Poverty's dwelling', to 'Think on the Poor', facing p.104. Engraved by Dalziel.

5. 1 December 1865 – 'My hopes do not end here', to 'Written for a Sick Boy', facing p.168. Engraved by Dalziel.

6. 1 March 1866 – 'Miss Rogers betook herself … to the poor widow's house', to 'Days of Grace', facing p.384. Engraved by Swain.

7. 2 April 1866 – 'God! I am straightened sore …', to 'Remonstrance', facing p.480. Engraved by Dalziel.

8. 1 May 1866 – 'Kate made her appearance …', to 'A Lecture fom a Widow', text by Andrew Whitgift, facing p.529. Engraved by Swain.

9. 2 July 1866 – 'The German Family in London', text by Andrew Whitgift, facing p.673. Engraved by Dalziel.

10. 1 December 1866 –
 'An evil spirit cannot dwell
 Where companions are singing well',
 to 'Luther the Singer', facing p.150. Engraved by Dalziel.

11. 1 February 1867 – 'Auntie's Lessons', facing p.320. Engraved by Dalziel.

12. 1 April 1867 – 'Widowed', facing p.464. Engraved by Swain.

13. 1 December 1867 – 'Frau Walhoff at work', to 'A Peep into a Westphalian Parsonage', p.192. Engraved by Dalziel.

14. 1 August 1868 and 1 September 1868 – Two illustrations to 'Madame de Krundener', pp.704, 785. Engraved by Dalziel.

15. 1 October 1868 – 'The Gang Children', to poem by Dora Greenwell, p.25.

16. 1 October 1868 to 1 September 1869 – Forty-six illustrations, to 'The Crust and the Cake', pp.1, 4, 5, 8, 9, 73, 76, facing p.77, 77, 80, 81, 137, facing p.139, 140, 141, 144, 145, 201, 204, 205, 208, facing p.209, 265, facing p.269, 272, 329, facing p.334, 336, 393, facing p.395, 400, 457, facing p.461, 464, facing p.521, 521, 529, 585, facing p.587, 592, 649, facing p.651, 656, facing p.713, 713, 720. Engraved by Dalziel.

17. 1876, Christmas story – 'The Lighthouse-keeper's story', p.65. Engraved by Dalziel. This illustration was published posthumously.

POYNTER, Edward John

CHURCHMAN'S FAMILY MAGAZINE

1. February 1863 – Three illustrations to 'The Painter's Glory', pp.124, facing p.131, 136. Engraved by Swain.

THE GRAPHIC

1. 11 June 1870 – 'Poetry', p.662.

LONDON SOCIETY

1. September 1862 – 'A letter from the Lord Dundreary', p.215.

2. October 1862 – 'The Lord Dundreary in the Country', facing p.308.

3. October 1862 – 'I can't thmoke a pipe: No by Jove, I can't', to 'Poor Richard's Sayings', p.328. Engraved by R.S. Marriott.

4. October 1862 – 'Tip-Cat', to 'Poor Richard's Sayings', p.331. Engraved by W. Thomas.

5. November 1862 – 'Dundreary explains himself', facing p.473. Engraved by W. Thomas.

6. 1862, Christmas number – 'The Kissing Bush', facing p.41. Engraved by Swain.

7. 1864, Christmas number – 'A Sprig of Holly', facing p.29. Engraved by Swain.

ONCE A WEEK

1. 11 January 1862 – 'The Castle by the Sea', p.84. Engraved by Swain.

2. 21 June 1862 – 'Wife and I', p.724. Engraved by Swain.

3. 13 September 1862 – 'The Broken Vow', p.322.

4. 27 September 1862 and 4 October 1862 –

Two illustrations to 'A Dream of Love',
pp.365, 393. Engraved by Swain.

5. 13 and 20 December 1862 – Two
illustrations to 'A Fellow-Traveller's Story',
pp.699, 722. Engraved by Swain.

6. 24 January 1863 – 'My Friend's Wedding
Day', p.113. Engraved by Swain.

7. 31 January 1863 – 'Of a Haunted House in
Mexico', p.141.

8. 18 April 1863 – 'Ducie of the Dale', to
poem by A.J. Munby, p.476. Engraved by
Swain.

9. 6 June 1863 – 'Ballad of the Page and the
King's Daughter', p.658. Engraved by
Swain.

10. 23 February 1867 – 'Feeding the Sacred Ibis
in the Halls of Karnac', facing p.238.
Engraved by Swain. This is a separate
illustration on toned paper, signed in
monogram and dated 1866 in the block.

SANDYS, Frederick

THE ARGOSY

1. March 1866 – 'If', to poem by Christina
Rossetti, facing p.336. Engraved by Swain.

CENTURY GUILD HOBBY HORSE

1. 1888, vol III – 'Danae in the Brazen
Chamber', p.47. Engraved by Swain.

CHURCHMAN'S FAMILY MAGAZINE

1. July 1863 – 'The Waiting Time', to 'The
Hardest Time of All', poem by Sarah
Doudney, facing p.91. Engraved by W.
Thomas.

THE CORNHILL MAGAZINE

1. May 1860 – 'Legend of the Portent', facing
p.617. Engraved by W.J. Linton.

2. September 1862 – 'Manoli', facing p.346.
Engraved by Swain.

3. September 1866 – 'Cleopatra', to poem by
Algernon Swinburne, facing p.331.
Engraved by Dalziel.

GOOD WORDS

1. 1862 – 'Until her Death', to poem by Mrs

Craik, p.312. Engraved by Dalziel.

2. 1863 – 'Sleep', facing p.589. No engraver's
name but presumably by Dalziel.

ONCE A WEEK

1. 23 March 1861 – 'Yet once more upon the
organ play …', to 'From the German of
Uhland', p.350. Engraved by Swain.

2. 13 April 1861 – 'The Sailor's Bride', to
poem by Marian James, p.434. Engraved by
Swain.

3. 24 August 1861 – 'From my Window', to
poem by Frederick Whymper, p.328.
Engraved by Swain.

4. 26 October 1861 – 'The three statues of
Aegina', to poem by Walter Thornbury,
p.491. Engraved by Swain.

5. 30 November 1861 – 'Rosamond, Queen of
the Lombards', p.631. Engraved by Swain.

6. 8 February 1862 – 'The Old Chartist', to
poem by George Meredith, p.183. Engraved
by Swain.

7. 15 March 1862 – 'The King at the Gate', to
poem by Walter Thornbury, p.322.
Engraved by Swain.

8. 24 May 1862 – 'Jacques de Caumont', text
by S. Baring-Gould, p.614. Engraved by
Swain.

9. 2 August 1862 – 'Harald Harfagr', to poem
translated from Old Norse by George
Borrow, p.154. Engraved by Swain.

10. 30 August 1862 – 'The Death of King
Warwolf', to poem by Walter Thornbury,
p.266. Engraved by Swain.

11. 22 November 1862 – 'The Boy Martyr',
p.602. Engraved by Swain.

12. 28 April 1866 – 'Helen and Cassandra', to
poem by Alfred Richards, facing p.454.
Engraved by Swain.

THE QUIVER

1. January 1866 – 'Yet she was so queenly in
her woe', to 'The Advent of Winter', poem
by Thomas Hood, p.201. Engraved by
Dalziel.

THE SHILLING MAGAZINE

1. June 1865, no. ii – 'Amor Mundi', poem by

Christina Rossetti, facing p.193. Engraved by W.H. Hooper while employed by Swain whose name appears on the block.

SHIELDS, Frederic

GOOD WORDS

1. 1868 – 'Among the Corn', p.441. In the index this drawing is given to F. Shield (*sic*) but it is not very remarkable.

ONCE A WEEK

1. 27 April 1861 – 'An Hour with the Dead', p.491.
2. 28 September 1861 – 'The Robber Saint', p.378. Engraved by Swain.
3. 26 March 1864 – 'Turberville and the Heiress of Coity', p.378.
4. 18 May 1867 – ' "Hide a stick, in a little hole" (A Somersetshire Game)', facing p.572. Engraved by Swain. This does not really qualify as an illustration as it accompanies no text in the magazine and states 'From a picture by F.J. Shields'. On toned paper.

THE SUNDAY MAGAZINE

1. 2 October 1865 – 'Even as thou wilt', text based on Matthew 25:22–8, facing p.33. Engraved by Swain.

SMALL, William

AFTER WORK

1. 1877 – Untitled illustration to 'Lillian Grey', text by Emma Worboise, p.193. Engraved by Frederick Wentworth.

THE ARGOSY

1. December 1865 to November 1866 – Twelve illustrations to 'Griffith Gaunt', text by Charles Reade, facing pp.5, 12, 82, 101, 195, 197, 257, 305, 345, 388, 429, 471. Engraved by Swain.
2. December 1866 to October 1867 – Ten illustrations to 'The History of Robert Falconer', pp.6, 81, 82, 161, 164, 241, 246,

321, 327, 401. Engraved by Dalziel.

THE BOY'S OWN MAGAZINE

1. January 1866 to December 1866 – Twenty-two illustrations including initial vignettes to 'Ralph de Walden', text by Francis Davenant, facing each of the following in vol. vii: pp. 1, 89, 165, 241, 317, 393; and with an initial vignette on each of the following pp. 1, 89, 165, 241, 317, 393. In vol. viii: facing each of the following pp. 1, 77, 153, 229, 305, 380; and with an initial vignette on each of the following pp. 1, 77, 153, 229. Engraved by W. Thomas.

CASSELL'S CHRISTMAS ANNUAL

1. 1866 – 'He bent over Laura's hand …', to 'Poisoned Arrows', facing p.22. Engraved by W. Thomas.

CASSELL'S ILLUSTRATED FAMILY PAPER

1. 19 August 1865 to 25 November 1865 – Fifteen illustrations to 'Bound to the Wheel', pp.17, 33, 49, 65, 81, 97, 113, 129, 145, 161, 177, 193, 209, 225, 249. Engraved by W.J. Linton.
2. 25 November 1865 to 13 January 1866 – Eight illustrations to 'The Secret Sign', pp.241, 257, 273, 289, 305, 321, 337, 353. Engraved by W. Thomas.

CASSELL'S MAGAZINE

1. December 1869 to September 1870 – Thirty-seven illustrations to 'Man and Wife', text by Wilkie Collins, pp.1, 17, 33, 49, 65, 81, 97, 113, 129, 145, 161, 177, 193, 209, 225, 241, 257, 273, 289, 305, 321, 337, 353, 369, 385, 401, 417, 433, 449, 465, 481, 497, 513, 529, 545, 561, 577. All engraved by Frederick Wentworth with the exception of one by R.S. Marriott.
2. 1870 – 'Monseigneur s'amuse!', to 'Young Men's Amusements', text by Matthew Browne, p.189. Engraved by Frederick Wentworth.
3. April 1871 – 'Thank *you* Miss Arnald', to 'A Mad Game, My Master's', p.9. Engraved by Frederick Wentworth.

THE CHILDREN'S HOUR

1. November 1865 – To 'Children I have known', p.89. Engraved by J. Williamson.
2. October 1865 to March 1866 – Six illustrations to 'Miss Matty or Our Youngest Passenger', all facing the following pp. 9, 51, 99, 152, 211, 257. Engraved by J. Williamson.
3. April to September 1866 – Six illustrations to 'Horace Hazelwood', text by Robert Hope-Moncrief, frontispiece to April number and all others facing the following pp. 67, 131, 179, 227, 275. Engraved by J. Williamson. The frontispiece is printed in brown.
4. 1 October 1866 to 1 March 1867 – Six illustrations to 'Found Afloat', text by Mrs George Cupples, frontispiece to the volume for 1867 and all others facing the following pp. 67, 130, 179, 227, 275.
5. 2 May 1870 – 'What is the matter, my poor child?', to 'Winnie Macqueen and her way to do good', facing p.80. Engraved by J. Williamson.

FRIENDLY VISITOR

1. 1 December 1868 – 'Lame Robie's Christmas Guest', text by Nelsie Brook, p.181. Engraved by J.D. Cooper.
2. 1 May 1869 – 'The Sunset of Life', p.77.

GOOD CHEER (Christmas Number of *Good Words*)

1. 25 December 1867 – 'Mad's Christmas Adventure', facing p.22. Engraved by Dalziel.
2. 25 December 1867 – 'Twopenny Trudge', facing p.26. Engraved by Dalziel.
3. 1869 – Two illustrations to 'Squire Brimley', pp.41 (an initial letter illustration), 48. Engraved by Dalziel.
4. 1869 – Two illustrations to 'At the Sign of the Golden Canister', pp.54, 57. Engraved by Dalziel.
5. 25 December 1870 – Eight illustrations to 'Gideon's Rock', text by Catherine Saunders, pp.8, facing p.10, 17, 24, 25, 32, 40, 48. Engraved by Dalziel.
6. 1871 – Six illustrations to 'The Neap Reef', text by Mrs Parr, facing p.1, pp.8, 17, 24, 33, 40.
7. 1872 – Two illustrations to 'Fair Margaret', facing p.8, 9. Engraved by Frederick Wentworth.
8. 1872 – Two illustrations to 'The Glover's Daughter', pp.16, 17. Engraved by Frederick Wentworth.
9. 1872 – Three illustrations to 'La Bonne Mere Nanette', pp.49, facing p.55, 56. Engraved by W.J. Palmer and W.H. Hooper.
10. 1873 – Two illustrations to 'Marie Hachette', pp.32, 40. Engraved by W.H. Hooper.
11. 1875 – Two illustrations to 'Hilda's Hope', pp.56, 64. Engraved by Dalziel.
12. 1876 – Nine illustrations to 'By the Stone Ezel', pp.1, 8, 17, 24, facing p.28, 32, 40, 48, 56. Engraved by Swain.

GOOD WORDS

1. 1866 – 'Lilies'; this illustration relates to a poem on p.814 and in bound volumes it appears as the frontispiece to the year. Engraved by Dalziel.
2. 1866 – 'Chrissy was grateful for his evident sympathy', to 'The Old Yeomanry Weeks', facing p.126. Engraved by Swain.
3. 1 October 1866 – 'Deliverance', to poem of same title on p.663, the illustration is facing p.649. Engraved by Dalziel.
4. 1 November 1866 – 'Carissimo', facing p.736. Engraved by Dalziel.
5. 1867 – Five illustrations to 'The Starling', text by Norman Macleod (the editor of the magazine), facing p.32, 138, 216, 280, 366. Engraved by Dalziel.
6. 1867 – 'Beside the Stile', facing p.465. Engraved by Dalziel.
7. 1867 – 'The Highland Student', facing p.663. Engraved by Dalziel.
8. 1868 – Twenty-five illustrations, to 'The Woman's Kingdom', text by Mrs Craik, relating to pp.12, 16, facing p.65, 73, facing

GOOD WORDS FOR THE YOUNG

THE GRAPHIC

THE INFANT'S MAGAZINE

LONDON SOCIETY

6. February and March 1871 – Two illustrations to 'Up and down Moel Vammer', facing pp. 163, 232. Engraved by Dalziel.

7. October 1871 – 'Ricardo's Benefit', facing p.328. Engraved by Dalziel.

ONCE A WEEK

1. 6 January 1866 – 'Billy Blake's best coffin', · text by John Whittaker, p.15. Engraved by Swain.

2. 27 January 1866 – 'Kattie and "The Deil" ', p.99. Engraved by Swain.

3. 17 February 1866 – 'The King and the Bishop', p.183. Engraved by Swain.

4. 17 March 1866 – 'The Stag-Hound', to poem by Charles Mackay, p.295. Engraved by Swain.

5. 31 March 1866 – 'Thunnor's Slip', to poem by Eleanora Hervey, p.351. Engraved by Swain.

6. 26 May 1866 – 'Larthon of Inis-Huna', to poem by Eleanora Hervey, p.575. Engraved by Swain.

7. 7 July 1866 – 'Eldorado', p.15. Engraved by Swain.

8. 6 October 1866 – 'Dorette', to poem by Evelyn Forest, p.379. Engraved by Swain.

9. 27 October 1866 – 'The Gift of Clunnog Vawr', p.463. Engraved by Swain.

10. 3 November to 17 November 1866 – Three illustrations to 'The Prize Maiden', pp.491, 519, 560. Engraved by Swain.

11. 24 November 1866 – 'Tranquillity', to poem by C.S. Calverley, p.575. Engraved by Swain.

12. 12 and 19 January 1867 – Two illustrations to 'A Queer story about Banditti', pp.55, 83. Engraved by Swain.

13. 30 November 1867 – 'Imma and Eginhart', to poem by J. Mew, facing p.645. Engraved by Swain.

THE PEOPLE'S MAGAZINE

1. 1 June to 5 October 1867 – Twenty illustrations to 'Up and Down the Ladder', Text by William Gilbert, pp.337, 353, 369, 385, 401, 417, 433, 448, 465, 481, 497, 513, 529, 545, 561, 577, 593, 609, 625, 641.

THE QUIVER

1. November 1865 – Two illustrations to 'Turned to the Wall', text by John Francis Waller, pp.13, 17. Engraved by W. Thomas.

2. November 1865 – 'Said I, "Those shadowy tissues fill up the silvery tide" ', to 'Babble', p.57. Engraved by J. Williamson.

3. December 1865 – 'Dead and alone by the trysting-stone', to 'Between the Cliffs', p.153. Engraved by J. Williamson.

4. January 1866 – Two illustrations to 'The Grey Glen of St. Kieran's', pp.161, 177. The first is engraved by J. Cooper and the second by J. Williamson.

5. January 1866 – 'Yet had there been more work she would have been contented', to 'East by East', p.217. Engraved by J. Williamson.

6. February 1866 – 'They formed a pretty idyllic group', to 'The Bybrook Powder-Mills', text by Walter Thornbury, p.241. Engraved by J.Williamson.

7. February 1866 – Two illustrations to 'Mr. Weston's Mistake', pp.273, 289. Engraved by J.D. Cooper.

8. March 1866 – 'What were you asking her, Hetty?', to 'The Wheel of Fortune', text by Clement W. Scott, p.321. Engraved by W.J. Linton.

9. March to May 1866 – Five illustrations to 'The Deeper Depth', pp.345, 369, 441, 465, 497. Engraved by J.D. Cooper and W.J. Linton.

10. October 1866 – 'There's life in the old dog yet', to poem by Clement W. Scott, facing p.24. Engraved by Cassell, Petter and Galpin.

11. November 1866 – 'St. Columb of Iona', to poem by S.J. Stone, facing p. 90. Engraved by Cassell, Petter and Galpin.

12. December 1866 – Two illustrations to 'Only a Clerk', text by I.D. Fenton, pp.161, 177.

13. January 1867 – 'From broken steel and

bleeding clay…', to 'A Sleep Too Sound', facing p.232.

14. January 1867 – 'Over the border – of Middlesex', p.257.

15. February 1867 – 'The Rose-Wreath', p.289.

16. March 1867 – Two illustrations to 'The Right of Wrong', text by William Duthie, pp.369, 385.

17. August 1869 – 'There's no help for it: we can't find work for you', to 'A Muddy Day in Muddlesford and what came of it', p.697.

THE SUNDAY AT HOME

1. 1 December to 29 December 1866 – Five illustrations to 'The Fortune of the Granbys', pp.753, 769, 785, 801, 817. Engraved by Swain.

2. 6 April to 25 May 1867 – Seven illustrations to 'Blind John Netherway', pp.209, 225, 241, 257, 273, 289, 321. Engraved by Swain.

THE SUNDAY MAGAZINE

1. 1 June 1866 – 'A Sunday Afternoon in a London Court', facing p.604. Engraved by Swain.

2. 2 July to 1 September 1866 – Three illustrations to 'Annals of a Quiet Neighbourhood', facing p.641, pp.713, 786. Engraved by Swain.

3. 1 October 1866 – ' "Wind me a summer crown", she said', to poem by M.B. Smedley, facing p.65. Engraved by Dalziel.

4. 1 August 1867 – 'Philip's Mission', facing p.752. Engraved by Swain.

5. 1 December 1867 – 'Sonday morning', facing p.182. Engraved by Dalziel.

6. 1 December 1869 – 'The Strength of Weak Things', text by Benjamin Orme, p.176. Engraved by Dalziel.

7. 1 January 1871 – 'The Seaside Well', to poem by John Kerr, p.249. Engraved by Dalziel.

8. 1 April 1871 – 'One of Many', facing p.446. Engraved by Dalziel.

9. 1 May to 1 September 1871 – Fourteen illustrations to 'The Story of the Mine',

pp.449, 457, facing p.461, 513, facing p.521, 521, 577, 584, facing p.592, 681, 689, facing p.693, 705, 713. Engraved by Dalziel.

10. c.May 1873 (day not known) – 'Perfect Peace', to poem by H.A. Page, p.496.

SOLOMON, Simeon

THE DARK BLUE

1. April 1871, vol I. – 'The End Of A Month', to poem by Swinburne, facing p.217. Engraved by Horace Harral. Signed with Solomon's monogram and dated 1871 in the block. Solomon's name is curiously misspelt 'Salaman' beneath the image.

GOOD WORDS

1. 1862 – 'The Veiled Bride', p.592. Engraved by Dalziel.

THE LEISURE HOUR

1. 3 February to 29 December 1866 – Ten illustrations to 'Jewish Ceremonies and Customs', pp.73, 168, 217, 329, 377, 476, 540, 604, 653, 824. Engraved by Butterworth and Heath.

ONCE A WEEK

1. 9 August 1862 – 'The Marriage Ceremony', to 'Jews in England', p.192.

2. 9 August 1862 – 'Lighting the Lamps, Eve of the Sabbath', to 'Jews in England', p.193.

WALKER, Frederick

THE ARGOSY

1. June 1867 – 'Guy Griffith', facing p.34. Engraved by Swain. Although placed within a story by William MacCall called 'The Hermit of Ganting' the illustration does not seem to belong to it. This is a costume piece apparently not known to Gleeson White or Forrest Reid.

THE CORNHILL MAGAZINE

1. February 1861 – 'Round about the Christmas Tree', to 'Roundabout Papers –

No 10', text by W.M. Thackeray, an initial letter vignette on p.250.

2. May 1861 – 'Nurse and Doctor', to 'Philip', text by W.M. Thackeray, facing p.556. Engraved by Swain.

3. June 1861 – 'Hand and Glove', to 'Philip' by Thackeray, p.641. Engraved by Swain.

4. July 1861 – 'Good Samaritans', to 'Philip' by Thackeray, facing p.1. Engraved by Swain.

5. August 1861 – 'Charlotte's Convoy', to 'Philip' by Thackeray, facing p.129. Engraved by Swain.

6. September 1861 – 'Morning Greetings', to 'Philip' by Thackeray, facing p.257. Engraved by Swain.

7. October 1861 – 'A Quarrel', to 'Philip' by Thackeray, facing p.385. Engraved by Swain.

8. November 1861 – 'Miss Charlotte and her Partners', to 'Philip' by Thackeray, facing p.513. Engraved by Swain.

9. December 1861 – 'Comfort in Grief', to 'Philip' by Thackeray, facing p.641. Engraved by Swain.

10. January 1862 – 'The Poor Helping the poor', to 'Philip' by Thackeray, facing p.1. Engraved by Swain.

11. February 1862 – 'At the sick man's door', to 'Philip' by Thackeray, facing p.129. Engraved by Swain.

12. March 1862 – 'A Letter from New York', to 'Philip' by Thackeray, facing p.257. Engraved by Swain.

13. April 1862 – 'Mugford's favourite', to 'Philip' by Thackeray, facing p.385. Engraved by Swain.

14. May 1862 – 'Paterfamilias', to 'Philip' by Thackeray, facing p.513. Engraved by Swain.

15. June 1862 – 'Judith and Holophernes', to 'Philip' by Thackeray, facing p.641. Engraved by Swain.

16. July 1862 – 'More Free than Welcome', to 'Philip' by Thackeray, facing p.121. Engraved by Swain.

17. August 1862 – 'Thanksgiving', to 'Philip' by Thackeray, facing p.217. Engraved by Swain.

18. November 1862 – 'Are cooks like ladies: Do they get to hate their lives sometimes?', to 'The Story of Elizabeth', facing p.623. Engraved by Swain.

19. December 1862 – 'On the top of the Hill', to 'The Story of Elizabeth', facing p.814. Engraved by Swain.

20. January 1863 – 'Out in the Garden', to 'The Story of Elizabeth', facing p.104. Engraved by Swain.

21. February 1863 – 'The First Meeting', to 'The … in the Closet. Passages extracted from the journal of the Baron Delaunay', facing p.203. The drawing is unsigned, but very close to Walker in style. Engraved by Swain.

22. May 1863 – 'Maladetta', facing p.621. Engraved by Swain.

23. August 1863 – 'Arrival of the Bride', to 'Mrs Archie', facing p.180. Engraved by Swain.

24. September 1863 – 'Horatia's first visit', to 'Out of the World', facing p.366. Engraved by Swain.

25. October 1863 – 'The Doctor's secret half surprised', to 'Out of the World', facing p.449. Engraved by Swain.

26. March 1864 – 'Little Denis dances and sings before the Navy Gentleman', to 'Denis Duval', text by W.M.Thackeray, facing p.261. Forrest Reid (p.142) remarks that this was a design made by Walker after a watercolour by Thackeray who had died some months before. Engraved by Swain.

27. April 1864 – 'Last moments of the Count of Saverne', to 'Denis Duval', facing p.385. Engraved by Swain. Also an initial letter illustration on p.385.

28. May 1864 – 'Evidence for the Defence', to 'Denis Duval', facing p.513. Engraved by Swain. Also an initial letter illustration on p.513.

29. June 1864 – 'Denis's Valet', to 'Denis

Duval', facing p.641. Engraved by Swain. Also an initial letter illustration on p.641.

30. July 1866 to January 1867 – Thirteen illustrations to 'The Village on the Cliff', text by Anne Thackeray, facing p.1, p.1 (vignette), facing p.129, pp.129 (vignette), 358 (vignette), facing p.487, 487 (vignette), facing p.513, 513 (vignette), facing p.641, 641, facing p.75, 75. Engraved by Swain.

31. June 1867 – Two illustrations to 'Beauty and the Beast', p.676, facing p.676. Engraved by Swain.

32. October 1867 – Two illustrations to 'Little Red Riding Hood', p.440, facing p.440. Engraved by Swain.

33. December 1867 to January 1868 – Four illustrations to 'Jack the Giant-killer', facing p.1, p.1, facing p.739, p.739 (vignette). Engraved by Swain.

34. March 1868 – Two illustrations to 'I do not love you', p.330 (vignette) and 'A kiss' facing p.330. Engraved by Swain.

35. November 1868 – 'Lady Jane', to 'From an Island', facing p.610. Engraved by Swain.

36. July 1869 – Two illustrations to 'Sola', p.102 (initial letter vignette) and facing p.102. Engraved by Swain.

EVERBODY'S JOURNAL

1. 21 and 28 January 1860 – Two illustrations to 'The Road of Wrong', text by Edmond About, pp.251, 265. Engraved by Swain.

GOOD WORDS

1. September 1861 – 'The Blind School', p.505. Engraved by Dalziel.

2. November 1861 – 'Only a Sweep', p.609. Engraved by Dalziel.

3. March 1862 – 'Love in Death', text by Dora Greenwell, p.185. Engraved by Dalziel.

4. 1862 – 'The Summer Woods', p.368. Engraved by Dalziel.

5. 1862 – 'Out Among the Wild-Flowers', p.657. Engraved by Dalziel.

6. 1864 – Eight illustrations to 'Oswald Cray', text by Mrs Henry Wood, facing pp. 34,

129, 202, 286, 371, 453, 532, 604. Engraved by Swain.

7. 1867 – 'Waiting in the dusk', facing p.776. Engraved by Swain.

THE GRAPHIC

1. 25 December 1869 – 'The lost path', p.85. Engraved by W. Thomas. Made after the watercolour, the design appears first as 'Love in Death' in *Good Words* for March 1862, p.185.

THE LEISURE HOUR

1. 26 December 1861 – 'Take this officer's sword and consider him your prisoner', to 'A True Story of the Great Fritz of Prussia', p.817.

LONDON SOCIETY

1. June 1862 – 'The Drawing-Room "Paris" ', facing p.441. Engraved by Dalziel.

ONCE A WEEK

1. 18 February 1860 – 'Peasant Proprietorship', p.165. Engraved by Swain.

2. 25 February 1860 – 'God Help our Men at Sea', p.198. Engraved by Swain.

3. 17 March 1860 – 'An Honest Arab', p.262. Engraved by Swain.

4. 7 April 1860 – 'Après', p.330. Engraved by Swain.

5. 21 April 1860 – 'Lost in the Fog', p.370. Engraved by Swain.

6. 5 May 1860 – 'Spirit Painting', p.424. Engraved by Swain.

7. 19 May 1860 – 'Tenants at number twenty-seven', p.481.

8. 2 June 1860 – 'The Lake at Yssbrooke', p.538. Engraved by Swain.

9. 30 June 1860 – Two illustrations to 'Once upon a time', poem by Eliza Cook, pp.24, 25. Engraved by Swain.

10. 11 August 1860 – Two illustrations to 'Markham's Revenge', pp.182, 184. Engraved by Swain.

11. 18 August 1860 – 'Wanted – A diamond ring!', p.210. Strangely unsigned though clearly by Walker and indexed as such.

12. 1 September 1860 – 'First Love', p.322.

13. 8 September 1860 – 'A Noctuary of Terror', p.294.

14. 22 September 1860 – 'The Unconscious Body-guard', p.359. Engraved by Swain.

15. 20 October to 3 November 1860 – Five illustrations to 'The Herberts of Elfdale', text by Mrs Crowe, pp.449, 454, 477, 505, 508. Engraved by Swain.

16. 17 November 1860 – 'Black Venn', p.583. Engraved by Swain.

17. 8 December 1860 – 'His hand upon the latch', p.668.

18. 22 December 1860 – 'Putting up the Christmas', p.723. Engraved by Swain.

19. 5 January 1861 – 'Under the Fir Trees', p.43. Engraved by Swain.

20. 12 January 1861 – 'Voltaire at Breakfast at Ferney', to 'The Heart of Voltaire Living and Dead', p.66.

21. 19 January 1861 – Two illustrations to 'Bring me a light!', pp.102, 105. Engraved by Swain.

22. 9 February 1861 – 'A General Practitioner in California', p.189.

23. 23 February 1861 – 'The Parish Clerk's Story', p.248. Engraved by Swain.

24. 2 March 1861 – Two illustrations to 'The Magnolia, for London with Cotton', pp.263, 267. Engraved by Swain.

25. 6 April 1861 – 'Dangerous!', p.416. Engraved by Swain.

26. 27 April 1861 – 'An Old Boy's Tale', p.499. Engraved by Swain.

27. 18 May 1861 – 'Romance of the Cab-Rank', p.585. Engraved by Swain.

28. 1 June 1861 – 'The Jewel-Case', p.631. Engraved by Swain.

29. 29 June 1861 – 'Jessie Cameron's Bairn', p.15. Engraved by Swain.

30. 13 July 1861 – 'The Deserted Diggings', p.83. Engraved by Swain.

31. 27 July 1861 – Two illustrations to 'Pray, Sir, Are you a Gentleman?', pp.127, 133. Engraved by Swain.

32. 7 September 1861 – 'A run for life', p.306.

33. 14 September 1861 – 'Cader Idris – The Chair of Idris', p.323. Engraved by Swain.

34. 12 October to 21 December 1861 – Eleven illustrations to 'The Settlers of Long Arrow', pp.421, 449, 477, 505, 533, 561, 589, 617, 645, 673, 701. Engraved by Swain.

35. 25 January 1862 – Two illustrations to 'Patty', pp.126, 127. Engraved by Swain.

36. 15 February 1862 – 'A Dreadful Ghost', text by Mrs Craik, p.211. Engraved by Swain.

37. 19 April to 12 July 1862 – Thirteen illustrations to 'The Prodigal Son', text by Dutton Cook, pp.1, 29, 57, 449, 477, 505, 533, 561, 589, 617, 645, 673, 701. Engraved by Swain.

38. 11 October to 25 October 1862 – Three illustrations to 'The Deadly Affinity', pp.421, 449, 477. Engraved by Swain.

39. 22 November 1862 – 'Spirit Rapping Extraordinary', p.614.

40. 28 March 1863 – 'Nach Zehn Jahren (After Ten Years)', p.378. Engraved by Swain.

41. 12 September 1863 – 'The Ghost in the Green Park', p.309. Engraved by Swain.

42. 27 January 1866 – 'The Vagrants', facing p.112. Engraved by Swain.

WATSON, John Dawson

THE BAND OF HOPE REVIEW

1. 1 October 1866 – 'Grandmother and Child', p.277. Engraved by John Knight. This illustration was also printed in colour on the cover of the volume for 1866.

THE BRITISH WORKMAN

1. August 1863 – 'Preparing for the Flower Show – A Sketch in St. George's Bloomsbury', p.413. Engraved by John Knight. This illustration was reprinted in colour on the cover of the volume for 1864.

2. January 1864 – 'The astonished sceptic and the influence of the old Bible', p.433. Engraved by John Knight. The illustration is dated 1863 in the block.

3. 1 August 1864 – 'My Account with Her

Majesty', p.461. Engraved by John Knight.

4. 1 October 1864 – 'The Princess of Wales giving flowers in the hospital ward', p.469. Engraved by John Knight.

5. 1 February 1865 – 'Parley the Porter and Mr Flatterwell', p.5. Engraved by John Knight.

6. 2 October 1865 – 'The Richest Man in the Parish', p.37. Engraved by John Knight.

CASSELL'S MAGAZINE

1. April 1867 – 'Ethel', to poem by H. Savile Clarke on p.23, bound in as the frontispiece.

2. 1870 – 'Ragged babes that weep', to 'The Children of the Poor', to poem translated by Swinburne, facing p.329. Engraved by Thomas Cobb.

3. August 1870 – 'She knew my hopes were hers', to 'Affinity', facing p.552. Engraver not ascertained.

CHURCHMAN'S FAMILY MAGAZINE

1. January 1863 – 'Only Grandmamma', facing p.88. Engraved by Dalziel.

2. January 1863 – 'The Christian Martyr', facing p.104. Engraved by Dalziel.

3. February 1863 – 'Sunday Evening', facing p.190. Engraved by Dalziel. This illustration was intended as the frontispiece of this number.

4. March 1863 – 'The Hermit', facing p.260. Engraved by Dalziel.

5. April 1863 – 'Her arms are wound about the tree', to 'Mary Magdalene', facing p.346. Engraved by Dalziel.

6. December 1864 – 'Crusaders coming in sight of Jerusalem', facing p.557. Engraved by Dalziel.

FRIENDLY VISITOR

1. 1 February 1867 – Untitled illustration, p.32.

2. 1 May 1867 – To 'The Empty Cradle', p.80.

3. 1 June 1867 – To 'John Brown, the Sensible Gravedigger', p.85. Engraved by Dalziel.

4. 1 July 1869 – 'The Shoes of iron and brass', p.109. Engraved by Dalziel.

5. September 1869 – 'The Old Folks at Home', text by Revd John Todd, p.141. Engraved by Dalziel.

GOOD WORDS

1. January 1861 – 'The Toad', text adapted from Victor Hugo, p.33. Engraved by Dalziel.

2. February 1861 – 'The Babes in the Wood', p.120. Engraved by Dalziel.

3. March 1861 – 'Oh, it's hard to die frae hame', p.161. Engraved by Dalziel.

4. April 1861 – 'An Artisan's Story', p.209. Engraved by Dalziel.

5. September 1861 – 'Wee Davie', text by Norman Macleod (the editor), this story first appeared in the magazine in February of the same year and was originally unillustrated; the illustration is to be found inside the front wrapper. Engraved by Dalziel.

6. 1862 – ' "Vesper" Make haste home children', p.9. Engraved by Dalziel.

7. 1862 – ' "Vesper" Old Customs, Old Folk', p.81. Engraved by Dalziel.

8. 1862 – Two illustrations to 'A Cast in the Wagon', text by Sarah Tytler, pp.144, 209. Engraved by Dalziel.

9. 1862 – 'The Crimson Flower', p.302. Engraved by Dalziel.

10. 1862 – 'The East', p.400. Engraved by Dalziel.

11. 1862 – 'The Sabbath Day', p.433. Engraved by Dalziel.

12. 1863 – 'A Pastoral', facing p.32. Engraved by Dalziel.

13. 1863 – 'Fallen in the Night!', to poem by Mrs Craik, facing p.97. Engraved by Dalziel.

14. 1863 – 'The Curate of Suverdsio', facing p.333. Engraved by Dalziel.

15. 1863 – 'The Aspen', facing p.401. Engraved by Dalziel.

16. 1863 – 'Rhoda; or the Whistle', facing p.520. Engraved by Dalziel.

17. 1863 – 'The Sheep and the Goat', to poem by George Macdonald, facing p.671. Engraved by Dalziel.

18. 1863 – 'Oliver Shand's Partner', facing p.774. Engraved by Dalziel.

THE GRAPHIC

1. 12 February 1870 – 'Duck Shooting in the North', p.249.
2. 19 February 1870 – 'The Life Brigade Man', p.273. Engraved by Horace Harral.
3. 22 October 1870 – 'The favourite of the Regiment', p.397.
4. 4 February 1871 – 'The Fisherman's Darling', p.101.
5. 7 October 1871 – 'The Autumn Campaign – The Messmates', p.337.
6. 4 November 1871 – 'The Fugitives from Chicago', p.437. Engraved by Horace Harral.

THE INFANT'S MAGAZINE

1. June 1866, no. 6 – 'A ramble in the fields', p.94. Engraved by Dalziel.
2. 1 March 1867, no. 15 – 'Asking a Blessing', p.48. Engraved by Dalziel.
3. 1 August 1867, no. 20 – 'Walk in the garden', p.127. Engraved by Dalziel.

LONDON SOCIETY

1. February 1862 – 'Spring Days', to poem by Keats on p.79, frontispiece. Engraved by Dalziel.
2. March 1862 – 'Ash Wednesday', to poem by John Keble, facing p.150. Engraved by Dalziel.
3. June 1862 – 'Romance and a Curacy', facing p.385. Engraved by Dalziel.
4. July 1862 – 'The Moment of Success', to 'Notes from the Life of a Tragedienne', facing p.1. Engraved by Dalziel.
5. August 1862 – 'A Summer's Eve in a Country Lane', this illustration relates to a poem on p.162; facing p.97. Engraved by Dalziel.
6. October 1862 – 'A view on the Coast', p.321. Engraved by Dalziel.
7. October 1862 – 'Moonlight on the Beach: A Sketch at Ramsgate', to 'On being shunted', p.333.
8. October 1862 – 'Holiday Life at Ramsgate', to 'On being shunted', p.338. Engraved by Dalziel.
9. November 1862 – 'Married! Married! and not me!' to 'In the "Times" ', facing p.449. Engraved by Dalziel.
10. December 1862 – 'How I gained a wife and fell into a fortune', facing p.551. Engraved by Dalziel.
11. 1862, Christmas number – 'What came of our Christmas Party', either facing p.1 or p.79. Engraved by Dalziel.
12. February 1863 – 'Struck Down!', to 'Why the Bishop gave Thompson a Living', facing p.106. Engraved by Dalziel.
13. April 1863 – 'The Heiress of Elkington', facing p.344. Engraved by Dalziel.
14. July 1863 – 'The Doctor's Fortune', either facing p.77 or frontispiece. Engraver's name not ascertained.
15. March 1864 – 'The Duet', facing p.193. Engraved by Dalziel.
16. November 1864 – 'Blankton Weir – A Waterside Lyric', facing p.416.
17. 1864, Christmas number – 'The Story of a Christmas Fairy', facing p.25. Engraved by ARM (not identified).
18. November 1865 – Three illustrations to 'Green Mantle', p.385, facing pp.388, 391. Engraved by BM (not identified).
19. 1865, Christmas number – 'Christmas at Oldminster', facing p.36. Engraved by BM (not identified).
20. 1866, Christmas number – 'Given Back on Christmas Morn', facing p.63. Engraved by Dalziel.
21. April 1867 – 'Changes', p.373. Engraved by Dalziel.
22. 1867, Christmas number – 'Christmas Eve at the Old Manor House', double-page illustration between pages 86 and 87. Engraved by Dalziel.
23. January 1868 – 'A Happy New Year!', facing p.47. Engraved by Dalziel.
24. June 1868 – 'One year ago', facing p.481 (as frontispiece) or facing p.563. Engraved by Dalziel.
25. 1868, Holiday number – 'In Dull Court', frontispiece to story on pp. 91–6 'From Dull Court to Fairview'. Engraved by Dalziel.

26. November 1868 – 'The Oracle', to 'The Maiden's Oracle', facing p.457 or as frontispiece. Engraved by Dalziel.

27. 1868, Christmas number – 'Aunt Grace's Sweetheart', facing p.22. Engraved by W. Thomas.

28. 1868, Christmas number – 'The Two Voices', to 'Suspiria de Profundis', poem by Robert Buchanan, facing p.86. Engraved by Dalziel.

29. June 1869 – 'Bringing home the May', facing p.528. Engraved by Dalziel. This illustration is indexed as being intended as the frontispiece of the bound volume.

30. 1869, Christmas number – 'Second Blossom; or the Christmas Sermon', facing p.16. Engraved by Dalziel.

31. 1870, Holiday number – 'Who would not be a landscape painter?', frontispiece relating to a poem on p.47. Engraved by Dalziel.

32. 1870, Christmas number – Two illustrations to 'What might have happened one Christmas Time', text by Mark Lemon (this was the last story Lemon wrote), facing p.9, p.19. Engraved by Dalziel.

33. 1870 – 'Going down to the boat', to the poem on pp.494–5, placed as the frontispiece to the volume. Engraved by Dalziel.

THE MARK (Christmas number of *The Quiver*)

1. 1868 – 'I have gems of gold of price untold', to 'Laurentius', facing p.36. Engraved by W. Thomas.

2. 1868 – 'Your hand in mine, I won sweet wife …', to 'Seasons', poem by J.F. Waller, facing p.60. Engraved by W. Thomas.

ONCE A WEEK

1. 23 May 1863 – 'Mawgan of Melluach, the Cornish Wrecker', p.602. Engraved by Swain.

2. 15 August 1863 – 'No Change', p.210. Engraved by Swain.

3. 29 August 1863 – 'My Home', p.266. Engraved by Swain.

THE QUIVER

1. December 1866 – 'The last country walk we took …', to 'My Cousin's Portrait', text by Isabella Fyvie, facing p.136.

2. January 1867 – 'The Conversion of Constantine', facing p.227.

3. January 1867 – 'Gloria in Excelsis', to poem by J.F. Waller, facing p.248.

4. April 1867 – '… his trusty page took the glad monarch in his arms', to 'The Sea King', p.441.

5. May 1867 – 'As when the sunlight on this prison floor …', to 'The Prisoner', p.537. Engraved by Cosson and Smeeton.

6. June 1867 – 'Why, like a traitor, hist and tremble …', to 'Ye Gospelle of Sainte John', facing p.596.

7. August 1867 – 'And o'er Dagmar, as he bent above her …', to 'The Dagmar Cross', text by H. Savile Clarke, p.745.

8. August 1867 – 'And he moves as one moves to a throne', to 'Moses', facing p.766.

9. October 1867 – 'Mother and little ones gather …', to 'An Idyll of Labour', poem by J.F. Waller, p.25.

10. October 1867 – 'With that he laughed upon my fallen pride', to 'A Dream of Sin', p.57.

11. December 1867 – 'And Wisdom then and there they slew', to 'Wisdom', p.201. Engraved by W. Thomas.

12. February 1868 – Two illustrations to 'Sowing in Tears', pp.321, 337. Engraved by W. Thomas.

13. April 1868 – 'I saw the pale face which had been with me in my dreams', to 'Over the Horn', p.497. Engraved by W. Thomas.

14. July 1868 – 'Pass sweetly to thy rest', to 'Fled!', p.681. Engraved by W. Thomas.

15. July 1868 – 'Slowly on by fount and

tree …', to 'Judgement and Mercy', p.713. Engraved by W. Thomas.

16. July 1868 – 'And now their journey endeth …', to 'Round the Walls', p.745. Engraved by W. Thomas.

17. December 1868 – 'The Artist's Boat', facing p.202. Engraved by W. Thomas.

18. February 1869 – 'And go thou forth a banished man', to 'The Woodland Flower', poem by Eleanora Hervey, facing p.315. Engraved by W. Thomas.

19. March 1869 – 'Sittest thou by the wayside ...', to 'By the Wayside', p.345. Engraved by W. Thomas.

20. April 1869 – 'Honour and wealth to the boldest hand', to 'The Idol-Breakers', p.409. Engraved by W. Thomas.

21. June 1869 – 'Cry loud! besiege Him with thy prayers…', to 'Light and Darkness', p.585. Engraved by W. Thomas.

THE ROUND ROBIN (The annual volume of *Merry and Wise*)

1. 1872 – 'Burying Cecil up to the neck …', to 'A Handful', facing p.56. Engraved by Edmund Evans.

2. 1872 – 'Spring', facing p.241. Engraved by Edmund Evans and printed in colour. This illustrates no text.

3. 1872 – 'John goes to school', to 'The Boy with an idea', text by Elizabeth Eiloart, p.281. Engraved by Dalziel.

4. 1872 – 'Autumn', facing p.721. Engraved by Edmund Evans and printed in colour. This illustrates no text.

5. 1872 – To 'A Night in a Snow Storm', text by Charles Bruce, p.888. Engraved by Dalziel.

THE SERVANT'S MAGAZINE

1. 1 March 1869 – 'She threw her trembling arms around the neck of her prodigal', to

'My Thieving; and what came of it', p.57. Engraved by Dalziel.

THE SHILLING MAGAZINE

1. June to December 1865 – Seven illustrations to 'Phemie Keller', June to August facing pp.129, 257, 385 and September to December facing pp.1, 129, 257, 385. There were, according to Gleeson White (p.65), eight illustrations to this story but I have only been able to see seven.

SUNDAY MAGAZINE

1. 1 March 1867 – 'The Cottar's Farewell', facing p.417. Engraved by Dalziel.

TINSLEY'S MAGAZINE

1. August 1868 – 'Separate', facing p.87.

2. September 1868 – 'A Year's Work', facing p.190.

3. October 1868 – 'Go with your father's sword, my boy', to 'Wyvil's Hour', facing p.278. Engraved by Edmund Evans.

WHISTLER, James McNeil

GOOD WORDS

1. 1862 – Two illustrations to 'The Trial Sermon', pp.585, 649. Engraved by Dalziel.

ONCE A WEEK

1. 21 June 1862 – 'The Major's Daughter', p.712. Engraved by Swain.

2. 26 July 1862 – 'The Relief Fund in Lancashire', p.140. This was intended to accompany an address by Tennyson concerning the plight of the Lancashire weavers, but he (Tennyson) was not well enough to write it.

3. 16 August 1862 – 'The Morning before the Massacre of St. Bartholomew, August 1572', to poem by Walter Thornbury, p.210. Engraved by Swain.

4. 27 September 1862 – 'Count Burkhardt', p.378. No engraver's name.

Index of illustrated books

This index is arranged alphabetically by the name of the author. Sources cited refer to first editions only unless otherwise stated. Dates and names of authors are enclosed within square brackets where such information does not appear anywhere in the books but is known from external sources. Books are listed under each author in order of date of publication. The dates given are those actually found in the books but many were published in the autumn of the preceding year in order to be available in good time for the Christmas market. Where I am certain that designs were reprinted from earlier editions this is stated, but with so many volumes examined it is inevitable that some of those included may well contain drawings from previous works and I crave the indulgence of readers. It was common practice for the illustrations to be re-used in a cavalier fashion often with entirely new titles and years after their original appearance. All books referred to were published in London unless noted otherwise.

'Previously unrecorded' is used, with no sense of triumph, to denote that I have been unable to find a record of a book in either of the two standard works by Gleeson White (1897) and Forrest Reid (1928). It is included simply to save the reader effort in attempting to search for a reference where none exists. However, the term should not be understood to suggest that a book, thus marked, may not be recorded in some other work.

Abbreviations

ABT Antiquarian Book Trade
BL British Library, Department of Printed Books
BM British Museum, Department of Prints and Drawings – Robin de Beaumont Collection and main collection
LL The London Library
MFAB Boston, Museum of Fine Arts – Hartley Collection
NE Not examined. Books thus marked, I am sure exist, but I have been unable to see a copy in any collection, public or private
NGA National Gallery of Australia – Eric de Maré Collection
PC Private Collection
PML Pierpont Morgan Library, New York – Gordon N. Ray Collection.

SPCK Archive of the Society for Promoting Christian Knowledge, London
V&A Victoria and Albert Museum, National Art Library – Harrod Collection

ADAMS, Revd H.C.

1. *Balderscourt or Holiday Tales*
 Pub. George Routledge and Sons, 1866.
 Seven engravings by Dalziel after Arthur
 Boyd Houghton. The frontispiece does not
 appear to be by Houghton.
 BM BL V&A

2. *Barford Bridge or Schoolboy Trials*
 Pub. George Routledge and Sons, 1868.
 Eight engravings by Dalziel after Arthur
 Boyd Houghton. These designs first
 appeared in *Routledge's Magazine for Boys* in
 1866. This magazine is also known as *Every
 Boy's Magazine*.
 BL

AESOP

3. *The Fables of Aesop and Others Translated into
 Human Nature by Charles H. Bennett*
 Pub. W. Kent and Co., [1857] (October)
 Engravings by Swain after C.H. Bennett.
 The book was issued in two forms: plain at
 6 shillings and 10 shillings and 6 pence hand
 coloured.
 BL MFAB

ALFORD, Dean Henry

4. *The Lord's Prayer*
 Pub. Longmans, Green, Reader and Dyer,
 1870.
 Nine full-page illustrations engraved by
 Dalziel after F.R. Pickersgill. Printed on
 toned paper.
 BM PML

ALLAN, Revd John

5. *John Todd and How He Stirred his own*

Broth Pot
Pub. Houlston and Wright and S.W.
Partridge, [1864].
Four engravings by John Knight after C.H.
Bennett. This book is dated 1863 in the
English Catalogue of Books but the British
Library copy was not received until January
1865. Hence my suggested date is a tentative
one.
Previously unrecorded
BL

ALLINGHAM, William

6. *The Music Master, A Love Song, and Two
 Series of Day and Night Songs*
 Pub. G. Routledge and Co., 1855.
 Engravings by Dalziel after Arthur Hughes
 (seven including vignette on title page) and
 one each after Rossetti and Millais.
 Rossetti's contribution is the celebrated
 'Maids of Elfen-Mere'. This is an enlarged
 and illustrated edition of *Day and Night
 Songs* which appeared with a title roundel
 vignette by Walter Deverell in 1854. A
 second edition entitled *Day and Night Songs
 and the Music Master. A Love Poem* was
 published by Bell and Daldy in 1860. In this
 edition Hughes's 'The Fairies' replaced his
 'Crossing the Stile' as frontispiece. The book
 was again reprinted in 1884 but without
 illustrations.
 BM BL V&A PML MFAB

7. *The Ballad Book*
 Pub. Macmillan and Co., 1864 (*Golden
 Treasury Series*).
 Title-page illustration is a steel-engraving by
 C.H. Jeens after Sir J. Noel Paton.
 BL

8. *Flower Pieces and other Poems*
 Pub. Reeves and Turner, 1888.

Frontispiece is a reprint of Rossetti's 'Maids of Elfen-Mere' (see *The Music Master*) and facing p.89 is a photograph of a drawing by Rossetti illustrating 'The Queen's Page'.
BL PML

9. *Life and Phantasy*
Pub. Reeves and Turner, 1889.
Frontispiece is a reprint of 'The Fireside Story' by Millais which had first appeared in Allingham's *The Music Master* in 1855. The book also contained a reprint of Hughes's 'The Fairies' which likewise made its first appearance in the same work.
BL

A.L.O.E. (A Lady of England) Pseud.
Charlotte Maria Tucker

10. *Exiles in Babylon or Children of Light*
Pub. T. Nelson and Sons, 1864.
Seven engravings printed in brown by Robert Paterson, George Hoddle and Williamson after William Small.
BL PML (1870)

11. *Marion's Sundays or Stories on the Ten Commandments*
Pub. T. Nelson and Sons, 1864.
Four designs printed in brown engraved by Robert Paterson after William Small.
PML

12. *On the Way or Places Passed by Pilgrims*
Pub. T. Nelson and Sons, 1868.
Seven engravings by various engravers after William Small.
Note I have only been able to see this book in a reprint of 1881.
Previously unrecorded.
PC

13. *Precepts in Practice*
Pub. T. Nelson and Sons, 1870.
Engravings by various engravers after several artists including William Small and John Lawson.
Previously unrecorded.
BL

ANDERSON, Revd John

14. *The Pleasures of Home*
Pub. Arthur Hall, Virtue and Co., [1856].
Frontispiece engraved by T. Williams after Millais. Professor W.E. Fredeman, to whom I am indebted for having drawn my attention to this illustration, believes that the correct date for this volume is 1855. I suggest the next year based on the accession date found in the British Library copy.
Previously unrecorded.
BL

ANONYMOUS

15. *Alice Gray or The Ministrations of a Child*
Pub. Society for Promoting Christian Knowledge, n.d.
Frontispiece engraved by an unknown engraver after J. Mahoney
Previously unrecorded.
SPCK

16. [Translated from the German of Christoph von Schmid] *The Basket of Flowers*
Pub. T. Nelson and Sons, Edinburgh, 1864.
Two engravings by Robert Paterson after William Small. There was another dated edition in 1868.
Previously unrecorded.
BL

17. *The Children and the Robin – A Book for Boys*
Pub. Frederick Warne and Co., [1874].
Two engravings by Dalziel after William Small. The other illustrations are by A.W. Cooper.
Previously unrecorded.
BL

18. *Days of Old – Three Stories from Old English History for the Young* by the author of *Ruth and her Friends*
Pub. Macmillan and Co., 1859.
Frontispiece engraved by W.J. Linton after W. Holman Hunt. The engraving is dated 58 (1858) in the block.

Previously unrecorded.
BL BM

19. *The Dowie Dens O' Yarrow*
Pub. For Members of the Royal Association
for the Promotion of the Fine Arts in
Scotland, 1860.
Six steel-engravings by Robert Bell, Lumb
Stocks and C.W. Sharpe after Sir Joseph
Noel Paton.
BM

20. *Eildon Manor: A Tale for Girls*
Pub. Routledge, 1861.
Engravings by Dalziel after J.D. Watson. I
have only been able to see proofs of these
engravings in the Dalziel Collection (British
Museum).
NE

21. *Eyebright – A Tale from Fairyland*
Pub. C.J. Jacob (Basingstoke) 1862.
Frontispiece engraved by an unidentified
engraver after Charles Keene.
BL

22. *Games and Sports for Young Boys*
Pub. Routledge, Warne, and Routledge,
1859.
Engravings by unidentified engravers after
various artists including C.H. Bennett.
Previously unrecorded.
BL

23. *Games of Skill and Conjuring*
Pub. Routledge, Warne and Routledge,
1861.
Engravings by an unidentified engraver after
various artists including C.H. Bennett.
Previously unrecorded.
BL

24. *The Gold Chain*
Pub. Society for Promoting Christian
Knowledge, [1866].
Engravings by an unidentified engraver after
various artists including J. Mahoney.
Previously unrecorded.
SPCK

25. *The Gold Stone Brooch*
Pub. Society for Promoting Christian
Knowledge, [1865].
Engravings by an unidentified engraver after
J. Mahoney.
Previously unrecorded.
SPCK

26. [Margaret Punnett, later Mrs Butlin]
Helen's Trouble
Pub. Society for Promoting Christian
Knowledge, [1869].
Frontispiece engraved by an unidentified
engraver after J. Mahoney.
Previously unrecorded.
SPCK

27. (A.E.W.)
Mary Ashford
Pub. Society for Promoting Christian
Knowledge, [1868].
Engravings by an unknown engraver after
J. Mahoney.
Previously unrecorded.
SPCK

28. *The Schoolmaster's Warning*
Pub. Society for Promoting Christian
Knowledge, [1865].
Engravings by an unidentified engraver after
J. Mahoney.
Previously unrecorded.
SPCK

29. *The Secret Fault*
Pub. Society for Promoting Christian
Knowledge, [1866].
Engravings by an unidentified engraver after
J. Mahoney.
Previously unrecorded.
SPCK

30. *Stories on the Commandments*
Pub. Society for Promoting Christian
Knowledge, [1865].
Four engravings by Whymper after
J. Mahoney. The dedication to Mrs Gatty is
dated April 1865.

Previously unrecorded.
PC

31. *Stories on my Duty towards God*
Pub. Society for Promoting Christian
Knowledge, [1865].
Engravings by an unidentified engraver after
J. Mahoney.
Previously unrecorded.
PC

32. *Tom Barton's Trial and other Stories*
Pub. Society for Promoting Christian
Knowledge, [1866].
Engravings by an unidentified engraver after
J. Mahoney.
Previously unrecorded.
SPCK

33. [Charles Manby Smith]
Tom Butler's Trouble – A Cottage Tale
Pub. Frederick Warne and Co., 1868.
Frontispiece and title-page illustration
engraved by Dalziel after William Small.
Printed in colours.
Previously unrecorded.
PML

34. *Tom Ilderton*
Pub. Hamilton (Edinburgh), 1865.
Frontispiece engraved by Williamson after
William Small.
I have only been able to see a later edition
(undated) of this book published by
Oliphant Anderson and Ferrier (Edinburgh).
Previously unrecorded.
PC

35. *The Trial of Obedience*
Pub. Society for Promoting Christian
Knowledge, [1865].
Engravings by an unidentified engraver after
J. Mahoney.
Previously unrecorded.
SPCK

36. *The Twins and their Stepmother*
Pub. Routledge, Warne and Routledge,
1861.

Four engravings by Dalziel after Frederick
Walker. Probably published in December
1860.
BL

37. *Woman's Strategy or The First time I Saw Her*
Pub. G.W. Carleton and Co. (New York)
and Hogg and Sons (London), 1867.
Nine illustrations engraved by Dalziel after
Thomas Morten. Reprinted from *London
Society* July-September 1863.
BL

ANTHOLOGY

38. *Art Pictures from the Old Testament*
Pub. Society for Promoting Christian
Knowledge, 1894.
Engravings by the Dalziel Brothers after
Leighton, Watts, T. Dalziel, Simeon
Solomon, Holman Hunt, Armitage, Dyce,
F.M. Brown, Poynter, Sandys, Pickersgill,
Pinwell, Burne-Jones, Houghton. Text by
Aley Fox. Ninety-seven engravings largely
from *Dalziel's Bible Gallery* (q.v.). Copies
appear with the same date bearing the
imprint of J.S. Virtue and Co. Ltd.
BM BL V&A PML MFAB

39. *The Attractive Picture Book*
Pub. Griffith and Farran, [1867].
Illustrations by C.H. Bennett, R. Doyle, du
Maurier, Gilbert, Pinwell, Harrison Weir
etc. All the designs are presumably reprinted
from other books.
Previously unrecorded.
NE

40. *Aunt Bessie's Picture Book*
Pub. George Routledge and Son, 1872.
Engravings by various engravers after
Watson, Barnes, Small etc. A routine
collection of reprints.
Previously unrecorded.
BL

41. *Aunt Emma's Picture Book*
Pub. Thomas Nelson and Sons, [1877].

A collection of reprints after various artists including Small and Watson.
Previously unrecorded.
BL

42. *Beauties of Poetry and Gems of Art*
Pub. Cassell, Petter and Galpin, [1865].
Engravings by various engravers after several artists including Pickersgill. Uniform with two other anthologies: *Jewels Gathered from Painter and Poet* and *Favourite Poems by Gifted Bards* (q.v.).
BL

43. *The Book of Elegant Extracts*
Pub. William Nimmo (Edinburgh), [1868].
Engravings chiefly by Scottish engravers after Scottish artists. Notable for 'The Nymph's description of her fawn' engraved by Frederick Borders after William Small (p.70).
BL

44. *The Boys' and Girls' Illustrated Gift Book*
Pub. Routledge, Warne and Routledge, 1863.
Frontispiece engraved by Dalziel after J.D. Watson. Evidently produced for the Christmas season in December 1862.
Previously unrecorded.
BL

45. *The Child's Book of Song and Praise*
Pub. Cassell, Petter and Galpin, [1870].
Engravings by various engravers after Watson, Pickersgill and Pinwell. 'The Old Washerwoman' by Pinwell' (p.224) is magnificent and unsigned and does not appear to be a reprint. A second edition of this book appeared in 1871.
Previously unrecorded.
PC

46. *The Child's Picture Scrap Book*
Pub. Routledge, Warne and Routledge, 1864.
Engravings by Dalziel after J.D. Watson entitled *Schoolboy Life* (possibly reprints). This book appears to have been issued

entirely hand coloured. I have not seen an uncoloured copy although such copies may exist.
Previously unrecorded.
BL

47. *Christian Lyrics Chiefly Selected from Modern Authors*
Pub. Sampson Low, Son, and Marston, 1868.
Engraved by J.D. Cooper after several artists including Barnes.
See [Fletcher, Lucy] (ed.) for the two editions of this work.

48. *The Cornhill Gallery*
Pub. Smith Elder and Co., 1864.
One hundred proof engravings all printed from the wood and reprinted from *The Cornhill Magazine*. Engraved mainly by Dalziel and Swain after Millais, Walker, Sandys, Leighton, du Maurier, Paton, Thackeray etc. The first edition was termed a de luxe version. A second edition to a slightly smaller format was published in 1865.
BM PML NGA

49. *The Cycle of Life*
Pub. Society for Promoting Christian Knowledge, [1870].
Large engravings by unidentified engravers after various artists including J. Mahoney.
SPCK

50. *Dalziel's Bible Gallery*
Pub. Dalziel Brothers, 1881 (published October 1880).
Sixty-two engravings by the Dalziel Brothers after Leighton, Watts, T. Dalziel, Simeon Solomon, Holman Hunt, Armitage, F.M. Brown, Poynter, Houghton, Sandys, Armstead, Pickersgill, Small, Burne-Jones. The work is subtitled *Illustrations from the Old Testament*.
BM BL V&A PML MFAB

51. *Dawn to Daylight*
Pub. Frederick Warne and Co., [1874].

Reprinted designs by several artists including Barnes, Houghton, Millais, Pickersgill and Small.
Previously unrecorded.
BL MFAB

52. *English Rustic Pictures*
Pub. Routledge, 1882.
Proof engravings on India paper by Dalziel after Pinwell (17) and Walker (15). All these designs are taken from *A Round of Days* and *Wayside Posies* (q.v.).
BL NGA

53. *Favourite English Poems and Poets*
Pub. Sampson Low, Son and Marston, 1870.
Illustrations by Pickersgill, Small, Keene etc. First published with fewer illustrations in 1859. All the designs appear to be reprints. Possibly the sole Keene 'The Rapids are near' may not be.
BL BM (1862) PML (1862)

54. *Favourite Poems by Gifted Bards*
Pub. Cassell, Petter and Galpin, [1864].
Engravings by various engravers after several artists including Pickersgill.
PC

55. *Gems of Literature – Elegant Rare and Suggestive*
Pub. William Nimmo, 1866.
Contains two illustrations engraved by Robert Paterson after Paton for Spenser's 'Una and the Lion'.
BL

56. *Golden Thoughts from Golden Fountains*
Pub. Frederick Warne and Co., [1867].
Engravings by Dalziel after Houghton, Small, Watson, Pinwell, North etc. Text and illustrations are printed in brown. In the second edition (*c.*1870) only the full-page illustrations are in brown, the remaining being in black (to their advantage).
BM BL V&A PML MFAB NGA

57. *Home Thoughts and Home Scenes in Original Poems*
Pub. Routledge, Warne and Routledge,
1865.
Thirty-five engravings by Dalziel after Houghton. Dalziel's 'Fine Art Gift Book' for 1865. There was a second edition in 1868. In 1874 30 of these engravings appeared in *Happy-Day Stories for the Young* edited by H.W. Dulcken from the same publisher. There was an interesting American edition entitled *The Horn of Plenty of Home Poems and Home Pictures*. This was published in New York by R. Worthington in 1879 and contained all the Houghton designs (reduced in size) as well as three of Barnes's from *Pictures of English Life*. Neither artist is mentioned on the title page nor indeed anywhere in this edition.
BM V&A PML MFAB NGA

58. *Household Tales and Fairy Stories*
Pub. George Routledge and Sons, 1872.
Illustrations engraved by Dalziel after J.D. Watson and other artists. An undistinguished volume containing reprints.
Previously unrecorded.
ABT

59. *Idyllic Pictures*
Pub. Cassell, Petter and Galpin, 1867.
Illustrations from *The Quiver* by Pinwell, Sandys, Small, Houghton etc. printed from the wood. This is one of the rarest books of the period. Forrest Reid (pp.14–15) gives a useful list of the artists since one is not included in the book itself.
BM V&A PML MFAB

60. *Jewels gathered from Painter and Poet*
Pub. Cassell, Petter and Galpin, [1864].
Engraved by Dalziel after various artists including Pickersgill.
PC

61. *The Large-Picture Primer*
Pub. George Routledge and Sons, [1878].
Engravings by various engravers after Small and Watson. Some good designs by Small but also several which show his move towards a type of wash drawing which was less suitable for reproduction by wood-

engraving.
Previously unrecorded.
BL

62. *Lays of the Holy Land from Ancient and Modern Poets*
Pub. James Nisbet and Co., 1858.
Four designs by Pickersgill and 'The Finding of Moses' engraved by Dalziel after Millais (p.51). Later re-issues were undated. There was a second edition dated 1871.
BM BL PML MFAB

63. *Little Laddie's Picture Book*
Pub. George Routledge and Sons, 1879.
Engravings by various engravers after Small and Watson, probably reprints.
Previously unrecorded.
BL

64. *Little Lassie's Picture Book*
Pub. George Routledge and Sons, 1879.
Engravings by various engravers after Small and Watson, probably reprints.
Previously unrecorded.
BL

65. *Little Lily's Picture Book*
Pub. George Routledge and Sons, [1872].
Engravings by various engravers after Millais, Watson, Walker, Small, Barnes etc. All reprints but a better than average selection.
Previously unrecorded.
BL

66. *Lyrics of Ancient Palestine*
Pub. Religious Tract Society, [1873].
Engravings by several engravers after various artists including J. Mahoney and J.D. Watson. A fine and little-known volume.
Previously unrecorded.
BL

67. *Mama's Return and other Tales*
Pub. George Routledge and Sons, [1876].
Forty-seven reprints by Watson, Small, Houghton, Barnes etc.
Previously unrecorded.
BL

68. *Master Jack and other Tales*
Pub. George Routledge and Sons, [1876].
A similar collection of reprints to the above involving some of the same artists.
Previously unrecorded.
BL

69. *The Months Illustrated by Pen and Pencil*
Pub. Religious Tract Society, [1864].
Engravings by various engravers after several artists including North and Barnes.
BM MFAB NGA

70. *National Nursery Rhymes and Nursery Songs*
Pub. Novello, Ewer and Co. and George Routledge and Sons, [1870].
Sixty-five engravings by Dalziel after Hughes, Griset, Houghton, Small, Pinwell, Mahoney. A companion volume to *Christmas Carols New and Old* (q.v.). For a detailed discussion of the issue points, see Robin de Beaumont, *Imaginative Book Illustration Society Newsletter*, no. 8, Spring 1998, pp.20–1.
BM PML

71. *Our Life Illustrated by Pen and Pencil*
Pub. Religious Tract Society, [1865].
Engraved by Butterworth and Heath after Watson, Barnes, du Maurier, Pinwell, North.
BM PML NGA

72. *Our People – Sketches from 'Punch' by Charles Keene*
Pub. Bradbury Agnew and Co., [1881].
Engraved by Joseph Swain. The first edition actually contains 404 illustrations. Later editions such as that of 1888 contain 400.
BM PML

73. *Passages from Modern English Poets Illustrated by the Junior Etching Club*
Pub. Day and Son, [1862].
Forty-seven etchings by Whistler, Keene, Lawless, Millais, Stacey Marks and others. The first edition has a preface dated April 1862 and appeared in large folio, small folio and octavo versions. In the large folio the plates are without letters or plate numbers

and the sheet size is 420 x 290 mm. In the small folio the plates carry a publication line and the date 1 December 1861. The sheet size is 370 x 275 mm. On the Millais plate 'Summer Indolence' his name is misspelt 'Millias'. In the octavo version the plates are cut down, removing the plate-mark, but the publication line remains and plate numbers are added. The sheet size is 235 x 160 mm.

In 1874 William Tegg published another version containing the same etchings. His plates have had the publication line erased but the plate numbers are retained. This edition is undated but the date is known from the English Catalogue of Books. It seems that Tegg also published an inferior edition with the plates transferred to stone as lithographs. This may have appeared in 1875 or 1876.
BM PML

74. *Pen and Pencil Pictures from the Poets*
Pub. William Nimmo (Edinburgh), 1866. Contains two designs engraved by Frederick Borders after William Small. Forrest Reid suggests that the book contains designs by Pettie but I can find no trace of them in the editions I have seen.
BL MFAB

75. *The Piccadilly Annual of Entertaining Literature*
Pub. John Camden Hotten, 1870 (December).
Contains reprinted illustrations from *Once a Week* by Holman Hunt, du Maurier, Morten, Lawless, Small, Crane. A curious and scarce volume which includes texts by Dickens, Longfellow and Mark Twain. Previously unrecorded.
BM

76. *A Picture Book for Laddies and Lassies*
Pub. George Routledge and Sons, 1879. Engravings by various engravers after William Small, J.D. Watson and others. An amalgamation of *Little Laddie's Picture Book* and *Little Lassie's Picture Book* (q.v.). Previously unrecorded.
BL

77. *Picture Posies*
Pub. George Routledge and Sons, 1874. One hundred and twenty-nine engravings by Dalziel after Walker, North, Houghton, Pinwell, Watson etc. Essentially a reprint of *Wayside Posies* and *A Round of Days*.
BM PML NGA

78. *Pictures of English Life*
Pub. Sampson Low, Son and Marston, 1865. Ten large wood-engravings, eight of which are after Robert Barnes and the remaining two being after Wimperis. Engraved by J.D. Cooper.
BM PML

79. *Pictures of Society Grave and Gay*
Pub. Sampson Low, Son and Marston, 1866. Ninety-five illustrations after Millais, Walker, Lawless, Crane, Morten, du Maurier, Watson, Sandys etc. Printed on toned paper all these designs are reprinted from *London Society* and the *Churchman's Family Magazine*.
BM PML MFAB

80. *Poems and Pictures*
Pub. Sampson Low, Son and Co., 1860. Engravings after various artists including Pickersgill. A reprint of a book published by James Burns in 1846 identically entitled. This 1840s-style book is made up of three books bound as one. It was split up later into *Jewels Gathered from Painter and Poet, Beauties of Poetry and Gems of Art* and *Favourite Poems by Gifted Bards* (q.v.). Their reappearance as late as the 1860s seems somewhat anachronistic in terms of style.
BM

81. *Popular Nursery Tales and Rhymes*
Pub. Routledge, Warne and Routledge, n.d. Engravings by Dalziel after various artists including J.D. Watson. Probably reprints.
ABT

82. *A Round of Days*
Pub. George Routledge and Sons, 1866.
Engravings by Dalziel after Pinwell,
Houghton, Walker, Morten, Watson,
Edward and Thomas Dalziel. Published in
October 1865 this was the 'Dalziel Fine Art
Gift Book' for 1866.
BM V&A PML MFAB

83. *Routledge's Sunday Album for Children*
Pub. George Routledge and Sons, [1873].
Engravings by various engravers after Small,
Watson, Barnes, Holman Hunt, Walker, du
Maurier, Pinwell, Pettie, Millais, Lawless,
Houghton, Sandys etc. A valuable and
varied collection of reprints both from books
and magazines. Unfortunately many of the
blocks have been reduced in size.
BL

84. *The Shilling Funny Nursery Rhymes*
Pub. Ward Lock and Co., [1878].
Engravings by Edmund Evans and others
after C.H. Bennett and R.B. Brough,
presumably all culled from earlier
publications.
Previously unrecorded.
BL

85. *The Spirit of Praise – A Collection of Hymns
Old and New.*
Pub. F. Warne and Co., [1867].
Engravings by Dalziel after Pinwell,
Houghton, Small, North, T. Dalziel, E.
Dalziel. Published in November 1866 at 21
shillings. There was a reprint in 1871.
BM BL PML NGA

86. *Sunday Reading for Good Children*
Pub. George Routledge and Sons, [1873].
Simply a reduced version of *Routledge's
Sunday Album for Children* (q.v.).
BL

87. *The Sunlight of Song. A Collection of Sacred
and Moral Poems*
Pub. Novello, Ewer & Co. and George
Routledge and Sons, 1875.
Engravings by Dalziel after Pinwell, Small

and J. Mahoney.
There are two issues both dated 1875. The
earlier would appear to be Novello, Ewer
and Co. where this is printed above the
Routledge name and in larger type on the
title page. In the Routledge issue this is
reversed and the Routledge name is stamped
in gilt on the spine. Although the front-
cover design in gilt and black is identical in
both, the blind stamping on the rear differs
between the issues. The Novello binding is
a bright red with the Routledge being a
drab brown. There may well be other
colour variants.
BL (Music Library) NGA

88. *Touches of Nature by Eminent Artists and
Authors*
Pub. Alexander Strahan, 1867.
Illustrations by Sandys, Walker, Millais,
Houghton, Pinwell, Lawless, Pettie, North,
du Maurier, Watson, Barnes, Armstead,
Small, Mahoney, Holman Hunt, Keene,
Morten, Shields etc. Most of the designs
here are reprinted from Strahan's magazines
Good Words, *The Sunday Magazine* and *The
Argosy*. Only Pettie's title-page vignette
comes from a book – *Wordsworth's Poems for
the Young*. A reprint containing only 47 of
the original 98 plates appeared in 1871.
BM PML MFAB

89. *Warne's Picture Book*
Pub. Frederick Warne and Co., [1868].
Contains at p.54 four engravings by Dalziel
after Houghton to *Pictures of Robinson Crusoe*
and at p.79 a further four also by Dalziel
after Houghton to *Pictures of a Little Boy*.
A remarkable and apparently little-known
book.
Previously unrecorded.
BL

ARTHUR, T.S.

90. *Words for the Wise*
Pub. T. Nelson and Sons, 1864.

Four engravings printed in brown by
Williamson after William Small.
BL

AYTOUN, W.E.

91. *Lays of the Scottish Cavaliers and other Poems*
Pub. William Blackwood and Sons, 1863.
Engravings by W.J. Linton, Edmund Evans,
Dalziel etc. after J. Noel Paton and Waller
H. Paton. The binding design is by J. Noel
Paton.
BL V&A PML MFAB

BALLINGALL, William

92. *Classic Scenes in Scotland by Modern Artists*
engraved by William Ballingall.
Pub. William Ballingall (Edinburgh), 1875.
Contains 'Queen Margaret and Malcolm
Canmore' engraved by Ballingall after Sir J.
Noel Paton.
Previously unrecorded.
BL

BARBAULD, Mrs (Anne Laetitia Aikin)

93. *Hymns in Prose for Children*
Pub. John Murray, 1864. Reprinted 1865.
Numerous engravings by James D. Cooper
after Barnes, Wimperis and others.
BM BL PML

[BARHAM, R.H.]

94. *The Ingoldsby Legends*
Pub. Richard Bentley, 1866.
Two volumes containing four illustrations
by du Maurier, in addition to those by G.
Cruikshank, Leech and Tenniel which had
appeared in the first thus illustrated one
volume edition in 1864.
NE

BARKER, Mrs Sale

95. *Flowers in May*
Pub. George Routledge and Sons, n.d.
(*c*.1874).
Forty engravings by various engravers after
several artists including J.D. Watson. A
wretched volume in almost every respect
with poor designs poorly engraved.
PML

96. *Routledge's Holiday Album for Girls*
Pub. George Routledge and Sons, 1877.
Illustrations by Lawless, Mahoney, Watson,
Small and Walker.
Careless in presentation with several
illustrations (all presumably reprinted)
appearing more than once.
BL

BAYNES, Revd. Robert H. (ed.)

97. *The Illustrated Book of Sacred Poems*
Pub. Cassell, Petter and Galpin, [1867].
Engraved by various engravers after Watson,
Small, Pickersgill, North and others. Small's
'The Lapidary's Daughter' is probably the
finest thing in this curiously depressing
collection. There was a later and poorer
edition also undated but probably *c*.1870.
BM PML

BELL, Catherine D.

98. *Home Sunshine*
Pub. Frederick Warne and Co., 1866.
Four illustrations engraved by Dalziel after
William Small. The one additional design in
the book is not by Small. The spine of the
book bears the legend *Cousin Kate's Library*.
BL

BENNETT, C.H.

99. *Shadows*
Pub. D. Bogue, [1857].

Lithographs without accompanying text by C.H. Bennett. The title-page illustration appears to be etched. Issued plain for 2 shillings and 6 pence or coloured at 4 shillings and 6 pence.
BL

100. *The Sad History of Greedy Jem and all his Little Brothers*
Pub. G. Routledge and Co., 1858.
Engraved by Edmund Evans after C.H. Bennett.
BL

101. *Birds, Beasts and Fishes – An Alphabet for Boys and Girls*
Pub. G. Routledge and Co., [1858].
Engraved by Edmund Evans after C.H. Bennett. Published in time for Christmas 1857 at 6 pence for the uncoloured version and 1 shilling for the coloured.
BL

102. *Old Nurse's Book of Rhymes, Jingles and Ditties*
Pub. Griffith and Farran, 1858.
Ninety engravings by various engravers after C.H. Bennett.
BL

103. *The Faithless Parrot* Designed and narrated by Charles H. Bennett.
Pub. G. Routledge and Co., [1858].
Engraved by Edmund Evans after C.H. Bennett. A Routledge Toy Book printed in colours issued at 1 shilling for foolscap or 18 pence printed on cloth.
BL

104. *The Frog Who Would a Wooing Go*
Pub. G. Routledge and Co., [1858].
Engraved by Edmund Evans after C.H. Bennett. It seems that these illustrations (and possibly others by Bennett) were reprinted in a compilation also from Routledge entitled *The Comical Story Book with Comical Illustrations* [1863], reprinted in 1869, which I have not examined.
BL

105. *Proverbs with Pictures by Charles H. Bennett*
Pub. Chapman and Hall, 1859.
The illustrations appear to be wood-engravings reproducing etchings by Bennett. A curious book with text by the artist.
BL

106. *The Nine Lives of a cat*
Pub. Griffith and Farran, 1860.
Twenty-four engravings by an unidentified engraver after C.H. Bennett. This book actually appeared in time for Christmas 1859.
BL

107. *London People: Sketched from Life*
Pub. Smith, Elder and Co., 1863.
Engravings by Joseph Swain after C.H. Bennett. Most but not all of these designs are reprinted from *The Cornhill Magazine*. Text also by Bennett.
BL

108. *The Book of Blockheads*
Pub. Sampson Low, Son, and Co., 1863.
Illustrated entirely by Bennett the designs appear to have been printed lithographically. They are all printed on separate sheets on good quality paper.
BL

109. *Nursery Fun – The Little Folks Picture Book*
Pub. Griffith and Farran, 1863.
Engraved by Edmund Evans after C.H. Bennett. Published for the Christmas market 1862.
BL

110. *The Stories that Little Breeches Told*
Pub. Sampson Low, Son, and Co., 1863.
Etchings by C.H. Bennett.
BL

111. *The Surprising ... Adventures of Young Munchausen*
Pub. Routledge, Warne and Routledge, 1865
Engraved by Dalziel after C.H. Bennett.

Large designs on good paper decently engraved.
BL V&A

112. *The Sorrowful Ending of Noodledoo …*
Pub. Sampson Low, Son and Marston, 1865.
Etchings by C.H. Bennett.
BL

113. *Lightsome and the Little Golden Lady*
Pub. Griffith and Farran, 1867.
Twenty-four engravings by an unidentified engraver after C.H. Bennett.
BL V&A

BENNETT, C.H. and BROUGH, R.B.

114. *Shadow and Substance*
Pub. W. Kent and Co., 1860.
Thirty engravings bearing an unidentified engraver's initials JS(?) after C.H. Bennett.
BL

115. *Character Sketches, Development Drawings and Original Pictures of Wit and Humour*
Pub. Ward, Lock and Tyler, [1872].
Engravings by an unidentified engraver with the initials J.S.(?) after C.H. Bennett.
BL

BENNETT, William C.

116. *Poems*
Pub. Routledge, Warne and Routledge, 1862.
Four engravings by Dalziel after J.D. Watson. Published in Routledge's *British Poets* series which was edited by R.A. Willmott.
PML

117. *Baby May and Home Poems* Part I
Narrative Poems and Ballads Part II
Pub. Henry S. King, 1875.
Two pamphlets, the limp cover of each bearing a design engraved by Dalziel after J.D. Watson.
BL

BEVERLEY, May

118. *Romantic Passages in English History*
Pub. James Hogg and Sons, [1863].
Eight engravings by R.S. Marriott after Robert Barnes. Wretched both in design and engraving with little hint of Barnes's mature style.
BL

BLACK, William

119. *A Daughter of Heth*
Pub. Sampson Low, Marston, Low and Searle, 1872.
Frontispiece is a photograph of a watercolour by Frederick Walker. The eleventh edition of this work.
BL

BOURNE, Captain B.F.

120. *The Giants of Patagonia*
Pub. Ingram, Cooke and Co., 1853.
Six engravings by Smyth after Charles Keene.
PML

[BOWEN, Mrs C.E.]

121. *Sybil and her Live Snow-ball*
Pub. Seeley, Jackson and Halliday and S.W. Partridge, [1865].
Four large engravings by John Knight after Robert Barnes.
Published in the *Children's Friend* series.
BL

122. *How Paul's Penny Became a Pound*
Pub. Seeley, Jackson and Co., [1866].
Four large engravings by John Knight after Robert Barnes.
Published in the *Children's Friend* series.
Previously unrecorded.
BL

123. *How Peter's Pound became a Penny*
Pub. Seeley, Jackson and Co., [1866].
Four large engravings by John Knight after
Robert Barnes.
Published in the *Children's Friend* series.
Previously unrecorded.
BL

BOWEN, Mrs C.E.

124. *Jack The Conqueror*
Pub. S.W. Partridge and Co., [1868].
Several full-page engravings by various
engravers after artists including Robert
Barnes and Birket Foster.
BL PML

125. *Ben's Boyhood*
Pub. S.W. Partridge and Co., [1873].
Six full-page engravings by an unidentified
engraver after Robert Barnes.
BL

BOWMAN, Anne

126. *The Boy Pilgrims*
Pub. George Routledge and Sons, 1866.
Eight engravings by Dalziel after Houghton.
The book was actually published for the
Christmas season in December 1865.
BL

BOYD, Mary D.R.

127. *Grace Ashleigh's Life Work*
Pub. S.W. Partridge, 1879.
Eight engravings by an unidentified engraver
after Robert Barnes.
Previously unrecorded.
ABT

BOYLE, Mary Louisa

128. *Woodland Gossip*
Pub. Thomas Mclean, 1864.

The frontispiece is a mounted photograph of
a drawing by Frederic Leighton. This
charming and little-known book contains
photographs of drawings by other artists all
of whom seem to have been amateurs.
Previously unrecorded.
BL

**BRAMLEY, Henry and STAINER, John
(eds)**

129. *Christmas Carols New and Old*
Pub. Novello, Ewer and Co. George
Routledge and Sons, [1871].
Engravings by Dalziel after Thomas Dalziel,
John Leighton, Zwecker, Arthur Hughes
and J. Mahoney. A companion volume to
the anthology *National Nursery Rhymes and
Nursery Songs* (q.v.).
BM V&A PML

BROOKS, Shirley

130. *Sooner or Later*
Pub. Bradbury Evans and Co., 1868.
Engraved throughout by Swain after du
Maurier. Originally issued in 16 monthly
parts starting in November 1866 and
finishing in February 1868.
BL V&A PML

BROUGH, John Cargill

131. *The Fairy Tales of Science*
Pub. Griffith and Farran, 1859.
Sixteen illustrations engraved by Swain after
C.H. Bennett.
BL V&A

BROWN, John

132. *Rab and his Friends*
Pub. David Douglas (Edinburgh), 1878.
Contains two steel-engraved designs by

R.C. Bell after Sir J. Noel Paton which are dated in the plate, 1857.
BL

BROWNE, Jemmett

133. *Songs of Many Seasons*
Pub. Simkin Marshall and Co. and Pewtress and Co., 1876.
Two engravings by Swain after du Maurier and one after Walter Crane.
BL

BROWNE, Matthew (Pseud. William Brighty Rands)

134. *Lilliput Levée*
Pub. Alexander Strahan, 1864. Reprinted 1867.
Seven illustrations engraved by Swain after Millais and Pinwell and printed in reddish brown. The Millais designs are reprints with the title-page vignette having appeared first the previous year in *Wordsworth's Poems for the Young* (q.v.). The Pinwells are new. In later editions such as that of 1868 the blocks were printed in black and illustrations by Charles Green and Basil Bradley were added. Forrest Reid (p.161) states: 'Most of the pictures are reproduced in a reddish brown tint by some lithographic process ...' I cannot be certain of this.
BM BL MFAB

135. *Lilliput Lectures*
Pub. Strahan and Co., 1871.
Four illustrations engraved by Dalziel after Arthur Hughes.
BM BL

136. *Lilliput Legends*
Pub. Strahan and Co., 1872.
Illustrations by Millais, Hughes, Pinwell and Small, all of which appear to be reprints.
BL PML

BRYANT, William Cullen

137. *Poems*
Pub. D. Appleton and Co. (New York), [?1854].
Engravings by Dalziel after numerous artists including Pickersgill and Edward Dalziel. I am uncertain over the date of publication since the title page is undated. However, this edition bears the information 'entered 1854' on the title-page verso. There was an English edition (Sampson Low) dated 1858. The BL copy was received on 20 November 1857.
BM (American edition) BL V&A PML (English edition)

BUCHANAN, Robert

138. *Ballad Stories of the Affections*
Pub. George Routledge and Sons, [1866].
Engraved by Dalziel after Pinwell, E. and T. Dalziel, Small, Houghton, John Lawson, J.D. Watson.
BM V&A PML

139. *North Coast and other Poems*
Pub. George Routledge and Sons, 1868.
Engraved by Dalziel after Pinwell, Houghton, Small, E. and T. Dalziel.
BM V&A PML MFAB

BUCHANAN, Robert (ed.)

140. *Wayside Posies; Original Poems of the Country Life*
Pub. George Routledge and Sons, 1867.
Forty-two engravings by Dalziel after Pinwell, North and Walker.
The last of the 'Dalziel Fine Art Gift Books'. Issued for Christmas 1866.
BM BL V&A PML MFAB NGA

[BUCHANAN, Robert]

141. *St. Abe and his Seven Wives – A Tale of Salt Lake City*

Pub. Strahan and Co., [1872].
Frontispiece engraved by Dalziel after
Houghton. First published also anonymously
in the same year but without the illustration.
This is the third edition 'Enlarged and
Revised'. Conceivably a reprinted design
from *Graphic America*.
Previously unrecorded.
BL

BUCK, Ruth (Mrs Joseph Lamb)

142. *The Carpenter's Family*
Pub. Society for Promoting Christian
Knowledge, [1865].
Three illustrations engraved by Whymper
after J. Mahoney. The fourth design does
not appear to be by Mahoney.
Previously unrecorded.
PC

[BUCK, Ruth (Mrs Joseph Lamb)]

143. *Thoughtful Joe*
Pub. Religious Tract Society, 1880.
Contains illustrations by Barnes.
Previously unrecorded.
NE

BUNYAN, John

144. *The Pilgrim's Progress*
Pub. Longman, Green, Longman and
Roberts, 1860.
Forty-four etched portraits by Bennett.
Eighty-two wood-engravings by Swain after
Bennett.
BM

145. *The Pilgrim's Progress*
Pub. Routledge, Warne, and Routledge,
1861.
Engraved throughout by Dalziel after J.D.
Watson.
BM V&A MFAB

146. *The Pilgrim's Progress*
Pub. Macmillan and Co., 1862.
Title-page illustration is a steel-engraving by
C.H. Jeens after Holman Hunt.
Published in the *Golden Treasury Series*.
BM BL

Illustrations to Bunyan's Pilgrim's Progress, 1864. See SHIELDS, Frederic J.

147. *The Pilgrim's Progress*
Pub. Strahan and Co., 1880.
Engraved by Dalziel chiefly after Frederick
Barnard but the book also contains two
designs by William Small. There was a de
luxe version of this work produced in an
edition of 500 copies in which proofs of the
illustrations were printed on Japanese paper.
BL MFAB NGA

BURNAND, F.C.

148. *Tracks for Tourists or The Continental
Companion* (reprinted from *Punch*)
Pub. Bradbury and Evans, 1864.
Numerous engravings by an unidentified
engraver after Charles Keene.
PML

149. *Mokeanna! A Treble Temptation*
Pub. Bradbury Agnew and Co., 1873.
Contains the illustrations by Millais and du
Maurier which first appeared
complementing the same text in *Punch* in
1863.
BM BL

BURROW, John Holme

150. *The Adventures of Alfan*
Pub. Smith Elder and Co., 1863.
Eight designs engraved by Dalziel after J.D.
Watson.
BL V&A

BYRON, Lord

151. For the Moxon edition of *The Poetical Works of Lord Byron* with illustrations by F.M. Brown see Rossetti, W.M. (ed.).

152. *Poetical Works*
Pub. Frederick Warne and Co., n.d. ?1878.
Contains four little-known designs engraved by Dalziel after Houghton. Also here are reprints of 'The Prisoner of Chillon' (F.M. Brown) and 'The Dream' (Millais) both of which first appeared in Willmott's *Poets of the Nineteenth Century* (1857) (q.v.). Published in the *Lansdowne Poets* series. It is conceivable that Houghton's designs may also be reprints but I have been unable to locate an earlier appearance of them. Paul Hogarth in his book on the artist (1981) dates this book 1868 but I have never found a copy so dated. (See Select Bibliography)
BM

CAMDEN, Charles

153. *The Boys of Axelford*
Pub. Bell and Daldy, 1869.
Illustrations engraved by Dalziel after Houghton (frontispiece), John Pettie and J. Mahoney. Reprinted from *Good Words for the Young* 1869.
BL

154. *The Travelling Menagerie*
Pub. Henry S. King, 1873.
Engraved by Dalziel after J. Mahoney. Reprinted from *Good Words for the Young*.
BL

CAMPBELL, Sir Colin

155. *Narrative of the Indian Revolt*
Pub. George Vickers, 1858.
Two engravings by an unknown engraver after Charles Keene.
Reprinted from *The Illustrated Times*.
NE

156. *Cassell's History of England*
Pub. Cassell, ?1867.
According to Forrest Reid this contains illustrations by Small and Morten. Some of these are to be found in his own collection of illustrations in The Ashmolean Museum, Oxford.
NE

CAUTLEY, G.S.

157. *A Century of Emblems*
Pub. Macmillan and Co., 1878.
Engravings by an unidentified engraver after various artists (mainly amateur) but including Robert Barnes. Barnes's slight designs are themselves based on sketches by the author. Previously unrecorded.
BL

CHAMBERS, Miss A.C.

158. *Annals of Hartfell Chase*
Pub. Society for Promoting Christian Knowledge, [1879].
Frontispiece engraved by an unidentified engraver after J. Mahoney.
Previously unrecorded.
SPCK

CHARLESWORTH, Maria Louisa

159. *Ministering Children – A Sequel*
Pub. Seeley, Jackson and Halliday, 1867.
Frontispiece is a steel-engraving of 'Benjamin Tovel twisting willow withes ...' engraved by C.H. Jeens after J.D. Watson. The title page is engraved and may also be the work of Watson.
Previously unrecorded.
PC

160. *The Child's Bible*
Pub. Cassell, Petter and Galpin, [1868–9].
Published in parts beginning on 9 September 1868 and containing 'New and Original Illustrations'. On p.141 an engraving by Swain after A.B. Houghton entitled 'Moses brings water from the Rock' appears to be unrecorded.
Previously unrecorded.
PC

COATES, Mrs W.H.

161. *The Beautiful Island*
Pub. Society for Promoting Christian Knowledge, [1866].
Engravings by an unidentified engraver after J. Mahoney.
Previously unrecorded.
SPCK

COLERIDGE, Samuel Taylor

162. *The Rime of the Ancient Mariner*
Pub. Art Union of London, 1863.
Lithographs by W.H. Mcfarlane after Sir J. Noel Paton.
BM

COLLINS, W. Wilkie

163. *Mr Wray's Cash-Box; or, The Mask and the Mystery. A Christmas Sketch*
Pub. Richard Bentley, 1852.
Frontispiece is an etching by Millais dated 1852 in the plate. This appears to be his earliest illustration.
BM PML

164. *After Dark*
Pub. Smith Elder and Co., 1862.
Four engravings by Dalziel after Houghton. Pictorial title page by Dalziel after Walter Crane.
BL

165. *No Name*
Pub. Sampson Low, Son, and Marston, 1864.
Steel-engraved frontispiece 'No Name – One half-hour' by John Saddler after Millais. Signed in monogram and dated 1863 in the plate.
BL

166. *The Law and the Lady*
Pub. Smith Elder, 1870.
Apparently a one volume edition with one or perhaps two designs by S.L. Fildes.
NE

167. *Basil*
Pub. Chatto and Windus (Piccadilly Novels), 1875.
Eight engravings by Dalziel after J. Mahoney.
Previously unrecorded.
ABT

168. *Hide and Seek*
Pub. Chatto and Windus (Piccadilly Novels), 1875.
Eight engravings by Dalziel after J. Mahoney.
Previously unrecorded.
ABT

169. *The Moonstone*
Pub. Chatto and Windus, 1875.
Frontispiece engraved by an unidentified engraver after du Maurier.
ABT

170. *The Frozen Deep*
Pub. Chatto and Windus (Piccadilly Novels), 1875.
Frontispiece by du Maurier and eight illustrations by J. Mahoney. Engraved by Dalziel.
NE

171. *Poor Miss Finch*
Pub. Chatto and Windus, 1875.
Frontispiece by du Maurier.
NE

172. *The New Magdalen*
Pub. Chatto and Windus, 1875.
Frontispiece engraved by an unidentified
engraver after du Maurier.
ABT

COOK, Eliza

173. *Poems*
Pub. Routledge, Warne and Routledge,
1861.
Engraved by Dalziel after several artists
including J.D. Watson, H.H. Armstead and
J. Gilbert.
BM V&A PML MFAB NGA

COWPER, William

174. *Table Talk and other Poems*
Pub. Religious Tract Society, [1868].
Engraved by various engravers after several
artists including Barnes, Watson and Tenniel.
BL

DALTON, Henry

175. *The Book of Drawing-Room Plays and Evening
Amusements*
Pub. James Hogg, [1861].
Engravings by Dalziel after du Maurier and
E.H. Corbould. Reprinted in 1868 by
Cassell, Petter and Galpin.
BM BL

DALZIEL brothers

176. *Dalziel's Arabian Nights' Entertainments*
Pub. in 21 monthly parts by Ward, Lock and
Tyler from January 1864 to September 1865.
Engravings by Dalziel after Millais, Tenniel,
Watson, Pinwell, T. Dalziel and Houghton.
The final part contains the index, general
title page and preface to the entire work.
Text revised by H.W. Dulcken. This was

published in book form in two volumes in
1865.
BM V&A PML NGA

DAVIES, G. Christopher

177. *Wildcat Tower. A Book for Boys*
Pub. Warne and Co., 1877.
Engravings by Dalziel after several artists
including J.D. Watson.
BL

DE CERVANTES, Miguel

178. *Adventures of Don Quixote de la Mancha*
Pub. Warne and Co., 1866.
One hundred engravings by Dalziel after
Houghton. In the first edition, first issue, the
foot of the spine reads *Illustrated*. In the
second issue it reads *Dalziel's Edition*. If there
is a difference between the dates of the
issues it can only have been a matter of
weeks. The book was reissued in 1868 in a
plainer binding but with an additional
vignette illustration on the title page.
BM V&A PML

DEFOE, Daniel

179. *History of the Plague of London*
Pub. Longman, Green, Longman, Roberts,
1863.
Six engravings by W. Morton and Swain
after Frederic Shields. No 5 in *Laurie's
Entertaining Library*.
BL MFAB

180. *The Life and Adventures of Robinson Crusoe*
Pub. Routledge, Warne and Routledge,
1864.
Engraved by Dalziel after J.D. Watson.
BM V&A MFAB NGA

181. *Robinson Crusoe*
Pub. Warne, 1865.
Apparently this contains four designs by

Houghton but I have been unable to locate a copy. It is mentioned both by Forrest Reid (p.195) and by Hogarth in his checklist in his monograph (1981) (p.42 no.45) (see Select Bibliography). However, see the anthology *Warne's Picture Book* which appears to contain the illustrations concerned.
NE

182. *Robinson Crusoe* (Edited by J.W. Clark)
Pub. Macmillan and Co., 1866.
Steel-engraved title-page design by an unidentified engraver after Millais. Dated 1862 in the plate.
BM BL

DE LIEFDE, Jan

183. *The Postman's Bag*
Pub. Alexander Strahan and Co., 1862.
Illustrated by several artists including John Pettie. Lithographed by A. Richie in Edinburgh. Translated from the Dutch.
BM BL

DE MUSSET, Paul

184. *Mr Wind and Madam Rain* (Translated by Emily Makepeace)
Pub. Sampson Low, Son and Co., 1864.
Twenty-eight engravings by Swain after C.H. Bennett.
BL

DE VEGA, Carpio Lope Felix

185. *Castelvines y Monteses* (Translated by F.W. Cosens)
No publisher's name, printed at the Chiswick Press for private distribution, 1869.
Frontispiece is engraved by Swain after du Maurier.
Previously unrecorded.
BL

DICKENS, Charles

186. *Hard Times*
Pub. Chapman and Hall, 1862.
Four engravings by Dalziel after Frederick Walker. Published with *Barnaby Rudge*.
PC

187. *Reprinted Pieces*
Pub. Chapman and Hall, 1862.
Four engravings by Dalziel after Frederick Walker. Published with *The Old Curiosity Shop*.
PC

188. *Hard Times and Pictures from Italy*
Pub. Chapman and Hall (Cheap edition), 1866.
Frontispiece engraved by Dalziel after Houghton.
PML

189. *Our Mutual Friend*
Pub. Chapman and Hall (Cheap edition), 1867.
Frontispiece engraved by Dalziel after Houghton. There was a reprint in 1868.
PC

190. *The Uncommercial Traveller*
Pub. Chapman and Hall, 1868.
Engraved by Dalziel after Pinwell. Some of the designs are dated 1865 in the blocks.
PML

191. *The Mystery of Edwin Drood*
Pub. Chapman and Hall, 1870.
Twelve illustrations engraved by C. Roberts and Dalziel after S.L. Fildes. Originally published in six parts between April and September 1870. There was a reprint in Chapman and Hall's *Household Edition* in 1879.
BL V&A NGA

192. *Oliver Twist*
Pub. Chapman and Hall (*Household Edition*), [1871].
Twenty-eight designs engraved by Dalziel

after J. Mahoney.

BL V&A PML

193. *Little Dorrit*
Pub. Chapman and Hall (*Household Edition*), [1873].
Fifty-eight designs engraved by Dalziel after J. Mahoney. This series also appeared in a *Subscriber's Edition* in which the full-page plates were hand-coloured.

BL V&A PML

194. *Our Mutual Friend*
Pub. Chapman and Hall (*Household Edition*), [1875].
Fifty-eight designs engraved by Dalziel after J. Mahoney.

BL V&A PML

DOUDNEY, Sarah

195. *Stories of Girlhood or The Brook and the River*
Pub. Cassell, Petter and Galpin, [1877].
Engravings by Swain, W.J. Palmer and others after Barnes, Small and Pinwell.
Previously unrecorded.

PC

DULCKEN, H.W. (Translator and Editor)

196. *The Book of German Songs*
Pub. Ward and Lock, [1856].
Engraved by Dalziel after Keene. There are also numerous illustrations by other unidentified artists.

BM BL PML

DULCKEN, H.W. (Adapted by)

197. *The Golden Harp; Hymns, Rhymes and Songs for the Young*
Pub. Routledge, Warne and Routledge, 1864.
Engraved by Dalziel after several artists

including T. Dalziel, J.D. Watson and Joseph Wolf.

BM PML

DULCKEN, H.W.

198. *Old Friends and New Friends*
Pub. Frederick Warne, [?1866].
Engraved by Dalziel after several artists including Watson and Houghton. The dating of this book is problematic since the English Catalogue of Books gives 1866 while the British Library copy (undated) was not received until 1868.

BM BL

EARDLEY-WILMOT, Sir John E.

199. *Reminiscences of the late Thomas Assheton Smith Esq*
Pub. John Murray, 1860.
Six engravings by J.W. Whymper after Frederick Walker.

BL

EDGAR, John G.

200. *Sea Kings and Naval Heroes*
Pub. Bell and Daldy, 1861.
Contains one design engraved by Horace Harral after Keene. The other drawings are by K. Johnson. The book was actually published in October or November 1860.

BM BL

EDWARDS, Amelia B.

201. *Barbara's History*
Pub. Hurst and Blackett, [1865].
Steel-engraved frontispiece by John Saddler after J.D. Watson. No. XIX in Hurst and Blackett's *Standard Library*

BL

[EILOART, Elizabeth]

202. *Patient Henry*
Pub. Frederick Warne and Co., 1865.
Four engravings by Dalziel after Houghton.
BL

EILOART, Elizabeth

203. *Ernie Elton, The Lazy Boy*
Pub. George Routledge and Sons, 1865.
Four engravings by Dalziel after Houghton.
BL

204. *Johnny Jordan and his dog*
Pub. George Routledge and Sons, 1867.
Eight engravings by Dalziel possibly after
Small. My attribution is uncertain since the
monogram is not definitely Small's but the
excellent designs are clearly in his style.
BL

205. *Ernie at School and What Came of his Going
There*
Pub. George Routledge and Sons, 1867.
Four engravings by Dalziel after Houghton.
BL

206. *The Boys of Beechwood*
Pub. George Routledge and Sons, 1868.
Eight engravings by Dalziel after Houghton.
BM BL

ELIOT, George (Mary Anne Evans)

207. *Romola*
Pub. Smith Elder and Co. (illustrated
edition), 1865.
Contains a frontispiece, title-page illustration
and two others engraved by Swain and
Linton after Frederic Leighton. These are
reprinted from *The Cornhill Magazine*,
1862–3.
BL

208. *Romola*
Pub. Smith Elder and Co, 1880.
Twenty-four engravings and numerous

vignette illustrations engraved by Swain and
Linton after Frederic Leighton. Reprinted
from *The Cornhill Magazine*, 1862–3, but
here printed on toned India paper from the
original blocks. This was a large paper
edition published in two volumes and
limited to 1,000 copies.
BL PML

209. *Adam Bede*
Pub. William Blackwood and Sons, n.d.
?*c*.1875.
Six engravings by J.D. Cooper after Small.
Previously unrecorded.
PC

210. *Scenes of Clerical Life*
Pub. William Blackwood and Sons, n.d.
?*c*.1875.
Three illustrations engraved by J.D. Cooper
after Robert Barnes.
Previously unrecorded.
BL

211. *Silas Marner*
Pub. William Blackwood and Sons, n.d.
?*c*.1875.
Two illustrations engraved by J.D. Cooper
after Robert Barnes.
Previously unrecorded.
BL

ELWES, Alfred

212. *Luke Ashleigh or School-Life in Holland*
Pub. Griffith and Farran, 1864.
Engravings by Swain after du Maurier.
BL PML

ENGELBACH, Alfred H.

213. *Victor Leczinski or The Road to Siberia*
Pub. Society for Promoting Christian
Knowledge, [1866].
Engravings by an unidentified engraver after
J. Mahoney.
Previously unrecorded.
PC

214. *The Wreck of the Osprey*
Pub. Society for Promoting Christian
Knowledge, [1866].
Four engravings by Dalziel after J. Mahoney.
Previously unrecorded.
BL

FARRAR, Revd F.W.

215. *Seekers after God*
Pub. Macmillan and Co., July–September
1868.
Frontispiece to Part I is an engraving by J.D.
Cooper after Arthur Hughes. Entitled
'Aurelius and his mother' it is printed in
brown. Published in three monthly parts
these issues formed no. 3 in the *Sunday
Library for Household Reading*.
Previously unrecorded.
BL

216. *The Life of Christ*
Pub. Cassell, Petter and Galpin, [1874].
Frontispiece to each volume is an engraving
by WH (?W. Hooper) after Holman Hunt.
This is the second edition of the work
published in two volumes. I am grateful to
Dr Judith Bronkhurst for having drawn my
attention to the existence of this edition.
Previously unrecorded.
BL

[FLETCHER, Lucy] (ed.)

217. *Christian Lyrics*
Pub. Sampson, Low, Son and Marston,
1868.
Engravings by J.D. Cooper after several
artists including Robert Barnes.
BL MFAB

218. *Christian Lyrics*
Pub. Frederick Warne and Co. (Chandos
Poets Series), [1871].
Numerous small engravings by different
engravers after several artists including

Barnes and Houghton. An enlarged edition
of the above which was first published in
1868.
BL

FORMBY, Revd Henry

219. *Pictorial Bible and Church History*
Pub. Longman, Brown, Green and
Longmans, [1862].
Parts VI and VII of this publication contain
11 designs engraved by Walter Barker after
Lawless.
BL

**FOXE, John (Revised by William Bramley-
Moore)**

220. *Book of Martyrs*
Pub. Cassell, Petter and Galpin, [1866].
Designs engraved by W.L. Thomas after du
Maurier, Watson, Houghton, Small, Barnes,
Morten, Fildes.
BM PML MFAB

FREEMAN, Frank (Pseud. ADAMS, W.T.)

221. *Paul Duncan's Little by Little*
Pub. Sampson Low, Son and Co., 1862.
Frontispiece engraved by Horace Harral
after Keene. Although the design is unsigned
its authorship is revealed in Sampson Low's
list of publications at the back of the book.
BL

FRITH, Henry

222. *Routledge's Holiday Album for Boys*
Pub. George Routledge and Sons, 1877.
A wretched production containing reprinted
designs by most of the major artists
including Millais, Watson and Keene. The
presentation is so careless that some of the
illustrations appear twice.
BL

223. *Little Valentine and other Tales*
Pub. George Routledge and Sons, 1878.
Contains a reprint of 'Swing Song' by
Millais facing p.21. This design made its first
appearance in *Once a Week,* vol. V, 1861,
p.434.
BL

GARRETT, Mrs Semple

224. *Our Little Sunbeam's Picture-Book*
Pub. George Routledge and Sons, 1877.
Contains designs by Barnes and Small and
'Tommy's Swing' which is the same block as
'Swing Song' by Millais in Frith's *Little
Valentine* (q.v.). This must rate as one of the
most frequently reprinted of Millais's drawings.
BL

GARROD, Alfred Baring

225. *The Nature and Treatment of Gout …*
Pub. Walton and Maberly, 1859.
Apparently contains engravings after Keene.
NE

GASKELL, Mrs Elizabeth

226. *Sylvia's Lovers*
Pub. Smith Elder and Co., 1863.
Four full-page illustrations and another on
the title page engraved by Swain after du
Maurier.
BM BL

227. *A Dark Night's Work*
Pub. Smith Elder and Co., 1864.
Engravings (probably four) by Swain after
du Maurier
NE

228. *Cranford*
Pub. Smith Elder and Co., 1864.
Four engravings by Swain after du Maurier.
Reprinted in 1867 and 1870.
BM

229. *Lizzie Leigh and other Tales*
Pub. Smith Elder and Co., 1865.
Four engravings by Swain after du Maurier.
There was a reprint in 1870.
V&A PML (1870 edition)

230. *Cousin Phyllis and other Tales*
Pub. Smith Elder and Co., 1865.
Four engravings by Swain after du Maurier.
BL

231. *The Grey Woman and other Tales*
Pub. Smith Elder and Co., 1865.
Four engravings by Swain after du Maurier.
BL

232. *Wives and Daughters*
Pub. Smith Elder and Co., (two vols), 1866.
Eighteen illustrations engraved by Swain
after du Maurier. Reprinted from *The
Cornhill Magazine.*
BL PML

233. *North and South*
Pub. Smith Elder and Co., 1867.
Four engravings and title-page illustration by
Swain after du Maurier. Du Maurier's name
is not mentioned in the book.
LL

GATTY, Mrs Margaret

234. *Parables from Nature* [1st Series]
Pub. Bell and Daldy, 1861.
Two illustrations engraved by Horace Harral
after Holman Hunt.
BM NGA

235. *Parables from Nature* [1st and 2nd Series]
Pub. Bell and Daldy, 1865.
In addition to the two designs by Holman
Hunt included in the first series this edition
contains drawings also engraved by Harral
after Burne-Jones (1), Keene (1) and other
artists notably Tenniel and George Thomas.
Both Forrest Reid and Gleeson White
believed this book to have been published
in 1867. The edition of that year must be

counted as the second.
BM PML

GILBERT, William

236. *The Washerwoman's Foundling*
Pub. Alexander Strahan, 1867.
Six designs engraved by Swain after William Small.
BL

GILLIES, Mary

237. *The Voyage of the Constance – A Tale of the Polar Seas*
Pub. Sampson Low and Son, 1860.
Eight engravings by Horace Harral after Charles Keene.
PML

GOETHE, J.W.

238. *Egmont* (Translated by Arthur Duke)
Pub. Chapman and Hall, 1868.
Frontispiece engraved by Swain after Millais.
BL

GOLDSMITH, Oliver

239. *Dalziel's Illustrated Goldsmith*
Pub. Ward and Lock, 1865.
One hundred engravings by Dalziel after G.J. Pinwell. Originally issued in parts. The true first issue has 'In Weekly Numbers, One Penny, Monthly Parts, Sixpence' to the head of the advertisements at the back.
BM V&A PML MFAB NGA

GRYLLS, M.

240. *Helen and her Cousins*
Pub. Society for Promoting Christian Knowledge, [1863].
Engravings by an unidentified engraver after

J.D. Watson.
Previously unrecorded.
SPCK

H, E.M. [Emily Marion Harris]

241. *Echoes*
Pub. Bell and Daldy, 1872.
The frontispiece is an engraving by Dalziel after Poynter which is dated 1871 in the block. The title page states that the work is by the author of *Four Messengers*.
Previously unrecorded.
BL

HAKE, Thomas Gordon

242. *Parables and Tales*
Pub. Chapman and Hall, 1872.
Nine engravings by Dalziel after Arthur Hughes. The drawings for this book are in the collection of the Art Gallery of South Australia, Adelaide.
BM BL V&A MFAB

HALL, S.C.

243. *The Trial of Sir Jasper – A Temperance Tale in Verse*
Pub. Virtue, Spalding and Co., 1873.
Contains an engraving 'Is it too late to save him?' by W. Ballingall after J. Noel Paton. The book also contains designs after Birket Foster and others. It was reprinted in 1874.
Previously unrecorded.
BL V&A

244. *An Old Story – A Temperance Tale in Verse*
Pub. Virtue, Spalding and Co., [1875].
Contains a frontispiece 'Watching and Waiting' engraved by J.D. Cooper after Millais. There are also designs after Birket Foster, J. Noel Paton and Alma Tadema. The book was reprinted in 1876.
Previously unrecorded.
PC

HALL, Mrs S.C.

245. *The Prince of the Fair Family*
Pub. Chapman and Hall, [1867].
Engravings by J.D. Cooper after various
artists including one after J. Noel Paton.
BL

HALLIDAY, Andrew (ed.)

246. *The Savage-Club Papers*
Pub. Tinsley Brothers, 1867.
Illustrations by du Maurier, C.H. Bennett,
Houghton and Watson among others. The
book actually appeared in December 1866.
BL V&A PML MFAB

HARDY, Thomas

247. *The Hand of Ethelberta*
Pub. Smith Elder and Co., 1877.
Six illustrations engraved by Swain after du
Maurier. The novel appeared first in *The
Cornhill Magazine* between July 1875 and
May 1876 where it was accompanied by 11
full-page illustrations and 11 vignette initials
all engraved by Swain.
BL

HEBER, Bishop Reginald

248. *Heber's Hymns*
Pub. Sampson Low, Son and Marston, 1867.
Engravings by J.D. Cooper after several
artists including William Small. There was a
second edition in 1870.
BL

HOOD, Thomas (the elder)

249. *Passages from the Poems of Thomas Hood
Illustrated by the Junior Etching Club*
Pub. E. Gambart, 1858.
Thirty-four etchings including two by

Millais, one by Simeon Solomon and one by
Keene.
BM

HOOD, Thomas (the younger) (ed.)

250. *Jingles and Jokes for Little Folks*
Pub. Cassell, Petter and Galpin, [1865].
Engravings by W.J. Linton after Thomas
Morten and C.H. Bennett.
BM BL PML

251. *Cassell's Illustrated Penny Readings*
Pub. Cassell, Petter and Galpin, [1866–8].
Numerous engravings by different engravers
after Small, S.L. Fildes, Watson, Houghton
and Mahoney.
BM BL

HOOLE, Barbara (later HOFLAND, Mrs)

252. *William and his Uncle Ben*
Pub. T. Nelson and Sons, [1865].
Frontispiece and title-page illustration
engraved by Robert Paterson after William
Small. Published late in 1864.
BL

HOPE-MONCRIEF, Robert

253. *Horace Hazelwood or Little Things*
Pub. Johnstone, Hunter and Co.
(Edinburgh), n.d.
Six engravings by Williamson after Small
reprinted from *The Children's Hour*. Twelve
of the main stories from this magazine were
reprinted in book form at 2 shillings and 6
pence or 3 shillings each.
Previously unrecorded.
BM PML

HOWE, Edward

254. *The Boy in the Bush*
Pub. Bell and Daldy, 1869.
Engravings by Dalziel after various artists

including J. Mahoney.
Previously unrecorded.
BL

1870.
Engravings by Swain after S.L. Fildes.
BL

[HUGHES, Thomas]

256. *Tom Brown's Schooldays by An Old Boy*
Pub. Macmillan and Co. (*Golden Treasury Series*), 1868.
Title-page illustration is a steel engraving presumably by C.H. Jeens after Arthur Hughes. The British Library copy was received on 8 February 1868 which suggests that this was actually published late in 1867. It is marked *Fifty-Fifth Thousand*. The design shares certain similarities with that facing p.307 in the 1869 edition of the book, with which it should be compared. I am indebted to Mr Leonard Roberts for having alerted me to the existence of this illustration. Previously unrecorded.
BM BL

257. *Tom Brown's Schooldays by An Old Boy*
Pub. Macmillan and Co., 1869.
Engravings by J.D. Cooper after Arthur Hughes and Sydney Prior Hall. First published unillustrated in 1857. This edition contains the author's preface to the sixth edition. There were many later editions sometimes in smaller format and occasionally undated which contain only 26 of the illustrations.
BM V&A PML MFAB NGA

HUGO, Victor

258. *Les Misérables*
Pub. Hurst and Blackett, [1864].
Steel-engraved frontispiece by John Saddler after Millais dated 'Feb 12th 1864' at foot of plate and 1863 in the plate. Volume xxviii in Hurst and Blackett's *Standard Library*.
BM BL

259. *By Order of the King*
Pub. Bradbury, Evans and Co. (three vols),

[INGELOW, Jean]

260. *Studies for Stories from Girls' Lives*
Pub. Alexander Strahan, 1866.
Five illustrations engraved by Swain and Dalziel after Millais (2), Houghton, Small and Barnes. Apparently the third edition of the work but the first to contain these designs.
BM PML MFAB

INGELOW, Jean

261. *Stories Told to a Child*
Pub. Alexander Strahan, 1865.
Two illustrations engraved by Swain after Houghton.
BM BL

262. *Songs of Seven*
Pub. Roberts Brothers (Boston, USA), 1866.
Seven engravings by Dalziel after J.W. North. Forrest Reid knew the designs from proofs in the Dalziel Archive in the British Museum (see p.165) but he did not know this book. Robin de Beaumont rediscovered it in 1976. The other (mediocre) designs in the book are not by North. Previously unrecorded.
BM

263. *Poems*
Pub. Longmans, Green, Reader and Dyer, 1867.
Engraved by Dalziel after Pinwell, E. and T. Dalziel, Houghton, Small, Poynter, Wolf, North. A *Dalziel Gift Book* published in November 1866 at 21 shillings.
BM V&A PML MFAB NGA

264. *The Little Wonder-Horn – A New Series of Stories Told to a Child*
Pub. Henry S. King, 1872.

Two designs engraved by Dalziel after J. Mahoney. Other illustrations called for, were not present in the copy examined (British Library).

BL

265. *Fated to be Free*
Pub. Tinsley Brothers, 1876.
Twenty-three illustrations engraved by Swain after Pinwell. Pinwell's name is not mentioned and the number of illustrations has been reduced from the serialization in *Good Words* in 1875.

BL

266. *The Shepherd Lady*
Pub. Roberts Brothers (Boston, USA), 1876.
Four engravings by Dalziel after Arthur Hughes. These designs were found by Forrest Reid in the Dalziel Archive (British Museum) but he was unable to identify the book for which they were intended (p.95). Previously unrecorded.

BM

JACKSON, Richard C.

267. *The Risen Life*
Pub. R. Elkins and Co. (third edition), 1889.
Facing p.9 is an illustration by an unidentified engraver printed in red after D.G. Rossetti. The design of a pelican biting her breast to feed her young (a symbol of piety) is repeated (gold on green) on the cover.

BM BL

JAY, Mrs W.M.L. (Pseud. Julia L.M. Woodruff)

268. *Without and Within: A New England Story*
Pub. James Nisbet and Co., 1871.
Six wood-engraved illustrations by an

unidentified engraver after J.D. Watson. Printed in colour in the *Golden Ladder Series*. The advertisements at the back, call for eight illustrations, but only six were present in the copy examined (British Library). Previously unrecorded.

BL

JERROLD, Douglas

269. *Mrs Caudle's Curtain Lectures*
Pub. Bradbury, Evans and Co., 1866.
Illustrations engraved by Swain after Charles Keene. The frontispiece is a colour lithograph. The first issue has 'Illustrated by Charles Keene' in red on the title page, Bradbury and Evans colophon on the verso of the title page instead of at the end, and advertisements at end stating this to be uniform with *The Story of a Feather*. There are also plain black endpapers with Leighton Son and Hodge binding ticket. The second issue should have tartan endpapers and an Edmonds and Remnants binding ticket but I have also seen copies with black endpapers which also appear to be the second issue. An interesting edition was published by R. Brimley Johnson [1902] which reprinted, not only Keene's designs, but also those of Leech and Doyle from the first appearance of the text in *Punch* apparently printed from the original blocks.

BM V&A PML MFAB NGA

270. *The Story of a Feather*
Pub. Bradbury, Evans and Co., 1867.
Engraved by Swain after du Maurier.

BM V&A PML NGA

[JOHNSON, Joseph]

271. *Clever Girls of Our Time and How they Became Famous Women*
Pub. Darton and Co., 1862. Reprinted 1865 (7th edition).

Eight engravings by William Measom after Thomas Morten. I have only been able to examine a later edition [1875] published by Gall and Inglis.
Previously unrecorded.
BL (1875)

JUDKIN, Revd T.J.

272. *By-Gone Moods*
Pub. Longman, Brown, Green and Longmans, 1856.
Facing p.56 is an engraving by Dalziel after Pickersgill 'The Surprisal.'
BM V&A

KEATS, John

273. *Endymion*
Pub. Moxon and Son, 1873.
Steel-engravings by F. Joubert after E.J. Poynter. Apparently published at the end of 1872.
BL

KEDDIE, Henrietta. See TYTLER, Sarah

KINGSLEY, Charles

274. *The Water Babies*
Pub. Macmillan and Co., 1863.
Contains a frontispiece and one other illustration by an unidentified engraver after J. Noel Paton. These illustrations were much reprinted until replaced by the more numerous and celebrated designs by Linley Sambourne which first appeared in 1885.
BL

KINGSLEY, Henry

275. *The Boy in Grey*
Pub. Strahan and Co., 1871.

Fourteen engravings by Dalziel after Arthur Hughes. Published for the Christmas market 1870. These designs first appeared in *Good Words for the Young*.
BM BL

KINGSTON, William H.G.

276. *Jack Buntline or Life on the Ocean*
Pub. Sampson Low, Son and Co., 1861.
Frontispiece engraved by Horace Harral after Charles Keene.
BL

LAMB, Charles and Mary

277. *Tales from Shakespeare*
Pub. Macmillan and Co., 1878.
Title-page illustration engraved by Swain after du Maurier.
Previously unrecorded.
PC

LANKESTER, Mrs Phebe

278. *Marian and her Pupils*
Pub. Routledge, 1865.
Apparently the first edition was illustrated by Walker and Watson while the revised edition was illustrated by Houghton. I have been unable to see any edition. The matter is further complicated by four proofs by Small in the Dalziel Archive (British Museum) which are also marked as being for this book.
NE

LEE, Holme (pseud.) PARR, Mrs Harriet

279. *In the Silver Age*
Pub. Smith, Elder and Co., (two vols), 1864.
Each volume contains a frontispiece engraved by Dalziel after J.W. North.

Previously unrecorded.

PC

LEIGHTON, Frederic

280. *Twenty-Five Illustrations by Frederic Leighton Designed for The Cornhill Magazine*
Pub. Smith, Elder and Co., 1867.
Proof wood-engravings with accompanying text. A folio costing 10 shillings and 6 pence. Uniform with the volume devoted to Millais (q.v.) and Walker (q.v.).
BM

LEMON, Mark (ed.)

281. *The Jest Book*
Pub. Macmillan and Co., 1864.
Title-page illustration is a steel engraving by C.H. Jeens after Keene.
BM BL PML

LEMON, Mark

282. *Legends of Number Nip*
Pub. Macmillan and Co., 1864.
Engravings by Swain after Keene.
BM BL V&A PML

283. *Fairy Tales*
Pub. Bradbury, Evans and Co., 1868.
Engravings by Swain after Richard Doyle and C.H. Bennett.
PML

LESLIE, Henry

284. *Little Songs for me to Sing*
Pub. Cassell, Petter and Galpin, [1865].
Frontispiece and six engravings by Swain after Millais.
BM V&A PML

285. *Henry Leslie's Musical Annual*
Pub. Cassell, Petter and Galpin, 1871.

Frontispiece is a steel-engraving by C.H. Jeens after Millais 'A Reverie' and the book also contains 'The Boatswain's Leap', a full-page engraving by Swain after Pinwell. The book was evidently published in December 1870.
BL(Music Library)

286. *Leslie's Songs for Little Folks*
Pub. Cassell and Co., [1883].
A reprint of *Little Songs for me to Sing* (q.v.). However, this contains a frontispiece design by Millais of a nun gazing out of a convent window which was not present in the earlier book. It appears to have been engraved by AHYER (not identified) and is apparently dated 1854 in the block. There is also an edition containing the same illustrations published by J.B. Cramer and Co., *c.*1885. This book should not be confused with another, similarly entitled, that appeared in 1873 – an entirely different work and, with the exception of a frontispiece by H.C. Selous, is unillustrated.
BL(Music Library) MFAB

LEVER, Charles

287. *Lord Kilgobbin*
Pub. George Routledge and Sons, [1877].
Contains some, but not all of the engravings by Swain after S.L. Fildes, which appeared first when the story was serialized in *The Cornhill Magazine* in 1870–2. Here the drawings are reduced in size and Fildes's name does not appear on the title page.
BL

LYNN, Elizabeth (later LINTON) known as Elizabeth LYNN LINTON

288. *Patricia Kemball*
Pub. Chatto and Windus, 1875.
Frontispiece by du Maurier.
NE

LLOYD, Mrs W.R. (FOX, Miss Bitha)

289. *The Flower of Christian Chivalry*
Pub. James Hogg and Sons, [1863].
Eight engravings by Dalziel after J.D.
Watson.
BM BL

LONGFELLOW, H.W.

290. *Poetical Works*
Pub. T. Nelson and Sons, 1866.
Seven engravings by Williamson and
Paterson after Small. They are printed in
brown, but in the second edition dated 1868
they appear more conventionally in black.
The designs differ from those which Small
made for the *Chandos* Longfellow (1867)
(q.v.).
Previously unrecorded. Reprinted in black
1867–8.
BM

291. *Poetical Works*
Pub. Frederick Warne and Co., (*Chandos
Poets*), 1867.
Engravings by Dalziel after North, Small,
Houghton and Paul Gray. Reid (p.199)
states that proofs of these engravings were
pulled in 1866. The book was reprinted in
1869. There was a later edition in the
Lansdowne Poets series (1889) which omits
the North and one of the Small designs.
BM

LUCAS, J. Templeton

292. *Prince Ubbely Bubble's New Story Book*
Pub. John Camden Hotten, [1871].
Contains an engraving 'Tom and the Ogre'
by WM (unidentified) after Robert Barnes.
BL

LUSHINGTON, Henrietta, Lady

293. *The Happy Home or The Children at the Red
House*

Pub. Griffith and Farran, 1864.
Four engravings by Swain after Pinwell.
This, Pinwell's first book, was actually
published in November 1863.
BM BL

294. *Hacco The Dwarf or The Tower on the
Mountain*
Pub. Griffith and Farran, 1865.
Four engravings by Swain after Pinwell.
Actually published in December 1864.
BM BL PML MFAB

MACDONALD, George

295. *Alec Forbes of Howglen*
Pub. Hurst and Blackett (*Standard Library*),
[1867].
Steel-engraved frontispiece by John Saddler
after Arthur Hughes. Beneath the plate is
the engraved date 15 June 1867. This book
formed no. xxiv in Hurst and Blackett's
Standard Library.
Previously unrecorded.
BL

296. *Dealings with the Fairies*
Pub. Alexander Strahan, 1867.
Engraved throughout by Dalziel after Arthur
Hughes.
BM BL PML

297. *England's Antiphon*
Pub. Macmillan and Co., 1868.
Contains three engravings printed in brown
by J.D. Cooper after Arthur Hughes. Issued
in three parts from October to December
1868 with the whole publication being
numbered iv in the *Sunday Library for
Household Reading*. The parts were issued in
decorative paper wrappers for binding
together which were dated. Part 3 was
unillustrated. The book issues were generally
undated.
BL PML

298. *At the Back of The North Wind*
Pub. Strahan and Co., 1871.

Engraved by Dalziel after Arthur Hughes and published for the Christmas market in 1870. Reprinted from *Good Words for the Young.*
BM BL MFAB

299. *Ranald Bannerman's Boyhood*
Pub. Strahan and Co., 1871.
Engraved by Dalziel after Arthur Hughes.
Reprinted from *Good Words for the Young.*
BL

300. *The Princess and the Goblin*
Pub. Strahan and Co., 1872.
Engraved by Dalziel after Arthur Hughes.
Reprinted from *Good Words for the Young* in 1871 and published in book form for Christmas 1871.
BL

301. *Gutta Percha Willie*
Pub. Henry S. King, 1873.
Engraved by Dalziel after Arthur Hughes.
Reprinted from *Good Words for the Young.*
BL

MACDONALD, Louisa Powell (Mrs George)

302. *Chamber Dramas for Children*
Pub. Strahan and Co., 1870.
Title page is an engraving by Dalziel after Arthur Hughes. The head and tailpieces do not appear to be by Hughes.
BL

MACKAY, Charles (ed)

303. *The Home Affections Pourtrayed by the Poets*
Pub. George Routledge and Co., 1858.
One hundred engravings by Dalziel after several artists including Millais, Birket Foster, Pickersgill, E. and T. Dalziel.
BM V&A PML MFAB NGA

304. *A Thousand and One Gems of Poetry*
Pub. George Routledge and Sons, 1867.
Engravings by Dalziel after several artists

including Millais and Pickersgill. All the designs appear to be reprints.
PC

[MACLAREN, Archibald]

305. *The Fairy Family: Ballads and Metrical Tales, of the Fairy Faith of Europe*
Pub. Longman and Co., 1857.
Steel-engraved frontispiece and title-page illustration and wood-engraved tailpiece by unidentified engravers after Burne-Jones. His earliest illustrations.
BM BL PML

MACLEOD, Norman

306. *The Gold Thread*
Pub. Alexander Strahan and Co. (Edinburgh) and Hamilton Adams and Co. (London), 1861.
Engravings by Dalziel after J.D. Watson and by other engravers after Gourlay Steele and J. Macwhirter. First published without illustrations in *Good Words* in 1860.
BM BL V&A

307. *Character Sketches*
Pub. Alexander Strahan, 1872.
Includes a frontispiece engraved by Dalziel after Pinwell and another illustration after Pettie. Both are reprints and are slightly cut down in size. The Pettie made its first appearance on 1 October 1868 in *The Sunday Magazine* to 'Philip Clayton's First-Born'. The Pinwell appeared originally as 'Billy Buttons' in *Good Cheer,* 1867, p.8. There was a second edition published by Daldy and Isbister in 1875.
BM

[M.D.]

308. *A Bonfire and What Came of it*
Pub. Society for Promoting Christian Knowledge, [1878].

Contains at least one engraving by an unidentified engraver after J. Mahoney. Previously unrecorded.
SPCK

MEREDITH, George

309. *The Shaving of Shagpat*
Pub. Chapman and Hall, 1865.
Steel-engraved frontispiece by John Saddler after Frederick Sandys. One of Chapman and Hall's *Standard Editions of Popular Authors*.
BM

MEREDITH, Owen

310. *Lucile*
Pub. Chapman and Hall, 1868.
Twenty-four engravings by W. Thomas after du Maurier.
BM BL V&A PML MFAB

MILLAIS, John Everett

311. *The Parables of Our Lord and Saviour Jesus Christ*
Pub. Routledge, Warne, Routledge, 1864.
Twenty engravings by Dalziel after Millais. Twelve of these illustrations made their first appearance in *Good Words* in 1863. This was the *Dalziel Gift Book* for 1864 and was actually published on 10 December 1863.
BM V&A PML MFAB

312. *Collected Illustrations*
Pub. Alexander Strahan, 1866.
Eighty illustrations almost all of which are reprints. Only the title-page design appears to be new. There was an undated reprint of the book (*c.*1872) published by Cassell, Petter and Galpin.
BM V&A PML NGA

313. *Twenty-Nine Illustrations by John Everett Millais Designed for The Cornhill Magazine*
Pub. Smith Elder and Co., 1867.

An illustrated Gift Book which cost 10 shillings and 6 pence. Issued at folio size these were proof engravings, presumably printed from the wood, with accompanying text from the magazine.
PML

MILTON, John

314. *Comus*
Pub. George Routledge and Co., 1858.
Engravings by Dalziel after various artists including Pickersgill.
V&A

315. *Ode on the Morning of Christ's Nativity*
Pub. James Nisbet and Co., 1868.
Engravings by W.J. Palmer after Albert Moore, Small and others. There were later editions published by Frederick Warne which are undated.
BM

MITFORD, Mary Russell

316. *Children of the Village*
Pub. George Routledge and Sons, 1880.
Engravings by J.D. Cooper after various artists including Robert Barnes (seven designs).
BL

MONTGOMERY, Florence

317. *Misunderstood*
Pub. Richard Bentley, 1874.
Eight full-page illustrations engraved by Swain after du Maurier.
BL PML

MONTGOMERY, James

318. *Poems*
Pub. Routledge, Warne and Routledge, 1860.
Engravings by Dalziel chiefly after John

Gilbert and Birket Foster but including also on p.49 'Morna' after Pickersgill.
BM V&A PML

MOORE, Thomas

319. *Irish Melodies*
Pub. Longmans, Brown, Green and Longmans, 1856.
Facing p.84 is a steel-engraving by T.O. Barlow after Millais entitled 'When First I met thee'. The original drawing (Private Collection) entitled 'Married for money' was exhibited in the Arts Council exhibition devoted to Millais held in 1979 (catalogue no. 21).
BL

320. *Poetry and Pictures*
Pub. Longman, Brown, Green and Co., 1858.
Contains three engravings by W.J. Linton after Pickersgill as well as designs by several other artists. There were later re-issues many of which are undated.
BM PML

321. *Lalla Rookh*
Pub. Routledge, Warne and Routledge, 1860.
Contains three engravings by Edmund Evans after Pickersgill as well as designs by several other artists.
BM V&A PML(1861)

MORLEY, Henry

322. *Fables and Fairy Tales*
Pub. Chapman and Hall, 1860.
Engravings by Dalziel after C.H. Bennett. Published for the Christmas season 1859.
BL

323. *Oberon's Horn*
Pub. Chapman and Hall, 1861.
Engravings by Dalziel after C.H. Bennett. Published for the Christmas season 1860.
BL

324. *The Chicken Market and other Fairy Tales*
Pub. Cassell, Petter and Galpin, [1877].
Engravings by Dalziel after C.H. Bennett many of which appeared first in Morley's *Fables and Fairy Tales*, 1860, (q.v.).
BL

MORRIS, William

325. *The Earthly Paradise*
Pub. F.S. Ellis, 1868.
Wood-engraved title-page engraving probably by Morris himself after Burne-Jones.
BL

[MULOCK, Dinah (Mrs Craik)]

326. *John Halifax, Gentleman*
Pub. Hurst and Blackett (*Standard Library* no. ii), [1861 or 1862].
Steel-engraved frontispiece by John Saddler after Millais entitled 'Ursula March' and dated 1861 in the plate.
BL

327. *Studies from Life*
Pub. Hurst and Blackett (*Standard Library* no. ix), [1862].
Steel-engraved frontispiece by Joseph Brown after Holman Hunt entitled 'Lost'.
BL

328. *Nothing New*
Pub. Hurst and Blackett (*Standard Library* no. xvii), [1861 or 1862].
Steel-engraved frontispiece by John Saddler after Millais entitled 'Jean Dowglas' and dated 1861 in the plate.
BM BL

329. *Mistress and Maid*
Pub. Hurst and Blackett (*Standard Library* no. xxvi), [1862 or 1863].
Steel-engraved frontispiece by John Saddler after Millais entitled 'Mistress and Maid'.
BL

330. *Christian's Mistake*
Pub. Hurst and Blackett (*Standard Library* no. xxxiii), [1866].
Steel-engraved frontispiece by John Saddler after Sandys entitled 'Christian' and dated 1 August 1866 below the plate.
BL

331. *The Woman's Kingdom*
Pub. Hurst and Blackett (*Standard Library* no. xxix), [1870].
Steel-engraved frontispiece by John Saddler after William Small entitled 'Edna and Letty'.
Previously unrecorded.
BL

MULOCK, Dinah (Mrs Craik)

332. *The Fairy Book*
Pub. Macmillan and Co., 1863.
The title-page vignette is a steel-engraving by C.H. Jeens after J. Noel Paton entitled 'The Sleeping Beauty'.
BL

[NOEL, Lady Augusta]

333. *The Story of Wandering Willie*
Pub. Macmillan and Co., 1870.
Frontispiece engraved by Robert Paterson after J. Noel Paton. Dated 1870 in the block.
BL

NORTON, Caroline

334. *Lost and Saved*
Pub. Hurst and Blackett (*Standard Library* no. xxvii), [1864].
Steel-engraved frontispiece by John Saddler after Millais entitled 'Lost and Saved' and dated beneath the plate, 15 December 1863.
Previously unrecorded.
BL

[ORMEWOOD, Oliver]

335. *Th' Greyt Eggshibishun e Lundun ... Be o Felley fro Rachde ...*
Pub. Hamilton Adams and others, (Rochdale), [1856].
Fourteen engravings by R. Langton after Frederic Shields. Written entirely in Rochdale dialect this is the third edition of the book but the first with these illustrations.
BM

O'SHAUGHNESSY, Arthur and Eleanor

336. *Toyland*
Pub. Daldy, Isbister and Co., 1875.
The frontispiece by Dalziel after Houghton is a reprint reduced in size of a design which originally appeared in *Good Words* in 1863.
BL

OWEN, Mrs Octavius Freire

337. *The Heroines of Domestic Life*
Pub. Routledge, Warne and Routledge, 1862.
Engravings by Dalziel after J.D. Watson.
BM

PALGRAVE, Francis Turner

338. *The Five Days Entertainments at Wentworth Grange*
Pub. Macmillan and Co., 1868.
Seventeen engravings by J.D. Cooper after Arthur Hughes.
BM BL V&A PML MFAB

PAULL, Mrs H.

339. *Horace Carleton*
Pub. Jarrold and Sons, 1874.
Frontispiece engraved by an unidentified engraver after Robert Barnes. I have only been able to see a very late edition of this

book dated 1898.
Previously unrecorded.
PC

PELHAM-DALE, Revd Thomas

340. *Life's Motto*
Pub. James Hogg and Son, [1869].
Frontispiece engraved by Horace Harral
after J.D. Watson.
Previously unrecorded.
BM

PENNELL, H. Cholmondeley

341. *Puck on Pegasus*
Pub. John Camden Hotten, 1869.
Contains a curious design facing p.140 of a
fire brigade apparently by Millais. Also
contains designs engraved by Swain after
Paton, Leech, M.E. Edwards and several
others. The frontispiece is an etching by
George Cruikshank. This is the revised and
enlarged sixth edition of a work which first
appeared in 1861.
PC

342. *Pegasus Re-Saddled*
Pub. Henry S. King, 1877.
Ten engravings by Swain after du Maurier.
BL V&A PML MFAB

PERRY, George G.

343. *History of the Crusades*
Pub. Society for Promoting Christian
Knowledge, [1865].
Four engravings by an unidentified engraver
after J. Mahoney.
PC

PICKERSGILL, F.R.

344. *Six Compositions from The Life of Christ*
Pub. Chapman and Hall, [1850].
Engraved by Dalziel without letterpress. An

ambitious project but one which was not
completed. In preparation were 'The
Miracles', 'The Parables' and 'The Acts of
the Apostles'. Issued at folio size the designs
were printed on toned paper.
BL

POE, Edgar Allan

345. *Poetical Works*
Pub. Sampson Low, Son and Co., 1858.
Engraved by different engravers after several
artists including Tenniel but especially
notable for the 13 after Pickersgill. There
was an undated reprint *c.*1865 by Ward,
Lock and Tyler.
BL V&A

POTTER, Frederick Scarlett

346. *Frank Newitt's Fortunes*
Pub. Society for Promoting Christian
Knowledge, [1877].
The frontispiece is a cut-down version of an
illustration engraved by Whymper after
Mahoney which first appears facing
p.113 in Ruth Buck's *The Carpenter's Family*
(q.v.). Here the drawing is entitled 'A Quiet
Scene'.
Previously unrecorded.
PC

PROCTER, Adelaide Anne

347. *Legends and Lyrics*
Pub. Bell and Daldy, 1866.
Engravings by Horace Harral after Samuel
Palmer, du Maurier, J.D. Watson, Keene
and Morten.
BM BL V&A PML MFAB

PROSSER, Mrs

348. *The Awdries and their Friends and other Tales*
Pub. Religious Tract Society, [1868].

Several engravings by Thomas Robinson after du Maurier which first appeared in *The Leisure Hour* in 1865. Here they are better printed.
PML

349. *The Door without a Knocker and other Tales*
Pub. Religious Tract Society, [1875].
Seven engravings by Swain after William Small illustrate the third story 'Blind John Netherway.' These designs appeared first in *The Sunday at Home*, vol 14, 1867.
Previously unrecorded.
PC

QUARLES, Francis

350. *Quarles's Emblems*
Pub. James Nisbet and Co., 1861.
Engravings by Swain and Edmund Evans after C.H. Bennett and W. Harry Rogers.
MFAB NGA

RALSTON, William Ralston Shedden (trans.)

351. *Krilof and his Fables*
Pub. Strahan and Co., 1869.
Twenty-four engravings by Dalziel after Houghton and 23 after Zwecker. Some of these vignette illustrations first appeared in *Good Words* in 1868. There was a second edition also published in 1869.
BM BL V&A PML

RANDS, William Brighty. See BROWNE, Matthew

READE, Charles

352. *Christie Johnstone*
Pub. Bradbury, Evans and Co., 1868.
Frontispiece and title-page illustration engraved by Swain after William Small.
BL

353. *Double Marriage or White Lies*
Pub. Bradbury, Evans and Co., 1868.
Frontispiece and title-page illustration engraved by Swain after Charles Keene.
BL

354. *It is Never too Late to Mend*
Pub. Bradbury, Evans and Co., 1868.
Frontispiece and title-page illustration engraved by Swain after G.J. Pinwell. This book, with the same frontispiece, was still being reprinted as late as July 1882 by Chatto and Windus.
PC

355. *Peg Woffington*
Pub. Bradbury, Evans and Co., 1868.
Frontispiece and title-page illustration engraved by Swain after S.L. Fildes.
BL

356. *Griffith Gaunt*
Pub. Bradbury, Evans and Co., 1869.
Frontispiece and title-page illustration engraved by Swain after S.L. Fildes.
BL

357. *Foul Play*
Pub. Chatto and Windus, 1882.
Apparently contains a design (probably a frontispiece) by du Maurier.
NE

REID, Captain Mayne (Pseud. BEACH, Charles)

358. *The Boy Tar or A Voyage in the Dark*
Pub. W. Kent (Late D. Bogue), 1860.
Twelve full-page engravings by Robert Loudon after Charles Keene. In the edition of 1861 the nude boy swimmer at p. 16 has now been rendered decent, by the addition of what appears to be a jacket. This was reprinted in a later edition from Routledge in red cloth [1870].
BM BL

[RICHMOND, D.]

359. *Accidents of Childhood*
Pub. George Routledge and Sons, 1861.
Twenty engravings by Dalziel after J.D.
Watson.
BM (1866 edition)

360. *The Maze of Life: Its Flowers and its Thorns*
Pub. Routledge, Warne and Routledge,
1861.
Four engravings by Dalziel after J.D.
Watson.
BL

RICHMOND, D.

361. *Through Life and for Life*
Pub. Routledge, Warne and Routledge,
1862.
Eight engravings by Dalziel after J.D.
Watson.
Previously unrecorded.
BL

ROGERS, Samuel

362. *The Pleasures of Memory*
Pub. Sampson Low, Son and Marston,
[1865].
Designs reproduced by Hyalography after
several artists including Samuel Palmer,
Wimperis, Charles Green and two by J.D.
Watson.
BM

ROSSETTI, Christina

363. *Goblin Market and other Poems*
Pub. Macmillan and Co., 1862.
Frontispiece engraved by Charles James
Faulkner and title-page illustration engraved
by W.J. Linton after Dante Gabriel Rossetti.
The frontispiece bears the initials of the
printer Morris Faulkner and Co. Dr W.E.
Fredeman discusses the differences between

this edition and the second dated 1865
(p.176, 44.3) (see Select Bibliography).
BM BL V&A MFAB

364. *The Prince's Progress and other Poems*
Pub. Macmillan and Co., 1866.
Frontispiece and title-page illustration
engraved by W.J. Linton after Dante Gabriel
Rossetti.
BM BL V&A MFAB

365. *Sing-Song. A Nursery Rhyme Book*
Pub. George Routledge and Sons, 1872.
One hundred and twenty engravings by
Dalziel after Arthur Hughes. An enlarged
edition appeared in 1893.
BM BL V&A PML MFAB

366. *Speaking Likenesses*
Pub. Macmillan and Co., 1874.
Twelve engravings by Dalziel after Arthur
Hughes. A book specifically aimed at girls.
BL V&A MFAB

ROSSETTI, William Michael (ed.)

367. *The Poetical Works of Lord Byron*
Pub. Edward Moxon, 1870.
Six steel-engravings by an unidentified
engraver after F.M. Brown and two after
Oliver Madox Brown. There was a later
undated edition where the quality of the
printing of the illustrations is markedly
inferior. This edition invariably lacks the
illustration to 'Sardanapalus'. However, I
have found clear first editions which also fail
to include this particular plate. A confusing
book bibliographically speaking.
Previously unrecorded.
BM

SANDYS, Frederick

368. *Reproductions of Woodcuts by F. Sandys
1860–66* – Edited by Mary Sandys
Pub. Carl Hentschel, [1910].
Published in a numbered, limited edition

with an introduction by Borough Johnson. An inferior, ordinary edition was also produced (n.d.). Enlarged edition with 27 plates, [1915].
BM

SANFORD, Mrs D.P.

369. *Frisk and his Flock*
Pub. Cassell, Petter and Galpin, [1876].
Contains a single design by an unidentified engraver after Robert Barnes.
Previously unrecorded.
ABT

SANGSTER, William

370. *Umbrellas and their History*
Pub. Cassell, Petter and Galpin, [1871].
Illustrations by an unidentified engraver after C.H. Bennett.
BL

SARGENT, G.E.

371. *Hurlock Chase*
Pub. Religious Tract Society, [1876].
Thirteen engravings by an unidentified engraver after George du Maurier. He originally provided 27 illustrations for the story when it first appeared in *The Leisure Hour* in 1864. Here, not only are there fewer designs, but those that remain are reduced in size.
PML

SARTORIS, Adelaide

372. *A Week in a French Country-House*
Pub. Smith, Elder and Co., 1867.
Two engravings by Swain after Frederic Leighton which had first appeared in *The Cornhill Magazine* between February and April 1867.
BL PML

SCOTT, Clement W.

373. *Round about the Islands or Sunny Spots near Home*
Pub. Tinsley Brothers, 1874.
Frontispiece and title-page vignette engraved by Swain after du Maurier.
BL

SCOTT, Michael

374. *Tom Cringle's Log*
Pub. Blackwood, 1861.
Seven designs engraved by J.W. Whymper after Frederick Walker. I have only been able to see proofs in the Leggatt Collection (British Museum, Department of Prints and Drawings).
NE

SCOTT, Walter

375. *Poetical Works*
Pub. Frederick Warne and Co (*Chandos Poets*), 1868.
Three engravings by Dalziel after Mahoney and one after Houghton. This was reprinted in Warne's *Lansdowne Poets* series in September 1877 but the number and size of the illustrations were reduced and the Houghton design omitted.
Previously unrecorded.
PC

SHIELDS, Frederic J.

376. *Illustrations to Bunyan's Pilgrim's Progress*
Pub. Simkin, Marshall and Co., 1864.
Nineteen engravings by Swain, Green, Orrin Smith and W.L. Thomas after Shields. There was a second edition in 1875.
V&A BM(Second edition)

[SIDEY, J.A.]

377. *Alter Ejusdem*
Pub. Maclachlan and Stewart, (Edinburgh), 1877.
At p.159 there is an illustration by William Small. An unimportant design probably reproduced by line-block.
Previously unrecorded.
BL

SMOLLETT, Tobias (Trans.)

378. *The Adventures of Gil Blas of Santillane* translated by Tobias Smollett from the French of Le Sage.
Pub. George Routledge and Sons, [1866].
Eight engravings by Dalziel after G.J. Pinwell.
BM PML

SOUTHGATE, Henry

379. *What Men Have Said about Woman*
Pub. Routledge, Warne and Routledge, 1865. Reprint 1866.
Engravings by Dalziel after J.D. Watson.
BM

380. *The Bridal Bouquet Culled in the Garden of Literature*
Pub. Lockwood and Co., 1873.
Nine engravings by J.D.Cooper after J.D.Watson.
Previously unrecorded.
PC

STEWART, Geraldine

381. *The Laird's Return and What Came of it*
Pub. James Hogg and Sons, [1861].
Six engravings by Dalziel after Thomas Morten.
BL

STRETTON, Hesba

382. *In Prison and Out*
Pub. William Isbister Ltd, 1880.
Twelve engravings by Charles Roberts after Robert Barnes.
PC

[STRETTON, Julia Cecilia]

383. *The Valley of a Hundred Fires*
Pub. Hurst and Blackett (*Standard Library* no. xix), [1861].
Steel-engraved frontispiece by John Saddler after Millais 'Mrs Leslie' dated 1861 in plate.
BL

STRIVELYNE, Elsie

384. *The Princess of Silverland and other Tales*
Pub. Macmillan and Co., 1874.
Frontispiece engraved by an unknown engraver after J. Noel Paton.
BL

SULLIVAN, John (of Jersey)

385. *Wace, ses oeuvres, sa patrie*
Pub. and date not known.
Millais provided an illustration for this work, a number of proofs of which is known. I have never seen a copy of the book itself and it may never have been published.
NE. Proofs in various collections including BM

SUSAN, Aunt (Pseud.) PRENTISS, Mrs Elizabeth

386. *Little Susy's Six Birth-days*
Pub. T. Nelson and Sons, 1868.
Engravings by Williamson after William Small. Small produced further illustrations for *Little Susy's Six Teachers* and *Little Susy's Little Servants* but I am uncertain of the exact date of the first edition of these publications.

Stylistically all the designs appear to have been made in the late 1860s.
Previously unrecorded.
PC

SWIFT, Jonathan

387. *Gulliver's Travels*
Pub. Cassell, Petter and Galpin, [1865].
Engraved by J.D. Cooper and W.J. Linton after Thomas Morten. The true first issue (published in October 1865) is bound from the 11 original parts, has 'illustrated by T. Morten' on the title page and has the frontispiece uncoloured. Almost immediately after Morten's death copies have 'illustrated by the late T. Morten' on the title page. Even later the frontispiece is found printed in colour.
BM PML NGA

388. *Gulliver's Travels*
Pub. Adam and Charles Black, (Edinburgh), 1865.
Frontispiece engraved by W.W. after J. Mahoney. This edition actually only contains 'A Voyage to Lilliput'.
PC

TABOR, Eliza (Stephenson)

389. *St. Olaves*
Pub. Hurst and Blackett (*Standard Library* vol. xxi), [1865].
Frontispiece engraved by John Saddler after Millais 'Alice' dated at foot of plate 16 October 1865.
BL

TAUTPHOEUS, Baroness (MONTGOMERY, Jemima)

390. *Quits*
Pub. Richard Bentley, 1864.
Frontispiece and title-page illustration

engraved by Whymper after du Maurier.
BM BL

391. *At Odds*
Pub. Richard Bentley, 1873.
Frontispiece and title-page illustration engraved by Whymper after du Maurier.
Previously unrecorded.
BL

[TAYLOR, Jane and Ann]

392. *Original Poems*
Pub. George Routledge and Sons, 1868.
Engravings by J.D. Cooper after several artists including Barnes, Wimperis, A.W. Bayes and J. Lawson.
BM BL MFAB

TAYLOR, Tom (Trans.)

393. *Ballads and Songs of Brittany*
Pub. Macmillan and Co., 1865.
Engravings by Swain after several artists including Millais, Keene and Tenniel. The Millais designs all first appeared in *Once a Week*.
BM BL V&A PML MFAB

TEMPLE, Ralph and Chandos

394. *The Temple Anecdotes*
Pub. Groombridge and Sons, 1865.
Five engravings by Dalziel after A.B. Houghton. A monthly publication which began in August 1864 and was apparently concluded in July 1865.
BM BL

TENNYSON, Alfred

395. *Poems*
Pub. Edward Moxon, 1857.
Engravings by several engravers after various artists including Millais, Rossetti, Holman

Hunt, Creswick, Horsley, Mulready, C. Stanfield. Frequently referred to as the Moxon Tennyson.

BM BL PML MFAB

396. *Enoch Arden*
Pub. Edward Moxon and Co., 1866.
Twenty engravings by Thomas Bolton after Arthur Hughes. The 16-page catalogue at the rear of the volume is dated December 1865.

BM V&A PML MFAB NGA

THACKERAY, Anne

397. *The Story of Elizabeth*
Pub. Smith, Elder and Co., 1867.
Four engravings by Swain after Frederick Walker. Three of the designs appeared when the story first appeared in *The Cornhill Magazine* in 1862 but the elaborate title page (a full-page drawing) is new.

BM PML

398. *The Village on the Cliff*
Pub. Smith, Elder and Co., 1867.
Six engravings by Swain after Frederick Walker. These illustrations appeared first when the book was serialized in *The Cornhill Magazine*.

BL MFAB

399. *Five Old Friends and a Young Prince*
Pub. Smith, Elder and Co., 1868.
Four engravings by Swain after Frederick Walker.

BL V&A MFAB

400. *To Esther and other Sketches*
Pub. Smith, Elder and Co., 1869.
Frontispiece by Swain after Frederick Walker. The design here entitled 'Horatia's first visit' originally appeared in *The Cornhill Magazine* in 1863 as 'Out of the World'.

BL

401. *Old Kensington*
Pub. Smith, Elder and Co., 1875 (November).

Title-page illustration by an unidentified engraver after Arthur Hughes. Volume 1 of Anne Thackeray's collected works.

BL

402. *The Village on the Cliff*
Pub. Smith, Elder and Co., 1875 (December).
Title-page illustration by an unidentified engraver after Arthur Hughes. Volume 2 of Thackeray's collected works, this is a reprint of the edition of 1867 (see above).

BL

403. *Five Old Friends and a Young Prince*
Pub. Smith, Elder and Co., 1876.
Title-page illustration by an unidentified engraver after Arthur Hughes. Volume 3 of Thackeray's collected works, this is a reprint of the edition of 1868 (see above).

BL

THACKERAY, W.M.

404. *Roundabout Papers*
Pub. Smith, Elder and Co, 1863.
On p.150 is an engraving by an unidentified engraver after Frederick Walker of a visit to a theatre. It first appeared on p.250 of *The Cornhill Magazine* in February 1861 (see Index of Magazine Illustrations). This book was actually published late in 1862.

BL

405. *The History of Henry Esmond Esq ... Written by Himself*
Pub. Smith, Elder and Co., 1868.
Eight engravings by Swain after George du Maurier. The book was reprinted in 1869.

BM PML

406. *Roundabout Papers and The Second Funeral of Napoleon*
Pub. Smith, Elder and Co., 1879.
Illustrations engraved by Swain after the author, Charles Keene and M. Fitzgerald. Vol. xxii of the de luxe Complete Edition of Thackeray's Works.

BL

407. *The Memoirs of Barry Lyndon ... and The Fatal Boots*
Pub. Smith, Elder and Co., 1879.
Four illustrations engraved by Swain after Millais. Vol. xix in the de luxe Complete Edition of Thackeray's Works.
BL

408. *The English Humorists*
Pub. Smith, Elder and Co., 1879.
On p.283 is an engraving by an unidentified engraver of Hogarth painting a drummer-girl after Frederick Walker. Published with *The Four Georges* in vol. xxiii of the de luxe Complete Edition of Thackeray's Works.
BL

409. *Ballads*
Pub. Smith, Elder and Co., 1879.
Illustrations engraved by Swain after George du Maurier.
BL MFAB

410. *Men's Wives*
Pub. Smith, Elder and Co., 1879.
Eight full-page designs engraved by Swain after S.L. Fildes. Vol. xx of the de luxe Complete Edition of Thackeray's Works.
BL

THOMPSON, Arthur Bailey

411. *The Victoria History of England*
Pub. Routledge, Warne and Routledge, 1865.
Frontispiece engraved by Dalziel after A.B. Houghton. 'King John signing Magna Carta.' The book was actually published in December 1864.
BL

THOMPSON, Darcy W.

412. *Nursery Nonsense or Rhymes without Reason*
Pub. Griffith and Farran, 1864.
Engravings by an unidentified engraver after C.H. Bennett.

The book was issued in both uncoloured and coloured forms.
BL

413. *Fun and Earnest or Rhymes with Reason*
Pub. Griffith and Farran, 1865.
Engravings by an unidentified engraver after C.H. Bennett.
Published for the Christmas season in 1864.
BL

THOMSON, Revd Andrew

414. *Sketches of Scripture Characters*
Pub. Johnstone, Hunter and Co., (Edinburgh), [1867].
Four engravings by Williamson after William Small. The book which was probably published late in 1866 also contains undistinguished designs by other artists.
BL PML

THOMSON, James

415. *The Seasons*
Pub. James Nisbet and Co., 1859.
Engravings by Dalziel after several artists including three after Pickersgill.
BM V&A

THORNBURY, Walter (ed.)

416. *Two Centuries of Song*
Pub. Sampson Low, Son and Marston, 1867.
Engravings by various engravers after several artists including Small (1) and Morten (2).
BM BL V&A PML NGA

THORNBURY, Walter

417. *Historical and Legendary Ballads and Songs*
Pub. Chatto and Windus, 1876.
Eighty-two engravings by different engravers after several artists including Whistler, Sandys, Pinwell, Lawless, Walker, Morten,

Watson, J. Lawson, Small, Houghton and Keene, all reprinted from *Once a Week*.
BM PML MFAB NGA

TOWNSEND, George Fyler (ed.)

418. *The Arabian Nights' Entertainments*
Pub. Frederick Warne and Co., 1865.
Sixteen engravings by Dalziel after T. Dalziel (8) and A.B. Houghton (8). This book contains different designs from those in the larger Dalziel edition also of 1865 (q.v.). There was a reprint in 1866 and a later undated edition in the *Victoria Gift Book* series in which only eight of the original illustrations appeared.
BM BL

TROLLOPE, Anthony

419. *Framley Parsonage*
Pub. Smith, Elder and Co., (three vols), 1861.
Six illustrations engraved by Dalziel after Millais. These first appeared when the novel was published in *The Cornhill Magazine* between January and April 1861. The type was reset for this first book publication. The first illustrated re-issue was in 1869 in Smith, Elder's series of *Illustrated Editions of Popular Works*. Only four illustrations were included in this edition.
BL

420. *Orley Farm*
Pub. Chapman and Hall, (two vols), 1862.
Forty engravings by Dalziel after Millais. The first issue was made up of bound copies of the parts. The novel originally appeared in 20 shilling parts from March 1861 to October 1862. Each part was dated with the month but not the year of issue and contained two illustrations. Both title pages of the book issue are dated 1862 but vol. i appeared on 3 December 1861 and vol. ii on 25 September 1862. The first American

edition (Harper and Brothers, New York, 1862) was in one volume and contained two fewer illustrations. There was a one volume reprint of the sheets of the first edition in 1866 (also Chapman and Hall) with 39 illustrations.
BM BL PML

421. *Rachel Ray*
Pub. Chapman and Hall, (Seventh edition), 1864.
Steel-engraved frontispiece by Millais of Rachel seated in a landscape. No engraver's name but on stylistic grounds possibly the work of John Saddler. See Sadleir, p.53 (note). Published in October 1864 in Chapman and Hall's *Standard Editions of Popular Authors*.
PC

422. *The Small House at Allington*
Pub. Smith, Elder and Co., (two vols), 1864.
Eighteen engravings by Dalziel after Millais. The novel first appeared in *The Cornhill Magazine* from September 1862 until April 1864. With each of the first 18 monthly instalments was issued one of the full-page illustrations published later in book form; the nineteenth instalment was unillustrated while the twentieth instalment contained a design by Millais which was not included in the book issue. The initial letter vignettes which appear in the magazine publication do not appear in the book edition.
BL

423. *The Three Clerks*
Pub. Richard Bentley, (New edition), 1865.
Frontispiece and title-page illustration engraved by J. Whymper after J. Mahoney.
BL

424. *Phineas Finn, The Irish Member*
Pub. Virtue and Co., 1869.
Twenty illustrations engraved by Dalziel after Millais. The first instalment was published in the first number of *Saint Paul's*

Magazine in October 1867 and the novel ran without a break until May 1869. There was one illustration in each monthly part.
BL

425. *Kept in the Dark*
Pub. Chatto and Windus, 1882.
Frontispiece engraved by an unidentified engraver after Millais.
BL

TUPPER, Martin Farquar

426. *Proverbial Philosophy*
Pub. Thomas Hatchard, 1854.
Engravings by Dalziel, Vizetelly, J. Thompson, Samuel Williams and Green after several artists including Tenniel, Gilbert, Foster and Pickersgill. There were further editions in 1860 and 1867.
BM V&A

TYTLER, Sarah (Pseud. KEDDIE, Henrietta)

427. *Papers for Thoughtful Girls*
Pub. Alexander Strahan and Co., 1863.
Four engravings by Dalziel after Millais. The fourth edition of this work. There was apparently an edition of 1862 but I have been unable to find a copy.
BM BL V&A MFAB

428. *Citoyenne Jacqueline*
Pub. Alexander Strahan, (*Popular Edition*), 1866.
Frontispiece and title-page illustration by an unidentified engraver after A.B. Houghton.
BM V&A

VALENTINE, L. (ed.)

429. *The Nobility of Life*
Pub. Frederick Warne, [1869].
Engraved by Dalziel after J.D. Watson, Houghton (6), Poynter and J. Mahoney. Printed in colour.
BM V&A MFAB NGA

VAUGHAN, Herbert (Pseud. Vaughan Morgan)

430. *The Cambridge Grisette*
Pub. Tinsley Brothers, 1862.
Engravings by Swain after Charles Keene.
BM BL PML

WALKER, Frederick

431. *Twenty-Seven Illustrations by Frederick Walker – Designed for The Cornhill Magazine*
Pub. Smith, Elder and Co., 1867.
A folio with proof wood-engravings with accompanying text reprinted from the magazine.
NE

WALLER, John Francis

432. *Pictures from English Literature*
Pub. Cassell, Petter and Galpin, [1870].
Engravings by different engravers after several artists including Barnes, du Maurier, Fildes, Small and Watson.
BL V&A

[WARNER, Anna Bartlett]

433. *The Word – The Star out of Jacob*
Pub. James Nisbet and Co., 1868.
Six engravings by an unidentified engraver after J.D. Watson printed in colours.
BL

[WARNER, Susan Bogert and WARNER, Anna Bartlett] (Pseud. WETHERELL, Elizabeth and LOTHROP, Amy)

434. *Ellen Montgomery's Bookshelf*
Pub. Frederick Warne and Co., (Complete Edition), 1866.
Engravings by Dalziel after J.D. Watson printed in colours.
PML BM (1867)

WATTS, Isaac

435. *Divine and Moral Songs for Children*
Pub. Sampson Low, Son and Marston, 1866.
Engravings by J.D. Cooper after Barnes,
Small etc.
BM PML MFAB NGA

436. *Divine and Moral Songs for Children*
Pub. James Nisbet and Co., 1867.
Illustrated in graphotype by Hunt, Watson,
du Maurier and Morten.
For a contemporary description of the
graphotype process see J. Carpenter in *Once
a Week* 16 February 1867, pp.181–4.
BM BL PML

WATTS, John G. (Selector)

437. *Little Lays for Little Folk*
Pub. George Routledge and Sons, 1867.
Engravings by J.D. Cooper after Barnes,
Small etc.
BM PML MFAB

WHITE, Mrs John

438. *My Face is my Fortune Sir, She Said*
Pub. Simkin Marshall and Co., [1886].
Cover design (printed in red) and six
illustrations of physiognomy by Frederic
Leighton. Presumably reproduced by some
type of process block, the designs which are
of little artistic interest, are only mentioned
here for the sake of completeness.
Previously unrecorded.
BL

WHITE, Revd L.B. (ed.)

439. *English Sacred Poetry of the Olden Time*
Pub. Religious Tract Society, 1864.
Engravings by Edward Whymper after du
Maurier, North, Watson, Walker and
Green. A companion volume to the
anthologies *The Months illustrated by Pen and
Pencil* [1864] and *Our Life illustrated by Pen
and Pencil* [1865] both also published by the
Religious Tract Society.
BM V&A PML MFAB NGA

WHYMPER, Edward

440. *Scrambles amongst the Alps in the Years
1860–69*
Pub. John Murray, 1871.
Engravings by J.W. and Edward Whymper
after Mahoney, North? and others. It is
difficult to believe that any of the designs in
this book are by North but according to the
title page he is represented here.
BL

WILLMOTT, Revd Robert Aris (ed.)

441. *The Poets of the Nineteenth Century*
Pub. George Routledge and Co., 1857.
Engravings by Dalziel after Millais, F.M.
Brown, Hughes, Tenniel, Foster, Pickersgill
etc.
BM V&A PML MFAB NGA

442. *English Sacred Poetry of the 16th, 17th, 18th
and 19th Centuries*
Pub. George Routledge and Sons, 1862.
Engravings by Dalziel after Holman Hunt, J.D.
Watson, Keene, Sandys, Armstead, Walker,
Pickersgill etc. Actually published late in 1861.
BM V&A PML MFAB NGA

WILLS, W.H. (Selector)

443. *Poets' Wit and Humour*
Pub. Bell and Daldy, 1860.
Engravings by W.L. Thomas and others after
C.H. Bennett and George Thomas.
BM(Second edition), MFAB(Second edition)

WILSON, Miss Henrietta

444. *The Chronicles of a Garden: Its Pets and its
Pleasures*
Pub. James Nisbet and Co., 1863.

Frontispiece engraved by George Pearson after C.H. Bennett. There was a second edition in 1864.
BL(Second edition)

WINKWORTH, Catherine (Trans.)

445. *Lyra Germanica, Hymns for the Sundays and Chief Festivals of the Christian Year*
Pub. Longman, Green, Longmans, and Roberts, 1861.
Engravings by several engravers superintended by John Leighton after Lawless, Keene, Stacey Marks etc. This edition was reprinted annually until 1865.
BM V&A PML NGA

446. *Lyra Germanica – The Christian Life*
Pub. Longmans, Green, Reader and Dyer, (2nd series), 1868.
Engraved under the superintendence of John Leighton by Butterworth, Heath, Cooper, Dalziel, Green, Leighton, Swain etc after Armitage, F.M. Brown and John Leighton.
BM BL V&A PML NGA

WOOD, Mrs Henry

447. *Oswald Cray*
Pub. Adam and Charles Black, (Edinburgh), 1866.
This contains the designs by Barnes and Walker which first appeared in *Good Words* in 1864. Sadly the engravings are here reduced in size, frequently clipping the artists' initials.
BL

WOOLNER, Thomas

448. *My Beautiful Lady*
Pub. Macmillan and Co., (Third edition only), 1866.
Frontispiece is a steel-engraving by C.H. Jeens after Arthur Hughes.
BM BL

WORDSWORTH, William

449. *Wordsworth's Poems for the Young*
Pub. Alexander Strahan, 1863. Second edition, 1866.
Engravings by Dalziel after Millais (title-page vignette), John Pettie and John Macwhirter.
BM PML

450. *Poetical Works*
Pub. William P. Nimmo, (Edinburgh), (*Popular Edition*), 1865.
Illustrated by William Small
NE

WRAXHALL, Sir Lascelles

451. *Golden Hair – A Tale of the Pilgrim Fathers*
Pub. Sampson Low, Son and Marston, 1865.
Eight engravings by Horace Harral after Thomas Morten. Not only is the artist's name misspellt 'Morton' on the title page, it is similarly rendered incorrectly even on one of the blocks.
Previously unrecorded.
BM

YONGE, Charlotte M.

452. *The Story of the Christians and Moors of Spain*
Pub. Macmillan and Co. (*Golden Treasury Series*), 1878.
Title-page illustration is a steel engraving by C.H. Jeens after Holman Hunt.
Previously unrecorded.
BL

Select Bibliography

All books are the first editions and are published in London unless stated otherwise.

BLACK, Clementina, *Frederick Walker*, 1902.

BUCHANAN-BROWN, John, 'British Wood-engravers c.1820–c.1860 – a Checklist', *Journal of the Printing Historical Society*, no. 17, 1982–3, pp.31–61.

CARPENTER, J. 'Concerning the Graphotype', in *Once a Week* 16 February, 1867, pp.181–4.

CARY, Elizabeth Luther, 'Dante Gabriel Rossetti, Illustrator', *Print-Collector's Quarterly*, vol. v, 1915, pp.316–39.

CHRISTIAN, John, 'Burne-Jones's Drawings for *The Fairy Family*', *Burlington Magazine*, vol. cxv, February 1973, pp.93–100.

CUMPER, A.H., *George John Pinwell 1842–1875. A Record of his Life and Work*, Sutton, Surrey, 1987.

CURRAN, Pamela White, *George John Pinwell: A Victorian Artist and Illustrator 1842–1875*, unpublished doctoral thesis, University of Kansas, 1991.

DE MARÉ, Eric, *The Victorian Woodblock Illustrators*, 1980.

DU MAURIER, Daphne, (ed.), *The Young George du Maurier – A Selection of his Letters 1860–1867*, 1951.

ELZEA, Betty, *Frederick Sandys 1829–1904. A Catalogue Raisonné*, Woodbridge, Suffolk, 2001.

EMANUEL, Frank L. *Charles Keene – Etcher, Draughtsman, and Illustrator 1823–1891*, 1935.

ENGEN, Rodney K., *Dictionary of Victorian Wood Engravers*, Cambridge, 1985.

ENGEN, Rodney K., *Pre-Raphaelite Prints*, 1995.

EWART, Henry C., (ed.) *Toilers in Art*, 1891.

FALK, Bernard, *Five Years Dead*, 1937, (contains a chapter on Simeon Solomon).

FLINT, Kate, 'Arthur Hughes as Illustrator for Children', pp. 201–20 in Gillian Avery and Julia Briggs (eds) *Children and their Books*, Oxford, 1989.

FORD, Julia Ellsworth, *Simeon Solomon: An Appreciation*, New York, 1908.

FREDEMAN, William E. *Pre-Raphaelitism – A Bibliocritical Study*, Cambridge, Mass., 1965.

GOLDMAN, Paul, *Victorian Illustrated Books 1850–1870 – The Heyday of Wood-Engraving*, 1994.

GOLDMAN, Paul and TAYLOR, Brian (eds), *Retrospective Adventures. Forrest Reid Author and Collector*, Aldershot and Oxford (Ashmolean Museum), 1998.

GRAY, Basil, *The English Print*, 1937.

GRIEVE, Alastair, 'Rossetti's Applied Art Designs – 2: Book-Bindings', *Burlington Magazine*, vol. cxv, February 1973, pp.79–84.

HALL, N. John, *Trollope and his Illustrators*, 1980.

HARDIE, Martin, *Catalogue of Prints – Wood Engravings after Sir John Everett Millais, Bart., P.R.A. in the Victoria and Albert Museum*, 1908.

HARDIE, Martin, *John Pettie*, 1908.

HARDIE, Martin, *Catalogue of Modern Wood-engravings – Victoria and Albert Museum*, 1919.

HARTLEY, Harold, 'George John Pinwell', *Print Collector's Quarterly*, vol. 11, 1924, pp.163–89.

HARTLEY, Harold, *Eighty-Eight Not Out – A Record of Happy Memories*, 1939.

HOGARTH, Paul, *Arthur Boyd Houghton*, 1981.

HOLMES, C.J., *The Woodcut Illustrations of Millais*, introduction contained in an exhibition catalogue, Hacon and Ricketts, 1898.

HOUFE, Simon, *The Dictionary of British Book Illustrators and Caricaturists 1800–1914*, Woodbridge, Suffolk, 1978.

HOUFE, Simon, *Fin de Siècle*, 1992.

HOUFE, Simon, *The Work of Charles Samuel Keene*, Aldershot, 1995.

JACKSON, Arlene M., *Illustration and the Novels of Thomas Hardy*, 1981

KELLY, Richard, *The Art of George du Maurier*, Aldershot, 1996.

KILGOUR, Raymond L., *Messrs. Roberts Brothers Publishers*, Ann Arbor, Michigan, 1952.

KITTON, Frederick G., *Dickens and his Illustrators*, 1899.

LAYARD, George Somes, 'Millais and *Once a Week*', *Good Words*, August 1893, pp.552–8.

LAYARD, George Somes, *Tennyson and his Pre-Raphaelite Illustrators*, 1894.

LIFE, Allan Roy, *Art and Poetry: A Study of the Illustrations of Two Pre-Raphaelite Artists, William Holman Hunt and John Everett Millais*, unpublished doctoral thesis, University of British Columbia, 1974.

LINTON, W.J., *Three Score and Ten Years 1820–1890. Recollections*, New York, 1894.

LUTYENS, Mary, (ed.), 'Letters from Sir John Everett Millais … and William Holman Hunt in the Henry E. Huntington Library, San Marino, California', *Walpole Society*, vol. 44, 1972–4, pp. 1–93.

LUTYENS, Mary, (Intr.), *The Parables of Our Lord*, New York, 1975.

MASON, Michael, 'The Way we Look now: Millais' Illustrations to Trollope', *Art History*, vol. 1, no. 3, September 1978, pp.309–40.

McLEAN, Ruari, *Victorian Book Design and Colour Printing*, 1963. (Revised edition, 1972.)

McLEAN, Ruari, *Joseph Cundall – A Victorian Publisher*, Pinner, 1976.

MARKS, John George, *Life and Letters of Frederick Walker A.R.A.*, 1896.

MERRIAM, Harold G., *Edward Moxon – Publisher of Poets*, New York, 1939.

MILLAIS, Geoffroy, *Sir John Everett Millais*, 1979.

MILLAIS, John Guille, *The Life and Letters of Sir John Everett Millais P.R.A.*, 1899.

MILLS, Ernestine, (ed.), *The Life and Letters of Frederic Shields*, 1912.

MUIR, Percy, *Victorian Illustrated Books*, 1971.

NEWLIN, Alice, 'Winslow Homer and A.B. Houghton', *Bulletin of the Metropolitan Museum of Art*, no. 21, March 1936, pp.56–9.

NOEL-PATON, M.H. and CAMPBELL, J.P., *Noel Paton 1821–1901*, Edinburgh, 1990.

ORMOND, Leonée, *George du Maurier*, 1969.

ORMOND, Leonée, 'The Idyllic School: Pinwell, North and Walker', pp.161–71 in Joachim Moller (ed.) *Imagination on a Long Rein – English Literature illustrated*, Marburg, 1988.

ORMOND, Leonée and ORMOND, Richard, *Lord Leighton*, 1975.

Oxford and Cambridge Magazine, 1856. As well as containing poems by Rossetti and contributions by Morris, pp.50–61 in the first number is the unsigned essay by Burne-Jones entitled 'Essay on the Newcomes' in which he made his celebrated observations on Rossetti's 'Maids of Elfen-Mere'.

PATTEN, Robert Lowry, *Charles Dickens and his Publishers*, Oxford, 1978.

PENNELL, Joseph, '*Once a Week*: A Great Art Magazine', *Bibliographica*, vol. iii, 1897, pp.60–82.

PENNELL, Joseph, *The Work of Charles Keene*, 1897. This contains the highly important bibliography of Keene's illustrations compiled by W.H. Chesson.

PHILLIPS, Claude, *Frederick Walker*, 1894.

RAY, Gordon N., *The Illustrator and the Book in England from 1790 to 1914*, 1976.

REID, Forrest, *Illustrators of the Sixties*, 1928.

REID, Forrest, 'Charles Keene, illustrator', *Print Collector's Quarterly*, vol. 17, 1930, pp.23–47.

REYNOLDS, Simon, *The Vision of Simeon Solomon*, Stroud, Glos. 1985.

ROBERTS, Leonard, *Arthur Hughes, His Life and Works*, Woodbridge, Suffolk, 1997.

SADLEIR, Michael, *Trollope – A Bibliography*, 1928.

St JOHN, Judith, TENNY, Dana and MACTAGGART, Hazel, *The Osborne Collection of Early Children's Books 1476–1910*, Toronto Public Library, 1958–75.

SHABERMAN, Raphael B., *George Macdonald. A Bibliographical Study*, 1990.

SURIANO, Gregory R., *The Pre-Raphaelite Illustrators*, New Castle DE and London, 2000.

SURTEES, Virginia, *The Paintings and Drawings of Dante Gabriel Rossetti*, Oxford, 1971.

TATHAM, David, *Winslow Homer and the Illustrated Book*, Syracuse, New York, 1992.

TAYLOR, John Russell, *The Art Nouveau Book in Britain*, Edinburgh, 1979. (Revised edition of a work first published in 1966.)

VAUGHAN, William, 'Incongruous Disciples: The Pre-Raphaelites and the Moxon Tennyson', pp.148–60 in Joachim Moller (ed.) *Imagination on a Long Rein – English Literature Illustrated*, Marburg, 1988.

WAKEMAN, Geoffrey, *Victorian Book Illustration – The Technical Revolution*, Newton Abbott, 1973.

WEAVER, Mike, *Julia Margaret Cameron 1815–1879*, 1984. This contains an interesting section which deals with the Moxon Tennyson and its influence on Cameron.

WHALLEY, Joyce Irene and CHESTER, Tessa Rose, *A History of Children's Book Illustration*, 1988.

WHITE, Gleeson, *English Illustration 'The Sixties 1855–70'*, 1897.

WHITELEY, Derek Pepys, 'Du Maurier's Illustrations for *Once a Week*', Alphabet and Image, no. 5, 1947.

WHITELEY, Derek Pepys, *George du Maurier*, 1948.

WILLIAMSON, George C., *George J. Pinwell and his Works*, 1900.

WITEMEYER, Hugh, *George Eliot and the Visual Arts*, New Haven and London, 1979.

Exhibition catalogues

BELFAST, Arts Council Gallery and elsewhere, *Illustrations of the Eighteen Sixties*, 1976.

BOLTON, Museum and Art Gallery and elsewhere, *The Drawings of John Everett Millais*, 1979, (Arts Council).

BRIGHTON, Museum and Art Gallery and SHEFFIELD, Mappin Art Gallery, *Frederick Sandys 1829–1904*, 1974.

CARDIFF, National Museum of Wales and LONDON, Leighton House, *Arthur Hughes 1832–1915*, 1971.

HARTLEPOOL, Gray Art Gallery and Museum, *Frederic Shields 1833–1911*, 1983.

LIVERPOOL, Walker Art Gallery, *Ford Madox Brown 1821–1893*, 1964.

LONDON, Christie's, *Charles Keene – The Artist's Artist 1823–1891*, 1991.

LONDON, Geffrye Museum and BIRMINGHAM, Museum and Art Gallery, *Solomon – A Family of Painters*, 1985–6.

LONDON, Hartnoll and Eyre Ltd, *Pre-Raphaelite Graphics*, 1974.

LONDON, Hayward Gallery and elsewhere, *Burne-Jones*, 1975–6. Text and catalogue by John Christian.

LONDON, National Gallery of British Art, Millbank (now Tate Gallery), *Book Illustration of the Sixties*, 1923.

LONDON, Royal Academy of Arts and LIVERPOOL, Walker Art Gallery, *Millais*, 1967.

LONDON, Victoria and Albert Museum, *Arthur Boyd Houghton*, 1975. Compiled by Paul Hogarth.

NEW HAVEN, Yale Center for British Art, *Pocket Cathedrals – Pre-Raphaelite Book Illustration*, 1991.

NEW YORK, Columbia University, *The Post Pre-Raphaelite Print*, 1995.

NOTTINGHAM, University Art Gallery and elsewhere, *English Influences on Vincent Van Gogh*, 1974–5.

TORONTO, Art Gallery of Ontario and elsewhere, *The Earthly Paradise – Arts and Crafts by William Morris and his Circle from Canadian Collections*, 1993.

Photographic captions

HENRY HUGH ARMSTEAD (1828–1905)

Plate 2.40 'The Trysting-Place' p.363 in Eliza Cook *Poems*, 1861, Private Collection
Plate 2.41 'A Dream' p.49 in R.A. Willmott (ed.) *English Sacred Poetry*, 1862, Private Collection
Plate 2.42 'The dead man of Bethany' p.303 in R.A. Willmott (ed.) *English Sacred Poetry*, 1862, Private Collection
Plate 2.43 'Evening Hymn' p.310 in R.A. Willmott (ed.) *English Sacred Poetry*, 1862, Private Collection
Plate 2.44 'The Fall of the Walls of Jericho' in *Dalziel's Bible Gallery*, 1881, Private Collection

ROBERT BARNES (1840–1895)

Plate 3.58 'A Surprise' facing p.257 in *The Cornhill Magazine*, September 1864, to *Margaret Denzil's History*, Private Collection
Plate 3.59 'Charity' unpaginated in *Pictures of English Life*, 1865, Private Collection
Plate 3.60 'The shy child' unpaginated in *Pictures of English Life*, 1865, Private Collection
Plate 3.61 'The race down the hill' unpaginated in *Pictures of English Life*, 1865, Private Collection
Plate 3.62 'The sick child' unpaginated in *Pictures of English Life*, 1865, Private Collection
Plate 3.63 'The Cottage Door' unpaginated in *Pictures of English life*, 1865, Private Collection

CHARLES HENRY BENNETT (1829–1867)

Plate 5.6 'Discontent' facing p.90 in John Bunyan *The Pilgrim's Progress*, 1868, (first published 1860), Private Collection
Plate 5.7 'The Jury' facing p.116 in John Bunyan *The Pilgrim's Progress*, 1868, (first published 1860), Private Collection
Plate 5.8 'Christiana' facing p.200 in John Bunyan *The Pilgrim's Progress*, 1868, (first published 1860), Private Collection
Plate 5.9 'Mrs Bat's-Eyes and Mrs Know-Nothing' p.209 in John Bunyan *The Pilgrim's Progress*, 1868, (first published 1860), Private Collection

Plate 5.10 'Ode to the Swell' p.212 in *London Society*, April 1862, Private Collection
Plate 5.11 'Ode to the Swell' p.213 in *London Society*, April 1862, Private Collection

FORD MADOX BROWN (1821–1893)

Plate 1.38 'Cordelia' etching in *The Germ*, March 1850, Department of Prints and Drawings, The British Museum
Plate 1.41 'The Prisoner of Chillon' p.111 in R.A. Willmott (ed.) *The Poets of The Nineteenth Century*, 1857, Department of Prints and Drawings, British Museum
Plate 1.42 Title page in W.M. Rossetti (ed.) *The Poetical Works of Lord Byron*, 1870, Department of Prints and Drawings, British Museum
Plate 1.43 'Childe Harold's Pilgrimage' facing p.18 in W.M. Rossetti (ed.) *The Poetical Works of Lord Byron*, 1870, Department of Prints and Drawings, British Museum
Plate 1.44 'The Corsair' facing p.107 in W.M. Rossetti (ed.) *The Poetical Works of Lord Byron*, 1870, Department of Prints and Drawings, British Museum
Plate 1.45 'Sardanapalus' facing p.273 in W.M. Rossetti (ed.) *The Poetical Works of Lord Byron*, 1870, Department of Prints and Drawings, British Museum
Plate 1.46 'The Two Foscari' facing p.294 in W.M. Rossetti (ed.) *The Poetical Works of Lord Byron*, 1870, Department of Prints and Drawings, British Museum
Plate 1.47 'Don Juan' facing p.401 in W.M. Rossetti (ed.) *The Poetical Works of Lord Byron*, 1870, Department of Prints and Drawings, British Museum
Plate 1.39 'Down Stream' facing p.211 in *The Dark Blue*, October 1871, Department of Prints and Drawings, British Museum
Plate 1.40 'Down Stream' tailpiece p.212 in *The Dark Blue*, October 1871, as Plate 1.39
Plate 1.48 'Joseph's Coat' in *Dalziel's Bible Gallery*, 1881, Department of Prints and Drawings, British Museum
Plate 1.49 'Elijah and the Widow's Son' in *Dalziel's Bible Gallery*, 1881, Department of Prints and Drawings, British Museum
Plate 1.50 'The Death of Eglon' in *Dalziel's Bible Gallery*, 1881, Department of Prints and Drawings, British Museum

EDWARD BURNE-JONES (1833–1898)

Plate 1.53 Frontispiece to [Archibald Maclaren] *The Fairy Family*, 1857, Private Collection
Plate 1.54 Title page to [Archibald Maclaren] *The Fairy Family*, 1857, Private Collection
Plate 1.55 Tailpiece to [Archibald Maclaren] *The Fairy Family*, 1857, Private Collection
Plate 1.51 'King Sigurd, the Crusader' in *Good Words*, April 1862, p.248, Private Collection
Plate 1.52 'The Summer Snow' in *Good Words*, May 1863, p.380, Private Collection
Plate 1.57 'The Deliverer' facing p.207 in Mrs M. Gatty *Parables from Nature*, 1865, Private Collection
Plate 1.56 'The Parable of the Burning Pot' in *Dalziel's Bible Gallery*, 1881, Department of Prints and Drawings, British Museum

GEORGE DU MAURIER (1834–1896)

Plate 3.3 '"I may die" he said ... ' frontispiece to Elizabeth Gaskell *Sylvia's Lovers*, 1863, Private Collection

Plate 3.4 'What ails yo at me? ... ' facing p.194 in Elizabeth Gaskell *Sylvia's Lovers*, 1863, Private Collection

Plate 3.1 'Molly's New Bonnet' facing p.129 in *The Cornhill Magazine*, August 1864, to Elizabeth Gaskell *Wives and Daughters*, Private Collection

Plate 3.2 'Vae Victis' facing p.385 in *The Cornhill Magazine*, October 1864, to Elizabeth Gaskell *Wives and Daughters*, Private Collection

Plate 3.5 'Patty at her mother's bedside' frontispiece to Douglas Jerrold *The Story of a Feather*, 1867, Private Collection

Plate 3.6 'The stolen watch' facing p.127 in Douglas Jerrold *The Story of a Feather*, 1867, Private Collection

Plate 3.7 'Beatrix' facing p.208 in W.M. Thackeray *The History of Henry Esmond*, 1868, Private Collection

Plate 3.8 'Reconciliation' facing p.357 in W.M. Thackeray *The History of Henry Esmond*, 1868, Private Collection

SAMUEL LUKE FILDES (1844–1927)

Plate 5.30 'As he went, he kept intently reading his book' p.493 in John Foxe *Book of Martyrs*, [1866], Private Collection

Plate 5.28 'In the Choir' facing p.537 in *Good Words*, 1 August 1867, Private Collection

Plate 5.29 'The Captain's Story' p.169 in *Good Words*, 1 March 1868, Private Collection

ARTHUR BOYD HOUGHTON (1836–1875)

Plate 3.42 'The Golden Opportunity' facing p.170 in Jean Ingelow *Stories Told to a Child*, 1865, Private Collection

Plate 3.29 'Camaralzaman commands Giondar to put the princes to death' p.349 in *Dalziel's Arabian Nights' Entertainments*, 1865, Private Collection

Plate 3.32 'Queen Labe unveils before King Beder' p.448 in *Dalziel's Arabian Nights' Entertainments*, 1865, Private Collection

Plate 3.30 'Noah's Ark' p.2 in *Home Thoughts and Home Scenes*, 1865, Private Collection

Plate 3.31 'The Chair Railway' p.15 in *Home Thoughts and Home Scenes*, 1865, Private Collection

Plate 3.39 'Rosinante fell ... ' p.19 in de Cervantes *Don Quixote*, 1866, Private Collection

Plate 3.40 'Hold, base-born rabble ... ' p.467 in de Cervantes *Don Quixote*, 1866, Private Collection

Plate 3.41 'Sancho Panza was conducted ... ' p.569 in de Cervantes *Don Quixote*, 1866, Private Collection

Plate 3.37 'Helga and Hildebrand' p.17 in Robert Buchanan *Ballad Stories of the Affections*, [1866], Private Collection

Plate 3.38 'How Sir Tonne won his bride' p.95 in Robert Buchanan *Ballad Stories of the Affections*,

[1866], Private Collection

Plate 3.33 'Crusoe on the raft' p.54 in *Warne's Picture Book*, [1868], British Library

Plate 3.34 'Crusoe meets Friday' p.54 in *Warne's Picture Book*, [1868], British Library

Plate 3.35 'Crusoe and the Spaniard' p.54 in *Warne's Picture Book*, [1868], British Library

Plate 3.36 'Crusoe and his family' p.54 in *Warne's Picture Book*, [1868], British Library

Plate 3.27 'Crossing a Canon' p.117 in *The Graphic*, 29 July 1871, for *Graphic America*, Private Collection

Plate 3.28 'Buffalo Hunting – Camping out' p.136 in *The Graphic*, 5 August 1871, for *Graphic America*, Private Collection

ARTHUR HUGHES (1832–1915)

Plate 2.24 Untitled illustration facing p.1 in Tennyson *Enoch Arden*, 1866, Private Collection

Plate 2.25 Untitled illustration p.10 in Tennyson *Enoch Arden*, 1866, Private Collection

Plate 2.26 Untitled illustration p.26 in Tennyson *Enoch Arden*, 1866, Private Collection

Plate 2.20 Untitled illustration p.121 in George Macdonald *At the Back of the North Wind*, 1871, Private Collection

Plate 2.21 Untitled illustration p.270 in George Macdonald *At the Back of the North Wind*, 1871, Private Collection

Plate 2.22 Untitled illustration p.350 in George Macdonald *At the Back of the North Wind*, 1871, Private Collection

Plate 2.23 Untitled illustration p.359 in George Macdonald *At the Back of the North Wind*, 1871, Private Collection

Plate 2.27 Untitled illustration p.71 in Christina Rossetti *Sing-Song*, 1872, Private Collection

Plate 2.28 'Lullaby, O lullaby' p.129 in Christina Rossetti *Sing-Song*, 1872, Private Collection

Plate 2.29 'The Dear white lady in yon tower ... ' p.11 in Jean Ingelow *The Shepherd Lady*, 1876, Private Collection

Plate 2.30 'Take now this crook' p.13 in Jean Ingelow *The Shepherd Lady*, 1876, Private Collection

Plate 2.31 'On Sunny slopes ... ' p.15 in Jean Ingelow *The Shepherd Lady*, 1876, Private Collection

Plate 2.32 'Above the Clouds' p.17 in Jean Ingelow *The Shepherd Lady*, 1876, Private Collection

WILLIAM HOLMAN HUNT (1827–1910)

Plate 1.25 'Recollections of the Arabian Nights' p.13 in Tennyson *Poems*, 1857, (the Moxon Tennyson), Department of Prints and Drawings, British Museum

Plate 1.26 'Recollections of the Arabian Nights' p.19 in Tennyson *Poems*, 1857, (the Moxon Tennyson), Department of Prints and Drawings, British Museum

Plate 1.29 'The Ballad of Oriana' p.51 in Tennyson *Poems*, 1857, (the Moxon Tennyson), Department of Prints and Drawings, British Museum

Plate 1.30 'The Ballad of Oriana' p.55 in Tennyson *Poems*, 1857, (the Moxon Tennyson), Department of Prints and Drawings, British Museum

Plate 1.31 'The Lady of Shalott' p.67 in Tennyson *Poems*, 1857, (the Moxon Tennyson), Department of Prints and Drawings, British Museum

Plate 1.27 'Godiva' p.281 in Tennyson *Poems*, 1857, (the Moxon Tennyson), Department of Prints and Drawings, British Museum

Plate 1.28 'The Beggar Maid' p.359 in Tennyson *Poems*, 1857, (the Moxon Tennyson), Department of Prints and Drawings, British Museum

Plate 1.32 Untitled frontispiece to *Days of Old*, 1859, British Library

Plate 1.21 'Witches and Witchcraft' p.438 *Once A Week*, 12 May 1860, Private Collection

Plate 1.23 'At Night' p.102 *Once a Week*, 21 July 1860, Private Collection

Plate 1.22 'Temujin' p.630 *Once a Week*, 1 December 1860, Private Collection

Plate 1.34 'The Light of Truth' facing p.45 in Mrs M. Gatty *Parables from Nature*, First Series, 1861, Private Collection

Plate 1.33 'Active and Passive' facing p.93 in Mrs M. Gatty *Parables from Nature*, First Series, 1861, Private Collection

Plate 1.24 'Go and come' p.32 *Good Words*, 1862, Private Collection

Plate 1.36 'The Lent Jewels' frontispiece in R.A. Willmott (ed.) *English Sacred Poetry*, 1862, Private Collection

Plate 1.35 Untitled title-page illustration to John Bunyan *The Pilgrim's Progress*, 1862, British Library

Plate 1.37 Untitled frontispiece to Charlotte Yonge *The Story of the Christians and Moors of Spain*, 1878, Private Collection

CHARLES SAMUEL KEENE (1823–1891)

Plate 5.13 Frontispiece to Daniel Defoe *Robinson Crusoe*, 1847, Private Collection

Plate 5.14 Untitled illustration facing p.31 in Daniel Defoe *Robinson Crusoe*, 1847, Private Collection

Plate 5.15 'A Battle Prayer' p.58 in H.W. Dulcken (ed.) *The Book of German Songs*, 1856, Private Collection

Plate 5.16 'The Hussites before Naumburg' p.296 in H.W. Dulcken (ed.) *The Book of German Songs*, 1856, Private Collection

Plate 5.17 Frontispiece to Herbert Vaughan *The Cambridge Grisette*, 1862, Private Collection

Plate 5.18 'The Boudoir-Bar' facing p.90 in Herbert Vaughan *The Cambridge Grisette*, 1862, Private Collection

Plate 5.12 'Mother's Guineas' facing p.1 in *The Cornhill Magazine*, July 1864, to George Eliot *Brother Jacob*, Private Collection

MATTHEW JAMES LAWLESS (1837–1864)

Plate 2.61 'The Betrayed' p.155 in *Once a Week*, 4 August 1860, reprinted in Walter Thornbury *Historical and Legendary Ballads and Songs* 1876 as 'The Wreck off Calais', Private Collection

Plate 2.65 Untitled illustration p.47 in Catherine Winkworth (trans.) *Lyra Germanica*, 1861, Private Collection

Plate 2.66 Untitled illustration p.90 in Catherine Winkworth (trans.) *Lyra Germanica*, 1861, Private Collection

Plate 2.62 'Dr Johnson's Penance' p.14 in *Once a Week*, 25 January 1861, Private Collection

Plate 2.64 'Faint Heart never won Fair Ladye' p.98 in *Once a Week*, 18 July 1863, Private Collection

Plate 2.60 'One Dead' facing p.275 in *Churchman's Family Magazine*, September 1863, Private Collection

Plate 2.63 'Heinrich Frauenlob' p.393 in *Once a Week*, 3 October 1863, Private Collection

FREDERIC LEIGHTON (1830–1896)

Plate 4.1 'The Great God Pan' facing p. 84 in *The Cornhill Magazine*, July 1860, Private Collection

Plate 4.2 'Suppose you let me look at myself' frontispiece to George Eliot *Romola* 1880: de luxe edition, first published in *The Cornhill Magazine* in July 1862, Private Collection

Plate 4.3 'The blind scholar and his daughter' facing p.64 in George Eliot *Romola* 1880: de luxe edition, first published in *The Cornhill Magazine* in July 1862, Private Collection

Plate 4.4 'A recognition' facing p.116 in George Eliot *Romola* 1880: de luxe edition, first published in *The Cornhill Magazine* in August 1862, Private Collection

Plate 4.5 'The first kiss' facing p.177 in George Eliot *Romola* 1880: de luxe edition, first published in *The Cornhill Magazine* in September 1862, Private Collection

Plate 4.6 'Coming Home' facing p.338 in George Eliot *Romola* 1880: de luxe edition, first published in *The Cornhill Magazine* in December 1862, Private Collection

Plate 4.7 'Cain and Abel', unpaginated, in *Dalziel's Bible Gallery*, 1881, Private Collection

JAMES MAHONEY (1847–79)

Plate 5.23 'Autumn Tourists' facing p.217 in *The Argosy*, August 1866, Private Collection

Plate 5.24 'Bell from the North' facing p.289 in *The Argosy*, September 1866, Private Collection

Plate 5.25 'The love of years' facing p.398 in *The Argosy*, October 1866, Private Collection

Plate 5.26 'As Arthur came over the stile ... ' p.97 in Charles Dickens *Little Dorrit*, (Household Edition), [1873], Private Collection

Plate 5.27 'And so he left her ... ' p.107 in Charles Dickens *Little Dorrit*, (Household Edition), [1873], Private Collection

JOHN EVERETT MILLAIS (1829–1896)

Plate 1.11 Untitled illustration (possibly intended as frontispiece) for John Sullivan *Wace, ses oeuvres, sa patrie* date unknown, no copy seen, Private Collection

Plate 1.12 Frontispiece to W. Wilkie Collins *Mr Wray's Cashbox*, 1852, Private Collection

Plate 1.18 'Cis Berry's arrival' frontispiece to Sarah Tytler *Papers for Thoughtful Girls*, 1863, Private Collection

Plate 1.19 'Dame Dorothy' facing p.190 in Sarah Tytler *Papers for Thoughtful Girls*, 1863, Private Collection

Plate 1.20 'Herr Willy Koenig' facing p.268 in Sarah Tytler *Papers for Thoughtful Girls*, 1863, Private Collection

Plate 1.13 'The Good Samaritan' in J.E. Millais *The Parables of Our Lord*, 1864, Private Collection

Plate 1.14 'The Pearl of Great Price' in J.E. Millais *The Parables of Our Lord*, 1864, Private Collection

Plate 1.15 'The Sower' in J.E. Millais *The Parables of Our Lord*, 1864, Private Collection

Plate 1.16 'The Prodigal Son' in J.E. Millais *The Parables of Our Lord*, 1864, Private Collection

Plate 1.17 'The Pharisee and the Publican' in J.E. Millais *The Parables of Our Lord*, 1864, Private Collection

THOMAS MORTEN (1836–1866)

Plate 5.5 'Who may you be, stranger?' facing p.206 in Sir Lascelles Wraxhall *Golden-Hair*, 1865, Private Collection

Plate 5.1 'I observed a huge creature walking after them in the sea' p.89 in Jonathan Swift *Gulliver's Travels*, [1865], Private Collection

Plate 5.2 'It was the most violent exercise that I ever underwent' p.148 in Jonathan Swift *Gulliver's Travels*, [1865], Private Collection

Plate 5.3 'He did me the honour to raise it gently to my mouth' p.336 in Jonathan Swift *Gulliver's Travels*, [1865], Private Collection

Plate 5.4 'The Dying Viking' p.239 in *Once a Week*, 3 March 1866, Private Collection

JOHN WILLIAM NORTH (1842–1924)

Plate 3.43 'The Home Pond' p.15 in *A Round of Days*, 1866, Private Collection

Plate 3.44 'At the grindstone' p.5 in Robert Buchanan (ed.) *Wayside Posies*, 1867, Private Collection

Plate 3.45 'The visions of a city tree' p.39 in Robert Buchanan (ed.) *Wayside Posies*, 1867, Private Collection

Plate 3.46 'Glen-Oona' p.45 in Robert Buchanan (ed.) *Wayside Posies*, 1867, Private Collection

JOSEPH NOEL PATON (1821–1901)

Plate 2.45 'The Execution of Montrose' p.41 in Aytoun *Lays of the Scottish Cavaliers*, 1863, Private Collection

Plate 2.46 'The Heart of the Bruce' p.63 in Aytoun *Lays of the Scottish Cavaliers*, 1863, Private Collection

Plate 2.47 'The Widow of Glencoe' p.105 in Aytoun *Lays of the Scottish Cavaliers*, 1863, Private Collection

Plate 2.48 'Blind Old Milton' p.195 in Aytoun *Lays of the Scottish Cavaliers*, 1863, Private Collection

Plate 2.49 'Hermotimus' p.206 in Aytoun *Lays of the Scottish Cavaliers*, 1863, Private Collection

JOHN PETTIE (1839–1893)

Plate 3.54 'What sent me to sea' p.264 in *Good Words*, 1862, Private Collection
Plate 3.55 'The Country Surgeon' p.713 in *Good Words*, 1862, Private Collection
Plate 3.56 'Address to a child during a boisterous winter evening' p.42 in *Wordsworth's Poems for the Young*, 1863, Private Collection
Plate 3.57 'The Cottager to her infant' p.88 in *Wordsworth's Poems for the Young*, 1863, Private Collection

FREDERICK RICHARD PICKERSGILL (1820–1900)

Plate 4.12 'There – Drink my tears ... ' p.117 in Thomas Moore *Lalla Rookh*, 1860, Private Collection
Plate 4.13 'Then knelt down the Holy one ... ' facing p.24 in Dean Henry Alford *The Lord's Prayer*, 1870, Private Collection
Plate 4.14 'So the strong one yielded ... ' facing p.26 in Dean Henry Alford *The Lord's Prayer*, 1870, Private Collection
Plate 4.15 'Jacob blessing Ephraim and Manasseh' in *Dalziel's Bible Gallery*, 1881, (unpaginated), Private Collection

GEORGE JOHN PINWELL (1842–1875)

Plate 3.9 'The Sirens' in *Once a Week*, 21 November 1863, reprinted as 'The Last of the Sirens' in Walter Thornbury *Historical and Legendary Ballads and Songs*, 1876, Private Collection
Plate 3.10 'At the threshold' p.7 in *A Round of Days*, 1866, Private Collection
Plate 3.18 'Prayer is the Christian's vital breath' p.19 in *The Spirit of Praise*, 1867, Private Collection
Plate 3.19 'God hears thy sighs and counts thy tears' p.107 in *The Spirit of Praise*, 1867, Private Collection
Plate 3.11 'The Shadow' p.1 in Robert Buchanan (ed.) *Wayside Posies*, 1867, Private Collection
Plate 3.12 'Shadow and Substance' p.8 in Robert Buchanan (ed.) *Wayside Posies*, 1867, Private Collection
Plate 3.13 'The Swallows' p.22 in Robert Buchanan (ed.) *Wayside Posies*, 1867, Private Collection
Plate 3.14 'The Journey's End' p.28 in Robert Buchanan (ed.) *Wayside Posies*, 1867, Private Collection
Plate 3.15 'King Pippin' p.32 in Robert Buchanan (ed.) *Wayside Posies*, 1867, Private Collection
Plate 3.16 'By the Dove-cot' p.35 in Robert Buchanan (ed.) *Wayside Posies*, 1867, Private Collection
Plate 3.17 'The Island Bee' p.47 in Robert Buchanan (ed.) *Wayside Posies*, 1867, Private Collection

EDWARD JOHN POYNTER (1836–1919)

Plate 4.8 'Pharaoh honours Joseph' in *Dalziel's Bible Gallery*, 1881, (unpaginated), Private Collection

Plate 4.9 'Joseph distributes Corn' in *Dalziel's Bible Gallery*, 1881, (unpaginated), Private Collection

DANTE GABRIEL ROSSETTI (1828–1882)

Plate 1.1 'The Maids of Elfen-Mere' facing p.202 in William Allingham *The Music Master*, 1855, Department of Prints and Drawings, British Museum

Plate 1.3 'The Lady of Shalott' p.75 in Tennyson *Poems* (the Moxon Tennyson), 1857, Department of Prints and Drawings, British Museum

Plate 1.4 'Mariana in the South' p.82 in Tennyson *Poems* (the Moxon Tennyson), 1857, Department of Prints and Drawings, British Museum

Plate 1.2 'The Palace of Art' p.113 in Tennyson *Poems* (the Moxon Tennyson), 1857, Department of Prints and Drawings, British Museum

Plate 1.6 'The Palace of Art' p.119 in Tennyson *Poems* (the Moxon Tennyson), 1857, Department of Prints and Drawings, British Museum

Plate 1.5 'Sir Galahad' p.305 in Tennyson *Poems* (the Moxon Tennyson), 1857, Department of Prints and Drawings, British Museum

Plate 1.7 'Buy from us with a golden curl' frontispiece to Christina Rossetti *Goblin Market*, 1862, Private Collection

Plate 1.8 'Golden head by golden head' title page illustration in Christina Rossetti *Goblin Market*, 1862, Private Collection

Plate 1.9 'You should have wept her yesterday' frontispiece to Christina Rossetti *The Prince's Progress*, 1866, Private Collection

Plate 1.10 'The long hours go and come and go' title page illustration in Christina Rossetti *The Prince's Progress*, 1866, Private Collection

FREDERICK SANDYS (1832–1904)

Plate 2.16 'Legend of the Portent' facing p.617 in *The Cornhill Magazine*, May 1860, Private Collection

Plate 2.3 'From my Window' p.328 in *Once a Week*, 24 August 1861, Private Collection

Plate 2.11 'The three statues of Aegina' p.491 in *Once a Week*, 26 October 1861, Private Collection

Plate 2.9 'Rosamond, Queen of the Lombards' p.631 in *Once a Week*, 30 November 1861, Private Collection

Plate 2.1 'Until her Death' p.312 in *Good Words*, 1862, Private Collection

Plate 2.10 'The Old Chartist' p.183 in *Once a Week*, 8 February 1862, Private Collection

Plate 2.13 'The King at the Gate' p.322 in *Once a Week*, 15 March 1862, Private Collection

Plate 2.14 'Jacques de Caumont' p.614 in *Once a Week*, 24 May 1862, Private Collection

Plate 2.12 'Harald Harfagr' p.154 in *Once a Week*, 2 August 1862, Private Collection

Plate 2.17 'Manoli' facing p.346 in *The Cornhill Magazine*, September 1862, Private Collection

Plate 2.2 'Sleep' facing p.589 in *Good Words*, 1863, Private Collection

Plate 2.4 'The Waiting Time' facing p.91 in *Churchman's Family Magazine*, July 1863, reprinted as 'Lancashire's Lesson' in *Pictures of Society*, 1866, Private Collection

Plate 2.18 'Bhanavar among the serpents of Lake Karatis' frontispiece to George Meredith *The Shaving of Shagpat*, 1865, Private Collection

Plate 2.15 'Amor Mundi' facing p.193 in *The Shilling Magazine*, June 1865, Department of Prints and Drawings, British Museum

Plate 2.5 'Yet she was all so queenly in her woe' p.201 in *The Quiver*, January 1866, to 'The Advent of Winter', Department of Prints and Drawings, British Museum

Plate 2.7 'Helen and Cassandra' facing p.454 in *Once a Week*, 28 April 1866, Private Collection

Plate 2.6 'If' facing p.336 in *The Argosy*, March 1866, Department of Prints and Drawings, British Museum

Plate 2.19 'Jacob hears the Voice of the Lord' in *Dalziel's Bible Gallery*, 1881, Department of Prints and Drawings, British Museum

Plate 2.8 'Danae in the Brazen Chamber' p.47 in *Century Guild Hobby Horse*, 1888, Department of Prints and Drawings, British Museum

FREDERIC SHIELDS (1833–1911)

Plate 2.50 'The Decision of Faith' frontispiece to Daniel Defoe *History of the Plague of London*, 1863, Private Collection

Plate 2.51 'The Plague-Stricken House' facing p.1 in Daniel Defoe *History of the Plague of London*, 1863, Private Collection

Plate 2.52 'Solomon Eagle' facing p.24 in Daniel Defoe *History of the Plague of London*, 1863, Private Collection

Plate 2.53 'Imprisoned family escaping' facing p.48 in Daniel Defoe *History of the Plague of London*, 1863, Private Collection

Plate 2.54 'Fugitive found dead by rustics' facing p.96 in Daniel Defoe *History of the Plague of London*, 1863, Private Collection

Plate 2.55 'The Good Shepherd' unpaginated in *Illustrations to Bunyan's Pilgrim's Progress*, 1864, Private Collection

Plate 2.56 'Apollyon' unpaginated in *Illustrations to Bunyan's Pilgrim's Progress*, 1864, Private Collection

Plate 2.57 'Mercy making garments' unpaginated in *Illustrations to Bunyan's Pilgrim's Progress*, 1864, Private Collection

Plate 2.58 'Christian Reading' unpaginated in *Illustrations to Bunyan's Pilgrim's Progress*, 1864, Private Collection

Plate 2.59 'Christian, Sloth, Simple etc' unpaginated in *Illustrations to Bunyan's Pilgrim's Progress*, 1864, Private Collection

SIMEON SOLOMON (1840–1905)

Plate 2.35 'The Circumcision' p.168 in *The Leisure Hour*, 17 March 1866, to 'Jewish Ceremonies and Customs', Private Collection
Plate 2.36 'The Eve of the Jewish Sabbath' p.377 in *The Leisure Hour*, 16 June 1866, to 'Jewish Ceremonies and Customs', Private Collection
Plate 2.37 'The Feast of Tabernacles' p.604 in *The Leisure Hour*, 22 September 1866, to 'Jewish Ceremonies and Customs', Private Collection
Plate 2.38 'The rejoicing of the Law' p.653 in *The Leisure Hour*, 13 October 1866, to 'Jewish Ceremonies and Customs', Private Collection
Plate 2.39 'The Week of Mourning' p.824 in *The Leisure Hour*, 29 December 1866, to 'Jewish Ceremonies and Customs', Private Collection
Plate 2.33 'Abraham and Isaac' unpaginated in *Dalziel's Bible Gallery*, 1881, Private Collection
Plate 2.34 'Melchizedek blesses Abraham' unpaginated in *Dalziel's Bible Gallery*, 1881, Private Collection

WILLIAM SMALL (1843–1929)

Plate 3.67 'The Monarch's Fall' p.180 in A.L.O.E. (Pseud. Charlotte Maria Tucker) *Exiles in Babylon*, 1864, Private Collection
Plate 3.65 'Hosanna to the Son … ' p.89 in Isaac Watts *Divine and Moral Songs for Children*, 1866, Private Collection
Plate 3.66 'The Thief' p.101 in Isaac Watts *Divine and Moral Songs for Children*, 1866, Private Collection
Plate 3.70 'Joy' p.97 in *The Spirit of Praise*, 1867, Private Collection
Plate 3.71 'The joys of harvest we have known' p.149 in *The Spirit of Praise*, 1867, Private Collection
Plate 3.68 'Knitting on the garden seat' p.31 in John G. Watts (Sel.) *Little Lays for Little Folk*, 1867, Private Collection
Plate 3.69 'The Sand Castle' p.83 in John G. Watts (Sel.) *Little Lays for Little Folk*, 1867, Private Collection
Plate 3.64 'But Peaceful was the night' p.17 in John Milton *Ode on the Morning of Christ's Nativity*, 1868, Private Collection

FREDERICK WALKER (1840–1875)

Plate 3.21 'A child in prayer' p.386 in R.A. Willmott (ed.) *English Sacred Poetry*, 1862, Private Collection
Plate 3.25 'Broken Victuals' p.3 in *A Round of Days*, 1866, Private Collection
Plate 3.22 'Autumn Days' p.43 in *A Round of Days*, 1866, Private Collection
Plate 3.20 'The Vagrants' facing p.112 in *Once a Week*, 27 January 1866, reprinted as 'An Autumn Evening' p.155 in Walter Thornbury *Historical and Legendary Ballads and Songs*, 1876, Private Collection

Plate 3.26 'The bit o' garden' p.3 in Robert Buchanan (ed.) *Wayside Posies*, 1867, Private Collection

Plate 3.23 'Rain' p.52 in Robert Buchanan (ed.) *Wayside Posies*, 1867, Private Collection

Plate 3.24 'Where the wind comes frae' p.87 in Robert Buchanan (ed.) *Wayside Posies*, 1867, Private Collection

JOHN DAWSON WATSON (1832–1892)

Plate 3.51 'Giant Despair beats the Pilgrims' p.147 in John Bunyan *The Pilgrim's Progress*, 1861, Private Collection

Plate 3.47 'Spring Days' Frontispiece to *London Society*, vol. 1, February 1862, relates to poem by Keats p.79, Private Collection

Plate 3.48 'Ash Wednesday' facing p.150 in *London Society*, March 1862, Private Collection

Plate 3.49 'Romance and a Curacy' facing p.385 in *London Society*, June 1862, Private Collection

Plate 3.50 'A Summer's Eve in a Country Lane' facing p.97 in *London Society*, August 1862, Private Collection

Plate 3.52 'Time and the Year' p.1 in R.A. Willmott (ed.) *English Sacred Poetry*, 1862, Private Collection

Plate 3.53 'Maley and Malone or the Evils of Quarreling' p.92 in H.W. Dulcken (adapt.) *The Golden Harp*, 1864, Private Collection

GEORGE FREDERICK WATTS (1817–1904)

Plate 4.10 'Noah building the Ark' unpaginated in *Dalziel's Bible Gallery*, 1881, Private Collection

Plate 4.11 'Esau meeting Jacob' unpaginated in *Dalziel's Bible Gallery*, 1881, Private Collection

JAMES ABBOTT McNEIL WHISTLER (1834–1903)

Plate 5.19 'The Trial Sermon' p.585 in *Good Words*, 1862, Private Collection

Plate 5.20 'The Trial Sermon' p.649 in *Good Words*, 1862, Private Collection

Plate 5.21 'The Morning before the Massacre of St. Bartholomew' p.210 in *Once a Week*, 16 August 1862, Private Collection

Plate 5.22 'Count Burkhardt' p.378 in *Once a Week*, 27 September 1862, Private Collection

Index

All references are to pages and entries printed in **bold** indicate plate pages. Entries are necessarily selective.

Appendix

This appendix includes fresh information obtained since the first edition was published in 1996, and which, for reasons of space, could not be inserted into the body of the text in the new edition. For the sake of uniformity, however, the style of the entries remains identical. It also contains corrections, clarifications, revisions and additions to the first edition which similarly could not be incorporated. Numerous small changes such as to spelling and to dates have, however, been successfully included within the main text.

Notes

CHAPTER 1. Page 7
Millais: Checklist of illustrated books: additions and omissions
1861 Anthony Trollope: *Framley Parsonage*
1863 [Anne Isabella Robertson]: *Myself and My Relatives*
1864 Caroline Norton: *Lost and Saved*
1865 Frederick Locker: *A Selection from the Works of Frederick Locker*
1865 Henry Leslie: *Little Songs for Me to Sing*
1865 Eliza Tabor: *St. Olaves*
1866 Anthology: *Pictures of Society Grave and Gay*
1867 Anthology: *Touches of Nature*
1872 Matthew Browne (William Brighty Rands): *Lilliput Legends*
1872 Anthology: *Little Lily's Picture Book*
1873 Anthology: *Routledge's Sunday Album for Children*
?1878 Byron: *Poetical Works*

CHAPTER 2. Page 55
Hughes: Checklist of illustrated books: additions
1858 Milton: *Comus*

Page 61. Footnote 3.
Renewed thanks are due to Mr Roberts for having alerted me to Milton's *Comus* of 1858 and to the Hughes design it contains on page 67 'Will O' the Wisp'.

CHAPTER 3. Page 129–30
Houghton: Checklist of illustrated books: additions
1865 Julia Luard: *The Childhood and Schoolroom Hours of Royal Children*
1868 Walter Scott: *Poetical Works*

Page 139
Barnes: Checklist of illustrated books: dates of publications corrected
[1868] George Eliot: *Scenes of Clerical Life*
[1868] George Eliot: *Silas Marner*

Page 142

Small: Checklist of illustrated books: addition and date of publication corrected

1866　H.W. Longfellow: *Poetical Works* (Nelson Edition)

[1867]　George Eliot: *Adam Bede*

CHAPTER 5. Page 229

Morten: Checklist of illustrated books: addition

1863　John Lothrop Motley: *The Rise of the Dutch Republic*

Page 232

Bennett: Checklist of illustrated books: addition

1865　Thomas Hood (The Younger): *Jingles and Jokes for Little Folks*

Page 233

Keene: Checklist of illustrated books: addition

1861　Cecilia Lucy Brightwell: *Difficulties Overcome: Scenes in the Life of Alexander Wilson the Ornithologist*

Page 237

Mahoney: Checklist of illustrated books: date correction

1868　Walter Scott: *Poetical Works* (Chandos Edition)

Index of magazine illustrations

Additions

BENNETT, Charles Henry

THE WELCOME GUEST
Volume 1, Second Series 1860

1. 'The Blind Countess' to poem translated from the German of Günther Nicol by John Oxenford, p.10, engraved by EL (? Ebenezer Landells or Edward Lee).
2. 'Wake not the Dead' to poem translated from the German by John Oxenford, p.50, engraved by EJ (? Edwin Jewitt).
3. Two untitled illustrations to 'Three Knocks at Quilcher's Door – A Christmas Tale' by Silverpen, pp 295, 302. No engraver's name.
4. 'Lord Macaulay' p.323 engraved by S (? Samuel Slader) from a photograph by Maull and Polybank.
5. 'The Sad Return' to poem translated from the German by John Oxenford, p.342 engraved by S (? Samuel Slader).
6. 'What the marks on the plate foreboded' to 'One of Our Orphan's Stories' by Frances Whiteside, p.362. No engraver's name.

HOUGHTON, Arthur Boyd

THE WELCOME GUEST
Volume1, Third Series, 1861

1. 'The Country Curate's Story', poem by Robert Buchanan, p.330. Engraved by William Measom.
2. 'The Steward's Story', text by Henry Vaughan, p.331. Engraved by William Measom.

MILLAIS, John Everett

GOOD WORDS

12. 1882. – 'Kept in the Dark'. Text by Anthony Trollope. Frontispiece or facing p.365. Engraved by Swain.

ONCE A WEEK
44. 1868, Christmas Number. 25 December,
 1868. 'Taking his Ease' facing p.64.
 Engraved by Swain.

MORTEN, Thomas

THE WELCOME GUEST
Volume 2, Second Series, 1860
1. 'The Legend of St.Christopher' to poem by
 Marian James, p.111. No engraver's name.
2. 'Do you hear ? He's out again !' to 'The
 Hunted Horseman: An Australian Legend'
 by Richard Rowe, p.170. Engraved by
 W. J. Linton.
3. 'Naomi' to poem by Albany Fonblanque,
 p.190. Engraved by W.J. Linton.
4. 'A Secret' to poem by Albany Fonblanque
 Junior, p.407. No engraver's name.
5. 'Too shabby for us' to 'The Shabby Young
 Man' by Frances Browne, p.410. No
 engraver's name.
6. Six untitled designs to 'The Hand of Glory'
 by John Hepburn, pp 411 (2), 431 (2), 447,
 450. No engraver's name.
7. 'What a jolly little 'Un'' to 'A Story
 of Assise' by Emilia Marryat, p.491.
 No engraver's name.
8. 'I perceived my flat stone was already
 occupied' to 'The Two Artists' by J. Brook
 Knight, p.510. No engraver's name.

Volume 1, Third Series, 1861
9. 'Here and There' to poem by Albany
 Fonblanque Junior, p.70. No engraver's
 name.
10. Two untitled illustrations to 'Recollections
 of a Relieving Officer', pp 154, 210.
 No engraver's name.
11. Nine untitled illustrations to 'The Indian
 Scout' by Gustave Aimard, pp 409, 468,
 496, 533, 561, 589, 617, 645, 701.
 Engraved by William Measom.
12. 'A Lady's heart to let' to poem by Albany
 Fonblanque Junior, p.392. No engraver's
 name.
13. Four untitled illustrations to 'The Painted
 Drudge' by Walter Thornbury, pp 421, 449,
 477, 504. Engraved by Edmund Evans.
14. 'Death of Clement D'Eyre' to 'The Artist's
 Story' by Albany Fonblanque Junior, p.347.
 Engraved by William Measom.

Index of illustrated books

Additions

Page 340 No. 209. Datable [1867]. Nos 210
and 211 datable [1868]
Page 351 No. 311. There was also published an
undated reprint by the SPCK [1885]
Page 351 No. 314. Also contains 'Will O' the
Wisp' after Arthur Hughes (page 67)
Page 353 No. 330. Later impressions of the
frontispiece are undated.
Page 358 No. 379. Eight engravings.

Additions

BRIGHTWELL, Cecilia Lucy

*Difficulties Overcome – Scenes in the Life of Alexander
Wilson the Ornithologist*
Pub. Sampson Low, Son and Co., 1861.
Frontispiece engraved by Horace Harral after
Charles Keene.
BL

LOCKER, Frederick

A Selection from the Work of Frederick Locker, Pub.
Edward Moxon, 1865. Frontispiece etched
portrait of Locker by Millais.
BL

LUARD, Julia

*The Childhood and Schoolroom Hours of Royal
Children*, Pub. Groombridge and Sons, 1865.
Second edition, 1887. Frontispiece engraved by
Dalziel after Arthur Boyd Houghton.
BL

MOTLEY, John Lothrop

The Rise of The Dutch Republic, Pub. Alexander
Strahan, 1863. Frontispiece 'The Siege of
Maastricht' engraved by Dalziel after
Thomas Morten.
BL

[ROBERTSON, Anne Isabella]

Myself and my Relatives, Pub. Sampson Low, 1863.
Second edition, 1887. Steel-engraved frontispiece
by Henry Adlard after John Everett Millais.
(I am indebted to Maroussia Oakley for having
drawn my attention to this book).
BL